# 1951-1993
# Visual Art

### Exploring Plane and Contour

The Drawing, Painting, Collage, Foldage,
Photo-Work, Sculpture and Film of Michael Snow
from 1951 to 1967
by Dennis Reid

### Around Wavelength

The Sculpture, Film and Photo-Work of Michael Snow
from 1967 to 1969
by Philip Monk

### Embodied Vision

The Painting, Sculpture, Photo-Work, Sound Installation, Music,
Holographic Work, Films and Books of Michael Snow
from 1970 to 1993
by Louise Dompierre

Art Gallery of Ontario | The Power Plant
Alfred A. Knopf Canada

Copyright © Art Gallery of Ontario/
The Power Plant – Contemporary Art Gallery
at Harbourfront Centre

The Art Gallery of Ontario is funded by the peo-
ple of Ontario through the Ministry of Culture,
Tourism and Recreation. Additional operating
support is received from the Municipality of
Metropolitan Toronto, Communications Canada
and The Canada Council.

The Power Plant extends its appreciation to
The Canada Council and the Ontario Ministry
of Culture, Tourism and Recreation, the Hon.
Anne Swarbrick, Minister, for insurance coverage
under the Ontario Fine Arts Insurance Plan.

The Michael Snow Project
Proudly sponsored by AT&T
Organized by the Art Gallery of Ontario and
The Power Plant – Contemporary Art Gallery
at Harbourfront Centre
Special funding made available by
the City of Toronto
Additional financial support from:
Museums Assistance Program of the Government
of Canada, the Exhibition Assistance Program of
The Canada Council, Government of Ontario
through the Ministry of Culture, Tourism and
Recreation, City of Toronto through the Toronto
Arts Council, The Municipality of Metropolitan
Toronto

Special thanks to:
Bowne of Canada, Ltd.
Canadian Filmmakers' Distribution Centre

Canadian Cataloguing in Publication Data
Reid, Dennis
Exploring plane and contour : the drawing,
painting, collage, foldage, photo-work, sculpture
and film of Michael Snow from 1951 to 1967...

(The Michael Snow project)
Catalogue of an exhibition held concurrrently at
the Art Gallery of Ontario and the Power Plant,
Mar. 11–June 5, 1994.
Includes bibliographical references.
ISBN 0-394-28053-9

1. Snow, Michael, 1929-  – Exhibitions.
I. Snow, Michael, 1929–
II. Art Gallery of Ontario.
III. Power Plant (Art gallery).
IV. Monk, Philip. Around wavelength.
V. Dompierre, Louise. Embodied vision.
VI. Title.
VII. Title: Around wavelength.
VIII. Title: Embodied vision.
IX. Series.

N6549.S5A4 1994  709'.2  C94-930309-7

Distributed by Random House of Canada
Limited, Toronto

# Table of Contents

**Exploring Plane and Contour**

The Drawing, Painting, Collage, Foldage,
Photo-Work, Sculpture and Film
of Michael Snow from 1951 to 1967
*by Dennis Reid*

**Around Wavelength**

The Sculpture, Film and Photo-Work
of Michael Snow from 1967 to 1969
*by Philip Monk*

**Embodied Vision**

The Painting, Sculpture, Photo-Work,
Sound Installation, Music, Holographic
Work, Films and Books
of Michael Snow from 1970 to 1992
*by Louise Dompierre*

This publication is a volume in a series of books that are part of The Michael Snow Project. The other volumes in the series are:

MUSIC/SOUND
The Performed and Recorded Music/
Sound of Michael Snow, Solo and with
Various Ensembles, His Sound-Films and
Sound Installations, and Improvisation/
Composition from 1948 to 1993

Edited by Michael Snow with texts by the artist, David Lancashire, Raymond Gervais, Bruce Elder and others

An introduction by Michael Snow discusses the image/sound inventions of his films and their sound tracks. Fellow jazz player and *Globe and Mail* journalist David Lancashire has contributed a biographical account of Snow's career as a jazz musician. He concentrates on what has become a mythical period in Toronto jazz history – 1948 to 1961 – when Snow played with many great American jazz musicians such as Pee Wee Russell, Cootie Williams, Jimmy Rushing and Vic Dickenson.

In an extensive three-part text, written in French by Raymond Gervais, Snow's recordings and his evolution from New Orleans/Dixieland/Blues Jazz to free improvisation is discussed. The book also includes a transcription of a three-way conversation between Snow, Allan Mattes and Nobuo Kubota (all founding members of the music ensemble CCMC) in which they discuss the aesthetics and history of the group and the international resurgence of free improvisation in the context of modern Western music. A written dialogue between Snow and Bruce Elder, a Toronto filmmaker, teacher and author of *Image and Identity*, brings together for analysis all the elements of Snow's work with sound – from live concerts, electronic music, film sound tracks to the many installations that have both sound and visual elements. They discuss the philosophical and psychological sources and implications of these works' multidisciplinary character.

A complete discography of Snow's recordings and about 150 reproductions of archival photographs are also featured in *Music/Sound*.

Available from Random House of Canada, 1265 Aerowood Drive, Mississauga, Ontario L4W 1B9, ISBN 0-394-28054-7, $33

## THE COLLECTED WRITINGS OF MICHAEL SNOW

This comprehensive anthology of Michael Snow's published and previously unpublished writings presents a history of a great Canadian artist, beginning with his early attempts at defining art and proceeding to his emergence and recognition on the international art scene. The texts are chronologically presented, and, if they are read in the same manner, this sequence gives a sense of the evolution of Snow's ideas and his career.

Since many of Snow's texts are meant to be seen as well as read, some are reproduced photographically in their original form. Other texts were performed at one time, that is, tape-recorded in advance and then lip-synced or mimed by the artist, rather than simply read. Also featured are texts printed on Snow's record album covers that are meant to be read while listening to his music. In addition to these less traditional forms, the book contains more typical essays, articles and interviews. Snow writes on the work of other artists as well.

*Collected Writings* acts both as a record of contemporary artistic thought by one of our leading Canadian artists and as a history book revealing important moments in the cultural life of this country since the Fifties.

Published by Wilfrid Laurier University Press / The Power Plant / Art Gallery of Ontario

## PRESENCE AND ABSENCE
### The Films of Michael Snow
### 1956-1991

Edited by Jim Shedden, with contributions by Jonas Mekas, Annette Michelson, Bart Testa, Bruce Elder, Kathryn Elder and Steve Reich

Snow's filmmaking, widely considered among the most important in the history of the avant-garde, overarches the duration of his career. Film is, perhaps, the medium where the sum of Snow's aesthetic concerns is witnessed: i.e., the nature of time, representation, consciousness, construction, language and transcendence. This book constitutes the most complete resource guide on Snow's filmmaking activity, combining a career overview with critical essays, anecdotal items, bibliography, filmography, film and video-related projects and a chronology.

Forthcoming title, to be published in 1994

# Preface

The Michael Snow Project realizes an ambitious and complex idea that Louise Dompierre, associate director and chief curator at The Power Plant, proposed to the Art Gallery of Ontario in 1989. She suggested that both organizations collaborate on a city-wide examination of the work of Michael Snow that would investigate the connections between his visual arts, music and writing. Four exhibitions are taking place from March 11 to June 5, 1994: three at the Art Gallery of Ontario, organized by Dennis Reid, curator of Canadian Art; Philip Monk, curator of Contemporary Art; Jim Shedden, assistant curator, Film and Video; and one at The Power Plant, organized by Louise Dompierre.

Each curator has taken a different approach to Snow's work: Reid examines the first fifteen years of his career as an artist; Monk focuses on three critical years in Snow's development (1967–69); Dompierre explores the artist's concern for the properties of photo-based imagery over the past twenty years; and Shedden provides a complete retrospective of Snow's filmmaking.

Over five years in development, The Michael Snow Project explores the many facets of Snow's work in painting, drawing, prints, sculpture, photo-works, film, video installations, music recordings, sound installations, bookworks and holographic works, and offers a rich selection of Snow's oeuvre. Concerts and performances by Snow and others are an integral part of the project. This is the first thorough investigation, documentation and analysis of the body of work created by Michael Snow from 1951 to the present.

The Michael Snow Project has been a stimulating collaboration between individuals and institutions. For all those involved with the project, we would like to thank first the artist, Michael Snow, for his ongoing and unfailing assistance. This project, whose development was extended over many years involved numerous meetings that no doubt added enormously to his already busy schedule. For his patience, but especially for the occasion of reflecting on his work and the pleasure of working with him, we will always be grateful.

We would also like to acknowledge the enthusiastic support for the project by the former director of the Art Gallery of Ontario, William J. Withrow, and two former directors of The Power Plant, William S. Boyle and Allan Mackay.

All the lenders to the exhibitions are to be thanked for their generosity. Those colleagues who have both facilitated the loan of works and provided useful information about them are also to be acknowledged: they are Josée Bélisle, Musée d'art contemporain de Montréal; Fern Bayer, Ontario Collection, Government Services; Barry Fair, London Regional Art and Historical Museums; David Falls, McIntosh Gallery; Gilles Gheerbrant, Casteinau-de-Guers, France; Charles Hill and Denise Leclerc, National Gallery of Canada; Mary Jo Hughes, Agnes Etherington Art Centre; Beverley Mack and Madeleine Palko, External Affairs and International Trade Canada; Darcy Moorey, The Canada Council Art Bank; Richard Rhodes; Natalie Ribhoff, The Toronto-Dominion Bank; Phyllis Rosenzweig and Judith Zilczer, Hirshhorn Museum and Sculpture Garden; Sandra Simpson and Sue Ellen McIntyre at the S.L. Simpson Gallery; Pierre Théberge and Elaine Tolmatch, The Montreal Museum of Fine Arts; Ian Thom, Vancouver Art Gallery; Serge Vaisman, Montreal; Michiko Yajima, Montreal. Bibliographic research assistance for *Exploring Plane and Contour* was provided by Niki Kavakonis.

Special thanks to Avrom Isaacs, Toronto, whose characteristic helpfulness was critical to the research for The Michael Snow Project.

Glenn D. Lowry,
   Director, Art Gallery of Ontario

Steven Pozel,
   Director, The Power Plant

# Foreword

AT&T's association with the arts is rooted in our belief that the arts are an important form of communication — and, of course, communication is at the core of our business. Artists see the world differently and they bring valuable insights and perspectives to us all. They expand our vision, challenge our assumptions. They test limits and disturb conventions. Those qualities prevent cultural stagnation. They also are important for business to celebrate. They are essential to the creative process in the R&D laboratory and to innovation in the marketplace.

In celebration of this communicative power of art, AT&T is proud to sponsor The Michael Snow Project as part of AT&T's international arts program. Through his rich and varied body of work, Michael Snow shares his insights and wit. His unique vision stretches beyond the museum gallery and into the public places of our daily lives.

AT&T is especially pleased to sponsor The Michael Snow Project, a major exhibition of the multiple achievements of one of Canada's great artists.

Robert E. Allen
  Chairman and Chief Executive Officer, AT&T

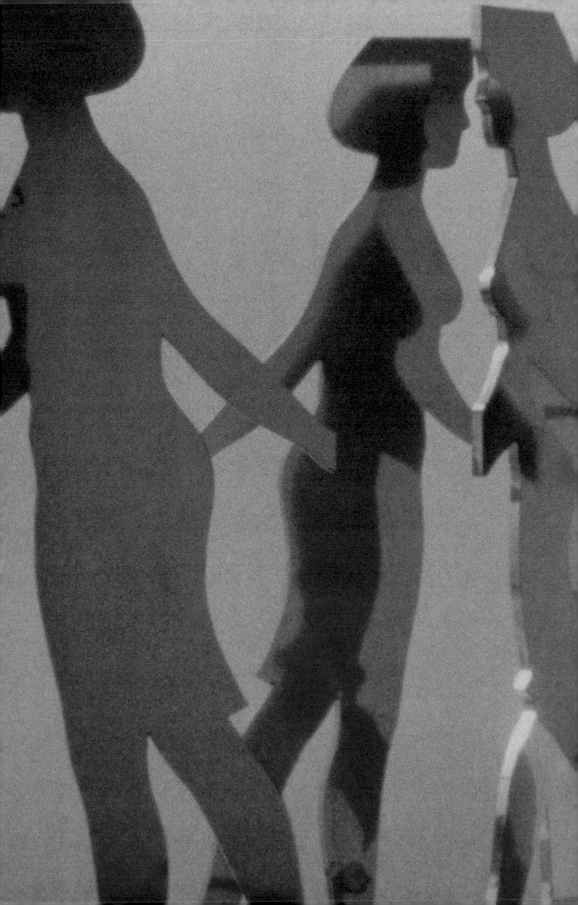

Dennis Reid

# Exploring Plane and Contour

The Drawing, Painting, Collage, Foldage,
Photo-Work, Sculpture and Film of Michael Snow

from 1951 to 1967

# Introduction

Michael Snow's Walking Woman Works are widely recognized to be a signal accomplishment in the history of Canadian art. His continuing development as an outstanding artist in music, film, photography, painting and sculpture, and the international recognition he has achieved in a number of these fields, has reinforced the historical importance of what from this point, a quarter century after the creation of the last major Walking Woman piece, might seem the foundation of a remarkable career. There are solid footings beneath that foundation. By the time of the first presentation of the Walking Woman, Snow had been exhibiting for ten years. Five solo exhibitions in Toronto had already gained him a reputation among a few astute observers of the small but rapidly expanding avant-garde scene as an innovative artist whose sometimes seemingly difficult work was immensely rewarding.

The purpose of this exhibition is to present a balanced view of the first fifteen years of Michael Snow's career as a visual artist, with as much emphasis on the now little-known work of the Fifties as on the famous Walking Woman Works. It will demonstrate that the most impressive features of his art were essentially in place at the beginning — that it entails both the act of perception and the process of its making, actually enlarges the capacity of media, the scope and complexity of visual effects, and sustains a vibrant link between the abstracted form enhanced by these effects and the representation of an image, that basic human urge to "picture" that brings meaning to it all.

My involvement in the Michael Snow Project has presented me with some challenges, not the least of which has been, as a historian, dealing for the first time with a subject who is not only still alive, but *very* alive. I've known Michael Snow since the late Sixties, however, and have followed his work closely since a few years before that, and so feel myself to be on familiar territory, by and large. In order to keep constantly before me, the reader and the exhibition visitor the fact that part of the material covered by this study resides in memory as well as in what we usually consider to be the more objective structures of historical conjecture, I have arranged it in three parts, and address the most familiar and recent first, then move back through time to conclude with the early years of a decade, the Fifties, that exists for me now more vividly as historical construction than as memory.

This reverse chronology provides a narrative based less on the concept of development than on that of discovery. Its goal is first of all to describe in some detail and with a semblance of order Michael Snow's production as an artist from the point at which he began to exhibit his work within a professional context until the

conclusion of the Walking Woman Works, when he was thirty-eight years old. In addition to this "reading" of the work, my text draws heavily for documentation on the artist's papers, now in the Edward P. Taylor Research Library and Archives at the Art Gallery of Ontario, and on family correspondence, kindly lent by the artist's mother, Mrs. Marie-Antoinette Snow Roig, and for interpretation on the artist's published writings and the contemporary reviews and commentaries of others. The writing of Robert Fulford, which covers virtually the whole period, is a remarkable resource in this regard. The one significant historical study of the period is Louise Dompierre's catalogue for the exhibition she organized in 1983, *Walking Woman Works: Michael Snow 1961–67*. It stands as a landmark in Snow studies and proved an invaluable guide as I navigated the sometimes difficult but always exhilarating currents of a career that is revealed to have emerged strong at its source and to have gained in breadth and depth ever since.

<div align="center">
The study that follows is fondly dedicated
to the memory of Greg Curnoe.
</div>

# I
# Remembering the Walking Woman

One of my strongest memories of the Universal and International Exhibition (Expo 67) at Montreal in the summer of 1967, of all the myriad displays of national pride, the vast international selections of cultural expression — all on the theme of "man and his world" — is the image of a woman, Michael Snow's Walking Woman, featured in a gleaming array of bright metal sculptures scattered about the grounds of the Ontario pavilion. It was an image by then familiar to everyone interested in contemporary Canadian art, although no less engaging for that. To those of us who had been following Snow's work over the previous few years, there was indeed a thrill in sighting that bold figure, striding briskly this way and that, confident, contained, secure in her identity, yet open, engaged.

None of us who tarried with the Walking Woman at Expo 67 was ever disappointed, I am sure, as we sought her familiar form about the complex site of the pavilion. Each glimpse of a fresh embodiment brought a shiver of excitement, succeeded soon by a deeper, spreading pleasure as we turned to bring this new experience to a reconsideration of the elements previously viewed. There were eleven of them altogether, concentrated mainly on the plaza that served as the entrance to the soaring vinyl tent-like structure of the pavilion; some, all simple, single silhouettes, if I recall, were to be discovered away from the crowds, strolling by the water, among the rough-cut granite blocks, white birch and aspen that had been mounded up around the site to evoke the character of Ontario's North.

There were six of these "cut-out" figures of the familiar silhouette, caught in strong mid-stride, alert, advancing, arms poised perfectly to balance a compact frame, tightly rounded, dress signalled by a notch where hem meets leg fashionably just above the knee, head held just so, hair neatly shaped, clear of the neck, pert nose, feet, hands and top of head cut cleanly away by an invisible frame, that necessary frame of reference that is the point of departure for all our musings on the specific nature of each particular manifestation of the Walking Woman (see 1a–f). These were larger than life size, flat sculptures not quite 3 cm thick and about 230 cm tall, unmodulated surfaces of polished stainless steel. Floating above their dark plate-steel bases on 15-cm pegs, the figures flared in the sun, turned dark

In the loft at 123 Chambers Street, New York, probably September 1965.

against sparkling water, were clothed in an ever-changing range of colours and patterns from the trees, sky, river, rocks and passing people. They disappeared entirely in the reflection of dense crowds.

There was one "negative" figure, the part of a rectangular slab of steel that would have remained when one of the six figures had been cut out, contained this time by an actual frame of shiny metal, bringing the total height to almost 245 cm (see no. 1g). There is one "crossing" figure — two figures, actually — joined as they passed each other, their overlapping bodies presented as a single plane of perfectly symmetrical metal, embellished by the delicate escutcheon-shaped space between their necks (see no. 1h). Their confident strides undiminished by this union, they in fact seemed to be stepping out of each other, like amoebae separating. The three remaining pieces dominated the entrance plaza, although they were subtly situated to direct the flow of visitors. The largest element was a huge, boxy, wall-like slab of mirrored metal that no longer survives, a block 305.0 cm tall, 457.0 cm wide, and 91.5 cm deep (see fig. 1). Out of one corner had pulled, it appeared, another aberrant clone of the Walking Woman, composed of two shiny silhouettes meeting at right angles at their noses (once the clean-edged corner of the block), their contours joined in a great arc through the 90-degree space between their backs like a segment of a smoothly turned top (see no. 1i). Finally, it seemed as though an even larger removal had been accomplished from the opposite corner of the massive block, resulting in

**Fig. 1** Plaza of the Ontario pavillion, Expo 67, showing the "wall" element of the *Expo Walking Woman*

a "stretched" figure, perfect at either end but connected between by a phalanx-like spread of almost 245 cm of smoothly modulated brushed stainless steel (see no. 1j).

The *Expo Walking Woman* was not widely remarked in print at the time. In an article on Canadian sculpture at Expo 67, one well-known commentator on the Toronto artistic scene, Harry Malcolmson, found little to praise at the fair. He did single out what he called "Michael Snow's 'Walking Woman' harem at the Ontario pavilion," a work that he felt was "strong," but strong "for reasons personal to Snow's idiosyncratic art," not because it fulfilled conventional expectations of sculpture. "Snow's work is really idea made visible," he wrote. "When Snow extracts his Walking-Woman shape from a painting, he never pretends it's a 'sculpture' he has made. It is clearly a painting-shape let loose into the world. The disconcerted spectator finds himself mentally clothing the Woman with a picture-

frame to restore her to her natural habitat."[1] While he appears to have appreciated the manner in which the *Expo Walking Woman* articulates the idea that framing is a precondition of all perception, Malcolmson not surprisingly failed at that point to understand the full implications of his observation as well as the complexity of the framing issues raised in the piece. On the other hand, we might have expected him to have appreciated other aspects of its sculptural sophistication. Although Snow had not made much conventional sculpture before the Expo piece, a long-time interest in working with three dimensions had intensified in recent years, and would culminate in a show of radically innovative sculptural pieces at the Poindexter Gallery in New York just three months after the closing of Expo 67. Indeed, there had been evidence of this new direction during Expo, when Snow was represented in a huge outdoor sculpture exhibition organized in Toronto by the National Gallery of Canada by *First, Last*, a large square grey slab whose major surfaces are punctuated by small glazed slots letting on to interior lenses that give unexpected views of sky, other viewers or just the space around.[2] There is no evidence of the Walking Woman in the piece, and it was but one of many signs that year that Snow had decided to retire what had become the most familiar image in Canadian art, a venerable icon of the imagination that for many of us in the early Sixties had represented a stable base from which to venture into the maelstrom of contemporary art. Snow had not abandoned us, of course. He would lead the faithful into ever more exotic realms of the imagination in the months and years to come, pursuing projects, most immediately in film, as well as sculpture, that would attract a whole new international audience. But in the summer of 1967, even for those of us who had heard him speak of his new direction, and who had caught glimpses of the new work, it was strange territory without the company of our constant travelling companion, the Walking Woman. Such thoughts brought a poignancy to the scale of the Expo piece, to its upstanding public nature, to the hauntingly hieratic quality of the symmetry of its major components. The *Expo Walking Woman* was a monument, we knew, to a figure and an era past.

The Walking Woman had been a part of every aspect of Michael Snow's artistic thinking and production since early 1961 (he dates the invention of the first silhouette to October 1960).[3] This period of some six years was one of remarkable change in his art, one that involved great decisions in his life, and that represented numerous significant junctures in his career. It was, at the same time, a period that in retrospect reveals steady development, a sense of reflective continuity and a consistency of vision that we will see has always been in the nature of his art. If this might seem to suggest plodding deliberation, it should be noted that the Walking Woman Works were presented not in a carefully orchestrated campaign of public

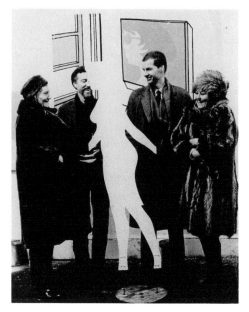

**Fig. 2** In the studio at 123 Chambers Street, New York, December 1965. From the left, Elinor Poindexter, Snow, Harry Malcolmson, Joyce Wieland.

exposure, but in the way that most artists present their work, in a series of exhibitions by which he responded, perhaps more cleverly than have many others, to the usual vagaries of opportunity in the art world. The main platform was five commercial shows, beginning with his long-time Toronto dealer, Avrom Isaacs, in March 1962, then, after he and his wife, Joyce Wieland (also an artist), moved to New York, with Elinor Poindexter in January 1964, Isaacs again in April that year, Poindexter in December 1965, and Isaacs the following April. That adds up to a show once every two years for each of his Toronto and New York audiences. This steady rhythm of major presentations of new work was intensified in the later years by three institutional exhibitions — a small retrospective at York University in Toronto in October 1965 featured work of the Fifties and very early Sixties as well as the Walking Woman; and exhibitions at the artist-run 20/20 Gallery in London, Ontario, and at the Vancouver Art Gallery, in October 1966 and January 1967 respectively, were overviews exclusively of the Walking Woman Works. He also seized most opportunities that arose to participate in group shows. All this activity elicited if not a constant, certainly a steady, stream of reviews, articles, broadcasts, photo spreads and other forms of journalism that kept the idea of the Walking Woman in front of everyone in Toronto, and increasingly those across Canada and among certain New York circles who had a developed interest in contemporary art.

What was this "idea" of the Walking Woman? It has, as we shall see, meant many different things to different people. Snow himself articulated his ideas on the subject, so to speak, in a piece he began to write during the months just before and after he and Joyce Wieland moved to New York in the fall of 1962. Although "A Lot of Near Mrs.," as he calls it, has been published in full twice before, it is well worth examining here in some detail, for it lays out his goals and strategies while in the process revealing the way he works.[4] Like many creative people, Snow is an inveterate note-maker, in both verbal and visual — that is, diagrammatic or otherwise drawn — forms. He saves, it seems, every note he makes, accumulating masses of thoughts around certain ideas. He reviews them constantly, picking up on repeated

notions and in countless other ways reflecting, cross-fertilizing, turning over the compost. As we will see later, Snow's art-making often centres on the deliberate exercise of technique, on what we might call the investigation of "effects." Activated by an unusually open and analytic mind, this approach underlies the often surprising turns we admire in his art, and, I think even more significantly, results in the complete engagement of both the intellectual and the sensuous elements of his being, leading, very often, to the fusion of those two elements in his work. "A Lot of Near Mrs." is a piece of writing that has emerged from the same process by which he creates his paintings, sculptures, films and music, and it, like them, presents this same fusion. It also can be said to exist in an exquisite tension between abstraction and representation, and this too we will see to be a central characteristic of Snow's art.

He commences "A Lot of Near Mrs." by situating his practice — "Closed shop. Trade*mark*. Trade: Art. *A* sign *to* sign" — but soon begins to interweave thoughts on how this practice, this sense of himself as something like a unionized worker, replicating a form that as a product declares his activity, also establishes certain characteristics of the art. "Simultaneity. 'She' is the same in different places and different times at same place and time." While isolating characteristics of the art in this way often can reveal philosophical and even metaphysical dimensions, it also reflects back on the practice. "Repetition: Trademark, my trade, my mark. Mock mass production. Art the only 'cottage industry' left." Further characteristics slide off into suggestions of use and range. "Juxtaposition: a 'surrealism' of media within one subject. Social comment, narrative, realism, satire, allegory, abstraction, didacticism, mysticism: art from drawing to past sculpture." And this leads back again to the practice — "Stage director" — and then again to the characteristics of the art, and the philosphical/metaphysical implications of those. "Fact and fiction: the relationships between space and light illusions (imagination?) and a physically finite object. Coloring books: anyone can do it. Jane Arden. Perils of Pauline."

It is a richly evocative way of exploring the work *and* the working, and effectively reveals Snow's concerns. Following is a further selection of his often aphoristic reflections from "A Lot of Near Mrs." that we will find useful later on:

— Women historically as subject in art. Women "characters," "types," "actresses" designed by artists. Cranach, Rubens, Ingres, Renoir, Pascin, Modigliani, Picasso, etc. "Abstract" *this* element of painting....

— Revelation of process as subject in Pollock, de Kooning continue. Scientific method. Experiments....

— The subject could have been *my* image but prefer to add, multiply create not mirror....

— My subject is not women or a woman *but* the first cardboard cutout of W.W. I made. A second remove depiction. Always use it same size as original. 5 ft. tall. W.W. is not an idea, its just a drawing, not a very good one either!...

— I'm not so interested in making a lot of paintings, sculpture etc. as finding out what happens when you do such and such a thing....

— "Art" and "life" problem. Duchamp. If you can use stuff from the street as art in an art gallery why can't you use "paintings" or art as art in the street. Not found art but *lost* art. Who can see it?...

— Exhibition "announcements" as much part of it as the paintings. All art....

— "New" representational art and its uses. A representation can be used for something else. I will take orders for any use to which "she" might be put. *Art pimp.* Lady fence, lady table, lady chair, lady lamp, rubber (balloon) lady, water bottle lady, fur lady, stained glass lady, lady road sign, lady shovel, lady car, lady dart board, lady hat rack, leading lady, first lady, lady like....

— What are the differences in "meaning" in comparing the same form (W.W.) in sponge rubber, in plastic, in sand, in light, etc.?...

— Little paintings, printings in street, subway, etc. Compositions of same. Perhaps another painter might paint it. Audience participation: people scribble on, attack, etc. These "posters," who thinks they are "art"? I've reclaimed some of the drawn-on etc. ones....

— Dispersal: 4 or 5 "paintings" in the street, related but separated by as many blocks....

— Influences and thank you: Duchamp, Matisse, de Kooning, Mondrian. Echoings of artist working in "Happenings" and "environments," the ideas, having never seen same....

— I'm optically amoral. I don't see what those signs and those things are selling. Some of my ideas turn out to be similar. An unexplainable coincidence which is not leading me to work directly from that material tho I often see signs, displays, etc., which are very interesting. I like work of Johns, Oldenburg, Dine, partly because apparently they came to similar conclusions arising out of the accomplishments of the great senior New York painters....

— In painting a figure on/in the rectangle the relationships exist between the figure and its environment. When you paint a "cut-out" flat representation of a figure rather than on a rectangle, the relationships now are internal. The "environment" of the figure now becomes separate, and out of my control. But now I think of where as well as what. ("lost" compositions, mail, females, publicity pix, etc.)....

— I *don't* "believe" in representation. But we really look and say "it's a woman!" Passing through. Is "material" a representation too. Is it any *realer*. We *must* believe that it is. My "subject" is the same in the 59 and 60 abstract paintings and sculpture but now it is acted....

— Women are the nearest "other." The first "other."

— There is something *inside* repetition....

"A Lot of Near Mrs." was written largely over a period, it seems, of some seven months, from the summer or late spring of 1962 when Snow was reflecting on the responses to his first Walking Woman exhibition (he later reported that he began it "basically to clarify things for myself," but that it was also prompted "by an attempt to answer what I felt were misunderstandings in what was being written about the work I was doing"), until he and Wieland had settled successfully in New York.[5] It reveals his thinking during one crucial phase in his career, just following the first public response to what had appeared at the time to have been a very radical shift in his work, and just as he was accomplishing what must have been an unsettling as well as exhilarating move. It also dates from a relatively early point in his development of the Walking Woman Works, and before the intense, stimulating environment of New York's lower Manhattan art scene had been able to exert much influence. If we keep these factors in mind, then "A Lot of Near Mrs." can serve as an effective tool in assessing the critical response to Snow's Walking Woman Works over the six years that he was engaged in their presentation, and as we take a closer look ourselves at the nature and extent of his production.

To further assist us in gaining some sense both of the extent of the Walking Woman Works and of the nature of their development over the six-year period (for certainly Snow's ideas about them changed and his interests shifted), it would be useful to categorize the production in relation to three phases. The earliest extended through 1961 in Toronto, culminating in the first Walking Woman exhibition at the Isaacs Gallery in March 1962. It was a period of intense activity, and although it is roughly only one year of the six devoted to the Walking Woman, it accounts for some 22 percent of the works that we can identify today. What with the disruption of the move to New York, it is not surprising to discover that only about 11 percent of the currently known titles date from the balance of 1962, and the second stage of real production began only very late that year, then ran through 1963 to the first Poindexter Gallery show at the end of January 1964, followed by the second Walking Woman show at the Isaacs Gallery three months later. A remarkable 36 percent of the known works date to that twelve- to fourteen-month period. The third phase then encompassed the period until December 1965 and the second Poindexter show, and what would be the last of the series of commercial exhibitions of the Walking Woman Works, at the Isaacs Gallery in April 1966, which opened just a week after Snow was awarded the Expo commission. This roughly two-year period accounts for only some 27 percent of the known works, although among them is *New York*

*Eye and Ear Control*, Snow's first ambitious film, premiered in Toronto in April 1965, and in New York the following fall, and the much shorter *Short Shave* (December 1965). Neither film was received at the time with either public encouragement or understanding. The New York screening of the first film "was one of those riots with people throwing things at the screen," and three-quarters of the audience walked out at the Toronto premiere.[6] They are important works of art, however, and *New York Eye and Ear Control* (which is subtitled *A Walking Woman Work*) is essential to our understanding of one major aspect of the production of this period, the extensive body of work exhibited or otherwise exposed outside art galleries. We will look at it, and *Short Shave*, when we later examine what Snow has called his "lost art" pieces.

The Walking Woman came to be known to those interested in contemporary art, then, primarily through the five commercial gallery exhibitions, and we will look back first to the most recent of those, held at the Isaacs Gallery in Toronto in April 1966 and at the Poindexter Gallery in New York in December 1965. They were essentially the same exhibition. Not large, as we will see later, by the standards of the earlier Walking Woman exhibitions held in the same spaces, they were notable for the number of large-scale pieces on display. The Isaacs Gallery space was long and narrow with a large free-standing wall about two-thirds of the way to the back, a much smaller one, like a spur but set away from the wall, closer to the front on the left, and another, attached this time, and thick, like a pier, that jutted out from the oposite wall a little closer to the front. The gallery was dominated by *Five Girl-Panels* (no. 16), which filled the forward side of the large free-standing wall, commanding the view from the door. There were fifteen other pieces (only twelve others in the New York showing, where *Five Girl-Panels* also visually dominated the space). *Morningside Heights* (no. 10) was on the front of the spur wall in Toronto, and *Sleeve*,[7] a huge piece spread across more than three and a half metres, made up of an arrangement of twelve separate elements in a variety of media, each employing different representational strategies, covered the left-hand wall of the space between it and the large free-standing wall. *Mixed Feelings* (no. 6), which is two and a half by one and a half metres, entirely filled the face of the pier, and *Just Once*,[8] and *Test Focus Field Figure* (no. 11), both canvases about as large, were interspersed among more multi-element works like *Hawaii* (no. 17) and *Sending and Receiving Crosswalk and After* (no. 3), as well as strange protruding relief works, one of which, *Seen* (no. 9), stuck out into the room like a big nose, and another, *Cry-Beam* (no. 8), intruded with ear-like wings.[9] There were only four works on paper included in the Toronto show (and but three in New York), and these, like *Ink Walk* (no. 14) and *Galaxy*,[10] substituted for the similar

*Encyclopedia* (no. 13), which had been sold in New York, were in the main large, visually complex works.

I recall that the Toronto exhibition, which had been anticipated eagerly for the two years since Snow's last one-man show at the Isaacs Gallery, was the talk of the town. Responses were mixed. Those who were most critical saw the show either, at the one extreme, as a psychedelic funhouse or, at the other, as a cynical parody of the "war of the styles" that was a feature of the contemporary art scene. Some embraced one or the other of these interpretations and praised the achievement. It was, after all, just before the peak of the first great enthusiasm for lysergic acid diethylamide, LSD or "acid," then among the most powerful of the mood-altering drugs that were fuelling the so-called psychedelic revolution.[11] The fascinating sequence of distortions in *Five Girl-Panels*, bracketing a "normal" figure, can be related to the extreme perceptual alterations that often are experienced when one uses LSD. The alteration effected by looking through the hot pink window of *Morningside Heights* is one also familiar to LSD users, as is the hypnotically expanding space that we experience when looking closely at the little Walking Woman painted on the tip of *Seen*, with the colours of her extremities rushing off in inverted perspective. There is the "wallpaper-alive" effect of *Encyclopedia*, the intense focus of *Cry-Beam*, the inexorable expansion of the Woman and her immediate space in *Test Focus Field Figure*, the melting, "bleeding" ink figures of *Ink Walk* and so on.

On the other hand, when *Five Girl-Panels* was shown in the 1964 Pittsburgh International exhibition, it was described in one review as "five views of the same figure rising like a shadow, only in color, from squat to stand to stretch and back down," a compositional strategy that was perceived as evidence of how "even Pop devices can be incorporated into art."[12] And in her 1966 survey, *Pop Art*, Lucy Lippard reproduces *Five Girl-Panels* and describes its maker as "Canada's best-known tangential Pop artist..." many of whose "paintings are strictly Pop; an equal number are not."[13] Some saw *Morningside Heights*, and particularly its sculptural floor element, as relating to the new Minimal art: indeed, it had been included in the *Polychrome Construction* exhibition that Snow had helped organize at the Isaacs Gallery in March the year before and that included work by the emerging master of New York Minimalism, Donald Judd. *Seen* and *Cry-Beam* were interpreted to be wry comments on the extremes of Shaped-Canvas painting that had been developing everywhere in response, in large part, to the work of the Englishman Richard Smith, some of whose recent pieces we had seen just a few weeks before when the travelling exhibition *London: The New Scene* stopped at the Art Gallery of Toronto (as the Art Gallery of Ontario was then still known).[14] This same exhibition contained recent work by Jeremy Moon and Bridget Riley, artists in the forefront of

the Op art phenomenon. Could Snow not also have been toying with their sorts of optical excitements in *Five Girl-Panels*, with its amazing magenta against burnt orange, brought into exquisite vibration by the electric white outlines of the silhouettes? And what of Hard-Edge, with *Hawaii*, where the deliberate drips appear to confront the aesthetic? Or of Post-Painterly Abstraction, fresh in receptive minds because of Clement Greenberg's defining exhibition, shown in Toronto just a year before?[15] Could *Mixed Feelings* be seen as anything other than an ironic eclecticism, a sampler of all the styles? Some of us believed that while Snow's intentions encompassed these two extremes — the "acid" sensations and the acid wit — the great weight of his intent nonetheless rested on deeper concerns than the current fashions of art, concerns that were motivated by his own long practice rather than by a desire to comment on the practices of others.

That his concerns ran deeper than artistic fashion is evident in the then still unpublished "A Lot of Near Mrs." Although it had been written three years earlier, it reads as if it were a guide to these last of his Walking Woman shows. Remember the uses he listed for his subject: "social comment, narrative, realism, satire, allegory, abstraction, didacticism, mysticism: art from drawing to past sculpture."[16] Almost all are addressed in *Mixed Feelings* alone, and "past sculpture" could describe *Seen* or *Cry-Beam*. Evident instances of the "revelation of process as subject" abound. *Just Once* is four figures in the same colours, but each in a different type of paint or paint application: sprayed enamel, brushed enamel, oil and acrylic. *Ink Walk* was achieved with a rubber stamp of the Walking Woman using ink that is prone to soaking into paper. With *Register* (no. 18), which was shown at the Poindexter Gallery but not at the Isaacs — it had been included in an exhibition in Toronto, *Art and Engineering*, about a year earlier[17] — Snow has created an elaborate wall piece in the form of a mechanical press of some sort (it was compared to a silk-screen press in the earlier show), which he then employed to create a monoprint. By bending down and craning our necks we can still see the virtually unchanged "original." *Register* is also an example of Snow's "finding out what happens when you do such and such a thing." "What happens" is not just the product resulting from pressing a still-wet oil painting against another flat surface, but also the partly concealed, charged space created between the two images when they are pulled apart and held, fixed as an intricate statement of their specific relationship. There indeed is "something *inside* repetition."

The New York critics did not make much of the Poindexter show. Jill Johnston, writing in *Art News*, simply described a few of the pieces, although the pleasure she took from them is evident: "A striking multi-piece work shows the woman in five progressive positions; a very low squat on a low rectangular canvas, medium squat,

normal and elongated (the canvas diagonally tilted) to a low slant on a shaped rhomboid."[18] Amy Goldin in *Arts Magazine* found little to please her, although she did believe that she understood what the show was about: "Mr Snow obviously finds the laws of perception among the most fascinating of the facts of life, but his enthusiasm does not seem highly contagious."[19]

The New York opening was news in Toronto, however, where it was reported by a correspondent that there were none "of the protest disturbances which marked the showings of Snow's recent avant-garde film. In fact, the predominantly beatnik audience — beards abounded — seemed to love the Torontonian's poppings."[20] Harry Malcolmson travelled to New York to give the show critical coverage. "Much of the show is what I would call sequence painting," he wrote.

> *Five Girl Panels* consists of a sequence of five canvases. Each canvas reproduces a distorted Walking Woman as if we are seeing her image in a Fun House mirror. Moreover, the distorted image dictates to the painting. Where the image is short and squashed, Snow uses a stubby canvas shape. Where the image is long and lean, the canvas is correspondingly tall and narrow.
>
> Then as a final virtuoso touch, Snow has made thick stretchers for the squat canvases, and thin stretchers for the lean image canvases.
>
> A Snow painting like *Five Girl Panels* resembles intellectual beading. The painting is a starting point for a chain of Snow ideas about the nature of reality. His work provokes a viewer's eyes, then his mind.
>
> Over a period of time, I have seen a number of Snow paintings with mirrors and mirror images themes running through them. *Five Girl Panels* is perhaps the best presentation of the problems he has been exploring.[21]

Reviewing the show in Toronto in April, Malcolmson pointed out that it was essentially the same show he saw in New York, although it looked

> 100 p.c. better in the Isaacs Gallery setting than it did at the Poindexter Gallery in New York. A Snow exhibition should be installed so as to have a will of its own: the constructions in particular should move people about the gallery, imposing its own pace on the viewers. That's what happens in the ample spaces of the Isaacs Gallery.

Because he had reviewed it in New York, he did not want to give the exhibition detailed attention again, but he offered a broad judgement of its merits.

> I find this to be the most outstanding Snow exhibition I have seen. Every piece is telling

and authoritative: After several years of working with the Walking Woman, Snow knows exactly what he wants to do in each new variation, and he does it.[22]

Kay Kritzwiser also saw in the exhibition evidence of Snow's mastery and of the serious nature of his program. "I want to make seeing palpable," she quotes him as saying. "I want to say something with static things — to fix something which has stopped within the flux of what's going on."[23] She herself, like Malcolmson long familiar with the Walking Woman, enjoyed the levels of engagement in the show.

> The immediate, and perhaps frivolous, impression is that the economic circumstances of Snow's Walking Woman have vastly improved. That is an acceptable thesis, provided one then digs below to Snow's true explorations. In Mixed Feelings, the Walking Woman develops a fetching cleavage, a flowered shift. She becomes Negro, then Chinese and she wears eye-shadow. But these striking panels also read with great interest, left, right and centre. The central figure's dress, made of tiny crosses, in turn becomes an X which leads the eye to surrounding panels, painted in primary colors, or in black and white, or following the color wheel, or in hard-edge stripes.[24]

Probably because these critics had dealt with the issues arising from the programmatic nature of the Walking Woman Works years before, their reports of the new work seem today too narrowly focused on what might be described as its literal content. To follow on with *Mixed Feelings*, for instance, what always strikes me first when I see it is how monumental it is. It is big, bold and grand, and no matter how caught up one might become in the wonderful anecdotal details of its fifteen distinct images, the sense of that great presence never recedes. That is partly because similarities between figures keep us conscious of the whole scheme. The eye moves naturally to connect those Women formed of large areas of various flat colours, for instance, as in the upper left, and the second from the right in the centre row, and the one directly below, only to be drawn off as one of those also connects with another group, the pink figure, second from the right on the centre row, again, leading us to her blue neighbour farther right, and then while we think increasingly of the subtle beauty of the monochrome, up to the right-hand corner, then to the lower left, and on and on. Sustaining our investigation, indeed spurring it, is the pleasure we find in the cleverness of Snow's colour and texture strategies, of the different methods of paint application, and of the variety of relationships of figure to ground. And in the effects he achieves: the clean, matte black, white, red and yellow against blue; the delicate violet ghosting of the edges of pink, dusty blue and grey shapes; the sharply cut in black silhouette; the feathery pink shadow on the inside of a knee.

*Test Focus Field Figure* similarly commands attention by its scale. Although its structure might at first seem less complex than that of *Mixed Feelings*, it too is deeply engaging. The image represents the experience of viewing a figure in three consecutively closer stages, as though through a telephoto lens. The complete figure on the left, in warm, intense colours that nonetheless have been applied softly to suggest atmosphere, is seen more closely in the centre, and so is more tightly cropped, the colour slightly diffused. Then the cropping is so tight on the right that only a fragment of the figure remains, and the colour is faded, anemic. Viewing it as a painting on the wall, we enter into this narrative structure of the filmic "zoom," but we also, and perhaps more naturally, read it pictorially, as a figure that is growing larger in each successive section, and moving toward us. In this visual ambiguity, within the tension between experiencing our perception moving in, and the figure growing up and out, resides the poetry of the piece.

The bubble-gum colours of *Hawaii* at first glance suggest a surprising superficiality. But for me two things work to create that experience that is the appeal of every Snow piece: first is the carefully constructed, complex spatial structure that, as we examine it carefully, seems magically to bring real substance to those tropical-fruit colours; the second is the clever shift of perspective. The right-hand Walking Woman "portrait," situated in a carefully composed interior, seems a normal picture on a wall, until we reflect on the "normal" panel in the centre, and then try to encompass the twist thrown in by the panel to the left with the "enhanced" perspective. The poetry here arises from the tension between substantial, enlivened structure and a shifting, ambiguous point of view.

Snow's first New York show, in late January 1964, and his second Walking Woman exhibition at the Isaacs Gallery, also two years earlier, in April 1964, were in certain respects very different from the last two. They contained considerably more work — twenty-one pieces in Toronto (compared with sixteen in 1966), and twenty-seven in New York (as against thirteen in 1965) — and they shared only eight pieces. The Poindexter show, as might be expected, was made up almost entirely of work of 1963, with a few pieces from the previous year, such as *Coat of Blue #1* (no. 45), *Four to Five, June 20th 1962* (no. 44) and *Green Skirt* (no. 46). The Isaacs show had only one work of 1962, *Coat of Blue #1*, and while the majority of pieces dated from the following, very productive year, there were a surprising eight works of 1964, including *Two Skirts* (no. 20) and *The Chiffons* (no. 19). Although large works did not dominate the spaces as they had in the shows of 1965–66, they still were prominent. There were six big pieces in Toronto and seven in New York, four of which — *Olympia* (no. 36), *Four* (no. 26), *Estrus*,[25] and *Four Grey Panels and Four Figures*[26] — were in both exhibitions. The Isaacs show also

had *Gone* (no. 28), and the spectacular *Clothed Woman (In Memory of My Father)* (no. 38). There was only one multi-element piece in Toronto, *Four Grey Panels...*,

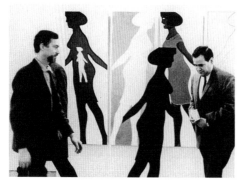

**Fig. 3** The Isaacs Gallery Toronto, April 1964
Snow and Avrom Isaacs in front of *Four Grey Panels*
*and Four Figures*

and only two in New York, it and *Bikini*,[27] and only three three-dimensional pieces in Toronto, the little table-top assemblage, *Display*,[28] and the wall pieces *Gone* and *Interior* (no. 30). There were five in New York: *Interior*, *Torso* (no. 29), *Corner Piece* (no. 25), *Sideway*[29] (a 1962 precursor of the "stretched" figure in the Expo piece), and *Greene*[30] (a 1963 variant).

The most sympathetic of the New York reviews was written by Donald Judd, and he, not surprisingly, admired these three-dimensional pieces most. (*Torso* is reproduced with his review.) It is apparent that he examined the whole show carefully, however, and his response, while mainly descriptive, is carefully measured and finally supportive. He proceeds by detailing Snow's overall strategy of juxtaposing the figures in what Judd calls "panels," although most of these are painted sections of larger canvases rather than groupings of distinct elements such as Snow usually would deploy later.

In the five-panel piece [*Olympia*], the first one shows the woman dressed; the shadows are blue and everything else is light green, regardless of boundaries. The second profile is a dotted outline. The third is a white silhouette on blue. The fourth is a purposely inept, art-school figure with a green background, and the last panel is a green pattern on white. Depicting a single thing in different ways is potentially interesting. Snow makes his subject, and in addition one pose, the constant part of his work; the style and technique vary widely. This is something of a point-to-line relationship, and it is the reverse of the old idea of a permanent style depicting everything. But Snow's variations aren't developed enough yet. The panel with blue shadows is the best in that piece. And the profile of the woman is obvious. All of this resembles Jim Dine's several depictions of a thing — which is also potentially interesting. I like the three-dimensional pieces best. The profile isn't so obvious, in fact almost justifies itself, since there is to be something recognizable in the objects, it has to be very simple in order to remain after the expansion into three dimensions.[31]

Stuart Preston, writing in *The New York Times*, appears to have caught not even a glimmer of those formal implications of Snow's work that Judd found interesting,

choosing rather to see the show as a more or less literal translation into Pop art terms of Henry James's classic "American Girl," "each one different but all linked in a dignified processional fashion."[32] Natalie Edgar in *Art News* found even less to interest her. Believing that she had quickly grasped Snow's method — "He reduces and then freezes subject-matter into the form of a 5-foot silhouetted female figure, which he then treats in any number of styles" — she turned the rest of her effort to crafting a one-line New York put-down to close: "It's like having a paper doll all your own."[33]

As we have seen, there was keen interest in Toronto in Snow's second New York exhibition of December 1965, even though it was to be transported here virtually intact about three months later. That was, if anything, even more the case with his first New York opening two years earlier. The respected arts journalist and critic Robert Fulford travelled down for the event, reporting for the popular *Maclean's* magazine. Not really a review, Fulford's article is a considered reflection on why Snow and his wife, Joyce Wieland, had left Toronto for New York a year and a half before, and on how their new environment was reflected in Snow's first New York show. It was, Fulford felt,

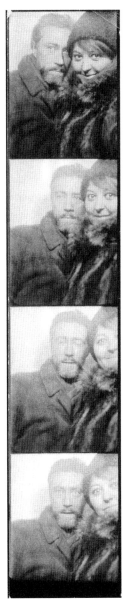

> the best exhibition of Snow's career so far, a new flowering of a remarkable talent, an exhibition that made it plain why Snow had moved to New York and why he had found it so satisfying a move.
>
> In Canada, Snow's painting had revolted as many people as it attracted, or more. It was always intransigent — an edgy, nervous kind of art, given to bumpy rhythms and abrasive, almost unacceptable color contrasts. He had worked in and around the abstract expressionist style with real originality and daring, but he had apparently always found it necessary to bridle his talent in one important way. He tended to shun "fine painting," warm and obvious bursts of color, and charming effects. I think the reason was at least partly his reputation, and the pressure it put upon him.
>
> About three years ago he began to use in his paintings and drawings a curious shape, a walking woman who seemed to have been cut out of some comic strip of his childhood. He stencilled the girl's shape on his canvas, outlined her at the edge of his paintings, worked her into countless drawings.
>
> Snow took the Snowgirl to New York with him (he's been working on a film centred on her for a year) and began using her in a new series of

**Fig. 4** Snow and Wieland, New York, New Year's Eve, 1964

paintings. But now she is used in a far less abrasive and "difficult" way — or so it seemed to me. Many of the paintings in the new show are brilliantly original, as Snow's work often is; what is new is that some of them are also charming and a few are genuinely elegant. My guess is that Snow, having moved away from his reputation, has been able to lift himself beyond it. In a city where few art lovers know him and few expect anything of him, he has been able to let his own personality spread itself across his art in a way that wasn't possible in Canada.[34]

My recollection of the talk among gallery-goers in Toronto following the opening at the Isaacs Gallery in April is that it largely revolved around Snow's relationship to New York Pop art. It is a question perhaps of only limited interest today, and back then was hardly the subject of sophisticated analysis, but by considering it, people came to understand the special nature of Snow's practice. Two years later, you'll recall, Lucy Lippard would declare that while many of his "paintings are strictly Pop; an equal number are not."[35] In Toronto in the spring of 1964 nobody sat on the fence. The question was on everyone's mind, because Pop art was. Defined in its American form by a series of exhibitions in the early Sixties — *New Paintings of Common Objects*, organized by the Pasadena Art Museum in California in September 1962, and *New Realists* at the Sidney Janis Gallery in New York in November of the same year, likely were the most influential — it caught the imaginations of both the critics and the broader art public almost immediately. Hailed as the long-awaited successor to Abstract Expressionism, and like it determined to be quintessentially American, Pop art had emerged just in time, it was widely believed, to maintain the position of the United States, and especially New York, as the world centre of contemporary art. A veritable deluge of American public gallery exhibitions in 1963, beginning with *Six Painters and the Object* at the Guggenheim Museum in New York, March–June, then *Pop Goes the Easel* at the Contemporary Arts Association in Houston, Texas, in April, *The Popular Image* at the Washington Gallery of Modern Art in Washington, D.C., in May, *Popular Art* at the Nelson Gallery-Atkins Museum in Kansas City, Missouri, also in May, *Six More* at the Los Angeles County Museum of Art, July–August, *Pop Art USA* at the Oakland Art Museum, California, in September, *Mixed Media and Pop Art* at the Albright-Knox Art Gallery in Buffalo, New York, November–December, *An American Viewpoint* at the Contemporary Arts Center, Cincinnati, Ohio, also in December, assured that media response to the phenomenon approached frenzy. It all came home to Toronto with the exhibition *The Art of Things* at the Jerrold Morris International Gallery in October 1963, an exhibition of work by nineteen artists, among them the already declared stars of the movement, Jasper Johns, Robert

Rauschenberg, Jim Dine, Robert Indiana, Roy Lichtenstein, Claes Oldenburg, James Rosenquist, Andy Warhol and Tom Wesselmann.[36] *Canadian Art* magazine came out with Andy Warhol's *Silver Liz* on the cover of its January/February 1964 issue and with a feature article in response to the Jerrold Morris show.[37]

Donald Judd had drawn comparisons between Snow's art and Jim Dine's in his review of the recent New York show (which appeared in March, just before the Isaacs opening), and if we go back to "A Lot of Near Mrs.," we can see that Snow himself had recognized a link. "I like work of Johns, Oldenburg, Dine, partly because apparently they came to similar conclusions arising out of the accomplishments of the great senior New York painters."[38] We'll explore that connection with Abstract Expressionism when in the next chapter we look at what Snow calls his "abstracts" of 1959–60. By situating himself with these recognized Pop artists solely in terms of their common roots, Snow implies that he perceives no closer connection. Indeed, his remarks on the subject in "A Lot of Near Mrs." are preceded by an observation that seems to allude to the popular subject matter that identified Pop art. "I'm optically amoral," he says, presumably meaning that he places no moral value on things seen. "I don't see what those signs and those things are selling. Some of my ideas turn out to be similar. An unexplainable coincidence which is not leading me to work directly from that material tho I often see signs, displays, etc., which are very interesting." In other words, although his work might sometimes resemble popular imagery, and although he often is attracted to such imagery, he does not consciously work from it in the manner that in the Sixties was one of the defining characteristics of Pop art.

That his work was figurative, representational, did suggest a connection with Pop art to some viewers. Only one piece in the Toronto show presented an evident connection to popular culture, however — *The Chiffons*, a lusciously coloured grouping of four Walking Woman heads that Snow named after one of the best "girl groups" of the day, a New York-based quartet whose hit single of 1963, "He's So Fine," we all had in our heads. *Corner Piece*, shown in New York, might have seemed Pop because it takes the form of a corner-mounted set of knick-knack shelves. But it is a Walking Woman that is contrived so (the work of the "Art pimp," putting his "lady" to a "'new' representational" use), and the work clearly has more to do with Snow's ever-fresh desire to keep "finding out what happens when you do such and such a thing" than with in some way entailing popular culture. Here he has collapsed his familiar shape into a corner, mounted three shelves on it and painted it hurriedly with thick, creamy white enamel that dripped and congealed in pools, but now has taken on a surface like old ivory. The shelves' edges are touched in with artist's colours in portions of the spectrum, yellow-orange at the top, the blue end

at the centre, and rose through magenta at the bottom, an effect that emphasizes the play of light on the sheen of the enamel and also accentuates, enlivens the curves of the shelves. That Snow's strategy was in fact to push in the other direction to Pop's flow is clearly articulated in *Display*, in the Toronto show, in which the Walking Woman is presented as a universal trademark, "my trade, my mark," her image affixed to an array of bottled and boxed products.[39]

The Toronto critics all recognized this distinction. Barrie Hale related it to his readers with a borrowed explanation, a quotation, he said, from *Art News*:

> . . . the private image, the personal signature of abstract expressionism, which "pop" artists oppose by their public brand name images that bring the mundane world into art, find a curious mutation in the personal trademark of Snow, who is trying through his walking woman to transplant art into the world.[40]

The article is illustrated with a photo of one of Snow's friends pulling open his shirt to reveal a Walking Woman T-shirt. Kay Kritzwiser reported in some detail on the twenty T-shirts Snow had handed out to be worn at the opening, and that "he has plastered New York" with Walking Woman stickers,[41] blocks of which, suitably overprinted, had been used as the mailed-out invitation for the Toronto show. Elizabeth Kilbourn, in a long, thoughtful review in which she celebrates the complex diversity of Snow's production, also took pains to distinguish Snow's practice from that of other artists:

> Unlike pop artists who take the products of other factories, soup labels, Liz Taylor ads, comic books, beds, toasters, and use them as art and bring them into the gallery, Snow audaciously manufactures walking women and puts them out into the everyday world.[42]

At the same time, virtually every reviewer balanced this need to explain the unique character of what might be called the programmatic aspect of Snow's work with enthusiastic reports of his sheer brilliance as a painter. Kilbourn, for instance, cautioned concerning her above remarks:

> If this suggests that Snow is only an intellectual, an artist who thinks and paints meaningfully about the mechanics of art and its relation to society, then let me assure you that Snow is much more than that. In "Clothed Woman" a very large painting dedicated to the memory of his father, he transforms his walking woman into a painting so rich and resonant in the interplay of color and form that it can satisfy the most romantic craving for Beauty with a capital B.[43]

*Clothed Woman (In Memory of My Father)*, completed the day his father died in late February 1963, is a monumental accomplishment. It was the largest painting Snow had ever attempted (and so far still is), one and a half by almost four metres, a veritable wall. Its seven "life-size" figures (the usual five-foot-tall silhouettes) stride through a frieze of subtly shifting form and colour. Not one silhouette is complete, although the head, neck and upper bosom of the figure fourth from the left, almost at the centre, is entirely there, a deep purply blue identifying cameo floating in a field of openly brushed lime green. Portions of backgrounds flood into figures, or the contours of figures give way to backgrounds, and parts here and there are left undone, revealing patches, often large, dynamic shapes (and in one instance almost half of a clearly defined torso), in underpainting white. The preparatory drawing for *Clothed Woman...*, an engrossing work of art itself (see no. 39), reveals Snow's methods well. The abstract shapes resulting from the elisions of forms (as though the ebullient colours themselves had to find the area of surface each would cover) were all worked out in detail in the drawing, although it is evident from the colour notations that the sequence of hues was changed almost completely in the execution of the canvas. Among a number of interesting notes on or attached to the drawing is one commanding principle: "separate / in the order that / one might note / things," and beside this a tiny list: "figure / dress / body / space between panels." Snow always works with a clearly defined strategy or procedure that allows him to fully explore the expressive limits thereby implied. "I'd like to make you laugh or make you cry — I'd like to have that kind of range," he told Barrie Hale at the time. "I have a vague half-image of where things will go — painting is in a difficult position. It's been argued for years about what can and can't be done on a flat surface ... it's almost as if the power of art were up against the power of reality."[44] "It is hard not to marvel at Snow's talents," concluded Harry Malcolmson in his review of the Isaacs show. "He combines an extraordinary control over his painting development with an enormous painterly instinct."[45]

By the conclusion of the exhibition Snow had achieved for himself and his work the highest level of admiration, and expectation, of the Toronto art world. (Expectation had been high even in advance of the show. Barrie Hale heralded the "important opening" in his column the weekend before the event.)[46] The Walking Woman had become not only a delight in itself but a signpost, a guide, and Michael Snow a trusted mentor. In an essay published some months after the exhibition, Marjorie Harris summarized what many now understood to be his role.

> Snow is a valuable painter to anyone at all interested in art. In a confused world and
> even more confusing art world, he has created his own symbol and used it as a constant

theme in his works not only to create new insights into the situations in which he places his Walking Woman, but also manifesting the timelessness of art once again; a re-emphasis of the problems of space, line, colour and composition with which the artist must cope.

If a necessary adjunct for art is contemplation, Snow has created a centre for this in an image which is very much a part of the kind of world we live in; she is lifeless and wooden, yet humanistic and full of new forms and meanings. By using this image, pushing and coaxing her into new positions, Snow not only gives greater meaning to his Walking Woman, but to the familiar things she touches.[47]

Bringing hindsight now to a reconsideration of the two exhibitions of 1964, I find that they are distinguished by two areas of concentrated investigation. There is on the one hand what appears to have been Snow's innovative move into hitherto unexplored issues in sculpture, a move that Donald Judd singled out for praise, and that in Toronto Harry Malcolmson thought remarkable. He explained: "These sculptures are works of the utmost boldness and originality for sculpture has almost by definition been three dimension, yet Snow nonchalantly continues to represent his Walking Woman in profile only."[48] And the other aspect of the shows that appears in retrospect to have been especially striking was Snow's handling of paint and, in particular, paint of intense colour. Robert Fulford might have been reacting to this when he commented that what was new in the New York show was that Snow no longer deliberately shunned "'fine painting', warm and obvious bursts of color, and charming effects."[49] We will see, as we later delve into his earlier work, what truth there is in Fulford's assertion that Snow tended formerly to "abrasive, almost unacceptable color contrasts."[50]

Certainly, in many of the key works shown in New York and Toronto early in 1964 the colour is bold, though still immediately appealing. This is true of the surging waves of near-primary colours that roll past the viewer in *Clothed Woman...*. Fulford was attracted enough to one of the boldest, and, I'm sure he would admit, the most winning of the works, to acquire it for himself. *Switch* (no. 23) is two slabs of intense colour, a burgundy red and greenish lemon yellow, each with a Walking Woman, delimited only by their shadows. The shadow is a very dark purply blue on the yellow side, and gives the appearance of having been cast by a strong light from the upper left. It is a clear, strong blue on the red section, cast by an imaginary light from the lower right. There is a narrow, clear green stripe down the right-hand side of the canvas, and a narrower purple one down the left. So we have not only the (near) primaries but complementaries, and it is the visual tension among these complementaries that intricately knits the figures to their painted environment, giving rise to poetry.

*The Chiffons* is notable for its brushy, saturated colours, and *Four* focuses particularly on the effect of colour by employing four pigments — blue, black, white and purple (almost magenta) — in a round of combinations over four figures. The hair is purple, skin white, dress black, ground blue, in the left-hand one, for instance, the hair black, skin blue, dress purple and ground white in the next one, and so on. The challenge to compare and contrast is heightened by the fact that each figure is painted as though on its own "panel," each signed separately (in a different one of the four colours), and they all float on a neutral grey ground-coat. The paint has been applied evenly, dispassionately and rapidly over pencilled outlines, and the instances of bleeding and dripping, and the many feathery interconnections where colour fields abut enhances the sense that it is specifically colour relationships that this painting is about. (Marjorie Harris chose rather to interpret these effects, and the drips in *Coat of Blue #1*, as "sloppy" painting, and "genuinely disturbing" evidence that "the ideas seem to be ahead of the quality of the painting.")[51]

*Beach-Hcaeb* (no. 27) also seems to encourage a particularly close examination of its radiant colours, which were applied thickly to certain elements of the left-facing woman, and to other elements of the right-facing woman, and then were completed by pressing the two sides tightly together while the paint was still wet. The result is a complex interrelationship of overlays and other painterly effects. *Green Skirt* is a classic example of *belle peinture*, with its luscious combination of scumbled blue and vigorously brushed green over a soft, washy, grey-green ground. *Coat of Blue #1* is a triumph of virtuoso brushwork in viscous paint. The clue to the significance of each one of its many elements, and levels, is in the upper torso, a thick coat of fleshy pink that has been brushed sensitively to emphasize the breast. *Half-slip* (no. 21), on the other hand, with its woman displayed horizontally and with its neatly juxtaposed, large areas of thick green, red, blue, black and white paint is like a festive banner in the breeze. In all these it is the colour effects that tighten down that exquisite tension between abstraction and representation that gives us such pleasure.

Colour plays a central role in the later Walking Woman Works, as we have seen, but it is colour that usually emanates from an evenly textured surface, and although it is often boldly saturated and intense, it does not seek the pure exuberance of the primary range that dominated the 1964 shows. Are these "warm and obvious bursts of color" new to the work made in New York, as Fulford contended? Perhaps we can tell after we have looked at the first Walking Woman show, which consisted entirely of work made in Toronto.

Mounted at the Isaacs Gallery in March 1962, the first Walking Woman show was the largest of the five commercial exhibitions devoted to the theme, with thirty works, three more than the first Poindexter show two years later, and nine more

than the second Isaacs show. It probably did not seem crowded, however, as much as busy, in an involving way. Only two pieces stood out by their large size, *Venus Simultaneous* (no. 47), at two by three metres, and *Turn*,[52] which is a bit taller and somewhat over half as wide. There were about seven more paintings, including *Noctambulation (Death Walk)* (no. 52), *A Falling Walking Woman* (no. 51), *Transfigure*,[53] and *61–62* (no. 48), that were roughly within the metre-and-a-half-square size, and a handful of smaller, often eccentric oils, like *Exit* (no. 49) and *Spring-sign* (no. 58). There were five pieces that were presented as free-standing sculpture, such as *She-scape* (no. 50), and *Project* (no. 60). What really distinguishes this first show from those that followed, however, was the number of works on paper. There were a dozen. A few, like *Top Woman* (no. 53), and *Rolled Woman II* (no. 56), were like small boxed sculptural reliefs, and most fell into the category of what Snow called "foldages," cut-out silhouettes of the Walking Woman that were then folded into beautiful and clever shapes, but two, *Walking Woman I* (no. 65) and *Walking Woman II* (no. 64), were full-size Walking Woman graphite drawings, and *Forty Drawings* (no. 62) was an assemblage of thirty-one sheets of ink drawings on one big panel. All the works were made in Toronto during 1961, except for *Venus Simultaneous*, *Goddess of Space*,[54] and *61–62*, which were completed in the new year sometime before the second week of March when the exhibition was installed.

Critical reaction to this first Walking Woman exhibition was prescient. Elizabeth Kilbourn, in a year-end analysis that appeared early the following January, saw Snow's March one-man show as "the one exhibition in Toronto this year which was a real breakthrough in [the] context of uncertainty and often unsuccessful experimentation" that otherwise marked the local art scene, an uncertainty arising from "the much-discussed death of abstract expressionism" that in New York "has left the younger artists struggling for a way to express in new forms, new understandings about a very different society from the one Gorky and de Kooning faced in the 1940s. The results are pop art, kitschnik art, neo-dada, 'happenings' and various other forms of purgation." While Kilbourn acknowledged that Snow's "name rouses the ire of many art followers in Toronto who are willing to embrace most so-called avant-garde art," for her his "annual one-man exhibitions at the Isaacs gallery over the past five years have been the touchstone by which all other Canadian painters can be measured. His scorn for fashion and his relentless pursuit of the most basic problems of art have freed him to produce works which are as pivotal in the history of Canadian painting as Borduas' was in the late '40's and '50's."[55]

Kilbourn earlier had reviewed the show for *Canadian Art*, and while her remarks at that time do not reflect such a developed assessment of the significance of Snow's contribution, they do convey a sense of the immediate impact of the exhibition.

A first impression of the Snow exhibition is one of jest — the Isaacs walls seem to be transformed into a big playroom for a gigantic paper doll who cavorts without inhibitions. But the longer one looks the more the paper doll becomes an abstract form, a philosophical device, a laboratory instrument for dissecting and probing the components of space. By employing this device Snow is left free to use colour also in a completely formal abstract way.... What Snow has done is take his paper doll (and for this particular task any pattern would do) and apply it to the canvas in a multiplicity of ways, pressing the flatness of the plane to yield new optical experiences, shoving space sideways, thrusting it into static movement or dynamic rest. The result is at once disturbing and oddly satisfying.

Kilbourn's analogy to a "paper doll" does not carry the pejorative edge of the New York critic's remark two years later, but reflects rather an engaged feminine point of view, as does the understanding she displays of the implications of the "femaleness" of the Walking Woman image.

The fact that Snow chose to use a representation of the female figure, a sort of latterday Venus, as his pattern rather than a rectangle or table-top or architectural structure as in his former work has many interesting facets. In the first place it almost seems as if Snow has said, "O.K., if everyone is saying we must get back to figurative painting, I'll give them pictures with lots of figures." But the emotional overtones of the female form are immense. By obsessively using a female form rather than a table, Snow immediately starts talking about every representation of woman from the Knidian Aphrodite to a Matisse Odalisque. But Snow has taken the female form, not as a sensuous object of desire or an ideal form, but as a cardboard cut-out as cruelly priapic and anti-sex as the display figures of sexotics outside a burlesque theatre, the female image at its most banal.

This is a witty show, a calculating clinical cruel show. Above all, a show of painting about painting. I liked it. A lot of people won't.[56]

The veteran art critic of *The Globe and Mail*, Pearl McCarthy, did not cover the show. Paul Duval, the other longstanding commentator on the Toronto scene, did, and while he did not approve of everything in the exhibition, he saw much that he liked.

Snow's group of paintings, drawings and constructions is the most promising of his career. His return to figurative subject-matter has added a richness to his paintings that I found almost totally lacking in his abstracts of the past few years....

I find Snow at his most effective in his paintings. His cut-outs and other construc-tions are as ephemeral in their visual impact as they appear to be in materials.

Among the straightforward oils on canvas, are a number which must be included among Snow's finest works to date. In the highly simplified Falling, Walking Woman, he has succeeded in turning the confrontation of two identical silhouettes into a challeng-ing composition....

The surest indication of Snow's potential is probably in the two large graphite draw-ings, Walking Woman 1 and 2. These betray the lyricism of feeling and technical capac-ity this artist has worked so far to camouflage in his stark, oversimplified designs of the recent past.[57]

The definitive coverage of what we now must consider to have been a landmark exhibition came from Robert Fulford, a sympathetic, although not uncritical, Snow supporter since the beginning of the artist's career. (Which was the beginning of Fulford's career as an art critic, as well. He explains in his memoirs that it was Snow who introduced him to the Toronto art scene.)[58] Fulford wrote two columns aris-ing from the exhibition, one an expression of incredulity, indeed of measured out-rage, that the Art Gallery of Toronto, having decided finally to acquire its first work by Michael Snow, had purchased a "minor piece ('Rolled Woman I') which is only interesting in the context of the show,"[59] and the other, which appeared the week-end following the opening, a considered assessment of this new turn in Snow's development as an artist or, as Fulford would have it, as a painter.

Snow's paintings have rarely shown recognizable objects or persons, but for this series he has created a central image which is both arresting and puzzling. His silhouetted woman is vulgar, like a cardboard figure standing outside a burlesque house, or a char-acter in an old-fashioned comic strip. She exists in two dimensions only; there is not even a hint that she might have substance.

This is a clue to the artist's intentions. He apparently wanted, for these pictures and assorted curiosities, an image that would remove his work from total abstraction and yet not interfere with the picture-making which is his real purpose....

The result of this unusual activity could be called abstract-painting-which-is-not-abstract-painting. It has the impersonality, the objectivity, of the abstract picture; but, on the other hand, there is the figure, large as life....

"Venus Simultaneous," the show's most complicated picture, is one of the most absorbing works I've seen in a long time. It presents the Snowgirl seven times, once on a piece of plywood which is set out from the canvas, twice in silhouettes which protrude from the sides. In this work Snow sums up all the ambiguities of the exhibition as a

whole — the use of shallow, varying space; the play of light and shadow; and the nervous, restless activity of his art, exemplified in this case by a painting which seems to be on the point of turning into sculpture....

In some ways this is Snow's most "difficult" exhibition. It presents more challenges than any other — the use of color, for instance, is more abrasive than ever — and strikes more severely at accepted ideas than any previous display of his art. But then, Snow is always difficult: He never stands still long enough to be acceptable. Whenever you believe you know all he has to say, he quickly changes the conversation. He is that kind of painter; the best kind.[60]

So Fulford is consistent in his opinion, expressed in his review of the first Poindexter exhibition, you will recall, that Snow tended to "abrasive" colour effects and deliberately shunned "fine painting." In its balance of hue with texture and with tone, in the delicacy of touch it reveals, in the rich but subtly controlled array of painting gestures it displays, *61–62* is among the very finest pieces of painting Snow has accomplished. Yet it confirms Fulford's observation. None of the colours is bright, and in fact a chief characteristic of the piece is the manner in which passages are toned by scrubbing or washing with cloudy veils of dark or light, resulting in wonderfully organic colours — burnt orange, a warm yellow, a velour-like grey-green — and a relatively equal tone overall, suppressing contrasts. Consequently, the colour combinations are unusual, and though beautiful, they are slow to affirm themselves, and perhaps could be called "difficult."

The same can be said of *Spring-sign*, a cut-out whose richly modulated green surface, with red and blue perimeter flashes, was modified by extended exposure to inclement weather before it was displayed. Here again, while the process has resulted in a narrow tonal range, unusual colours and consequently "difficult" combinations, an organic quality has been achieved that gives the appearance that the colour is inherent to the object. *She-scape*, even though its colour relationships revolve around the red-green complementaries, in its final effect is infinitely more subtle, more complex, because yellow has been mixed in with the green, and a high blue horizon has been painted over the red, thereby introducing a second pair of complementaries to resonate with the first. The resulting colours may be more acid, but once again they have an organic quality that introduces another level of poetry to the work.

Other pieces that, while they now seem wonderfully inventive in their use of materials and effects, might have seemed crude, or almost worse, casual, in 1962, would include *Project*, a Walking Woman tentatively painted on a boxy, free-standing construction that has been banged together from old drawers and other bits of

wood and that in a touchingly rudimentary fashion suggests a figural presence in space. And there is *Femetal* (no. 61), painted in oil on an aluminum sheet, but with the bare sheet that is the woman's body stretched three or four times as wide as usual to maximize the rippled, shimmeringly reflective surface of the metal between her front and back, the outer edge of the expanded silhouette brushed in with thick black tar-like oil paint. Then there is the sinister *Noctambulation (Death Walk)*, its black, red and dark pinky brown colours so close to one another in tone that the surface at first glance reads as a near-homogeneous covering of burnished leather. And *Walking Woman* (no. 54), one of the five sculptural pieces, is a bulky, scarecrow-like figure assembled from numerous small bits of wood, all painted white.

All these are highly subtle, sophisticated pieces, despite their apparent difficulty at first glance. *Walking Woman*, for instance, has been sensitively fleshed out through the thoughtful building up of evidently hand-shaped pieces of wood, resulting in a rough but convincing corporality. The preparatory *Study for "Walking Woman"* (no. 55) reveals clearly the deliberate manner in which the figure will be created from pieces of wood of predetermined shape, belying the appearance that the work is a contrivance of found materials. The work itself presents numerous clever instances of the sort of optical plays that Cubism has made us familiar with, such as convex shapes becoming concave, impressions actively assisted by the constant shift of shadows as we move around it. There is as well an extraordinary sense of movement in the piece that relates to Futurist sculpture and further enhances its accessibility.

**Fig. 5** The Yonge Street studio, Toronto, 1961

Paul Duval, you'll recall, found *A Falling Walking Woman* very appealing, a "challenging composition," and indeed it is a wonderful example of how Snow's inspired articulation of the formal elements almost magically strikes a deep chord of identification with the figures as human, female presences. In this case the two figures, of an intense saturated vermillion, almost black, colour, are suspended horizontally, one above the other, against a heavily textured white field that has an engaging life of its own. The spaces between the two figures are particularly dynamic. In fact there is a dynamism throughout the piece, induced by the rough and incomplete framing of the textured rectangular background, and by slivers of magenta that dart out of the lower right and upper left corners, putting a gentle spin on the whole piece. It is an effect that left Robert Fulford with "an acute sense of individual power."[61]

Duval also found the two large drawings, *Walking Woman I* and *Walking Woman II*, particularly revealing of Snow's "lyricism of feeling and technical capacity." Although these are technically what Max Ernst called *frottages* — that is, rubbings — in this case over a Walking Woman template, they reveal as well Snow's hand control: the even cross-hatchings, arcing from the elbow in the more open *Walking Woman II*, but mainly from the wrist in the tighter, wonderfully dense *I*, are modulated over the surfaces to suggest in the most satisfying manner imaginable the subtle roundness of the forms. (Snow created a second version of *Walking Woman I* for its owner in 1964, in which he modulated the internal modelling with even greater nuance, arcing the cross-hatching entirely from the wrist.)[62]

We might forget sometimes that every one of the Walking Woman Works begins with a template or a stencil of the figure (or later, a rubber stamp). Another drawing in the first show underlines this rule by breaking it, and with disastrous but affecting results. *Forty Drawings* is a grouping of thirty-one sheets of varying sizes, some with one woman, others with two, to the sum of forty. None is traced, all are free-hand attempts to draw the Woman. Some get quite close, but others go remarkably wrong, resulting in fat figures, skinny figures and strange combinations of the two. What is so engrossing, however, is the way that some of the distortions make the figures so expressive, or the way that even a minimal internal framing brings the proportions into line, or the way that a thick line (all are drawn with a draughtsman's nib in ink) pulls the figure toward it, or the way that no matter how malformed a figure might be, it always manages to engage the whole sheet.

None of the critics remarked on *Forty Drawings*, but it and a handful of other works that took as their points of departure a traditional artistic form or technique — such as *Un-named Woman* (no. 59), in which a cut-out bust painted with a waxy impasto of rich burgundies and mustard evokes an Edwardian bronze; or *Walking Woman*, the white sculpture that seems to address most of the sculptural innovations of the earlier twentieth century; or the two big drawings that Paul Duval so admired — must have offered access for the more conservative. And one would think that would have been the case with the "foldages," which were by then, as we will see later, familiar inventions of Snow's. *Top Woman* develops not only from that practice, but in its background of delicately sculpted paper relief, and, indeed, in the way that the black ink articulates the folded figure and ties it into the subtly complex ground, continues investigations that Snow had first brought to successful fruition, as we also will see later, back in 1956. None of this appears to have been noted, except, in a way, by Duval, who, you remember, judged that the "cut-outs and other constructions are as ephemeral in their visual impact as they appear to be in materials."

**Fig. 6** Graeme Ferguson's car, New York, probably 1963

Perhaps it was to deal with this perceived narrowness of interpretation of the Walking Woman Works Snow began writing "A Lot of Near Mrs." in the months that followed. Certainly it was in large part to reveal a potentially broader application of his invention that was not evident in that first exhibition (although the weathered pieces, such as *Spring-sign* and *January 1–31*,[63] might have suggested some form of extra-gallery display). This is what he called *"lost* art." "If you can use stuff from the street as art in an art gallery why can't you use 'paintings' or art in the street."[64] Snow set out to explore that issue about two and a half months after the exhibition closed when he engaged a photographer, Arthur Coughtry, and took a Walking Woman cut-out onto the streets of Toronto to record his art in the general urban environment. Sixteen of the photographs were mounted together in a piece he entitled *Four to Five, June 20th, 1962*, included in the first Poindexter exhibition. They show the Walking Woman at bus stops or on subway platforms or at any of a number of other busy locations, always purposefully intent on her own business, as the populace rushes on about theirs.

A year later Snow was engaged in extending the idea of what he called in "A Lot of Near Mrs." the "development of events-for-capture" by taking a Walking Woman cut-out into the streets of New York and recording her on film. This new project was first noted publicly in an interview-based article on Snow by Arnold Rockman in *The Toronto Daily Star* in early July 1963. When told "we're making a movie," Rockman asked, "Who's we?"

> "Ben Park, he's a film-maker, Jackie Rosenfeld's husband, you know, the playwright, and Hugh Downs, the TV personality, and I. Ben Park came around, got excited by the walking woman and a few weeks ago we started to shoot a movie. No script. Just the woman all over New York — on the subway, waiting for a bus, on Wall St., at the docks, as a poster on a wall, as a negative cutout through which you can see the traffic of New York. It'll be shown on TV and in the art houses."
>
> "Why do you want to get into films?"
>
> "I don't. It's just another way of using the walking woman."[65]

The idea of such a film dates back at least to the previous winter, when in early

December Joyce Wieland reported to Snow's mother that

> We were guests last week of the Great french Master Marcel Duchamp — We have admired
> him for many years and finally met him. He was very nice to us. I made him laugh.
>
> He will appear in Michael's film. A producer from N.B.C. is making a film of Michael's
> work and it should be very exciting.[66]

Greg Curnoe, an artist-friend in London, Ontario, wrote in May about "the movie you're working on,"[67] which suggests that it was by then under way.

Since settling in New York Snow had begun to push his idea of "lost art" in new directions, as well. He related to Rockman:

> "Sometimes I make posters of her and stick her up on the street. When I get her back
> she's all torn and covered with slogans. That's the start of a new painting. Or I stick small
> versions on the subway and sometimes I get them back. An ad agency friend of mine is
> trying to sell her to a company for a trademark. You'd see her all over the city on the sides
> of trucks."[68]

Rockman followed up this newspaper interview with a feature article in *Canadian Art* in the fall, but although he reproduced one of the photographs of the Walking Woman on a Toronto street that Snow had used in *Four to Five, June 20th, 1962*, and a frame enlargement from what is described as "the film Walking Woman in New York by Michael Snow and Ben Park," and also quotes from "A Lot of Near Mrs." (described as "*Walking Woman Works*, unpublished manuscript, August 1963"), he mentions the film only in passing in the text and makes no reference at all to the dispersed pieces, the "lost art."[69]

The announcement for the first Poindexter Gallery exhibition, in January 1964, opens up into a large reproduction of a wonderful photograph of one of the Walking Woman posters Snow had mentioned to Rockman the previous summer, hanging on a mouldering brick wall, torn and perhaps "covered with slogans," although none are evident. Snow did not use one of these posters as the "start of a new painting," as he had suggested to Rockman he might, but following the show he put together a photo montage he called *Places* (no. 15), which uses the Poindexter announcement, four photographs — two of one of his posters on a construction hoarding, and two of the same one used in the announcement, one of which is a close-up showing a dated signature, "SNOW 62" — a piece of paper with a rubber-stamped Walking Woman, and a small silhouette painted green, orange and white, mounted on heavy black card, which has been viciously attacked with a sharp object.

This latter is inscribed lower left, in ball-point pen, "Fulton St. I.R.T. Subway Stop 1963," and in pencil, lower right, "Subway Dec '62." A couple of years later Wendy Michener reported in a profile in *Maclean's*:

When he and his wife Joyce Wieland left the Toronto art scene for New York four years ago, Snow immediately announced his presence by papering the town. He crept out in the middle of the night, like an advance man for a circus, with a pot of glue and a pile of walking women posters and stuck them up on hoardings along Wall Street. He made forays around Greenwich Village armed with hundreds of the seven-inch walking-woman stickers that had been printed up for a one-man show at the Isaacs Gallery in Toronto. He inserted them into paperbacks in drugstores, made "compositions" on subway cars, and stuck them up on all the lampposts on Madison Avenue between 82nd and 56th Streets.[70]

Many years later, Snow recalled the precise incidents that had presented the material for the photographs used in *Places*:

I made four painted figures, in four different colours, in enamel on paper, each five-foot high. In the early morning Joyce and I went out to a construction site and we glued them on the four sides of this boarding where signs were to be put up. It was pretty interesting because it was the first time I was dispersing the elements of one composition and that I tried to work with memory.... The next day when I went back one had been very carefully taken away... after a while you could see the outline left by the glue. The other three hung around for a while and started to rip.... I think I photographed one of them as it started to fall apart....

I used stencils to make tiny paintings and I put them on the subway's advertising panels before posters were mounted on them... it was just black.... Sometimes, I would also put them on posters. I usually had some kind of obscure rationale which had to do with colour or the distance between them.... One of them was violently attacked with some kind of knife. I went there and waited around until there was nobody in the station and I then cut it out and retrieved it....

I also did things in a bookstore, the 8th street bookstore. I made a set of rubber stamps on different coloured paper. I made the set of them so they had some relationship between them all — 5 or 10 of them. Then I took them to the bookstore. I was thinking of them as markers in a book and I stayed there and I browsed and I put them in several books that I thought might have some relationship — the colour of the book or something. So they were all there and that was that. Later somebody that I knew bought a book and phoned me up and said I just bought a book with one of your works in it![71]

More photographs were taken of the Walking Woman cut-out at a Toronto subway entrance in the fall of 1964. By Michel Lambeth this time, they were published in the magazine supplement of *The Toronto Daily Star*.[72] A small block-cut of the Woman appeared in *The Village Voice* in New York, 4 February 1965 (no. 7), and the following January a head-and-shoulders cut of the ubiquitous profile popped up in John Wilcock's regular column in the same newspaper.

"Though Snow's walking woman hasn't earned him a fortune yet," observed Wendy Michener in her September 1966 profile of Snow in *Maclean's*,

> her shape is familiar to thousands — people who don't know anything about art, not even what they like. She's turned up in Eaton's ads, in a New York printmaker's illustrations for a book of love poems, as a column heading in *The Village Voice*, and in one of Sid Barron's Toronto *Star* cartoons about suburbia. She's even travelled abroad. Two of Snow's friends spent this summer in Lebanon and the USSR, diligently papering walls and washrooms with WW stickers as they went.
>
> And then there was that Coke ad. When it appeared on the back cover of *Maclean's* last summer, both Snow and The Isaacs Gallery were besieged by letters and inquiries from people who'd noticed the similarity. Some thought Snow should take legal action. The ad was photographed in New York in 1963, just after the time Joyce and Michael Snow were sneaking out of their downtown loft at night to plaster the town with posters. Is that where the admen got their idea? Coca-Cola isn't saying.[73]

Earlier in 1965 Snow designed an album cover for the recording *Barrage*, by the Paul Bley Quintet (ESP-Disc 1008, recorded 20 October 1964), which features two reverse images of his Walking Woman and a sequence of six negative prints, increasingly overexposed to virtual blankness, of a photograph of a life-size "negative" cut-out of the Walking Woman (a precursor of the negative element in the Expo piece), with a kerchiefed and rain-coated woman behind, caught in mid-stride as she attempts to fill the space of the silhouette. The same photograph — of the jazz pianist and composer Carla Bley (one of the cuts on *Barrage* is a Carla Bley composition titled "Walking Woman") — is the basis for a Snow print, part of a portfolio called *Toronto 20*, published the summer of 1965 (no. 5). Sometime in 1966 Snow retired the shirt he had worn while painting since 1962, a sweatshirt suitably emblazoned with a stencilled Walking Woman, and decided to keep it as yet one more component piece of the multifarious Walking Woman Works (no. 2). In September 1966 another element was added, in the form of a record album cover again, this one for a recording by Albert Ayler, Don Cherry, John Tchicai, Roswell Rudd, Gary Peacock and Sonny Murray, a group assembled for the occasion (the recording had been

51

made two years earlier, in July 1964) that included a number of musicians then on the leading edge of jazz developments in New York. *New York Eye and Ear Control* (ESP-Disc 1016), as it is called, signals the conjunction of two of Snow's significant interests, just as he was deciding to step back from the practice of painting. One of these interests was new, and the other older even than his involvement with art.

The abiding interest manifested in the *New York Eye and Ear Control* album is music, specifically jazz. We will learn in later chapters of its important role in Snow's life when he supported himself in Toronto, and earlier when travelling in Europe, as a jazz musician. When he and his wife moved to New York in the fall of 1962, he decided to put the music aside in order to devote his full attention to the Walking Woman Works. Their new home, a loft at 191 Greenwich Street, just a couple of blocks south of Fulton Street and two west of Lower Broadway, in the oldest part of New York (now the site of the World Trade Center), was not too far from the jazz clubs, and he kept connected. He remembered years later:

> Although I made the decision to stop playing, I was still interested in music. I had the good fortune to meet Roswell Rudd who is one of the greatest trombonists in the world. He was new then. I got introduced to what was the newest stage in jazz which had prac- tically no popular appeal at all.... I got a piano from Roswell. Actually, he had to sell it, he was very poor. Joyce and I had two lofts one over the other. One was my studio, the other was Joyce's studio and home. I put the piano in my studio and...asked people if they wanted to play. Most of these guys had absolutely no work or no access to a piano. The next thing I knew I had rehearsals at my place and was able to listen to some of the greatest music at that time. Literally everybody...has become a star. For example Cecil Taylor, Don Cherry, Paul Bley, Archie Shepp, Albert Ayler, Milford Graves. The first rehearsal of the Jazz Composers Orchestra took place in my studio. I used to play with them occasionally but I was trying not to play. I did a few jobs while I was there to make some money but basically I was trying to stop it.[74]

It was in his Greenwich Street loft in July 1964 that Snow recorded *New York Eye and Ear Control*, as a sound-track for a film of the same name, and it is film that is the second, newer interest signalled by the *New York Eye and Ear Control* album cover.

While Snow had worked for a commercial film company in Toronto, Graphic Associates, for about a year and a half in the mid-Fifties (and made one personal animated short then, which we will examine in a later chapter), he did not continue with the medium in the years following. When he and Joyce Wieland were visiting New York in the late summer of 1962, looking for a place to live, they stayed with a filmmaker, Graeme Ferguson, also a veteran of Graphic Associates.[75] Another

Canadian friend then resident in New York who helped them settle, Bob Cowan, also was a filmmaker, but the essential factor that brought Snow — and Wieland — back to filmmaking was that their move to New York coincided exactly with the emergence of a group of independent filmmakers who were intent on innovative exploration of the visual aspects of film rather than on those dramatic structures that enjoyed wide popularity and the support of the big Hollywood studios. Dubbed the "New York Underground," they found a focus in the Film-Makers' Cooperative, established in 1962 largely through the efforts of Jonas Mekas, a respected film scholar (founder of *Film Culture* magazine in 1955) and film critic for *The Village Voice*. Mekas also began what he called Film-Makers' Showcase screenings, first at the Charles Theater on East Twelfth Street, and then, renamed in 1964 the Film-Makers' Cinematheque, at a sequence of temporary locations, mainly on the Lower East Side.[76] Snow made it clear a few years later that these screenings brought them back to film. "The real influence on Joyce and me after we moved to New York ('62) was just Jonas and the amazing existence of the Cinematheque. We've been frequent attenders. Everybody made it possible just to think about actually making a film."[77]

The film Snow had been making with Ben Park in 1963 was never completed, however. About a decade later he recollected that Park

> was really taken, either with me or the idea, and he put up the money to start the film. So we shot a lot of film — at least six hours — and it seemed really interesting, but all of a sudden he just lost interest in it. He'd just realized what he'd done, I guess. He still has the film. I really wanted to do that, but I went on from that and made *Eye and Ear Control*.[78]

This implies that *New York Eye and Ear Control* is a direct extension of the "Walking Woman in New York" film that Snow had been making with Park, which in turn appears to have been an extension of the "development of events-for-capture" strategy exemplified by the photographic piece *Four to Five, June 20th, 1962*. We cannot know how the Park-Snow film might have turned out, but it seems reasonably clear that *New York Eye and Ear Control* is a more rigorous work than the collaboration could have been. Speaking a couple of years after it was made, Snow recalled that "I used some of the things that were happening in the earlier film. I just decided to go ahead and do it myself. It's different. If the first one were ever made it would be quite a different film."[79] And, at about the same time, he described it as "a true determinate simultaneity. It is all (about/is) polarities, opposites, supposed opposites."[80]

In an interview-based article a couple of years later Snow explained:

I tried to do something in which the sound and the image had an equal power. Like you can take any piece of film and play any kind of music with it, and no matter how great the music is it will become subservient — it will be used the way Bach is used in some French movies. It's still great music, but it becomes some other thing because it helps to set moods and you don't hear the music any more; and I was interested in doing a thing where you could see and hear at the same time. So I made a counterpoint with the images — which were measured and classical — as opposed to this very spontaneous, very emotional sound.[81]

And a few years later than that, in 1976, the subject came up in a letter in which he discusses the diverse nature of his work throughout his career, and his various attempts to respond to that diversity. He describes *Mixed Feelings* of 1965 as "one of the very best of these works" in which variety is a conscious theme.

The other work that comes to mind that consciously tried to cope with what are, loosely (to say the least) described as "opposites" is "New York Eye and Ear Control," 1964 film. Here I tried to make it possible for the "improvised," spontaneous, raw, "vocal," raucous, expressionist, emotional, "romantic" music of Albert Ayler, Don Cherry, etc. to co-exist with the "classical," measured, refined, considered, composed, calm, "intellectual," temporal images. That's what the title means. I think it works. It's a simultaneity, not just one thing accompanying another.[82]

In order to establish this basic premise of simultaneity, and the equal but independent nature of the two elements that this implies, the musicians played without having seen the film. "The music was recorded prior to the production of the film," it states on the album jacket, although Snow has on numerous occasions noted that the shooting of the film was undertaken during the spring and summer of 1964. As late as October, however, it was still only "ready for editing," although it was already booked for a screening in Toronto in February.[83] It was shown finally on Sunday, 5 April, as part of the closing program of that season's Ten Centuries Concerts, a series of evenings of unfamiliar and experimental music held in the Edward Johnson Building of the Faculty of Music at the University of Toronto. Snow had been approached the previous year by one of the organizers, Harry Freedman, a Toronto composer with special interests in both jazz and painting, and Ten Centuries Concerts paid for about a third of the production costs of the film. The evening was a disaster. More than three hundred of the four hundred in attendance stomped out during the screening, and the only critical coverage was a journalist's contemptuous report of the incident.

Of the 100 who stayed, one wonders how many hung on for the same reason as one young man who was heard to say, "Let's wait, it's bound to get dirty yet."

That it did — but not before the audience had to put up with an endless stream of disconnected shots of everything from Snow's famed "walking woman" cutout to lingering, out-of-focus views of the ocean, woods, and New York city. All this, over the drone of a far-out jazz group. After that, even the "dirty parts" were dull.[84]

The same paper's drama critic, maliciously adding insult to injury, revealed that the directors of the series were not surprised by the audience reaction.

They were dismayed when they themselves saw the film, which had been commissioned from the painter [Michael Snow]. At one point they considered scrapping it from the program. But then they decided that, as theirs is an experimental series, they were honor-bound to present the film and suffer the consequences.[85]

The first public screening in New York was later that year, likely in the early fall.[86] The response there was, in the main, also disappointing. A couple of years later, Snow recalled:

When *Eye and Ear* was first shown at the Cinematheque (Astor Playhouse '65) it was one of those riots with people throwing things at the screen. When the film was over I recall Gerard Malanga running up the aisle to the projector and saying "That couldn't have been made in 1964!"[87]

Malanga, a poet, was an associate of Andy Warhol, whose *Sleep*, a six-hour film of a man sleeping, was first screened publicly at the Film-Makers' Showcase in January 1964. Warhol had begun making films only the year before, but with *Kiss*, *Haircut* and a series of other stationary-camera "portraits," culminating in *Empire*, an eight-hour examination of the Empire State Building, shot through one night in July 1964 and premiered at the Film-Makers' Cinematheque the following March, he moved rapidly to the forefront of underground developments.[88] His work not only challenged the hand-held, active camera, and complex, often rapid editing of most underground filmmaking of the day, but affirmed the range of visual effects arising from the filmmaking process by accepting tonal or textural changes due to stock inconsistencies and by leaving the flares of light at the end of each reel of his multi-reeled films. Gerard Malanga did not believe that *New York Eye and Ear Control* could have been made without foreknowledge of Warhol's innovations. Snow must have had to answer that challenge at the time, and he recorded his response not long afterward.

*Eye and Ear Control* was finished summer of '64 and sometime late fall saw first Warhols: *Henry Geldzhaler* and others at the New Yorker which I very much admired. I was amazed at the coincidence, I mean shocked, to my thinking in *Eye and Ear*. I not only used light-struck ends, there are a set of "portraits" and the time sense is similar. To continue the amazement I later read about *Empire*. In *Eye and Ear* there is a dawn sequence which is much shorter than I'd intended but is essentially the same thought. . . . Later Andy told me he thought the film was "wonderful" which pleased me very much. The differences are of course vast as well.[89]

The Film-Makers' Cinematheque was located at the New Yorker Theater for less than a month, in December 1964.[90] *New York Eye and Ear Control* was virtually complete by then, but when it was first screened publicly in New York some ten months later, it was perceived to bob in the wake of Warhol, and, as Snow put it, promptly disappeared.[91] He showed it a second time in Toronto late in November 1965, at a weekend of Mixed Media Concerts organized at the Isaacs Gallery by Udo Kasemets, but it was only after his next long film, *Wavelength*, was widely acclaimed in the later Sixties that critical attention was turned to *New York Eye and Ear Control*. Since then it has been understood mainly by its relationship to a specific moment in the history of the New York underground filmmaking scene, and

**Fig. 7** Frame enlargement from *New York Eye and Ear Control*

has been appreciated primarily for the foretaste it offers of the remarkable qualities of *Wavelength* and the long list of always innovative films by Snow that have followed.

I first saw *New York Eye and Ear Control* at one of the three screenings presented at the Isaacs Gallery as part of the *Music For the Eye and Ear* concerts the weekend of 27–28 November 1965, the first of five weekends of mixed-media concerts offered through to mid-April. I've seen it many times since and it is difficult to isolate the first impression, but my recollection is that I was taken with how engagingly sensuous the images are, with how the tones and textures seem to be constantly shifting, even though it is a film of relatively long shots, and with how arbitrary the relationship of the raw, often emotive music to the images seems — but with how strangely exciting it is when the two fortuitously reinforce each other. Experiencing the film again today, and particularly in the context of this study, I am struck by how thoroughly integral to

the Walking Woman Works it is. As we noted much earlier, Snow identifies the film as *A Walking Woman Work* in the subtitle. A black-and-white 16 mm film, 34 minutes long, it opens with a Walking Woman image, closes with one, and the Walking Woman, as cut-out or in her "negative" guise, is almost always on screen.

The film's deliberate, carefully measured structure, what Snow calls its "classical" visual aspect, counterpoints the impulsive music. By comparing and contrasting other pregnant opposites — black/white, city/coun-

**Fig. 8** Frame enlargement from *New York Eye and Ear Control*

try, fire/water, male/female, aggression/peace, nature/civilization, night/day and so on — fixed in the structure, and by attentively following these concepts and presences through the sequence, a viewer may appreciate that in the film, and in fact, opposites cohere to create a union, a unity.

A number of comments in "A Lot of Near Mrs." relate directly to what we see in the film. Snow said about the earlier effort with Ben Park, for instance: "Opposites. Film I'm working on seems to concern itself with the poetry of the juxtaposition of the static and the dynamic, absence, presence, development of events-for-capture," and, as he added, this relates to the "art series of photographs taken in Toronto April '62."[92] A filmmaker is even closer to that metaphorical "Stage director" that he saw in the maker of the Walking Woman Works, exploring "Fact and fiction: the relationships between space and light illusions (imagination?) and a physically finite object."[93] We know already that Snow thought of *New York Eye and Ear Control* as an effective expression of simultaneity, although in a way that brings another dimension to the sense that "'she' is the same in different places and different times at same place and time." The pursuit of the "revelation of process as subject" when the process was filmmaking opened a door onto previously unimagined visual effects, not to speak of the potential in this new medium of "finding out what happens when you do such and such a thing." Snow's "subject," as he says, "is the same...but now it is acted." That is more true of *New York Eye and Ear Control* than of any other of the Walking Woman Works.

Snow's experience with film is evident in other of the Walking Woman Works, tentatively before 1964, when in a canvas like *Clothed Woman (In Memory of My Father)*, he began to explore sequential relationships, but increasingly more boldly after he had completed *New York Eye and Ear Control*, as we can see in the complex

play with framing evident in *Hawaii,* or in the exploration of the spatial compression of close-ups in *Cry-Beam,* or, almost definitively, in the filmic premise that lies behind *Test Focus Field Figure.* These concerns became the subject of a performance piece Snow staged in November 1965, apparently first at the Film-Makers' Cinematheque, and then three times over the weekend of 27–28 November, along with the screening of *New York Eye and Ear Control* at the *Music for the Eye and Ear* concerts at the Isaacs Gallery in Toronto. Called *White Leader* in the Toronto program notes, it has been known as *Right Reader* since as long ago, perhaps, as a second presentation at the Film-Makers' Cinematheque, likely in 1967.[94] Snow recalled the performance many years later.

> I did that first in New York at the Filmmakers' Cinematheque. It was a solo piece. It's called *Right Reader* and later I did it here (Toronto). I can't remember whether I did it again in New York or not. I think I did it here a couple of times at The Isaacs Gallery.
>
> It's almost a kind of commercial for a show which I was about to have at the Poindexter Gallery. In front of me I hung a piece of clear plexiglass with a rectangle of black tape on it. This framed my head as in what's called a "head shot" in film. There was one movie light on stage aimed at my head. In front of me was a table with all these cards which I'd made. The piece was like a re-enacted film or like television in a way. The text which I wrote was read by someone else (Ray Jessel as a matter of fact) and tape recorded. The tape was played back over the sound system in the theatre and I mimed my mouth to the sound. At the end, the tape said whose voice that was. It's very much like a film situation because the sound track was separate and I was the image miming to it. I held up these cards which would fill the frame and obscure me sometimes. One of them was a zoom in four or five cards where the W.W. zoomed — I put this one down, put another one up and the W.W. frame would gradually get bigger and the voice would continue talking about the W.W.
>
> There was a hand-made fade-out which went in 4 or 5 moves from a transparent plastic sheet to more opalescent rectangles to an opaque black card all of which I held in front of my face one after another.[95]

*Short Shave,* a short (4 minutes) black-and-white, 16 mm film Snow made in December 1965, after his Poindexter opening on the seventh, incorporates some of these actions, and effects, with the sheets of varying opacity and the Walking Woman cards. It first, however, records in a similarly lengthy head shot, but in time lapse, Snow's beard, which he had maintained since his arrival in New York, being shaved off. There are more than a few affecting moments in *Short Shave*: the pixillation technique of stop-action photography, for instance, gives the impression that as Snow's

beard mysteriously reduces and then disappears, he is simultaneously afflicted with a series of uncontrollable spasms — but for Snow, at least in retrospect, one of the reasons for making it had little to do with how the film looks. In a recent interview he recalled his thinking about the Walking Woman at the time: "I still had ideas for it, but I decided that it had to stop. And making that film, shaving that beard off, was part of trying to make the change."[96] Film was leading him, and as we follow this story, us, to that point of departure in the middle of the decade when he decided to put the Walking Woman aside.

But we want to continue in the other direction, back in time. One thing remains to do, however, before we move to the next chapter, into the period when there was no Walking Woman, and that is to look at how she began. In fact, both the chapters that follow detail her beginnings, for she was the consequence of a long development, of the slow emergence of an idea, of a device that answered a gradually defined need. The actual creation of the image, of the familiar silhouette, occurred within a period of a few months over the winter of 1960–61. Snow has a few things to say about it in "A Lot of Near Mrs."

> Made first cut-out or wall life size "realistic" figures of cardboard in Oct. 1960. They were result of several years worrying about *where* the figure is or could be or would be. This is the problem. I solved it by removing the figure from *where* and putting it *here*. On the wall or in the room. She was detached from her background or removed from her "environment" and placed in a "foreign" one. In painting a figure on/in the rectangle the relationships exist between the figure and its environment. When you paint a "cut-out" flat representation of a figure rather than on a rectangle, the relationships now are internal. The "environment" of the figure now becomes separate, and out of my control. But now I think of where as well as what.[97]

He recollected many years later of those October 1960 cut-outs:

> I did three of them. One of a woman walking backward that you could see from behind walking into the wall, as it were; there was another one of a woman jumping as seen from below as though she was jumping out of a window; the other one was a side view of a walking figure.[98]

There is a 1960 photograph of Snow in his Yonge Street studio in Toronto that shows one of these cardboard cut-outs, a tall curvaceous figure walking straight toward the viewer, not one of the three he remembered (see fig. 9). Another one Snow had forgotten, perhaps a more developed form — it is made of sturdier mate-

rials (still mainly cardboard, but reinforced with masonite, actually someone else's discarded painting), is painted with an apparently more deliberate strategy, employing swoops of impasto to accentuate the curves, and is dated 1961 — has actually survived (see no. 66). The woman's figure is perhaps a bit fuller, her hips and breasts

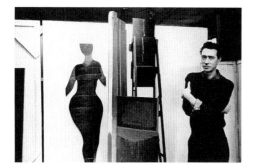

are more accentuated, and she is cropped a bit more tightly, resulting in a compact, dynamic form. She has a similarly featureless face, but unlike the earlier cut-out has a short bobbed hair-do. There also is a preparatory drawing for her (inscribed "do this small / about 3' high / ? 2'").

The drawing is in the upper left-hand corner of a sheet, also dated 1961, that shows ideas for three such cut-outs (see no. 68). The other two are for the figures that Snow later described as "walking into the wall," and "as seen from below as though she was jumping out of a window." The sheet is one of four with similar drawings of ideas for cut-outs, all precise outline drawings, showing nine women altogether, mostly variations on the types already mentioned, but including two of "a side view of a walking figure" that could be prototypes of the Walking Woman (see nos. 67–70). And finally, there are among the artist's papers a few rough drawings and perfunctory outlines, including a sheet of two drawings showing variations of the jumping figure and the one striding out of the wall that depict the thickness of the material from which they were to be made, and that retain portions of the rectangular painted "environment" (see fig. 10).

None of these drawings accepts the flatness that Snow came to see was an essential characteristic of his Walking Woman (although the two "side view" figures come close). They all reveal the artist playing with the complex spatial paradox (parody, almost, at times) that he had discovered when he suppressed the rectangular, framed environment of his figure. He was, however, working on other fronts at the same time, generating ideas that contributed to the brilliant solution he finally achieved. Some of these paintings, explorations of issues around abstraction that had been occupying him for the past four or five years, we will look at later. Another, a seemingly eccentric departure into large-scale figuration, confirmed the simple silhouette as the ideal form of representation if the abstract, formal qualities over which Snow held such mastery were to continue to play a full role in his art.

That painting is *January Jubilee Ladies*, a large, rough collage, almost one and a half by two metres, which Snow completed probably early in 1961 (no. 71). A del-

icate composition of earthy red, blue, white and a range of ochres, it is, in spite of its urgent drawing and at times crude, almost expressionistic painting, cutting and pasting, evocative of the *gouaches découpées* of Henri Matisse from the end of his life in the early Fifties; and in tapping deeply into the wellsprings of European modernism *January Jubilee Ladies* also raises memories of Pablo Picasso's great *Demoiselles d'Avignon*. Preparatory drawings demonstrate Snow's characteristically careful planning of the seemingly spontaneous composition (see nos. 72, 73), and a small collage study reveals him exploring some of the effects presented by the medium and colour range, and refining his technique (see no. 74). All this too, we will see, was a consequence of by-then well developed practice. New, or at least new on this scale, was the idea of marshalling an array of similar cut-out silhouettes and the resulting poetic interplay, an exquisite tension, in many areas, between the figurative content and the aesthetic force of colour and abstract forms. It was a discovery, as we have seen, that Snow was to exploit fully.

## Notes

1. Harry Malcolmson, "Sculpture: Disappointments at Expo," *Saturday Night* 82 (July 1967): 43.

2. Now known as *First to Last*. Painted plywood, aluminum, glass, 208.5 x 208.5 x 15.2 cm, Art Gallery of Ontario; repr. in this volume: 314.

3. Michael Snow, "A Lot of Near Mrs.," in Regina Cornwell, *Snow Seen: The Films and Photographs of Michael Snow* (Toronto: PMA Books, 1980), 161; also in Louise Dompierre, *Walking Woman Works: Michael Snow 1961–67: New Representational Art and its Uses* (Kingston: Agnes Etherington Art Centre, Queen's University, 1983): 19.

4. Ibid. The entire text occupies only two pages in the latter source (18, 19), and just over two in the former (160–62), and so there is no need to make individual references to the quotations that follow.

5. Snow, "A Lot of Near Mrs.," in Dompierre, *Walking Woman Works*: 18. While he here also suggests that it was written in Toronto (though during the period when he was "making frequent trips to New York to prepare for a long stay there", that is, during the late summer and early fall of 1962), references in the text to a film, which would be the never-completed film of the Walking Woman in various New York locations that Snow undertook with Ben Park and that is first mentioned in December 1962, and appears to have been well under way by the following May, would suggest that it was at least the end of the year before the text was finished. It is first quoted in print only in November of the following year, however, and is dated then "August 1963". See Snow and Wieland, 191 Greenwich St., New York, letter to Mme Levesque Snow, c/o Mr.

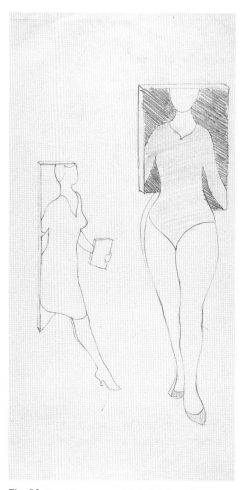

**Fig. 10** Graphite on paper, 30.5 x 15.3 cm, Snow Fonds, Edward P. Taylor Research Library and Archives, Art Gallery of Ontario, Toronto

Roberto Roy, Claremont, Ontario, 6 December 1962, with Marie-Antoinette Snow Roig, Toronto; and Greg Curnoe, c/o Elmwood Lawn Bowling Club, 17 Edward St. (rear), London, Ontario, letter to Snow, 191 Greenwich St., New York, postmarked 17 May 1963, in Michael Snow Fonds, Edward P. Taylor Research Library and Archives, Art Gallery of Ontario, Toronto; and Arnold Rockman, "Michael Snow and his Walking Woman," *Canadian Art* 20 (November–December 1963): 345.

6. "Letter From Michael Snow, 21 August 1968," *Film Culture* 46 (Autumn 1967, published October 1968): 5; and see Ralph Thomas, "300 flee from far-out film," *Toronto Daily Star*, 5 April 1965. Not only did the film demand Snow's time during this period, but he and Wieland had to find a new loft when in the fall of 1965 the Port of New York Authority gave notice of the expropriation of most of Greenwich Street for the planned World Trade Center. Snow relocated his studio to 123 Chambers Street, between West Broadway and Church, and the following spring when it became their home and Wieland's studio, Snow found another studio at 300 Canal Street, just west of Broadway.

7. Paint, wood, vinyl, masonite, acetate, photograph, canvas, polyethylene, plexiglass, etc., 365.8 x 365.8 x 304.8 cm, collection of the Vancouver Art Gallery; repr. in this volume: 448.

8. Brushed and sprayed enamel, oil, acrylic on canvas, 152.4 x 214.3 cm, collection of Brascan Limited; repr. in Dompierre, *Walking Woman Works*: 138.

9. Neither *Test Focus Field Figure* nor *Hawaii* were included in the New York version of the exhibition. The former was on tour in the retrospective exhibition organized by York University.

10. Ink on printed paper, 149.5 x 68.5 cm, collection of Canada Council Art Bank, Ottawa; repr. *Sélection des œuvres de la banque d'œuvres d'art du Conseil des Arts du Canada* (Paris: Centre culturel canadien, 1973): no. 31 (n.p.).

11. See Richard Alpert and Sidney Cohen, *LSD* (New York: The New American Library, 1966). William Marshall and Gilbert W. Taylor, *The Art of Ecstasy, an investigation of the psyche-*

*delic revolution* (Toronto: Burns & MacEachern Limited, 1967), documents the wildly successful weekend symposium on psychedelia at the University of Toronto, *Perception 67*.

12. Frank Getlein, "Art: Peaceable in Pittsburgh," *New Republic* 151 (12 December 1964): 25. Pittsburgh, Pennsylvania, Museum of Art, Carnegie Institute, 30 October 1964–10 January 1965, *The 1964 Pittsburgh International*, no. 32.

13. Lucy R. Lippard, *Pop Art* (New York, Washington: Frederick A. Praeger, 1966): 195, repr. 197.

14. Toronto, Art Gallery of Toronto, 8 January–6 February 1966, organized by the Walker Art Center, Minneapolis, Minnesota.

15. Toronto, Art Gallery of Toronto, 20 November 1964–3 January 1965, *Post-painterly abstraction*, organized by the Los Angeles County Museum of Art.

16. Snow, "A Lot of Near Mrs.," in Dompierre, *Walking Woman Works*: 18. The following quotations are from the same source.

17. Toronto, Art Gallery of Toronto, 13 February–14 March 1965, *Art and Engineering*, no. 18A.

18. "Reviews and Previews," *Art News* 64 (January 1966): 16.

19. "In the Galleries: Michael Snow," *Arts Magazine* 40 (February 1966): 65.

20. Aaron Einfrank, *Telegram* (Toronto), 8 December 1965.

21. "Art and Artists," *Telegram* (Toronto), 24 December 1965.

22. Harry Malcolmson, "Two Outstanding Exhibitions this week," *Telegram* (Toronto), 16 April 1966.

23. Kay Kritzwiser, "Snow's Walking Woman walks again," *Globe and Mail* (Toronto), 9 April 1966.

24. Ibid.

25. Oil on canvas, 154.0 x 234.0 cm, collection of the Imperial Life Assurance Company of Canada; repr. in Dompierre, *Walking Woman Works*: 102.

26. Oil on canvas, four elements, each 152.4 x 50.8 cm, collection of Mr. and Mrs. Jules Loeb, Toronto; repr. in Natalie Edgar, "Reviews and previews: Michael Snow," *Art News* 62 (February 1964): 18; since altered.

27. Oil on canvas, three elements, 153.5 x 153.0 cm, 154.0 x 18.5 cm, 154.5 x 50.6 cm, collection of the Art Gallery of Greater Victoria, Victoria, B.C.

28. Mixed media assemblage, 51.9 x 40.9 x 30.4 cm, collection of Michael Snow, courtesy S.L. Simpson Gallery, Toronto; repr. in Dompierre, *Walking Woman Works*: 101.

29. Oil on plywood, aluminum, mounted with metal brackets on a wooden base, 157.5 x 50.8 x 111.7 cm, collection of Chiat Day Mojo Inc. Advertising, Toronto; repr. in Dompierre, *Walking Woman Works*: 40, illus. 18.

30. Typed *Freene* in the checklist. Enamel on plywood and canvas, 152.4 x 127.0 x 50,8 cm, destroyed; repr. in Dompierre, *Walking Woman Works*: 59.

31. "In the Galleries: Michael Snow," *Arts Magazine* 38 (March 1964): 61; reprinted in *Donald Judd, Complete Writings 1959–1975, Gallery Reviews, Book Reviews, Articles, Letters to the Editor, Reports, Statements, Complaints* (Halifax, New York: The Press of the Nova Scotia College of Art and Design, New York University Press, 1975): 120.

32. "Bring the Past to the Bar of the Present," *New York Times*, 2 February 1964.

33. Edgar, *Art News*: 18.

34. Robert Fulford, "On Art: some Canadian painters — like Michael Snow — have to quit Canada," *Maclean's* 77 (7 March 1964): 55.

35. Lippard, *Pop Art*: 195.

36. 19 October–6 November 1963. In her text, Lippard mistakenly places this exhibition in the David Mirvish Gallery (*Pop Art*: 194), although she cites (and sites) it correctly in her bibliography (206).

37. Arnold Rockman, "Superman comes to the Art Gallery," *Canadian Art* 21 (January/February 1964): 18–22. *Silver Liz*, purchased from the show by the Jerrold Morris Gallery, is now in the collection of the Art Gallery of Ontario.

38. Snow, "A Lot of Near Mrs.," in Dompierre, *Walking Woman Works*: 19.

39. All quotations in this paragraph ibid.

40. "World of Art: Snow Show Brilliant," *Telegram* (Toronto), 25 April 1964, quoting from a text by Kim Levin in the possession of Michael Snow that apparently was never published.

41. "At the Galleries: T-Shirts Painted for Show," *Globe and Mail* (Toronto), 25 April 1964.

42. Elizabeth Kilbourn, "Art and Artists: Snow's achievement," *Toronto Daily Star*, 25 April 1964.

43. Ibid.

44. "World of Art: Another Gallery Returns," *Telegram* (Toronto), 2 May 1964.

45. Harry Malcolmson, [untitled], *Telegram* (Toronto), 2 May 1964.

46. Barrie Hale, "World of Art: 'Poetic Ingenuity'," *Telegram* (Toronto), 18 April 1964.

47. Marjorie Harris, "The Snow Man's Woman," *Commentator* 8 (June 1964): 16.

48. Malcolmson, *Telegram* (Toronto), 2 May 1964.

49. Fulford, *Maclean's*: 55.

50. Ibid.

51. Harris, *Commentator*: 15.

52. Oil on canvas, 228.5 x 177.5 cm, collection of the Robert McLaughlin Gallery, Oshawa, Ontario; repr. in Dompierre, *Walking Woman Works*: 84.

53. Oil on canvas, 152.4 x 114.3 cm, location unknown.

54. Oil on canvas, 177.8 x 152.4 cm, location unknown.

55. "Art and Artists: 1962 — Bang and Whimper," *Toronto Daily Star*, 5 January 1963.

56. "Michael Snow at the Isaacs Gallery," *Canadian Art* 19 (May–June 1962): 178.

57. "Accent on Art: Feminine Flavor for New Shows," *Telegram* (Toronto), 24 March 1962.

58. Robert Fulford, *Best Seat in the House: Memoirs of a Lucky Man* (Toronto: Collins, 1988): 90.

59. "World of Art: How Not To Buy," *Toronto Daily Star*, 31 March 1962.

60. "World of Art: Snowgirl," *Toronto Daily Star*, 17 March 1962.

61. Ibid.

62. Graphite on paper, 170.4 x 58.4 cm (sight), now collection of Dr. J. Fremes, Toronto; repr. in Dompierre, *Walking Woman Works*: 129.

63. Weathered watercolour collage, 61.0 x 48.3 cm, private collection, Toronto. This might be a fourth work of 1962 in that first show, although it is dated 1961 in the checklist, which would make it one of the first Walking Woman Works.

64. Snow, "A Lot of Near Mrs.," in Dompierre, *Walking Woman Works*: 18.

65. Arnold Rockman, "Same Woman, But In All Shapes And Sizes," *Toronto Daily Star*, 6 July 1963.

66. Snow and Wieland, 191 Greenwich St., New York, letter to Mme Levesque Snow, c/o Mr. Roberto Roy, Claremont, Ontario, 6 December 1962, with Marie-Antoinette Snow Roig, Toronto. Snow has published his recollection of the visit with Duchamp: Michael Snow, "Marcel Duchamp," *Brick* 34 (Fall 1988): 34–35; and *Brushes with Greatness* (Toronto: The Coach House Press, 1989): 43–47.

67. Greg Curnoe, c/o Elmwood Lawn Bowling Club, 17 Edward St. (rear), London, Ontario, letter to Snow, 191 Greenwich St., New York, postmarked 17 May 1963, Snow Fonds.

68. Rockman, *Toronto Daily Star*, 6 July 1963.

69. Arnold Rockman, "Michael Snow and his Walking Woman," *Canadian Art* 20 (November–December 1963): 345–47.

70. Wendy Michener, "Where's The Walking Woman Walking? To The Bank," *Maclean's* 79 (3 September 1966): 17, 39.

71. Michael Snow, taped interview with Louise Dompierre, 4 October 1982, Agnes Etherington Art Centre, Queen's University, Kingston, Ontario, excerpted in Dompierre, *Walking Woman Works*: 8.

72. Gail Hutchison, "This Woman Walked Right Into Michael Snow's Life," *Canadian Weekly* (Toronto, 24 October 1964): 18–19.

73. Michener, *Maclean's*: 39.

74. Excerpt from taped interview in Dompierre, *Walking Woman Works*: 9.

75. Snow and Wieland, c/o Graeme Ferguson, 924 West End Ave., New York, letter to Mrs. G.B. Snow, c/o Mr. R.G. Roy, Claremont, Ontario, 2 September 1962, with Marie-Antoinette Snow Roig, Toronto.

76. See Jonas Mekas, "Showcases I Ran in the Sixties," in David E. James, ed., *To Free the Cinema: Jonas Mekas & The New York Underground* (Princeton, New Jersey: Princeton University Press, 1992): 323.

77. "Letter From Michael Snow, 21 August 1968," *Film Culture* 46 (Autumn 1967, published October 1968): 5.

78. Joe Medjuck and Michael Snow, "The Life & Times of Michael Snow," *Take One* 3 (January–February 1971, published April 1972): 7. A few years earlier, Snow remembered that they "shot about three hours of film," and that Park then simply "took over the thing. He owns it." Jonas Mekas and P. Adams Sitney, "Conversation with Michael Snow," *Film Culture* 46 (Autumn 1967, published October 1968): 2.

79. Mekas and Sitney, *Film Culture*: 2–3.

80. "Letter From Michael Snow," *Film Culture*: 4.

81. Medjuck and Snow, *Take One*: 7.

82. Michael Snow, "Michael Snow: A Letter to Alvin Balkind from Michael Snow, April 1976," in Alvin Balkind, *17 Canadian Artists: A Protean View* (Vancouver: The Vancouver Art Gallery, 1976): n.p.

83. Joyce Wieland, Corrective Films, 191 Greenwich St., New York, letter to Maman [Mrs. Robert Roy, Claremont, Ontario], October 1964, with Marie-Antoinette Snow Roig, Toronto.

84. Ralph Thomas, "300 flee from far-out film," *Toronto Daily Star*, 5 April 1965.

85. Nathan Cohen, "Politicians and players," *Toronto Daily Star*, 7 April 1965.

86. It was screened when the Film-Makers' Cinematheque was located in the Astor Place Playhouse, on Lafayette St., which was from 4 June to November 1965. See Mekas, *To Free the Cinema*: 323.

87. "Letter From Michael Snow," *Film Culture*: 5.

88. See Jonas Mekas, "Movie Journal: On Andy Warhol's *Sleep*," *Village Voice*, 30 January 1964; Mekas, "Movie Journal: Warhol Shoots *Empire*," 30 July 1964; Mekas, "Movie Journal: The Premiere of *Empire*," 11 March 1965; reprinted in Jonas Mekas, *Movie Journal: The Rise of the New American Cinema, 1959–1971* (New York: Collier Books, 1972): 116, 150–52, 180–81, respectively.

89. "Letter From Michael Snow," *Film Culture*: 5.

90. Mekas, *To Free the Cinema*: 323.

91. See "Letter From Michael Snow," *Film Culture*: 4.

92. Snow, "A Lot of Near Mrs.," in Dompierre, *Walking Woman Works*: 19.

93. Ibid.: 18. The following quotes are also from these two pages.

94. No record of the first New York performance has been found. Four photographs of the performance in Dennis Young, et al., *Michael Snow/A Survey* (Toronto: Art Gallery of Ontario, 1970): 62, are identified as "*Right Reader* / Performed by Snow / Filmmakers Cinematheque / New York / 1965 / (41 St. Theatre)". The Film-Makers' Cinematheque was located at the Forty-first Street Theater between early in 1967 and 30 August 1967. See Mekas, *To Free the Cinema*: 323. The first performance of *Right Reader* would have been at the Astor Place Playhouse, and likely was part of the *New Cinema Festival I* program that ran there in November 1965, and was

noted for the number of performance-related works staged. See Jonas Mekas, "Film Journal: More on Expanded Cinema: Emshwiller, Stern, Ken Jacobs, Ken Dewey," *Village Voice*, 2 December 1965; reprinted in Mekas, *Film Journal*: 215–17.

95. Excerpt from a taped interview in Dompierre, *Walking Woman Works*: 12, 14.

96. Scott MacDonald, "Michael Snow," in *A Critical Cinema 2: Interviews with Independent Filmmakers* (Berkeley/Los Angeles/Oxford: University of California Press, 1992): 61.

97. Snow, "A Lot of Near Mrs," in Dompierre, *Walking Woman Works*: 19.

98. Excerpt from a taped interview in Dompierre, *Walking Woman Works*: 6.

# II
## Addressing the Abstracts

At one point in "A Lot of Near Mrs.", when Snow reflects on the representational aspect of the Walking Woman Works, he follows a line of query leading from consideration of the idea that painting materials "represent" themselves in a painting, to the assertion that the "subject" of his art in the Walking Woman Works is virtually the same as in his earlier abstract paintings. "Is 'material' a representation too", he asks, and answers. "Is it any *realer*. We *must* believe that it is. My 'subject' is the same in the 59 and 60 abstract paintings and sculpture but now it is acted."[1] These "abstracts" of 1959–60 dropped out of sight after the first Walking Woman show (although, as we will see, Snow showed some in Montreal in April 1963, and they were part of the York University retrospective in October 1965, which subsequently toured to Kingston, Windsor and Waterloo), but anyone who frequented the Isaacs Gallery would have seen some of them from time to time, and they were a part, if only a small one, of my circle's understanding of Michael Snow. I recollect looking closely at *Lac Clair* (no. 78), *Before and After* (no. 77), and *The Drum Book* (no. 82), probably as early as 1965. Most everyone with whom I talked about such things enjoyed the intimate, sophisticated play between figure and ground that these works presented, and the curious way in which the imagery, caught in the tension of this play, wholly engaged the material nature of the paint or graphite; however, we hardly thought about how innovative they would have seemed when first exhibited, or of their relationship to the much more familiar Walking Woman Works. Having examined the chronology of the Walking Woman with some care, we now know that Snow's earliest investigations of the cut-out, the beginning of his "play" with the figure over the winter of 1960–61, would have coincided with the production of some of the later abstracts, specifically *Theory of Love* (no. 75), completed in January 1961; *Red Square* (no. 76), dated on the back 21 December 1960; *Before and After* and *Lac Clair*, both also of December; and probably *Between* (no. 80), of October 1960. What was the "subject" of these paintings that persisted into the Walking Woman Works? Was it recognized and appreciated at the time?

Snow presented these culminating abstract canvases of 1960 and very early

In front of *Bracket I*, January 1960

1961 in a considered, remarkably coherent exhibition at the Isaacs Gallery in March 1961. It was the second-to-last exhibition installed in the storefront at 736 Bay Street that Avrom Isaacs had occupied since late in 1955.[2] Described as "Paintings etc." on the printed invitation, the show was divided into three parts, designated on the gallery checklist as "paintings", "fold-collage-painting-reliefs", and "painting-construction-sculptures". That these distinct categories are interrelated is suggested by the repetition of terms in all three, a notion conveyed even more emphatically in an advertisement for the show — a witty play on mirror imagery that Snow rendered himself — which appeared not too long after the opening. Here the contents are described not as distinct categories but as something more like points on an almost grid-like continuum:

> Paintings, Painting-collages
> Painting-collage-foldages
> Painting-collage-foldage-reliefs
> Painting-collage-foldage-relief-constructions
>     "       "     "     "       "
>       — sculpture.[3]

Regardless, visitors were presented with the tripartite division — a lucid arrangement of eight paintings, eight foldages and two sculptures that would have comfortably filled the relatively small space. The paintings included the six already mentioned — *Between*, *The Drum Book*, *Red Square*, *Theory of Love*, *Lac Clair* and *Before and After* — as well as *Two* (no. 81) and *Green in Green* (no. 79). The highly imaginative foldages were represented by *Blews*,[4] *White Trash* (no. 88), *Tramp's Bed*,[5] *Yellow Street*,[6] *Paperape*,[7] *Years* (no. 87), *Blue Monk* (no. 86) and *A Package of Orange* (no. 85). The installation was completed with two painted wood constructions, *Quits* (no. 89) and *Colour Booth* (no. 92).

Robert Fulford, an attentive follower of Snow's progress over the years, you will remember, saw in the exhibition a masterful resolution of various elements previously evident in Snow's work that in their blending revealed hitherto hidden aspects of a remarkably wide-ranging sensibility. He was drawn particularly to the foldages.

> The form is a sort of painting-and-sculpture combination — painting, because it is framed and because paint is used; sculpture, because the paper juts out from the basic surface....
>
> The most important aspect of all this is that it introduces into Snow's work an element of romantic fantasy which has rarely appeared before. In a sense it throws together

and synthesizes all those elements — intellectual, comic, sensual — which have been important in Snow's painting and drawing up to now.

It becomes plain, after a short examination-for-discovery, that Snow is reclaiming and asserting the values of adult play in art: The values of a cool mind and a rich comic sense, working over the joyful possibilities of visual forms.

By stressing what he sees to be the values of play in Snow's art, Fulford, in spite of his own emphasis on the role of fantasy, is drawing our attention to the deliberate, purposeful nature of the making of the foldages. He then turns to the other half of the exhibiton, the paintings.

> To compare these with the memory of Snow's previous paintings is to notice immediately that he is becoming more and more intellectual. There is nothing here which could be called, by any stretch of the imagination, "an action painting." Indeed, the word "non-objective" seems almost irrelevant here; there are no "subjects," but certainly the painter's stance is close to being an objective one.
>
> Two paintings suggest the range of themes. "Drum Book," totally formal, is a collection of nine rectangles and squares, arranged in a close-to-perfect dynamic tension. "Theory of Love" is a cool, almost chaste re-working of the phallic symbolism which has turned up once or twice before in Snow's art. Both make their impacts slowly, and are to be absorbed in serenity.[8]

What these paintings are not seems as important to Fulford as what they are. They are not "action" paintings, that is, expressive, gestural, subjective. They are objective, formal, deliberate, revealing an approach that is intellectual, cool.

The more conservative Paul Duval, while acknowledging Snow to be "unquestionably one of the most intent and serious artists in the country," felt "the direction of his efforts open to question".[9] Duval was critical primarily of the reductive nature of works like *Lac Clair*, which he singled out as "Snow's flat blue area of canvas,... unbroken except for four short lengths of brown paper tape stuck to the corners." Like Fulford he was attracted to the foldages, but only to the degree of admitting them to be "a group of diverting textural exercises. Snow's considerable talents," he concluded, "are capable of much more than such diversions." A week earlier, Pearl McCarthy, who, as we have seen in the previous chapter, would choose not to review the first Walking Woman exhibition in March 1962, was more deeply disturbed than was Duval by this earlier manifestation of Snow's radically experimental tendencies, although she acknowledged that Snow had his supporters. In little more than an aside in her column she noted that among a number of contro-

versial shows then on view, "the exhibition that is most startling is that by Michael Snow at the Isaacs Gallery. In the opinion of this column, the show is not startling, but depressing in its negation. There are others who praise it."[10]

What was it about Snow's work that caused those, like Duval and McCarthy, with years of sympathetic support of modernist formal values in art behind them, to turn so bitterly on his work? A similar response resulted later, in April 1963, from his first exhibition in Montreal (and his only one until December 1979), when he shared the Gallery XII space devoted to showcasing contemporary Canadian artists at the Montreal Museum of Fine Arts in an improbable juxtaposition with another Isaacs Gallery artist, the naive realist and moralist William Kurelek. Although this was in the middle of the Walking Woman period, Snow chose to present a slightly edited version of the 1961 Isaacs show, with fourteen works that included *The Drum Book, Lac Clair, Red Square, Blue Monk, Before and After, White Trash, A Package of Orange, Years* and *Colour Booth*, plus *Nineteen Nights* (no. 83), a framed collection of tiny foldages of February 1961, and two works of 1960, *Sunset*,[11] a painted metal relief, and *Shunt* (no. 90), a painted wood construction. The show elicited but one review, by Robert Ayre, the veteran art critic of *The Montreal Star* and a long-time defender of modernist values in art. He heaped scorn on Snow and his work. It seemed to him "trivial".

> I see little reason for painting, let alone exhibiting, works like "Lac Clair," a blue square bound with strips of sticky brown paper, or "Drum Book," nine black squares on drab yellow, and I can't get anything out of his tricks with paper — the greenish thing, "Shunt," that slithers down the wall and along the floor, the "Tramp's Bed" of folded tattle-tale-gray and brown paper (though it has its fanciful humor) and "19 Nights," tiny bits of paper folded and carefully framed. One of his titles is "White Trash" and "Trash" just about sums it up.[12]

Back in 1961, however, Robert Fulford was not the only one to praise Snow. Elizabeth Kilbourn had also been following the young artist's progress for some time and would be a sympathetic, loyal supporter in the years to come. She recognized the rigour inherent in Snow's latest stage and understood every bit as well as Fulford the real achievement it represented.

> The latest of Michael Snow's yearly exhibitions at the Isaacs Gallery is by all odds the farthest out in the spareness of its statement. But there is an underlying sensuousness and elegance in Snow's handling of the paint itself which rescues him from the starkness of these contemporary disciples of Mondrian like the "hard edge" school with

which his work shows a certain affinity. In a canvas like *Lac Clair*, the surface is completely covered with flickering strokes of sky-blue, banded at top-left and bottom-right corners by a strip of brown sticky paper. The two-dimensional quality of the canvas is explored by the simplicity of the medium and calls into play the space around it to complete the image. By the very allusiveness of the painting, it accretes to itself a new constellation of images.[13]

Kilbourn appreciated the sheer beauty of Snow's paint handling, of the effects that he had achieved, and she understood and enjoyed the way that his insistence on the essential flatness of *Lac Clair* contributes to its capacity to engage its surrounding space dynamically. She did not strive to ascribe a meaning or purpose to the work, to ascertain what Snow called its "subject", but she did summarize what we might describe as an evident sensibility.

> Like experimental jazz, Michael Snow's work is "cool." The classical underpinnings are never denied; the formal structure is firm and sure but stripped down to the absolute essentials. The themes and rhythms gain rather than lose intensity by the very allusiveness and understatement in their handling.[14]

Fulford also sought to isolate the sensibility evident in the exhibition, a complex, encompassing sensibility, to his mind, but one that was intellectual, cool. He also, you will recall, reflected on the way that Snow's approach to art-making resembled serious play, an analogy not unlike Kilbourn's to playing jazz. Fulford even quoted Snow in support of his interpretation. "I make up the rules of a game,...and then I attempt to play it."[15]

Fulford was quoting from a statement Snow had prepared probably just before the show, reproduced in facsimile in *evidence*, a new "little magazine" of experimental artistic activity in Toronto. The second number, containing as well as the statement a seven-page photo spread on Snow — pictures by Kenneth Craig probably taken in December, one showing Snow placing the tape on *Lac Clair*, and another a *Red Square* that is virtually complete but not yet stretched — appeared after the opening, probably in the spring.[16] This statement of January or early February 1961 is similar in intention to "A Lot of Near Mrs." (a few points that appear in the latter in fact have their genesis in the former), and like it can serve as a guide to looking at Snow's art. Since it is not written entirely in a linear fashion, a transcription can convey only part of its meaning, but it can present Snow's thoughts more or less in the sequence that he recorded them. Here is the full text.

*Title* or *Heading*

To tell the Truth

Very Interested in Myself and what I do

Art Creation (Experiment in it) is an experiment on oneself.

Very Important.                    Living — "Doing Time"

Reciprocal                         "Realism"

The artist is a Biography of his work

P. Valéry's Life and Work

About My Work:

I make up the rules of a game, then I attempt to play it.

If I seem to be losing I change the rules.

"Intention" is as much a part of my painting as paint.

(Sometimes as something to escape from.)

A "Foil" to Chance (Ironic)

Dualities, unity and/or opposition.★

Kiss or Kill                                    ★Words for opposites

Absence (      ) — Presence (      )            really indicate the

Time (Before, Now, After)                       "ends" of "scales."

Soft — Hard                              Between Black and White

Fast — Slow                              is a grey gliss also

Hot — Cold                               between 9 and 10.

Up — Down

[...]

*Unknown Cliché*

Essential of Painting

"Tension" between 2D surface space and the illusory

space in and out of the canvas.

OR. Simultaneous Depth and Surface

Surface and Depth

Object and Illusion

This means MATTER and MIND★

★Very Important

Painting is a Bridge.

(Some new way to affect

the eye-imagination.)

Crisis of Creative Painting above.

"Reaction Painter"

Psychosexual IMAGE

74

Desire

The City,

(Process makes)

Clear

Baffling

Blue

Beauty

Edges.

(Art Space)

art is "Relationships"

      like everything else.

…is a kind of mummification.

*How is What.*

Revelation of Process as Subject in Pollock and de Kooning.

Clean things (New?) that get used, soiled (old?)

(Process of Painting) = Former Aristocrat.

The Quality that Mondrian called "Dynamic Equilibrium"

Solid-Color-Space-Ladies

Painting is not communication it's a form of secrecy.

  "    has a great past    "School of Fontainebleau"

  "    "  "   "  future

  "    "  "   "    "

Say that 200 times a day and you still won't believe it.

Difficult Entertainment. (Art) | No Nostalgia No Cuisine

                                    | No Happiness and Suffering

Contemplation Experience Hand Made.

Depth of commitment is the catalyst in painting so that the Passion

of an *Obsession can convert anything into Art

                         *To convert something into Art

About Technique: "One must go into oneself, armed to the teeth"

Keep Trouble out of Painting

Many many influences and likes

M-anet, -atisse, -alevich, -ondrian, -onk, -iró.

A, B, Cézanne (Best Painter) Duchamp

E F G H Ingres

J. Coltrane Heat and Mind

Klee, de Kooning, Bud Powell, C. Parker, Arp, J. Wieland, Vermeer, Seurat, Rothko, Reinhardt, Newman, Stendhal, Flaubert, David, Goya, Blakey, Roach, Kline, Agostini, B. Greene.[17]

This tells us a great deal about, among other things, what Snow believed to be the "subject" of his painting. Perhaps most important to him is what he called the "Essential of Painting", the tension between the flat surface, which is actually a very shallow space, "and the illusory space in and out of the canvas" created by colour relationships, by modelling, perspective rendering and so on. It is a tension that presents the viewer with a consciousness simultaneously both of "Surface and Depth", that is of "object and illusion", with, ultimately — and this is the most important consequence arising from that basic tension — an engaged awareness of both "MATTER and MIND". The "Revelation of Process as Subject", as exemplified in the drip paintings of Jackson Pollock and the slashing, splashing, gestural painting of Willem de Kooning, is also very important to Snow. It assists the transformation of the "How" into the "What", so that the meaning of painting is seen to reside in its specific material nature. He muses on, among other things, the conceit that art-making is a process whereby clean new things are transformed by the "use" of painting into soiled old things — objects with a history. Art is "Difficult Entertainment", not sweet memories, not catering to taste, not pandering to emotion. It is "Contemplation Experience", and it is "Hand Made". It "is an experiment on oneself", it is deliberate. "Intention" is as important a component of the final object as is paint, and deep "commitment is the catalyst". Mastery of technique is essential, for "one must go into oneself, armed to the teeth".

Fulford and Kilbourn certainly understood and appreciated Snow's commitment, and his masterful technique, and if pressed they would have had no problem acknowledging that good art was "Difficult Entertainment". Their analogies to his art, both, as we have seen, in a sense borrowed from Snow, were adult play and jazz. Although these imply programs, among many other characteristics, neither critic did more than allude to the essentially programmatic nature of the work, the never methodical but nonetheless purposeful, deliberate, intelligent exploration of the limits of a defined range of aesthetic ideas and effects, a practice to which we have become accustomed through the Walking Woman Works. And as with the Walking Woman Works, Snow was wittily testing the widely accepted aesthetic of the day with these late abstracts and foldages, principally the subjective, expressively gestural "action painting" that by the late Fifties had for at least a few years been practiced almost everywhere in emulation of New York Abstract Expressionism. As we have noted, Snow, in determining what for him was essential in art, valued highly

the contributions of the senior New York–school painters Jackson Pollock and Willem de Kooning (although he valued equally the "Dynamic Equilibrium" underlying the geometric abstraction of the early-twentieth-century Dutch modernist Piet Mondrian). What he admired in the work of Pollock and de Kooning, you will recall, and presumably in Abstract Expressionism in general, was what he termed the "Revelation of Process as Subject" — that intense experience of the material aspect of the art object that assists directly in heightening the viewer's consciousness of the tension between the illusory space in the painting and the actual shallow space of its surface. This was the key, for Snow, to achieving the essential awareness of — in fact, to being entirely engaged by — both matter and mind. The real trick, so to speak, was to achieve this end without engaging in the existential dance with paint and canvas that it was generally believed was the subject recorded on Abstract Expressionist canvases, a supposedly free flow of expressive gesture that by that time could only be self-conscious or even parodic. Snow's approach, as Fulford claimed, was intellectual, a strategy to realize quite clearly understood goals. Because it was a strategy that drew on his years of experience of art and art-making, it resulted in work that was far from being dryly intellectual, but that was richly allusive. It seemed intentionally ambiguous to those fixed in their ways, however, perhaps even mocking, subversive of those near-canonical formal values that were the foundation of modernist art. If you are bothered by the apparent casualness of the gesture of using paper tape to create a dynamic image, or if the almost methodical, evidently predetermined conformation of a picture's brushwork destroys for you all sense of spontaneous expressiveness, then a work such as *Lac Clair* is not magic but an affront. Each of the eight paintings in the exhibition, for instance, displays a vital tension between its actual surface and its shallow but convincing illusory space, a quality to which Kilbourn alludes in her description of *Lac Clair*. The effect is almost magical in *Lac Clair* (which is probably why it especially drew the ire of all the disinclined critics), wherein the aura of benign force conjured up by the strong and various, but fundamentally ordered, strokes of shimmering blue paint builds almost to the level of a force of nature as it softly swells against the visual torque generated by the four strips of brown paper tape stuck halfway along each side of the square canvas.

The other paintings reveal equally deliberate strategies. *The Drum Book* achieves its majestic presence not as a consequence of the eccentric framing of sensitive brushwork but through the arrangement of nine evenly painted rectangles in what Fulford called "a close-to-perfect dynamic tension", an effect enhanced by the fact that the rectangles, of a cobalt blue so saturated that it is almost black, sit on a particular yellow ground that suspends them as though held in a powerful magnetic

field. *Between*, like *Lac Clair*, has been worked uniformly almost all over, but with the most delicate strokes of dark, saturated teal blue, resulting in a substantial paint layer that sucks in the light, but then releases just enough to create a gentle, calm, water-like surface. This remarkable sea of teal doesn't cover the entire canvas, however, but leaves revealed through a rectangular gap at the upper left corner, with slivers running out along each side for a distance, an undercoat of intense black, a strip of electric blue at the upper right, and an angle of powdery blue in the lower right corner.

*Before and After* also mesmerizes with the complexity of the spatial dynamic trapped within its thin skin. The skin here is not paint but graphite, applied evenly all in one direction in a skein of fine strokes to a white oil-primed canvas, everywhere but in the area of eight small rectangles; one in each corner of the tall, narrow canvas received an extra coat of white before the drawing, and four boxing the centre were treated to a range of densities of drawing so as to seem to sit two on top of the drift of graphite, four within it, and two beneath. The placement of the rectangles implies an underlying grid, which in turn brings another level of dynamic tension to the surface. The symmetry of *The Drum Book* introduces a grid to that work as well, and at some level there is an actual or implied geometric structure in each of the eight paintings in the show. The grid in *Green in Green* is asymmetrical, and since all the lines connect, it presents a kind of dynamic figuration. Here the surface has been painted all over with lusciously generous, bright green brushwork, across strips of masking tape that had been placed to mark the lines of the grid. When the painting was completed, the tape was pulled away to reveal a darker, but still airy, green undercoat. The sense that we are glimpsing a hidden layer of dynamic space is heightened by the dance of light reflected from the numerous individual brushstrokes that make up the surface of the dominant paint layer. The configuration of the brushwork, tending to arcs in the corners and slightly concentrated at the centre, also seems to suggest the natural reach of the painter standing before the canvas, an effect apparent in *Lac Clair* as well.

The grid in *Red Square* even more evidently derives from the process of making the painting. In this case the ground colour is either the residue of a previous work that was scraped off, or results from the pigment having been rubbed in. The unstretched canvas was then folded over a number of times into a tight packet and rubbed some more, revealing, when it was opened out again, a batik-like surface criss-crossed with a pattern of dark creases. A roughly square, open form has then been pulled from this grid by crudely filling in rectangular portions of it with bright red paint. Just enough of the surface is engaged by the red to strike a dynamic balance with its smoky, greenish blue stain.

The role of the grid is suppressed in *Two*. The ground is a thick coat of orange-red paint, almost lava-like in places, and now checkered with a network of cracks. Over this has been painted quickly but deliberately a large oval shape (it touches three sides) in openly brushed magenta, out of which a large bite has been cleanly removed by pulling away a previously laid rectangular bed of tape. As in *Green in Green* and *Lac Clair*, there is a sense of the painting having been worked from a position in front of its centre, and the consequent shaping of the large brushstrokes suggests volume in the oval form, an organic quality that in turn introduces a figurative aspect. *Theory of Love* is also in this sense figurative. (Fulford referred to its "phallic symbolism", although a vulvar symbol is equally prominent.) The basic grid is subsumed to this image, although the reflective characteristics of metallic paint are employed to suggest the ghosts of geometric forms just beneath the surface, one a cruciform structure not only supporting the particular spatial tension that brings character to this work but also introducing another layer of meaning to the image. The "ghosts" may in fact be in part the topography of an earlier painting, for *Theory of Love* is painted over an apparently never exhibited work, identified on the back of the canvas by a now partially obscured inscription as *Sigh*, of December 1958. Snow may have cannibalized earlier works to produce others of these late abstracts. We've already noted that possibility with *Red Square*, and through the cracks of *Two* can be seen a layer of blue paint that has no apparent relationship to the current composition. The colour of the dominant top coat of *Between* is the consequence of major layering, a strategy, in fact, that is an essential element of its composition. Painting, indeed, is a "form of secrecy". Finally, it should be pointed out that the incipient imagery we have noted in *Theory of Love* and *Two* — to which should be added *Lac Clair*[18] and *The Drum Book*[19] — introduces the struggle to achieve a dynamic balance between representation and abstraction that is one of the principal "games" that will occupy him, and us, in the Walking Woman Works.

An analysis of the eight foldages shown in the March 1961 exhibition similarly would reveal Snow's "subject" to be the deliberate investigation and exploitation of those ambiguities and tensions, those contending "realities" of material and image from which arise the poetry of art. It is enough now, perhaps, simply to describe some of these inventive objects that captivated those who, like Fulford, were convinced that the exhibition demonstrated Snow's virtuosity, were appreciated simply as attractive diversions by others who, like Duval, were unsure of the direction he had taken in his painting, and were dismissed as "tricks with paper" by the likes of Robert Ayre, who felt that all these abstract works of Snow's were just so much trash.

*White Trash* was one of the works that got Ayre's goat. He genuinely seems to

have believed that it was a piece of garbage, whereas we can see it to be a witty, and beautiful, embodiment of Snow's insightful remark that painting is, at the material level, a process of dirtying and aging something that is new. Here, plain white paper has been folded and then rubbed, soiled to a patina that highlights the creases and the paper's imperfections. The folds and creases articulate a sequence of elegantly random descending forms that cohere into a structure of remarkable presence because of the almost muscular tension in the shifting spatial relationships of the forms. The foldages present shallow relief, not just the slightly textured surface of the paintings, but Snow still manipulates the illusory space that can be contrived with colour, texture and shape to great effect. Because of their scale, the foldages appear particularly precise, deft and concentrated. Yet because of the materials they are made of, they seem at first impression not as substantial as the paintings, not as serious. Fulford described Snow's achievement with *Blue Monk*, which stands on a table by itself like an enchanted lectern or music stand, as "a casual, shrugging poetry".[20]

The foldages are nonetheless complex, involving works equally as demanding as the paintings. Pieces like *A Package of Orange* and *Years* are virtuoso performances in colour, form and space. The imaginative folding in the former results in convincing structure, substance and visual depth, actual material aspects and illusions enhanced by the red of the folded package shape, floating on a green corrugated-cardboard ground, holding an orange rectangle. These colours are so intense, so substantial, that they give delight by themselves while still supporting the structure and illusion of the precious container and its even more precious contents of the colour orange. *Years* is like a huge chrysalis, or some other natural accretion, formed of a cascade of overlapping pieces of carefully torn dark red paper, attached to a deep, dark blue corrugated-cardboard ground. Suggesting age and the process of growth, it at the same time openly displays its structure and method of manufacture for all to see, and admire.

One foldage piece that was innovative in a manner unlike the others appears not to have been noticed by any of the critics, probably because it was not included in the exhibition checklist. Snow individually folded and then pressed with an iron every one of the one thousand cards mailed out to advertise the show. An early experiment in working variations within a clearly defined range (the central concept of the Walking Woman Works), the piece likely could be fully understood only after a visit to the exhibition, as Snow explained in an interview many years later. "Every one that got an invitation got an original work. But they didn't know it unless they were able to compare their work with someone else's work...which was possible during the exhibition as there were others available at the gallery."[21]

Another whole category of work in the show was ignored entirely by critics at the time — the two painted wood constructions identified in the gallery checklist as "painting-construction-sculptures", and in Snow's advertisement by the term that accumulated all the forms, "Painting-collage-foldage-relief-constructions-sculpture". Of the two, *Colour Booth*, the one work of 1959 in the show, is more closely related to the paintings and foldages. It is an elegantly handsome work, constructed of two sheets of plywood — one short and wide, the other tall and narrow — abutted at right angles on a piece of two-by-four lumber. The short element is painted purply blue on the inside with a dark blue band, like a stain, creeping down from the top, and on the outer side with a wide band of this darker colour at the top, below which is an even wider stretch of burgundy, separated from the blue by a dripping band of green, and with a narrow band of red at the bottom. The tall element is green on the inside, with a narrow orange stripe running across the panel just above the floor, and a mustard yellow stripe about a third of the way up, into which abut two more yellow stripes, one mustard again, and the other a little bit greener. Its outside is mainly green, with a narrow bar of blue at the top and a band of purply blue at the bottom. The two-by-four is painted green and blue. Although the piece is determinedly planar, it becomes dynamically three-dimensional as one walks about, causing the colour and space to shift through an endlessly complex series of seemingly expressive relationships, belying the rigidly determined form of the actual construction.

*Quits* deviates further from conventional sculpture, and for that matter, painting, concerns. Shown first four months earlier in a group exhibition at the Isaacs Gallery entitled *Sculpture by Painters*, it, and indeed the whole show, was greeted then with what might best be described as amusement. Snow was joined by six other Isaacs artists, Dennis Burton, Graham Coughtry, Richard Gorman, Robert Hedrick, Robert Markle, Gordon Rayner and Robert Varvarande, and while quite a bit of the work shown was modelled in plaster or other materials, assemblages of bits of wood and other found objects appear to have dominated the display. As well as *Quits*, Snow showed *A Day* (no. 93) and *Window*, a composition made up of a letter box, a plastic visor, a bottle and other deliberately coloured objects assembled within and upon a rough approximation of a window frame.[22] Pearl McCarthy was firm in her response. "Our opinion is that, while such a show will probably wake people up to see how expressive form can be, that does not make it art. It takes more than whacking things up to make sculpture."[23] Paul Duval judged: "There is much that is clumsy here, but nothing that is dead. Michael Snow's witty, colored wood constructions *Window* and *A Day* are at least a welcome relief from the retreads of Victorian patterns which too often cluttered up local sculpture shows in the past."[24]

Robert Fulford found the show "in most respects a disappointment". Among the "few pieces of interest," however, he cited "Michael Snow's 'Quits' (a comic wooden piece about a step-ladder which has given up and retired from service)".[25]

While *Quits* does have an almost human ungainliness (like an exhausted figure leaning back against a wall), and has elements that might be interpreted as collapsed steps, it is too complex a work to be termed "comic", although humour certainly is an aspect of its nature. (The same can be said of *Shunt*, another floor-and-wall piece — the drawings for both it and *Quits* are on the same sheet [see no. 89] — that was first exhibited in 1963, you will recall, when Robert Ayre, mistaking it for an elaborate foldage, could describe it only as "that greenish thing...that slithers down the wall and along the floor".) In fact, rather than as a clownish ladder, *Quits* might be seen as an object that introduces paintings to the condition of sculpture. There are in it five panels of similar size, all painted black with a sensuous little run of paint down their centres. The highest panel is flat against the wall, just like a small painting, and those below fall progressively farther away, until the fifth panel is face down on the floor. A rudimentary framework, also black, holds the panels fixed in position in the sequence of their falling. The dribbles running down the panels are dark blue, except for the one on the floor, which is green. Then, as you approach the piece, you notice that those panels that can be examined on both sides have a green dribble down their backs as well as the blue on their fronts. This physical evidence of a frozen narrative charges the open space within the supporting structure with a dynamism, a joyful energy that certainly can bring a smile to your lips.

*A Day* combines aspects of *Quits*, *Window* and *Colour Booth* with a confident legerdemain that is breathtaking. It suggests a window, a ladder, an easel, a painting in space. Defiantly planar, it is remarkably engaging in the round. Stirring in its relationships of colour, line, plane, space, it is witty too. (The painted red shadows that run obliquely away from the bottoms of both legs always delight.) What perhaps is most affecting, however, is the sense of urgency implied in the brilliant cobbling together of whatever incongruous scraps of wood and tube-ends of paint were to hand to achieve its precise arrangements of form and colour and dynamic space. In the *evidence* statement Snow wrote: "Depth of commitment is the catalyst..." and then went on, "so that the Passion of an Obsession (To convert something into Art) can convert anything into Art".

One of the reasons the initial response to these sculptural pieces was as though they were some sort of comic relief is that they were perceived to derive from ideas first promulgated by participants in the Dada movement in Europe during and just after World War I. Those artists were motivated by nihilist principles, but in the

late Fifties they were seen by many to have been the great pranksters of twentieth-century art. "It's back to Dada art," Pearl McCarthy quoted someone as saying about the *Sculpture by Painters* exhibition,[26] and they were right. Richard Gorman in fact organized an exhibition in the Isaacs Gallery over the Christmas holiday season two years later that, while unnamed, was dubbed "Dada". Gorman, Snow, Rayner and Burton were joined by the photographer Arthur Coughtry, by Joyce Wieland and by the London, Ontario, artist Greg Curnoe. Among the pieces Snow displayed — most of which were amusing and irreverent objects created for the occasion — was *Window*.

Michel Sanouillet, then a professor of French literature at the University of Toronto and a pioneering scholar of the Dada movement, wrote a glowing review of the show for *Canadian Art*, relating it to similar Dadaist revivals in Paris and New York.[27] Robert Fulford wrote two pieces on the show, also pointing to similar revivals abroad, and underlining the great interest the show engendered in Toronto.[28] Back in October 1960 he was not so encouraging of the trend, however, as he explained his misgivings about *Sculpture by Painters*.

> A large part of the show borrows the vocabulary of recent New York art — the kind that might, for the moment, be called post-action painting. In the last few years such New York painters as Jasper Johns, Robert Rauschenberg, Richard Stankiewicz and other painters and sculptors have brought some of the devices of surrealism and Dada-ism back into current art, and in this way have achieved an uncommon degree of comic freshness. By now their separate lines of development have converged at least to the point where they can be called a movement.
>
> But apparently their insights (unlike those of the older American generation) are not transferable. Certainly the attempts of the Isaacs artists to catch the most up-to-the-minute New York spirit are mostly dogged and stale.[29]

This is not the place to try to assess Fulford's judgement of the Isaacs Gallery artists' apparent efforts to assimilate the latest New York trends. He may, in fact, have meant to exempt Snow's work from his condemnation when he pointedly referred to the attempts being "*mostly* dogged and stale".[30] Indeed, probably less than a month later he was writing a profile of Snow for *Canadian Art*, in which he listed among the artist's influences "modern jazz (he is a professional pianist as well as a painter), film animation, and several senior members of the New York school".[31] More than a decade later, after Snow had located in New York, when asked in an interview why he had made the move he also emphasized his interest in the earlier generation.

Well, I came here to try to get better. I was oriented toward what was going on here and yet I was getting information late, in a way, through the magazines and stuff like that. I used to read *Art News*, which was the main magazine at that time, and follow what was going on. I was very much involved in it and it seemed that even though I was trying to work out my individual style, that I was still related to what was going on here and if I was going to do anything at all I might as well try here.

*Were there any artists you were particularly involved with?*

Well, I liked all the abstract expressionists and still do. I think I like de Kooning as much as anybody and Rothko too, and Newman, whom I didn't really see until I came here. That's what I was basically interested in. I didn't like very much Rauschenberg... things like that....[32]

By 1960 Snow was deeply involved in a vibrant cultural scene in Toronto centred on the old "Greenwich Village" on Gerrard Street at Bay, just a few blocks north of City Hall and the centre of the city. The focus of Toronto's bohemian and art student life since the late Twenties (it's just a few blocks north-east of the Ontario College of Art), the Village had spread in the mid-Fifties with the addition of a handful of commercial galleries (Av Isaacs's was the first), coffee houses, bars, book shops, jazz clubs and so on. About the end of the decade redevelopment around Bay and Gerrard forced the scene to relocate to Yorkville, near Bloor Street, some ten blocks to the north. Snow and his wife lived in modest bohemian comfort just south of Bloor and east of Yonge Street in a ground-floor unit of the Charles Street Apartments, 70 Charles Street East, at Church, where Joyce Wieland painted.[33] Snow himself shared a studio with Robert Hedrick on Yonge Street at Elm, just above Dundas. Halfway between, at 23 Grenville Street, was the House of Hambourg, well known for jazz, poetry and artist-organized art exhibitions. Snow supported himself and Wieland playing piano with Mike White's Imperial Jazz Band, a Dixieland group that during the period performed nightly in the Basin Street bar at the Westover Hotel, at Dundas and Sherbourne streets, on the rougher south-east perimeter of the downtown scene. In spite of the musical idiom, they were "hipsters", and highly aware of the music, poetry, drama, art and ideas coming out of the original Greenwich Village and its environs in New York City.

The flavour of this hip Toronto scene is vividly conveyed in the little magazine *evidence*, published out of the Village, beginning probably late in 1960. The first issue listed among its contributors "William Ronald — Toronto abstract expressionist painter now living in New York...", "Ray Jessel — Well known writer of songs and sketches for Canadian revues... [l]atest revue soon to be opening in New York", who wrote an appreciation of Miles Davis. Among other contributors were Joyce Wieland,

Gerald Gladstone (another Isaacs artist) and the writers Austin Clarke and Kenneth Craig, the editor of the magazine. The second issue includes the photo spread on Snow mentioned earlier, an evocative appreciation of Willem de Kooning's 1957 painting *February* by Joyce Wieland, and a number of photographs by Arthur Coughtry of the House of Hambourg Theatre's production of *The Connection* by the American Beat dramatist Jack Gelber. The third issue, dated fall 1961, has a photograph of Marcel Duchamp on the cover, and the text of an interview with the artist transcribed from a New York radio broadcast by Robert Cowan, one of the Canadians, you'll recall, who would later help Snow and Wieland settle in New York, a lengthy, considered essay decrying the criminalization of marijuana use, a photo spread on Gordon Rayner, and in addition to such regular literary contributors as Austin Clarke, reflecting the magazine's widening circle of readership and greater ambition, the poet Gwendolyn MacEwen, and from Montreal, Leonard Cohen, Irving Layton and Gertrude Katz.

Interaction between the literary and artistic scenes was encouraged by regular poetry readings at the Isaacs Gallery (begun in the spring of 1958 as the Greenwich Gallery Poetry Nights, organized by a committee that included Robert Fulford), and in 1960 Av Isaacs published two volumes of poetry, one of recent work by Raymond Souster illustrated by Michael Snow.[34] Tipped in at the front and back are two small lithographs in black on coated white paper of witty drawings that relate to *Theory of Love*, but throughout the volume is an extraordinarily involving series of markings — intersecting lines, scribbles, circles, erasures, speech balloons, and so on — that Snow seems to have drawn directly on the offset printing plates in subtle response to the texts of the poems and the edges of the pages.

The Duchamp cover of *evidence*, appearing just before the Dada show at the Isaacs Gallery in late December 1961, underlines the close links at the time between this core Toronto group and New York, ties that certainly, as Fulford remarked, extended back at least as far as a year earlier, when in October 1960 he registered his disappointment at "the attempt of the Isaacs artists to catch the most up-to-the-minute New York spirit", emulating the "post-action painting" of such as Jasper Johns, Robert Rauschenberg and Richard Stankiewicz.[35] There can be no doubt that the Toronto artists were aware of this first significant new direction in New York art since Abstract Expressionism. Some may even have seen the important exhibition at the Martha Jackson Gallery in New York in June, *New Media — New Forms I*, the first to focus on the new concern for assemblage and the appropriation of popular imagery, and they all would have read about it in *Art News*.[36] What, then, of Fulford's apparent desire to exempt Snow from his general disapproval, or of the artist's disclaimer of interest in Rauschenberg and the others? It is hard to imagine

that Snow was not encouraged to move toward a *Lac Clair* or *Green in Green* by the example of Jasper John's one-colour encaustic targets, such as *Green Target* of 1955.[37] Could his *Tramp's Bed* have come to mind without the example of Robert Rauschenberg's famous combine painting *Bed*, also of 1955?[38] Perhaps. What Fulford knew and what we will discover is that Snow's foldages, and paintings like *Lac Clair*, did not spring suddenly into being, but developed from a long process of engagement with drawing and painting in which an admiration for aspects of Abstract Expressionism was but one component of many. Snow knew, as did all the brightest artists of his generation, that it was impossible to emulate what they admired. They had to find new ways to achieve those heights again.

We can see Snow isolating precisely these issues in an exhibition of new paintings at the Isaacs Gallery in February 1960. The show was reviewed by only two critics, Colin Sabiston writing for *The Globe and Mail*, and Robert Fulford in his regular column in *The Toronto Daily Star*. The two responded remarkably similarly, although Fulford's reading of the work, as we might imagine, is both more sensitive and more complex. Neither, however, understood the essentially critical nature of Snow's investigations. Sabiston, although he never uses the term, saw Snow as an action painter on the model of practitioners of New York Abstract Expressionism or Parisian "tachism". He recognized a degree of diversity in the exhibition, but for him it was work that reflected some sort of free-form self-expression that dominated.

> Some of the 12 offerings are geometric in design, but most of them are composed (if that is not too formal a word) of collages that contain bits of metal, cardboard, textile cuttings and miscellanea or daubs, smears, blots, splatters and drips. Categorically, Snow is an abstractionist, sub-category tachist — or better still, perhaps, an impulse painter....
>
> Personally, I value such art for its autobiographical content. Any aesthetic pleasure is a welcome dividend.[39]

The show, as Sabiston notes, was relatively small, consisting of twelve works — six oils, four pieces described in the checklist as "oil and collage", one as "collage", and the smallest, a work of about 55 x 70 cm, as "tempera and collage". As Sabiston also remarked, some might be described as "geometric", but while only half actually employed collage elements, the spirit of collage touched virtually every piece.

Fulford's review reflects to some degree the exploratory nature of Snow's working method, but his real interest was in how the works, and the exhibition as a whole, reflected a developing talent.

We have come to expect a high standard of painting from Snow in the past, but it seems to me that in this collection of recent works he maintains a more consistent level than ever before.

But this is not to say that Snow strikes the same note, again and again. . . . He stands as far as possible from the kind of stylized abstractionist (like Jean-Paul Riopelle) who produces painting after painting in the same mood and style. For Snow, each work seems to be a crisis. For his audience, each work can be an experience.

On one wall, made up mainly of paintings produced last summer, Snow offers us both "Summer Snow," a delicious, laughing, many-colored abstraction, and "Trane," a complicated, dark, sullenly honest piece of work. On the wall opposite he has hung a series of more obviously serious works, culminating in "Bracket I," his latest painting and perhaps his best.

At first glance, "Bracket I" reaches closer to purity and simplicity than any Snow I can remember, but its simplicity vanishes as we examine it carefully. Its gradually changing colors and its quite unorthodox composition reveal a high degree of subtlety.

Like Sabiston, Fulford sought in the work some reflection of Snow himself, although his understanding of that aspect of the pictures was more refined than *The Globe* critic's belief that he had encountered "autobiographical content". What Fulford sought to interpret was Snow's sensibility, a developing quality that, again, as we have seen already, would continue to be for him one of the chief attractions of the artist.

In several of these paintings, Snow reveals his basic nature more clearly than at any time in the past. His spirit, these paintings suggest, is poised somewhere between intellect and pure passion — between, say, Piet Mondrian and Jackson Pollock. He has all the finer instincts of the formalist, coupled with the well-digested lessons of action painting. To put it mildly, he is an excellent painter.[40]

*Trane* and *Summer Snow*, as Fulford points out, are works of contrasting mood, although they share a basic approach whereby freely painted, expressive shapes are worked into an intimate relationship to a predetermined underlying grid, "felt" into the right position, it seems, which results in a shallow but complex space within which the forms are held in marked visual tension.[41] This also comes close to describing *Bracket I* (no. 98), the latest work in the show, dated February 1960 on its back. It and *Self-Centered* (no. 99), completed in January, are the most "geometric" of the twelve pieces, their greatly simplified grids clearly articulated by large areas of quite evenly modulated colour that virtually overwhelm the grid by breaking out dramatic, iconic shapes, a squat, thick, and somewhat top-heavy capital I in the for-

mer (similar to the logo Av Isaacs would adopt for his gallery when he relocated to Yonge Street in May 1961), a cross in the latter. *Bracket I* struck Fulford as being radically simple, and it certainly can be seen as a precursor of *Lac Clair*. Its colour is more complex, however, with searing greenish yellow bars at each side, the big I dark red, almost burgundy, at top and bottom, and bright saturated red at the centre, but with a touch of bright red splashed on the dark, and some of the dark splashed on the bright, a bit of sleight-of-hand that denies both colours primacy and fuses the whole canvas into an intense, smouldering, unitary presence.

*Self-Centered*, as its title suggests, is witty, lighter, although it too, upon close examination, is seen to be the product of a complicated sequence of paint applications that both reveals and obscures aspects of the remarkable formal dynamic that gives it its special character. The speed with which these layers appear to have been applied, resulting in the luscious splashes that are such an important part of the visual appeal of the work, suggests gestural painting more emphatically than does the splashing in *Bracket I*, in this most geometric of the paintings in the show. Snow continued his exploration of the shifting ground between geometry and gesture that

**Fig. 11** *Secret Shout* in the Yonge Steet studio, Toronto, January 1960

seems to define the show with three major canvases produced in April and May, right after the exhibition, *Pascal/Napolean* (no. 96), *Duol* (no. 95) and *Red Cross* (no. 94). They led him to a closer examination of the reality of paint on the surface of canvas, but the centrepiece of the exhibition exemplifies this quality of a certain resolution combined with future promise every bit as well. *Secret Shout* (no. 100), the third work of 1960 Snow included (it is dated January on the reverse), was featured on the exhibition mailer, photographed sitting on its easel under the painting lights, a potent product of the alchemy of the studio (see fig. 11). In colour prescient of *The Drum Book*, its right-hand side an early, in all ways darker, version of *Bracket I*, and with a smaller *Two* to the left, it presents a play of tension between these figural elements that, given that an earlier, now-obscured title written on the back was *Eros and Psyche*, suggests a sexual theme. If the *Secret Shout* is sex, then *Bracket I* is a male symbol, and *Two* a female, yet two more instances of Snow's struggle to achieve a dynamic balance between representation and abstraction. *Secret Shout*

demonstrates most perfectly that formal balance between reasoned structure and passionate gesture that Fulford so admired and that was the constant, unifying feature of the show. The achievement of this balance was neither spontaneous nor fortuitous, but the consequence of tireless investigation — working through and around ideas, defining issues, devising solutions, pressing the boundaries — in the manner, as we have seen, that Snow would continue to find so effective throughout his career.

The vibrant evidence of this primary research is in the various drawings and other works on paper that have survived. There are preparatory drawings, such as that for *Secret Shout* (see no. 101), one of at least two that contributed to the accomplishment of the canvas. (Both drawings can be seen in the photograph used for the exhibition announcement, as can some long rectangles of what might be paint-covered tape, which suggests that the negative spaces on either side of the I may have been achieved by masking, although drips and splashes appear to have been added to "mask" this technique. That Snow manipulated apparently accidental characteristics of the painting process in this deliberate fashion is confirmed by an inscription in the upper right-hand corner of the drawing: "Paint the yellow to flow in shape direction".) *Line Situations* (no. 97), the group of drawings in which Snow worked out the delicate, spidery grid of *Pascal/Napoleon*, shows him working within a narrow range. Other drawings reveal his ranging more broadly through a series of variations on the theme of brushy or splashy forms related to complex grids of various proportions (see nos. 106–9), often seeking, and achieving, colour effects, such as the delicate pink in the lower element of the I in the last drawing of this group, or the almost acidic lime green washed ground of the one before it, which would suggest applications in oil on canvas. (Note the electrifying ultraviolet effect in the long vertical element of *Secret Shout*, achieved by scumbling red over blue.) Some works on paper, like the rough but ready *Arrival* (no. 102), or the serenely calm *Warm Scene* (no. 104), show Snow testing the issues with collage elements, and in the latter, with folding. The breathtaking *Painting Un-Foldage* (no. 103) takes the folding so far as to point directly to *Red Square* in technique, and to *Lac Clair* in spirit.

The various forms of balance noted earlier in the composition of *Secret Shout* can be extended to its position in the exhibition, for as much as it was a centrepiece, it was also a fulcrum, on the one hand spawning forms that would be realized more fully — that is, independently — in later works, and on the other wresting that potent spawn from the oil-and-collage works that preceded it. The relationship to *Blues in Place* (no. 105) is clear in this regard. Included in the exhibition under the title *Time Place*, and completed five months earlier than *Secret Shout*, in September 1959, it shows Snow achieving a dynamic, evocative arrangement of brushy blocks and

patches of collage on an open skeletal grid that manages to achieve a balancing role in the composition by creating discrete forms of its ostensibly vacant spaces. A couple of months earlier, in July, Snow was working with a denser, much more concentrated accretion of forms in *Notes from the Underground* (no. 110), a tight, centrally focused composition of white, greys and earth colours in which few of the constituent forms are entirely discrete, and many, in fact, appear to be taking shape before our eyes. *Goodbye* (no. 111), another work of July in the exhibition, is described in the checklist as simply "collage", but it too is painted — not on a canvas, though. It is composed on the back of an old chest of drawers that had been painted black before it was broken apart, or perhaps after, but then leaving exposed the marks of the runners or drawer stops, creating, of course, a simple grid. A series of rectangular collage elements are visually submerged in or emerge from the gridded ground, an effect much like that of *Trane*. While in the context of the February 1960 exhibition these three paintings might appear to be the beginning of something, they all, and *Goodbye* in particular, in fact fall at the end of a series begun more than a year before, as we will see in the following chapter.

This appearance of a strictly linear evolution is deceiving, however. Granted, as we have moved back through time we have found ample evidence of a sort of sequential development arising from experimentation, but it has been just as evident that Snow's method is to work around a defined problem, exercising the issue, so to speak, testing the limits, expanding his range of techniques.

There is a remarkable example of this, what might be called centrifugal way of working, in a group of drawings that Snow was developing precisely during the fall of 1959 when he also was preparing his paintings for the Isaacs exhibition of the following February. Really one extended piece, *Drawn Out*, as he now calls it, consists of twenty-two charcoal drawings and a framed magazine clipping (no. 112). It is an exploration of twenty-one different ways of rendering a portrait, all based on a magazine illustration that likely attracted Snow because of its formal qualities. The dramatic tonal relationships arising from the photographic and printing processes have emphasized the component forms of the image, giving each a fascinating life of its own. Snow plays with that fact in his variations, but also deliberately employs different drawing styles, different techniques, varies the formats, and in the process ends up creating different moods, revealing different characters. The subject photograph, of a convicted killer, could be a study in the banality of evil. (The other photograph in the clipping is of the convict's lover, whom he also victimized; Snow includes one searching drawing of her.) The series of drawings is a profound investigation of the power of art to reveal complex layers of meaning in the shallow space of the surface of a sheet of paper.

Snow did not exhibit the piece at the time (it has been shown publicly only once, as a self-contained exhibition at the Isaacs Gallery in June 1989, two or three months short of thirty years after it was made), probably because it seemed, at least superficially, to be unconnected to his current concerns as a painter. We know from a sheet of drawings that Snow was thinking of using these images in a series of paintings that would group the two subjects, and a second woman, as separate portrait studies on a single, long, horizontal canvas, with each portrait painted as though lit from a different direction.[42] Rendered on the back of a flyer advertising an engagement of Mike White's Imperial Jazz Band at Basin Street in the first week of November 1959, it presents a vivid foretaste of that use of figuration that will emerge again, definitively, exactly one year later. The virtuoso drawing it demonstrates speaks just as vividly of a past, and it is to the decade preceding *Drawn Out*, which in the most literal sense created it, that we will now turn.

## Notes

1. Michael Snow, "A Lot of Near Mrs.," in Louise Dompierre, *Walking Woman Works: Michael Snow 1961–67. New Representational Art and its Uses* (Kingston: Agnes Etherington Art Centre, Queen's University, 1983): 19.

2. The Isaacs Gallery reopened in splendid new quarters at 832 Yonge Street, just a short block and a half north of Bloor, in May.

3. *evidence* 2 [spring 1961]: n.p.

4. Dimensions and location unknown.

5. Oil on folded paper on board, 139.7 x 88.9 cm, collection of Trevor Hall, Montreal, in 1970. See *Michael Snow/A Survey* (Toronto: Art Gallery of Ontario, 1970): 102.

6. Oil on folded paper on board, 59.7 x 74.9 cm, private collection, Toronto.

7. Oil on folded paper on board, 170.2 x 61.0 cm, collection of Betty and William Kilbourn, Toronto; repr. in *Michael Snow/A Survey*: 109.

8. Robert Fulford, "World of Art: Cool and Playful," *Toronto Daily Star*, 4 March 1961.

9. "Accent on Art: Intent and Serious," *Telegram* (Toronto), 18 March 1961.

10. "Art and Artists: Art Shows Prompt Controversy," *Globe and Mail* (Toronto), 11 March 1961.

11. Oil on folded sheet metal, 93.0 x 110.0 cm, collection of Michael Snow, Toronto.

12. "Humanity and Trash In Gallery XII," *Montreal Star*, 20 April 1963. On Ayre, see Sandra Paikowsky and Lois Valliant, *Robert Ayre: The Critic and the Collection* (Montreal: Concordia Art Gallery, 1992).

13. Elizabeth Kilbourn, "Coast to Coast in Art: Toronto-Hamilton," *Canadian Art* 18 (May–June 1961): 184.

14. Ibid.

15. Fulford, *Toronto Daily Star*, 4 March 1961.

16. "Michael Snow," *evidence* 2 [spring 1961]: n.p. The magazine is not dated, but is described in a press release issued by the Isaacs Gallery just before the show as "forthcoming". A copy of the release is in the artist's file, Edward P. Taylor Research Library and Archives, Art Gallery of Ontario, Toronto.

17. Ibid.

18. Lac Clair was the site of Snow's mother's family's summer cottage in the Lac Saint-Jean region of Quebec. See *Michael Snow/A Survey*: cover.

19. A sheet of notes survives with a drawing of the composition, identified as a "page of that book on drumming of Larry's." Larry Dubin was the drummer in a jazz group with which Snow played. The sheet also contains ideas for other "masked" compositions, that is, ones made with the aid of masking tape. Michael Snow Fonds, Edward P. Taylor Research Library and Archives, Art Gallery of Ontario, Toronto, box 31.

20. Fulford, *Toronto Daily Star*, 4 March 1961.

21. Michael Snow, taped interview with Louise Dompierre, 4 October 1982, Agnes Etherington Art Centre, Queen's University, Kingston, Ontario, excerpted in Dompierre, *Walking Woman Works*: 6. Two of the folded cards are repr. in *Michael Snow/A Survey*: 110.

22. Wood, acrylic, polyethylene, glass, paper, cotton, wire, sheet metal and chrome-plated sheet metal, 96.8 x 67.9 x 8.9 cm, collection of the National Gallery of Canada, Ottawa; repr. in *Michael Snow/A Survey*: 119.

23. Pearl McCarthy, "Art and Artists: Sculpture by Painters," *Globe and Mail* (Toronto), 28 October 1960.

24. "Accent on Art: From (Almost) Realism To Abstraction," *Telegram* (Toronto), 29 October 1960.

25. Robert Fulford, "World of Art: Not Transferable," *Toronto Daily Star*, 29 October 1960.

26. McCarthy, *Globe and Mail*, 28 October 1960.

27. "The Sign of Dada at the Isaacs Gallery, Toronto," *Canadian Art* 19 (March–April 1962): 111.

28. "World of Art: Anarchy," and "Everybody Wants to Get Into the Act," both *Toronto Daily Star*, 23 December 1961 and 6 January 1962 respectively.

29. Fulford, *Toronto Daily Star*, 29 October 1960.

30. Ibid., my emphasis.

31. Robert Fulford, "Snow," *Canadian Art* 18 (January–February 1961): 46.

32. Andree Hayum, "Information or Illusion: An Interview with Michael Snow," *Review* (New York) 72 (Winter 1972): 57.

33. See Helen Parmelee, "Meet the Avante-Garde Artists," *Telegram* (Toronto), 24 September 1960.

34. *Place of Meeting: poems 1958–1960* (Toronto: Gallery Editions, [1960]).

35. Fulford, *Toronto Daily Star*, 29 October 1960.

36. See Thomas B. Hess, "Mixed mediums for a soft revolution," *Art News* 59 (summer 1960): 45, 62.

37. Collection of the Museum of Modern Art, New York; repr. in colour in Russell Ferguson, ed., *Hand-Painted Pop: American Art in Transition 1955–62* (Los Angeles and New York: The Museum of Contemporary Art and Rizzoli International, 1992): 130.

38. Collection of the Museum of Modern Art, New York; repr. in colour in Mary Lynn Kotz, *Rauschenberg/Art and Life* (New York: Harry N. Abrams, Inc. 1990): 84.

39. "Snow Best Described As Impulse Painter," *Globe and Mail* (Toronto), 20 February 1960.

40. "World of Art: Canada To Enrich World Art?" *Toronto Daily Star*, 20 February 1960.

41. *Trane*, oil on canvas, 88.9 x 127.0 cm, collection of Betty and William Kilbourn, Toronto. *Summer Snow*, oil on canvas, 114.3 x 129.5 cm, collection of Linda Munk, Toronto.

42. Snow Fonds, box 26.

# III
# Discovering the Fifties

"Among the scores of remarkable individuals thrown up by the culture of the 1950's in Toronto," wrote Robert Fulford near the end of that decade, in June 1959, "— among all the quizmasters and sopranos, copywriters and set designers, folk singers and revue writers — you can find only a few who match, for interest and originality, the shy, witty young man named Michael Snow." Fulford elaborated:

> This enormously talented thirty-year-old Torontonian manages to combine the careers of abstract painter and jazz pianist, and, much more important, manages to be unusually good at both of them. In the afternoons, Snow paints prize-winning and praise-winning paintings which are shown regularly at the Greenwich Gallery (one of the two important modern galleries in Toronto) and accepted in the leading exhibitions everywhere in Canada. In the evenings, Snow plays piano in Mike White's Imperial Jazz Band, a robust Dixieland group which can be heard six nights a week and Saturday afternoons in the quaintly-named "Basin Street" basement saloon of the Westover Hotel....
>
> Snow's brilliant, angular, uncompromising canvases make him that extremely rare person, the legitimate *avant garde* painter. Large numbers of abstract artists in Toronto are capable of adroitly copying the old (and sometimes not-so-old) masters of New York, the men who have pushed non-figurative art to its highest peaks so far. A somewhat smaller group of artists, while imitating the masters to some extent, produce honest, personal abstract painting that depends for its effect on the originality of the painter himself. But only a very few painters can strike out on their own, as Michael Snow has done, and produce canvases which (while quite naturally showing the influence of older men) undertake the difficult task of asking new questions and finding new answers. Snow's shy, hesitant, quietly "negative" paintings do just this, again and again: his raw, biting color and his powerful, well-built forms are now among the most interesting aspects of art in this part of the world.[1]

Our guide as we move back in time from this point at the end of the decade, into virtually uncharted territory, will be an exhibition Snow was invited to pre-

Paris, April 1954

95

sent at the Art Gallery of Toronto (now the Art Gallery of Ontario) in February-March 1959, a portion of one of the *Four Canadians* series of shows begun in 1954 to showcase contemporary Canadian artists and held two or three times a year. Snow was linked with two sculptors, Ted Bieler and Gerald Gladstone, and with the painter Bain Ireland, but, as was the custom with the series, each artist's works were selected independently and were presented on separate checklists. Snow deviated from custom, however; rather than emphasizing his latest work, he chose to present a balanced mini-retrospective of his production of the previous four years. Although no final version appears to have survived, there are notes on two sides of a single sheet for a brief explanatory statement that Snow seems to have meant to be displayed in the exhibition. The statement does not deal with the meaning of the work but simply describes its range. The sheet also bears a number of provisional lists of the contents. Snow originally planned to include eleven paintings covering a period back to 1953. A deadpan fillip at the end of his brief description suggests both a touch of anxiety at what he left out of the showing (and perhaps of the description), and a self-mocking allusion to the evident evolution of his work. "I have chosen to show works from various periods of my work over the last 6 years. Where possible I have chosen what I consider to be the strongest one of each particular series. Missing, of course, are examples of several other voyages, especially the latest one. God is the latest. Speed God."[2] It is not this unused text that will lead us through these years, however, but the selection of works. Snow showed nine pieces, finally, that fitted neatly into five groups, presenting a succinct survey of his development as an artist during the second half of the decade. There was a canvas of February 1959; an abstract from what was his second solo exhibition of October 1958; three oils of 1957, a period in which he negotiated his way from figuration to a kind of gestural abstraction; two canvases from his first solo exhibition of October 1956; and two works of 1955, one from a group of remarkable collages first shown in February 1956, and the other an oil of the previous September.

Only one critic responded to Snow's carefully presented visual statement, Robert Fulford. Such an exhibition offered him the perfect opportunity to stress what he considered to be Snow's unique accomplishment, and to raise many points that he would refine in his profile of Snow the following June. He noted that at the early age of thirty, Snow was one of the few genuine "avant-garde" painters, working "out at the edge of the known art world, exploring and charting new regions of sensibility".[3] It was a sensibility, Fulford believed, that had been shaped at least in part by Snow's deep involvement with jazz. "His paintings concentrate on the value of movement. They are never static. They move with jagged, irregular rhythms (something like modern jazz rhythms). His shapes clash and clang, crackle and stutter,

as they shift across the canvas." In the earliest work in the show "the viewer can easily see the painter's original inspiration...the shape of the human body," which Snow used "abstractly, beginning with natural forms and ending with something that is both unique and powerful". The other seven pieces appeared to Fulford to have evolved far from their sources in "reality", while remaining "most certainly related to life. His art reflects, as very little contemporary Canadian art does, the diversity and intensity of life, the tension and tragedy and peculiar beauty of the world of 1959." While Fulford does not enumerate exactly how the work so vividly reflects its time, it would appear from his concluding remarks that he believes that it is because it reflects Snow's personal qualities: "a sense of unending spontaneity [that] is one of the marvels of the current Toronto art scene," and a "remarkable... confidence in the face of a generally indifferent Toronto art audience".

Enlightened as we now are by hindsight, we can see the nine works in the Art Gallery of Toronto show as so many points on a line along which Snow had developed inexorably from figuration to something near pure abstraction. Fulford was right to stress that all appear to have their sources in reality, but the very fact that the last work on the checklist, *To Orangeville*, of 1958,[4] is the most abstract, and that the second-to-last position in the otherwise strictly chronological list is filled by a work, *News* (no. 113), that while dated to the following year, still plays with representation in a manner that might seem to precede *To Orangeville*, makes Snow's intention clear. Fulford perceived *News*, the most recent work in the show, to be similar to the other canvases, wherein "the shapes jump and crackle as they move across the canvas," although "now they are tightly unified and give a sense of completion".[5]

If we acknowledge that it does relate both to works that precede it, such as *To Orangeville* and, with its loose painterliness presented within a clear, if complex, grid system, to the abstracts that follow, what perhaps is the most important thing to notice about *News* is that it is based on the structure of the front page of a newspaper. Snow has remarked that his realization then "that one could use existing 2D surfaces as *subject*" was "the basic working insight of Jasper Johns and subsequent 'Pop' painters", but that he arrived at the realization "independently".[6] He was thinking of *Flag* of 1954–55, and its subsequent variations, exhibited in Johns's first one-man show at the Leo Castelli Gallery in New York in late January 1958.[7] A painting of an American flag as a flat object the same size as the painting, Johns's famous work confronts the issues of subject and object, of illusion and reality more dramatically than does Snow's *News*.

A page of drawings and notes that has survived shows that Snow was thinking of a range of possible two-dimensional subjects at the time: "words letters num-

bers", such as "BLUE — painted in red"; "symbols flags signs", including the French flag and the Union Jack; "trademarks / mathematical equations / poems / wheel / a label / cover of downbeat", the jazz magazine; and at the end of the list, with a little drawing, "a *newspaper* front page / greys black white / nothing legible".[8] That he was proceeding cautiously is suggested by a further notation, right beside the *News* notes: "is uneasiness a sympton of the end"? The visual reference to a newspaper is tempered, certainly, by the brushy nature of Snow's handling (it is more like the image of a memory of a newspaper), and by his use of colour. The greys are warm and richly modulated, and there is a green band at the bottom and a blue one at the top, and bits of red here and there throughout. *News* is a tentative step toward bringing figuration into play with the material surface of the painting, but an important step that will, as we have seen, result in bolder moves in that direction later on.

Some of the forms employed in *News* were developed from a series of large charcoal drawings (see nos. 114–116), the "headline" portion specifically from a work now called *Headline (Sketch for "News")* (no. 114). They are yet another example of Snow's characteristic way of working: setting parameters and then relentlessly investigating the potential. In this case a basic structure — made up of letter forms, boxes, what might be furniture and so on — is drawn in with broad, strong strokes of charcoal, and then this "figure" is knitted into the ground by rubbing and smudging, and even erasing, where the removal of the medium becomes a kind of drawing. The lines of the grid in *Headline*, for instance, are entirely the result of erasure, a technique that recalls Robert Rauschenberg's now classic *Erased de Kooning Drawing* of 1953, a work created by almost entirely erasing one of Willem de Kooning's "woman" drawings.[9] But as with *News*, the relationship of these drawings to recent New York innovations is tentative (it is not even a conceptual link, in this case, but only at the level of technique). And also as with *News*, these large manipulated charcoal drawings not only are consistent with Snow's later practice, but, as we will see, derive directly from his earlier.

Just four months before the Art Gallery of Toronto show, Snow had staged his second solo exhibition with Av Isaacs, in the dealer's Greenwich Gallery, as it was then known.[10] Described on the invitation as "Paintings, also Drawings and Sculpture", it was dominated by nine large abstract paintings, but also included a sculpture, *Versailles*,[11] and eleven drawings. It was this show that sparked the confrontation that would set Snow supporters against Snow detractors for the next few years, when the fervour of the former encouraged them to see something like a conspiracy of silence among the latter. Paul Duval gave the exhibition short shrift in his column in *The Telegram*:

A young Canadian contemporary whose work poses some problems facing painters today is Michael Snow. In an exhibition at the Greenwich Gallery, he shows large oil abstracts side by side with a group of romantic figure drawings.

Personally, we prefer the drawings to the lozenge-shaped patterns of the canvases. It would be interesting to see what would emerge if Snow painted up such themes as his fine drawings, Antoinette and Women Waiting.[12]

But more to the point, it was not until two weeks after the opening that Pearl McCarthy of *The Globe and Mail* finally responded, and not to the show (although she professed some admiration for Snow's efforts), but to the lobbying of the artist's supporters.

Michael Snow's exhibition at the Greenwich gallery is neither better nor worse because there has been a spate of letters from admirers of this young artist's work to "prompt" giving him a high ranking. These contained more abuse of other artists than had ever through the years reached this desk.... Mr Snow really does not need such behavior, for the truth is that he is a gifted person working his way to art of considerable depth.[13]

Robert Fulford at this point was not yet a regular columnist for *The Toronto Daily Star*, but for the past year and a half had been reporting the local art scene on a regular Sunday afternoon program on CBC radio.[14] He reviewed the Snow show the day after McCarthy's column appeared.

Michael Snow is at the same time one of the most stimulating and one of the most difficult painters in Toronto. I mean difficult in the sense that it takes far more conditioning to enjoy his work than to enjoy that of, say, Robert Hedrick or Graham Coughtry, two painters of Snow's approximate age and stature. But those who have seen enough of his art to begin to feel its considerable depth know that he achieves some unique and quite exciting moments — perhaps more of them than most other painters of his generation.... Snow's best work...is distinguished mainly by the fact that so much *happens* in it. His pictures are never still; they move...in sharp, jerky, irregular rhythms. Yet there is never a hasty feeling about them; they all show the effects of a great deal of thought and work, and each of them conveys a unique impact. Snow not only manages to carry off a number of successful canvases — he also manages to assert a style all his own, and this is surely a statement that can be said about only a few abstract painters.[15]

Writing for *Canadian Art* a few months later, Hugo McPherson, a professor of English literature at the University of Toronto with a deep interest in contempo-

rary art, was even more direct: "...Michael Snow's exhibition at the Greenwich Gallery produced a half a dozen of the wittiest, most arresting canvases of the season. This painter's style is alert and nervous — at once conscious of fine shades of meaning and capable of reducing experience to its large, essential outlines."[16]

All the paintings in the show presented rough rectangles of varying sizes embedded in thickly painted grounds. Some, such as *Off Minor*[17] and *Narcissus Theme*,[18] are simple in structure, serene, consisting of only two or three elements. Others, such as *To Orangeville* or *Petrograd 1917* (no. 117), as Fulford remarked, are full of action. Both Fulford and McPherson stressed the coherant style Snow had achieved in the show, but neither specifically remarked the variety of moods the work suggested, a characteristic, as we have seen, that would become a hallmark of the artist's presentations. McPherson does draw our attention to the "various unorthodox arrangements of colour" in a work he calls *Bright Corners* (actually *Brilliant Corners*[19]), which he sees as in part evoking "the brilliant midnight corners of a crossing like Toronto's Dundas and Yonge". And *Nightways*,[20] "a related canvas, gives us a sense of looming buildings and garish store-fronts flashing by at 30 m.p.h."[21] *Petrograd 1917*, completed just one month before the exhibition opened, also evokes night streets, although, as suggested by the title, of a historical and decidedly more violent sort. We must be cautious of too literal, or at least too narrow, a reading, however: as Snow reminded an interviewer from a University of Toronto newspaper just a month after the show, the titles "are put there when the work is finished".[22] There well could be, as Fulford believed, a source in "reality" for every one of these paintings,[23] but that does not determine their outcome. They are meant to engage us entirely, as we can see in *Petrograd 1917*, at the formal level — with dynamic balance, rhythmic movement, and seductive deployment of paint — while spinning off visual associations that are richly multi-levelled. McPherson thought not only of Toronto's busiest street corner when he contemplated *Brilliant Corners* but "of the Japanese diagrams designed to test color-blindness".[24] "It should puzzle", Snow informed the university interviewer of his painting: "it is good if it is a little enigmatic.... You sit in front of the painting and let it come to you. Feel with it, enjoy it, but don't understand it!"[25]

The single sculpture in the show, *Versailles*, made at table-top scale with wire and flat plates of polyester resin painted to look like bronze, was a three-dimensional version of the paintings, but also resembled a modern, multi-levelled stage design. Less clear in intent within the context of the show were the eleven drawings, works entirely ignored by Fulford and McPherson, but preferred over the paintings by Duval. We don't know the actual works Snow showed (Duval mentions two pieces by name, *Antoinette* and *Women Waiting*, which he describes as "romantic figure draw-

ings"[26]), but if they were at all like two small works of 1958 now in the National Gallery of Canada, then in the long view they represent a dramatic link between earlier figure drawings we will be examining shortly and the female figure that emerged in Snow's work three years later. Both drawings show a silhouette of a vital dancing woman. In *Dance* (no. 123), the figure is created entirely by leaving the sharp, clean shapes of arms and legs as negative spaces within an otherwise brushy, ragged drift of black ink. *White Figure I* (no. 122) probably began that way, but Snow brought her uniquely to life by altering the negative silhouette with white gouache, then darkening the figure with a scrubby grey, and finally adding a roughly torn piece of paper as a left arm. That this same intuitive, "feeling into place" approach lies behind the paintings is revealed by the little pencil drawings in which Snow developed his compositions (see nos. 119–121). Here we can experience the rectangles being gently worked by rapid hatching, rubbing and erasure into the precise size, density and complexity of interrelationships with one another, the ground, and the format of the sheet required to achieve the exact weight of mood and evocative imagery of scale that Snow desires.

One of the most impressive of the paintings in the group derived from these little drawings was not included in the October 1958 exhibition. *Detroit Blues* (no. 118), which was being saved for the Carnegie International in Pittsburgh in December,[27] is a brooding, resonant image of a few whole and partial squares embedded in a dark ground divided into three rows by a simple grid, suggesting a form of primitive but emotionally exact musical notation. *Goodbye* (no. 111), in Snow's February 1960 exhibition, was a witty reprise of *Detroit Blues* and, as suggested in the last chapter, can be seen, along with *Notes from the Underground* (no. 110), and perhaps one or two other works in that show, as a more or less deliberate conclusion to this strategy of expressive placement of discrete rectangular forms within a viscous painterly ground. *Detroit Blues* is one of the earliest proposals in this direction, completed early in May 1958, just after Snow and Wieland had returned from an extended vacation in Cuba, and had moved into the

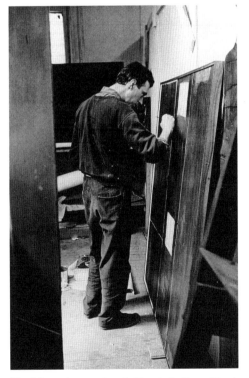

**Fig. 12** Touching up *Detroit Blues*, in the Yonge Street studio, Toronto, late 1960

apartment on Charles Street East that they would occupy until they left for New York in 1962.

They had departed for Cuba likely very late in December or early in January, travelling through Florida, and had intended to continue on into the Caribbean or to Mexico, but found transportation too expensive. They spent some time in Havana, but passed the bulk of the visit, at least a month, in a rented hut in a fishing village, La Boca, near Trinidad, an ancient, isolated hill town about midway along the southern coast of the island. They returned to Toronto, probably in late March or early April, via New York.[28] The trip was of no particular artistic importance to Snow (though one work in the October exhibition, *La Boca (Cubaism)*,[29] commemorates it), but because he and Wieland let go of their previous apartment/studio before departing, and, as mentioned, moved into a new location on their return, it does mark a minor watershed. During the year before, they had both worked at whatever occasional commercial art jobs they could pick up, but just after returning Snow experienced a bit of a windfall when he was commissioned to design a cover for *Canadian Architect* magazine, another shortly after for the August Mayfair and yet another for the October *Imperial Oil Review*.[30] Based on bright, witty graphic collages, they proved so successful that he was asked to provide three more covers for *Canadian Architect* the following summer.[31] More important, however, by the fall of 1958 he had begun playing nightly at the Westover, a handy job that was creative, provided a degree of financial security, and gave him afternoons free to paint. It was a way of life that encouraged remarkable developments in his painting, as we have seen, and one that Snow remembers enjoying immensely.[32]

Before leaving for Cuba, Snow and Wieland had lived in an apartment over a store at 312 College Street, with studio space on the third floor, a block and a half west of Spadina Avenue in the vibrant Kensington Market area. This was about as close to the Greenwich Gallery on Bay as the Charles Street apartment would later be, but to the west instead of north-east. They had found it when they married, in September 1956, and although it was small, it was also cheap. That was necessary because neither had a steady job. They survived on a bit of free-lance commercial design, and Snow got the occasional musical engagement. He did not have a show in 1957.

It was, nonetheless, an important period of painting, and he included three works of that year in the *Four Canadians* show: *Aqua Table*,[33] *Table and Chairs in Blue and Reds*[34] and *Summer Storm*.[35] This last, a brushy green-and-black composition combining billowy and gusty forms, is the most abstract of the three. Completed in June, it is one of a small group of similar canvases Snow painted that summer, including *Move* (no. 125), finished in July. All are full of movement (a theme signalled by the

titles, although it should be pointed out that "Move" is also the name of a piece by the innovative jazz trumpeter Miles Davis), and all present focused investigations of the effects that can be achieved with broad sweeps of paint, often scumbled, dragged over previous coats. *Move*, for instance, presents a blocky, yet elaborately articulated, form in dark blue, around and partly over which are brushed broad, closely valued areas of creamy paint tinted a variety of delicate hues — pink, green, yellow, brown. Closer examination reveals that the work we see now appears to have been painted over another picture, perhaps incorporating part of the earlier work. The image of the figure or dark form in *Move* is very similar to some of the manipulated charcoal drawings of early 1959 we looked at a while ago, particularly *Theatre* (no. 116). A photo of Snow in his studio that accompanied the December 1958 article by the university student shows him surrounded by what seem to be ink or gouache studies of similar sprawling and yet vital forms, what are called in the caption "his 'ideas' — abstract anticipations of a final canvas".[36] They resemble the black-and-white paintings of the New York Abstract Expressionist Franz Kline.

*Move* and other paintings of the summer of 1957 are the closest in appearance to classic gestural painting that we will see in Snow's work, and they suggest a sudden response to the paintings of the senior generation in New York, although, as we will discover, Snow had been looking at and thinking about de Kooning, Kline and the others for some time by then. One event that year that may have precipitated such a response, however, was the first one-man exhibition in New York, at the prominent Kootz Gallery, of the Toronto painter William Ronald. He was one of the artists later involved with *evidence* and also, with Snow, one of the original members of the Greenwich Gallery stable. A copy of the invitation to the Kootz Gallery show, which ran from 15 April to 4 May 1957, is in Snow's papers, and he likely travelled to New York for the opening.[37]

Snow and Wieland visited the city at least twice a year during this period, to hear new jazz primarily but also for the art. They saw *The New American Painting* at the Museum of Modern Art the summer of 1959, for instance, a landmark survey exhibition of Abstract Expressionism that had toured Europe the previous year in a kind of triumphal procession. They saw de Kooning's *February* then, which Wieland wrote so beautifully about in *evidence* two years later.[38] They also would have seen the work of artists of their own generation. If they did make it to Ronald's opening in mid-April 1957, they doubtless visited *Artists of the New York School: Second Generation* at the Jewish Museum (10 March–28 April), a much-discussed exhibition that included the work of Alfred Leslie, just one example among many of a painter wrestling with the challenge of de Kooning's accomplishment in a way that Snow would have understood.[39]

*Move* grew directly from Snow's own experience, however, not from his response to the experiences of others, as much as they may have encouraged him in the direction he was taking. There are works slightly earlier than *Move*, for instance, that also relate closely to its spatial dynamic and the particular conformation of its figure-ground relationship. *Chairs* (no. 126), in ink on roughly torn paper collage, is a good example. If we think of it as possibly being in its present form a reworking, a cannibalizing of an earlier piece (the process that may also inform *Move*), then that earlier piece likely would have resembled *Blue Table and Chairs* (no. 128), one of a group of gouache (or sometimes ink) studies in which Snow explored ideas that he then worked out in canvases over a four- or five-month period from November 1956 through the late winter. The resulting canvases are all images of tables or of tables and chairs, presented in different styles and reflecting different moods. The figure-ground relationships

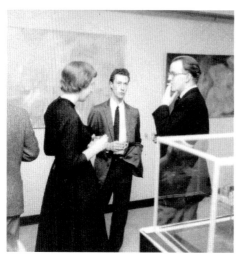

**Fig. 13** Jocelyn and Robert Fulford with Snow, The Greenwich Gallery, October 1956

might be manipulated to achieve a powerfully iconic presence, as in *Table and Chairs No. 1* (no. 129), of November 1956, or a more gestural, lyric abstraction, as in *Sky Table* (no. 127), of January. One can imagine either of these underlying *Move*, their swelling power dispersed to a degree, fragmented, but still strong, now present across the whole surface of the painting.

It is curious that Snow did not hold an exhibition of these table and chairs paintings. Perhaps he was not yet ready to stand behind the variety of styles they represented, or he may have felt that his work was developing rapidly to an indeterminable resolution. He did show them, however. Four, including *Table and Chairs No. 1*, were in a group show at the Greenwich Gallery in March 1957,[40] and he sent *Sky Table* and a work titled *Table and Chairs No. 3* to the Winnipeg Art Gallery's annual contemporary show in November, sharing the top painting prize with Graham Coughtry (they split $300).[41] The chance of prize money, the exposure, and the possibility of sales encouraged Snow to participate in the various annual exhibitions run then by public galleries and museums or by professional artists' organizations, artistic venues that in the Fifties still retained a degree of viability. They were important to Snow in his earliest years, as we will see later, but they failed to serve him well much past

the middle of the decade. He did not submit work to the Canadian National Exhibition show after 1958, for instance (one of his paintings was ridiculed that year when it was inadvertently hung on its side). And at his last outing with the Ontario Society of Artists the following year, he was criticized in *Saturday Night* magazine for incorporating drips and splashes in his painting.[42] That *Detroit Blues* passed unnoticed in the 1958 Carnegie International in Pittsburgh was perhaps less discouraging, but when after sharing the top prize at Winnipeg in 1957, his *Off Minor* was ignored in 1959 (he did not participate in 1958), he stopped submitting there.[43] The carefully presented solo exhibition was a far superior method of placing his work, and ideas, before the public, and as we have seen, he would become a master of the form.

Snow's first one-man exhibition, at the Greenwich Gallery in October 1956, was precisely this sort of deliberately structured public statement of his aesthetic position. Meticulously ordered, it also, as would become characteristic, encompassed within its clearly defined parameters a wide range of expression. Entitled matter-of-factly *Paintings, Sculpture, Drawings by Michael Snow*, it consisted of eight oils, three small sculptures and four drawings. Something of its quality is captured in an introduction that appeared in the folder serving as an invitation to the show, "About Michael Snow", by Robert Fulford.

Snow, in essence, is a romantic painter. In a time when *pattern* is a catch-word for artists of many schools and *design* is everywhere king, he has turned his back on the bloodlessness of decorative painting and produced pictures that reflect directly the joy he finds in the interaction of the act of painting and the subjects themselves. The subjects may be furniture, an interior, the feeling of a time of day, landscape, the forms of the human figure, a quality of light or a reminiscence of a city square.

Lately this emotionalism has been joined in his work by a special fluidity. Many of his paintings, even the still-lifes, are essays in motion; at times the canvases seem to be animals that have stopped breathing only for a moment and may soon begin again. The twin ideas of growth and change also play exceptionally large roles in his work. His sculpture, "Chair Metamorphosing," for instance, is a chair that seems to be caught in the act of changing into something else. In an even more subtle state the same dynamic turns up in his pictures.[44]

The reviews of the show were, without exception, similarly encouraging. Even Pearl McCarthy, the veteran critic for *The Globe and Mail*, expressed a measured approval: "Michael Snow has a one-man exhibition at the Greenwich Gallery which gave us one of the happiest surprises of months. The last work of his we had seen

looked too clever by half and without cohesion. Therefore we went full of solemn intent to be dutiful — and promptly beamed with unexpected pleasure."[45] All the critics also agreed that Snow was a romantic expressionist. Hugo McPherson reported on "CJBC Views the Shows":

> At the Greenwich Gallery in "the Village" I saw a small collection of the paintings and sculpture of a young Torontonian, Michael Snow. I say "young" because I feel that Mr. Snow's painting is at once very promising and somewhat tentative in style. The world which he shows us is essentially a romantic world of sunset and dawn and unfolding half-lights. His paintings suggest not the solid shapes of a well-lit studio or a street, but the fluid forms and atmosphere of reverie. This is a world in which the painter escapes the forces of gravity and geometry. He is literally a *floating* spectator in the scenes which he creates; thus the objects which possess significance for him group themselves in obedience to the laws of *feeling* and *imagination....* There is a witty wisdom in his vision of plants which lie on their sides, stoves which show their burners full face and tables which lean nonchalantly in several directions. Mr. Snow is an intelligent observer who understands, as Paul Klee did, that objects seen out of context, or in a context of their own, reveal a personality that we normally overlook. We should add that this carries over into the three small sculptures included in the show.[46]

It was a student reviewing the show for a University of Toronto newspaper, however, who best caught a sense of the range of Snow's expression.

> Mr. Snow has a delicate and whimsical sense of humour that is unique. This is most evident in his pen drawings of shy, wispy chairs and tables. This subtle humour, which showed to advantage in the drawings, looked merely flimsy in his sculptures. His large oils, often on the same subject — tables and chairs — occasionally showed a nightmarish schizophrenic quality, at other times appearing to be enchanted impressions of everyday objects. Most impressive was a large flaring landscape of grass and sky and light all rushing up in an incantation of growth.[47]

This last work, called simply *Landscape*, was the largest piece in the show.[48] Robert Fulford used it and another work displayed then in an article he wrote following the exhibition to make a point concerning Snow's response to his environment. His surroundings, Fulford argued

> seem to bear heavily on much of his work. This was demonstrated with happy (for the critic) precision by two pictures at Snow's one-man show in the Greenwich Gallery last

autumn. They were painted just before and after Snow's marriage and move from his parents' home in Rosedale to an apartment on College Street near Spadina Avenue. The first, *Landscape*, reflected a sort of fire amid the Victorian quiet and enclosed grace of Rosedale, the district that was once the finest in Canada and still manages to keep up appearances nicely. The second, *Painting 1956*, seemed almost a declaration of personal and artistic independence. It reflected violently the ethnic riot of the new section of the city in which Snow, to his delight, had just found himself. It is a district that was until recently largely Jewish but is now occupied mainly by newly-arrived Germans and East Europeans. In these works Snow was showing two moods of Toronto and his own attitudes toward them.[49]

Snow's range also included a circular canvas, *Around Red*, that McPherson described in his report as a "vivid" work in which "the forms of chair-backs and bureaus unfold in brilliant color as they might to the eye of someone just awakening".[50] But the determined exploration of the limits — of a subject, of a style, of an emotion or an idea — that always has fascinated Snow and fuelled his art is most evident when we compare the two canvases from this first one-man show that he chose to include in the *Four Canadians* exhibition — *Interior at Dawn* (no. 130) and *Leaving Blackness* (no. 131), both painted the summer of 1956 when he was still living with his parents in a large Queen Anne–style house at 110 Roxborough Drive in exclusive Rosedale. They are elevated views of large interiors, doubtless principal rooms in Snow's home, with the furniture come to life, piled together in writhing heaps, their legs spread out and arms joined together, some flying up, others transforming into figures, or blending, fusing with the heavy atmosphere that determinedly reveals itself in numerous passages

**Fig. 14** Snow and his mother, The Greenwich Gallery, October 1956

to be paint. The effect of both canvases might at first seem claustrophobic, but their finally complex characters preclude a simple emotional response. *Interior at Dawn* is sensuous and brushy. The paint has been applied in billowy cloud forms, an effect that is in places like a delicate wash. There is a suggestion of prismatic light across the surface and throughout the shallow but still substantial space, running from blue-

greens on the left to pinks, delicate oranges and mauves on the right. Where we might imagine the contents of the room in *Interior at Dawn* finally slipping into a sensual torpor, the furniture in *Leaving Blackness* is excited, agitated. It jumps higher, is more angular and is picked out against the black background and darkened atmosphere in reds and purples and blues and flashes of white of great intensity. Some furniture seems to be congealing, and the black paint has coagulated in knots here and there. The resolution of this scene, we might imagine, will be apocalyptic destruction.

Although the critics made only passing reference at the time to the sculpture and drawings in the show, they are as important as the paintings, both as works in themselves and in how in relation to the paintings they reveal Snow at this early point in his career exploring a constant theme through various media. Fulford understood this without, of course, foreseeing how it would develop into a rigorous *modus* in later years. When he first heard that Snow was making sculpture, in the late spring of 1956, he reported the event as hot news. What struck him first about the three pieces he saw in the cluttered basement studio on Roxborough Drive, and that later were included in the October exhibition — *Three Chairs* (no. 132), *The Table* (no. 133) and *Metamorphosis — Chair* (no. 134) — was what he perceived to be their stylistic relationship to the paintings.

> They fit neatly and consistently into the style Snow has lately maintained, a style that is almost never static and implies motion, some sort of motion, in almost every line. And, like most of the Snow paintings, the sculpture contains a special sort of excitement, a kind of refined joy that pervades even the works purported to picture despair.

A little further on he touches on the shared subject matter, and even reflects upon Snow's special way of working.

> Coupled with this desire for motion is a preoccupation with growth and change. One of his pieces of sculpture, titled Chair Metamorphosing, shows a chair that is warped and twisted but is still very much a chair. It appears to be in the process of changing into something else — a girl, say, or a bathtub.
>
> In the sculpture, as in many recent paintings, Snow conveys to the viewer a unique mystery he finds in static objects. As he begins to work his mind fastens on one item, usually a piece of furniture, and works it over as he makes sketch after sketch. Finally it reaches a new and challenging form and Snow puts it in metal or oil.[51]

*Metamorphosis — Chair*, dated 1955 on the underside of its base, is the earliest of the three, and relates in its soft, ovoid planes and contained forms to a series of col-

lages Snow produced in 1955 and very early 1956, works that doubtless suggested to Fulford it was a "girl" the chair was aspiring to become. There is a group of working drawings and notes that in fact confirms the relationship, showing various ideas for sculptural chairs that take human form, and one sheet that shows a "seated nude / in plaster white / about 12″ high / same pose as collage", on a "copper wire / chair / just linear", that, while it was not realized, nonetheless assisted the final form of *Metamorphosis*.[52] Another drawing shows a stool grown taller than a man, its seat turned up and out like a mushroom cap, or a head, that also relates to the finished sculpture; and yet another shows a "man / on a stool / plaster metal", which in its extreme attenuation manifests clearly that the work of the sculptor Alberto Giacometti here lies behind Snow's thinking.[53] *Three Chairs*, made of resin-encrusted wire, and *The Table*, a little still-life *cum* miniature cityscape of found metal objects arranged on a metal plate set on four spindly legs, both also relate in their attenuation and texture to Giacometti's work, but don't stop there. The humour, dynamic rhythm and what they reveal of the nature of the materials employed all reflect Snow's own deeply held concerns, and the subject of these three sculptures, sentient furniture, also places them squarely in his camp.

Although Fulford associated Snow's sculpture with his paintings, they are more intimately related to his drawings. While only one of the four he exhibited that October is known today, *In the Kitchen*, which was reproduced on the invitation, certainly it is, and likely the other three are, integral to a large group of similar drawings that span the period from the fall of 1954 into 1957.[54] Many, such as *In the Kitchen* and an untitled one in blue ink that Snow gave to Fulford as a wedding present in 1956 (no. 138), depict metamorphosing tables and chairs. They are not simple drawings. The anthropomorphic aspect of the furniture is often complex. The thin, nervous line might appear anxious, even neurotic at times, but it can be muscular as well, and it is always deliberate. In *I think / Brushes should be big / and / Pens small* (no. 140), although everything rushes off toward the upper right of the sheet, we are acutely aware of Snow's having placed each element, including his inscription, very carefully on the page, working intuitively in the direction of the flow, as if writing. The splaying of the tables and chairs flattens the image, creating a shallow space and bringing the figures into a more intimate relationship with the ground. Splatters of ink enhance this effect, and contribute as well to the quality of nervous energy. The imagery itself has subtle levels. The kind of rocket-like female figure we see in *Three Figures in a Book* (no. 153), of 1955, a glorious incendiary display in violet-red and blue inks, which also plays on the depiction of a flat object (a page of a book), becomes a sculpture on a pedestal in *I think / Brushes...*, whereas a stool is the furniture family's dog. The inscription/title draws our attention to the fitful

penmanship, the at times shaky, wiry line, and the omnipresent splatters. They are deliberate. Snow customarily worked on these serious whimsies in his sketchbooks with a plastic swizzle-stick as his drawing instrument, a technique that thwarted his natural facility and introduced accident and a struggling, groping sense of discovery to the process (see no. 149). The figure subjects convey this sense of risk, of the emotional and physical tension arising from dealing with the direct consequences of deliberate action, most effectively, an anxiety that is patent, for instance, in the humorous but affecting *A Portrait of Kierkegaard* (no. 142).

The earliest works in the *Four Canadians* exhibition were both of 1955, one a collage, the other an oil. The collage was one of a group Snow produced during the fall of 1955 and on into the new year, three of which he included in the opening exhibition of the Greenwich Gallery in February 1956. Snow, one of five artists in the show, was represented by seven works altogether, a gouache (or tempera, as it was called), a small oil and two ink drawings. We don't know if *Seated Nude* (no. 145), the collage in his Art Gallery of Toronto mini-retrospective in February 1959, was included in the Greenwich Gallery opening show three years earlier. *A Man at a Desk* (no. 148) was, but the two other collages, titled *Of the Earth* and *Of Men*, seem since to have been renamed. All the collages known today, except for *A Man at a Desk*, are stylized female nudes, all figures entwined in their backgrounds both by Snow's innovative technique and their own nature as images. One, today called simply *Reclining Figure* (no. 146), of 1955, most suggests landscape forms, and could thereby be "of the earth". The others, and particularly *Enchanted Woman* (no. 144) and another *Reclining Figure* (no. 143), both of 1956, are related to shapes suggestive of upholstered couches or easy chairs, and might then be rather "of men". Identifying them is not so important, however, because while varied in mood, in colour, and in the conformation of their intricately interrelated collage elements, they are all closely related by virtue of their technique.

More than two decades after they were made, Snow wrote in some detail about this technique and its genesis to a curator organizing an exhibition on collage in Canada. In the covering letter he explained that "these knife-drawn works" were real precursors of the Walking Woman. "In fact the original Walking Woman is absolutely a daughter of these early collages as it was cut out of cardboard using the same type of 'mat' or 'Exacto' knife as the collages and 'drawing' the same kind of forms."[55] He then elaborated in a statement prepared for the catalogue of the exhibition:

I had done collages using paper when I was a student at o.c.a. around 1954 and later probably 1956 I started doing "watercolours" using Kodak photographic dyes which are

much more intense than regular watercolour. I don't remember how I found these dyes or how I started (using "Bond Fast" or "Elmers" glue) to glue sheets of white paper on top of each other and dye-paint layers and sections leaving parts of the underpainted papers showing etc. I was (and still am) very impressed with Willem de Kooning's early figurative and abstract paintings as was another American artist Corrado Marca-Relli whose work I saw a reproduction of. Using de Kooning's kind of figure-abstract shapes he did oil and canvas collage with the separate shapes cut out with a knife or scissors and applied to the canvas ground. This seemed an appropriate way to make such shapes and I applied a variation of it in my figurative collages. Despite the "imitation" I don't think these works look like his. My method was to glue a patch of paper on the cardboard or on the previous sheet of paper and immediately cut the shape out with a "mat" knife, paint it, perhaps glue another on top, cut and paint etc, building up layers of painted paper cut-out shapes. I'm still proud of how integrated and fused all the elements of these works are. I was very interested in Matisse then too (and still am) but I don't think there's any evidence of that in these works, they're closer to de Kooning or Gorky.[56]

There were no reviews, as such, of the Greenwich Gallery opening exhibition, although *The Varsity* covered the actual opening, reporting that "the best of Boheme had turned out to acknowledge their own in an atmosphere which was full of smoke and the feeling that something was happening".[57] And shortly after Fulford wrote a piece about Avrom Isaacs and his new gallery — the first in the city "dedicated… to modern art of the highest standard" — in which he described briefly the steps that had brought a University of Toronto graduate in political science and economics to undertake such a venture, and speculated as to whether the seven artists associated with the gallery would come to be seen as a "school".[58] "The Greenwich artists shudder at the idea," he noted, although he was pleased to report that the five in the exhibition shared at least "a higher regard for the emotional content of art than is generally found in the modern painting of the 1950's". They were William Ronald, "a Hans Hofmann pupil" who displayed a single "outright non-objective canvas"; Gerald Scott, represented by "almost traditional portraits"; Robert Varvarande, whose "powerful oil… titled Trojan Horse" was "so strong in its stiff, honest lines and dogged affirmation that it shamed his other, more decorative painting hanging beside it"; Graham Coughtry, with "extremely beautiful figure drawing"; and Snow, whose "three *collages*, including Man at the Desk, an astringent study in marbled agony", were among "the memorable items in the show".[59]

Eight months later, in the introduction to Snow's first one-man show, Fulford remarked that the artist "has a huge capacity to absorb human shapes and reproduce them in significant and moving form. This may indeed be the most impres-

sive of his several talents."[60] He doubtless was thinking, at least in part, of the collages. Pearl McCarthy, on the other hand, in her review of the same exhibition, and also looking back to Snow's previous showing at the opening of the Greenwich Gallery, found the collages and other works "too clever by half and without cohesion".[61] She must have meant that the whole group of pieces in various media that Snow displayed on that occasion did not cohere, because one of the most impressive aspects of the collages, as Snow himself proudly pointed out, is how thoroughly integrated they are. The sensuously organic shapes that constitute the collage elements flow together because of the way Snow cut the forms when they were in place, a technique that also knitted the figure into its background at countless points. The resulting overlapping creates what is in effect a shallow relief that enhances the sense of dynamic play between figure and ground. The photo dyes are rich in colour, yet subtle, like stains rather than paint. The layered hues distinguish the figure from its ground in some cases, such as the Jessel *Reclining Figure*, where the figure, in the softest cool whites, tinged with pink, blue and yellow, lies on a purple bed or platform against a yellow-green wall, a tripartite division that suggests a landscape. The staining of the Edmonton *Reclining Figure*, on the other hand — the colour of crushed raspberries, quite purple in spots, an almost grubby brown-green-olive in others — tends to float the figure within the enveloping forms of a flower-like chaise longue. Some, such as this, are quite abstract, while others, such as *Seated Nude*, are unambiguously female figures, although the layered, sometimes splayed forms evoke a dream-like stop-action effect. It is clear that Snow does not want us to relate to these images in an obviously emotional, sentimental way — the figures have no hands, feet or faces (neither does *A Man at a Desk*). They are symbolic images, multi-levelled and purposefully ambiguous, pre-erotic for male viewers in spite of their sensual character, and finally about sensing, perceiving art, for all.

These collages of the fall and winter of 1955, most produced when Snow was only twenty-five years old, are highly resolved works of art, and to all appearances independent of their inspiration in the work of de Kooning and Gorky. (It's surprising that Snow mentions Matisse in their connection. The collages used as magazine covers in 1958 and 1959, however, and, as we saw, *January Jubilee Ladies* of 1961 [no. 71], all reveal a thoughtful familiarity with the French master.) It is the sensuously organic imagery of Arshile Gorky in the Forties, and more directly the abstract-figurative works of Willem de Kooning of the mid-Forties — his *Pink Angels*, is a good example — that suggested to Snow how powerfully evocative the by-then traditional surrealist imagery of polymorphous organic shapes could be when depicted with that acute awareness of the balanced relationship between figure and ground that in turn heightens the awareness of the tension between reality and illu-

sion.[62] As Snow notes, it was the work of another admirer of these particular works of de Kooning, Corrado di Marca-Relli, that suggested cutting out the forms rather than just drawing them on the canvas in charcoal as de Kooning did.[63] But de Kooning continued to interest him. The New Yorker's black-and-white paintings, a series of mainly black yet dynamically balanced works of 1947–49, was the inspiration for *Leaving Blackness*, and, as we have seen, as Snow became more deeply engaged by the issues raised by Abstract Expressionism, de Kooning remained a principal touchstone.

There is something else at work, though — that element of wit, of whimsy, that was noted in the drawings he showed in October 1956, and that is there, certainly, in the consummately executed pen-and-ink hatching of *A Night* (no. 149), one of two ink drawings in the Greenwich Gallery opening exhibition. And whimsy is the defining quality of Snow's first film, *A to Z*, a four-minute 16 mm animation in blue and white that he completed in February 1956, during the Greenwich Gallery opening exhibition.[64] A delightful story of furniture love, it began with the bright idea of animating his still-life drawings — "start with it still then slowly start vases, flowers, tea cups floating", he wrote down, then circled the note and added "WOW!" — and soon developed into a full narrative with a shot-by-shot storyline that fills two long pages.[65]

Fulford saw this animated film as the natural extension of the movement evident in all Snow's work. "With the help of Warren Collins, a cameraman," he exclaimed at the time, "he has turned out a short animated film in which the items actually *do* move. The film has evidently satisfied his passion for motion, since he has determined to do more along the same lines."[66] In fact Snow made no more animated films, probably because the circumstances that encouraged the experiment disappeared. In February 1956 Snow was working for Graphic Associates, "as an animator of television commercials and later as director of the animation department," as Fulford explained in June 1956. "He was there until he left to become a freelance artist last winter."[67] Years later, Snow recollected working at Graphic Associates, which was run by George Dunning.

> Graham [Coughtry] was there, Warren Collins, Richard Williams, Sid Furie, Jim McKay, an animator who's been at the Film Board too. So I took the job, and I met Joyce [Wieland] there. That was my first contact with film. They did some live stuff there — that's what Sid Furie was doing — but mostly they did animation, and that's what I was doing. For a while I was director of the Animation Department — just before the place folded.[68]

Snow had begun with Graphic just a little over a year earlier, and so was working

full-time at animation (with perhaps a little drawing on company time) while still managing to realize the collages, numerous drawings and even some oils and gouaches. A work in the Greenwich Gallery opening exhibition entitled *The Mirror* should be related to a gouache of 1955 known as *Young Girl* (no. 157). The mirror-like outline of the subject's blue-over-pink face floats on an elaborately worked ground of golden russet hair, which in turn lies against a background made up of successively worked layers of all three hues. A little ring of green at her left ear, a single strand of pearls at her neck and a delicate flower rising from her left hand bring the image to the verge of sentimentality, but the strong, sharp outline of the mirror-like face pulls us in to delicately incised features that hover, with just a hint of pigment, on the threshold of perception. Another small work of 1955, this one an oil, also tests the limits of a gender stereotype. *On the Hero Myth* (no. 156), a painfully tumescent caricature of male force, its salient points isolated and calibrated, is at first comical, but finally tragic.

The major oil painting of 1955 to survive (it was the other work of that year included in the *Four Canadians* exhibition), similarly pulls two ways. *Seated Nude (Red Head)* (no. 155) is at first appearance a humorous figure, seeming from our low point of view to be over life size as she swells up to almost fill the canvas, her opalescent body the sheen of mother-of-pearl, her wiry red hair vibrating in contrast to the green upholstered chair. Then the force of that presence begins to take over. That it is a physical presence is underlined by the lack of facial features, by the lack, in fact, of all but the most rudimentary articulation of the details of the body. The blend of pulsating pinks, blues, peaches, greens, yellows and whites that appears to hover like a local atmosphere just off the surface of the body seems to absorb our gaze, suspending it in an ambiguous condition between pure sensuous delight and aesthetic pleasure, a condition akin to that state of tension between representation and abstraction that soon would lie at the core of Snow's practice. At this early stage in his career it seems to have been an instinctive goal, although a note alongside a drawing for the canvas reminded him to "bleed strokes make front / mass / into backg[round] / tie them together".[69]

*Seated Nude (Red Head)* was important to Snow. He exhibited it at the Canadian National Exhibition right after it was painted,[70] and then submitted it to the first Winnipeg show in November 1955, where is was also accepted.[71] The vibrancy of its warm, sensuous colours, richly worked, as in *Young Girl*, to float free of the brush-work (brushwork that has, nonetheless, been subsumed to an overall textured surface that plays its own dynamic role in the aesthetic structure), sets it somewhat apart from his later work, although in its presentation of the figure it gives dramatic testament to that "huge capacity to absorb human shapes and reproduce them in

a significant and moving form" that Fulford so admired the following year, and that would be played out so effectively in the Walking Woman Works.[72] The approach to colour and texture we see in the works of 1955 (at least before the collages), and the great interest in drawing, and, indeed, an interest in animation, Snow shared with a colleague at Graphic Associates, an artist who also would be a participant in the Greenwich Gallery opening exhibition, Graham Coughtry. A year before the Greenwich event, in fact, they also shared what was for both of them their first public exhibition.

Quasi-public might be a better description. *Graham Coughtry, Michael Snow, recent paintings and drawings* was held at the Hart House Art Gallery of the University of Toronto in early January 1955, a space that was open only to members (the male students and faculty of the university), except for Wednesday afternoons, when female students and faculty were allowed, and Sunday afternoons, when the public was invited. When, however, acting on the complaint of an early visitor, the newly elected mayor of Toronto, Nathan Phillips, demanded the removal of three drawings he deemed obscene (one drawing by Coughtry was briefly removed, then reinstalled, by the art committee), the show became highly public, garnering more press and visitor attention than either Coughtry or Snow would see again for a decade or more. Of course the art was largely overlooked in it all. No checklist survives. The newspapers report that six of the ten drawings shown were by Coughtry, and that there were some thirty-five paintings. Four works by Snow were mentioned: *Woman with a Clarinet* (no. 158), *Wall Panel I*,[73] *Wall Panel V* (no. 177), *At the Jazzband Ball*,[74] and *Colin Curd About to Play* (no. 173). These range in date from 1954 back to the early winter of 1951, when Snow was still in the middle of his final year at the Ontario College of Art. There is as well a list of twenty-nine works of this same period that likely represents Snow's most ambitious plans for the show.[75]

Despite the extensive press coverage, there was only one review of the exhibition, by a student in the university newspaper. Although he admired the earliest works, "the non-objective wall panels", he found Snow's group of paintings confusing. "The pictures are made with different techniques and they do not show a consistent viewpoint which would help me comprehend individual pictures". He found the drawings, in which Snow used "a rough, broken brush line or nervous, jagged pen line to depict mostly female figures in situations of strongly sexual connotation", to be unattractive, as well as "unrelated to his painting styles".[76] This sounds almost like the contents of a student show, and one well might wonder why we are paying such attention to our artist's apparently first fruitful struggles. Remember, however, that employing different techniques, exploring the range of possibilities within a theme will increasingly be characteristic of Snow's approach,

and in its extremity will become his unique way of working with the Walking Woman Works. And in a university interview the following day he demonstrated an impressive understanding of his own practice, and of the goals of art, touching on a number of points that, again, would persist and intensify over the years to emerge in the *evidence* statement and in "A Lot of Near Mrs." "My jazz interest," he said,

> is related to my painting; not in the end result, but in the procedure of working out a painting. In both, one starts with a theme and through improvisation and organization one places his personal stamp on the work.
>
> Although the process is free from rules, after it is born I expect it to be a statement, something one can stand on, not just a helter-skelter salt and pepper effect.... Actually all I want to do is present some kind of moving image using all the cements [elements] of painting, colour, line, form, texture. It must end up being an object which rewards, invites, provokes contemplation, awareness.
>
> A painting is a small experience in feeling and thinking, that is, living.[77]

We can move back in time yet again with confidence, then, that there is still substantial work to be experienced and ideas to be explored.

Snow began working for Graphic Associates about the time of the Hart House exhibition, but before then must have been making do with bits of commercial work and the occasional paying musical engagement.[78] Living with his parents, he had few expenses, and he must have been able to devote a lot of time to his drawing and painting. All the work of this period during the fall and summer of 1954 is small in scale, in gouache or ink. The female figure is his favourite subject, and as the Hart House reviewer remarked, it is often "in situations of strongly sexual connotation". That is true of the ink drawing, *Woman with a Clarinet*, and of the self-consciously "primitive" but complexly multi-levelled *From the Catalogue of the King's Dancers* (no. 163) — which is also an early instance of Snow's using a flat page of text as his subject, as is the contemporary *The Message* (no. 162), both precursors of *News*, with which we began this chapter. The richly worked gouache still-life, *Table Life* (no. 160), the apparent genesis of many of Snow's concerns over the following two or three years, and more, also sports a leaping "dancer". But the central work of these months is the gouache called *Georgine* (no. 161), a portrait from memory of the woman who had been his girlfriend in his final year at OCA, and whom he lost to another man when he left her behind to seek art and life experience in Europe. The worked-up layers here, perhaps more evidently than in other pieces of the time, both reveal and conceal, creating that shifting ground on which we struggle to grasp

truth. It is a portrait of Georgine as a vital, engaged, intelligent woman, an object of beauty, of desire, and here entirely the creation of the artist who, reduced to his eyes, floating disembodied in the background, is condemned to gaze on his creation for eternity.

Snow's European journey was in many respects like that of the hundreds of thousands of other North American university and college students of the Fifties and after who undertook this intense rite of passage. Approaching it as we are, as deep background, Snow's passage appears unique, formative. He left early in April 1953, with a friend from OCA, Bob Hackborn, also a jazz musician, a drummer.

Snow couldn't take his piano, so he took a trumpet, which he was just learning to play. They travelled by boat from New York to Southampton, England, where they caught the train to Paris. Georgine went as far as New York, where she saw them off.

The plan was to try to find work playing jazz in order to support their travels around Europe and art-making, and it worked, in a fashion. They ended up employed as musicians during the summer at three Club Méditerranée camping resorts, at Golfo de Barrati on the Tuscany coast, on the island of Elba,

**Fig. 15** Snow, Georgine Ferguson, Bob Hackborn, New York, April 1953

then at Becici-Budva, on the coast of Crna Gora (Montenegro) in Yugoslavia. Snow subsequently had a paying job at a jazz club in Brussels during September and October. Travelling then through Germany, Switzerland, southern France and Spain, they ended up in December in Malaga, on the Spanish Mediterranean coast, where they stayed, painting, until the end of January. After stopping briefly at Tangiers, they made their way north to Paris, where they soon lucked in to another job playing at Méribel-les-Allues in the French Alps. That lasted less than a month, and after about another month in Paris (where they ran into Graham Coughtry and Richard Williams, who had spent part of the winter on Ibiza, one of the Spanish Balearic Islands), they moved to London near the end of April. An alarming letter from Georgine brought Snow home the middle of May.[79]

In spite of the amount of time spent travelling and playing, Snow produced a large amount of work in Europe that year. The bulk, including the only oils, was completed in Malaga, but he brought back sketchbooks from throughout the trip and sent home gouaches and watercolours before leaving Brussels. The most impressive works are the two oils that survive, *Colin Curd About to Play* and *Man Examining*

a Line (no. 171). Snow was so pleased with *Colin Curd...* that he immediately shipped it to Toronto for submission to the Ontario Society of Artists exhibition. It was accepted.[80] He explained to his mother in a letter, "it's partly inspired by Colin Curd a wonderful character and musician I met in Paris.... As usual it is not just one subject but a multiplicity of meanings, the largest one discussing the position of all artists (flautists, magicians, painters or poets) and the audience. As you can see I consider both ends uno poco loco."[81] He had earlier reported that the Malaga paintings were "my first attempts with a palette knife using a technique I developed with gouache so they may be a bit clumsy".[82] As we would expect by now, there are numerous preparatory drawings for the painting in the sketchbooks, including a page of various compositional ideas (see no. 174). The subject of the audience pops up in a number of other guises, principally in drawings done in Spain (see no. 169), but also later, in Paris (see no. 165).[83] There are also numerous gouache studies in which he perfects the technique used in *Colin Curd...* of building up fragmentary layers of pigment so numerous that a richly mottled but still uniform surface results (see no.170). It is a technique he had begun to use early in the trip — we see it in *Notre Dame* (no. 175), likely done in Paris just after his arrival or in Brussels in September-October.[84] Later in the journey, however, when in Malaga, but even as late as early April in Paris, Snow explored traditional scumbling techniques with gouache in a systematic fashion ("Let the paint dry!" he noted beside one page of experiments related to the *Colin Curd...* audience),[85] and more radical methods of scumbling over patches of masking tape, then glazing in a variety of ways after the tape was removed.[86] And he experimented even further in Malaga by scraping away a painted surface to set the ground for a delicate line drawing in paint in *Man Examining a Line*, a work that demonstrates the keen Snow wit even at the beginning of his career.

*Man Examining a Line* is not only a visual pun, but also a moving reflection on perception, and if one theme can be said to dominate in the European sketchbooks, and in many of the large finished drawings and paintings, it is the exploration of the complex emotions and thoughts arising from reflecting on looking and seeing. The major work completed at Mérebel-les-Allues is a large ink drawing called *Ocul* (no. 166), based on a sketch done in Malaga (see no. 167) in which a table-top still-life beside a female nude becomes a staring male figure, and everything is constructed of images of eyes. Snow's acute powers of observation and facility with traditional draughtsmanship are focused on the eye of a cock in a number of pages of a Malaga sketchbook (see no. 168). The few pages of drawings he made on his brief stop in Tangiers are almost all of women's eyes framed by the opening in the chador.[87] *Colin Curd...* is a chorus of eyes.

Snow graduated from the Ontario College of Art in the spring of 1952, and not long afterward he and Bob Hackborn were commissioned to design a mobile to hang in the grand staircase of Wymilwood, the new Student Union at Victoria College in the University of Toronto.[88] He also soon found a job doing paste-ups and other entry-level work in a commercial art firm that made catalogues. "It was horrible and I was horrible," Snow recollects, but he saved just enough money to be able to plan the trip to Europe.[89] A disastrous fire in his parents' home at the beginning of March destroyed five of the paintings in his basement studio, probably precipitating the decision to leave.[90] At OCA he had taken the design course, although he pursued painting at home on his own, encouraged by one of his teachers, John Martin. Thirty years later he recollected, "He suggested reproductions that I ought to see and books that I ought to read. Among the books he mentioned were the *Documents of Modern Art* series, a collection of various artists' writings, Mondrian, Kandinsky, etc. I read those and I became interested in Paul Klee and he told me about other books that were available."[91]

The *Documents of Modern Art* series began to appear in the late Forties, and they made available for the first time in English, among other things, some of the important texts of the Bauhaus movement, an approach to art that, at risk of simplifying, treated design as art, and brought the analytic method of design to art, a message that was impressive to a young designer-in-training with an artistic bent. In Europe, Paul Klee was Snow's principal inspiration: the intensity of drawing in Klee, the conscious development of "vocabularies", even visual languages, the wit, the whimsy, the unerring design and the profound humanity. Even Snow's far-ranging technical experimentation, such as the complex scumbling of layer after layer of paint, is characteristic of Klee, whose favourite "spatter" technique Snow employed to make *Moonlit House* (no. 176), not long after arriving in Europe. Klee's *Pedagogical Sketchbook*, in which he laid out his practical theory of the emotive capacity of aspects of visual design, was first published in English by Praeger in New York in 1953. Could Snow have obtained a copy that year? He did see a huge Klee show in Berne in November 1953, and wrote to Martin about it.[92]

Before then it was geometrical abstraction, with richly worked surfaces, inspired likely by the example of the English painter Ben Nicholson. The direction was encouraged by Martin, and understanding the high quality of the results, he also encouraged Snow to submit work to the Ontario Society of Artists annual exhibition while he was still in his final year at the college. Two pieces, *Wall Panel II* (no. 179) and *Polyphony*, were accepted.[93] Snow was delighted, and even more so when his "sharp colour sense" was noted in a review of the show.[94] The year before that, he designed a cover for *Canadian Art* for a school project that Martin thought was

so successful that he brought it to the attention of the editors of the magazine, who, sharing his enthusiasm, used it for the summer 1951 cover (see fig. 16). And on top of that, it subsequently was chosen for the annual magazine exhibition of the American Institute of Graphic Arts.[95]

How far back can we go, should we go? A handful of black ink drawings of classic jazz musicians survives, drawn on the backs of copies of a program of early 1949 for a "Jazz Concert — Dance" organized by the Jazz Society of Toronto and featuring Ken Dean's Jazz Band, Mike Snow, piano (Bob Fulford, M.C.).[96] The band came together when Snow was still in high school, Toronto's exclusive Upper Canada College, where he won the art prize when he graduated in June 1948, although he later "could never figure out why. I never did anything at all in high school."[97] We could go back further, dig deeper for evidence of nascent talent, of formative experiences, for while Snow's art, as we have seen, developed through the Fifties and Sixties engaged by the leading artistic issues of the day, always fresh, provocative in its response to the currents, it flowed from a source deep within his sense of self. To track that source would take us back beyond the decade that is the subject of this chapter, of course, and into realms of investigation and conjecture outside the usual province of art history. Snow has declared his own interest in such things, with the family history and family and other personal photographs he included in the catalogue he designed for his 1970 survey exhibition,[98] and someday, in another context, perhaps that story will be told more fully. For now, all we can do is symbolically chart the field by recording that Michael Snow was born in Toronto 10 December 1929 to Marie-Antoinette Snow, née Levesque, of Chicoutimi, Quebec, and Gerald Bradley Snow of Toronto, civil engineer, and that he has said, "I think the two most important things in my life were that my father went blind when I was 15, and that my mother loved music."[99]

**Fig. 16**  *Canadian Art* 8 (Summer 1951)

# Notes

1. Robert Fulford, "Jazz Painter," *Royal York Magazine* 1 (June 1959): 26.

2. Michael Snow Fonds, Edward P. Taylor Research Library and Archives, Art Gallery of Ontario, Toronto, box 30. Another, incomplete, version on the sheet is unrelentingly descriptive: "...each work here represents one example of the several avenues of expression which I have been exploring in the 5 years that I've been painting — there are many other phases including many types of drawings and sculpture."

3. Robert Fulford, "World of Art: Snow Explores Edge of Art," *Toronto Daily Star*, 7 March 1959.

4. Oil on canvas, 121.9 x 152.4 cm, collection of Sara Bowser Barney, Toronto; repr. in Sara Bowser, "An Interview with Michael Snow," *Canadian Architect* 4 (April 1959): 75.

5. Fulford, *Toronto Daily Star*, 7 March 1959.

6. Quoted from a letter of 28 June 1975, in William C. Forsey, *The Ontario Community Collects, a survey of Canadian painting from 1766 to the present* (Toronto: Art Gallery of Ontario, 1975): 182.

7. Collection of the Museum of Modern Art, New York; repr. in colour in Russell Ferguson, ed., *Hand-Painted Pop: American Art in Transition 1955–62* (Los Angeles and New York: The Museum of Contemporary Art and Rizzoli International, 1992): 120.

8. Snow Fonds, box 30.

9. Collection of Robert Rauschenberg; repr. in colour in Ferguson, *Hand-Painted Pop*: 30.

10. It was renamed the Isaacs Gallery in September 1959.

11. Bronze lacquer on polyester resin and metal, on oil-painted wooden base, 55.9 x 91.4 x 27.9 cm, destroyed.

12. Paul Duval, "Accent on Art: Canadian Who Liked Solitude Painted Unique 'Essence' of Nation," *Telegram* (Toronto), 11 October 1958.

13. "Art and Artists: Abstract Gains in Prominence," *Globe and Mail* (Toronto), 18 October 1958.

14. See Robert Fulford, *Best Seat in the House: Memoirs of a Lucky Man* (Toronto: Collins, 1988): 95–96, 117–20.

15. "CJBC Views the Shows, Excerpts," typescript, 19 October 1958, copy in artist's file, Edward P. Taylor Research Library and Archives, Art Gallery of Ontario, Toronto.

16. Hugo McPherson, "The Autumn Season: 1958. Toronto," *Canadian Art* 16 (February 1959): 57.

17. Oil on canvas, 152.4 x 101.6 cm, collection of Joseph Gladstone, Toronto.

18. Oil on canvas, 153.1 x 106.9 cm, collection of the Robert McLaughlin Gallery, Oshawa, Ontario; repr. in McPherson, *Canadian Art*: 57.

19. Oil on canvas, 138.5 x 121.9 cm, collection of Michael Snow, Toronto.

20. Oil on canvas, 152.5 x 113.7 cm, collection of Michael Snow, Toronto.

21. McPherson, *Canadian Art*: 57.

22. Liz Hubbell, "Snow: impressionist," *Gargoyle* (University College, Toronto), 19 December 1958.

23. Fulford, *Toronto Daily Star*, 7 March 1959.

24. McPherson, *Canadian Art*: 57.

25. Hubbell, *Gargoyle*, 19 December 1958.

26. Duval, *Telegram*, 11 October 1958. The dimensions and locations of *Antoinette* and *Women Waiting* are unknown.

27. Pittsburgh, Carnegie Institute, 5 December 1958–8 February 1959, *The 1958 Pittsburgh Bicentennial International Exhibition of Contemporary Painting and Sculpture*, no. 408.

28. See Snow and Wieland, La Boca, Cuba, letter to Mr. and Mrs. G.B. Snow, Toronto, February 1958, with Marie-Antoinette Snow Roig, Toronto.

29. Oil on canvas, 96.4 x 94.4 cm, collection of Michael Snow, Toronto.

30. *Canadian Architect* 3 (April 1958); *Mayfair* 32 (August 1958); *Imperial Oil Review* 42 (October 1958).

31. *Canadian Architect* 4 (June, July, August 1959).

32. See Joe Medjuck and Michael Snow, "The Life & Times of Michael Snow," *Take One* 3 (January–February 1971, published April 1972): 7.

33. Oil on canvas, 81.3 x 119.4 cm, collection of Mr. and Mrs. Ben Park, Toronto; repr. in *Michael Snow/A Survey* (Toronto: Art Gallery of Ontario, 1970): 120.

34. Oil on canvas, 101.6 x 121.9 cm, location unknown. It was listed as "Private collection, Montreal", when exhibited in *Michael Snow/A Survey*: 101, no. 35 (as *Red & Blue Table & Chairs*, 1956).

35. Oil on canvas, 127.5 x 89.0 cm, collection of Michael Snow, courtesy S.L. Simpson Gallery, Toronto; repr. in Denise Leclerc, *The Crisis of Abstraction in Canada: The 1950s* (Ottawa: National Gallery of Canada, 1992): 183.

36. Hubbell, *Gargoyle*, 19 December 1958.

37. Snow Fonds, box 22.

38. Joyce Wieland, "de Kooning's 'February'," *evidence* 2 [Spring 1961]: n.p.

39. See Paul Schimmel et al., *Action Precision: The New Direction in New York, 1955–60* (Newport Beach, California: Newport Harbor Art Museum, 1984): 102–13.

40. Toronto, Greenwich Gallery, 8–28 March 1957, *Group Show: Graham Coughtry, Gerald Scott, Michael Snow, Robert Varvarande*. There is a typed checklist in the Isaacs Gallery Papers.

41. Winnipeg, The Winnipeg Art Gallery, 9 November–1 December 1957, *The 3rd Winnipeg Show*, nos. 112, 113. *Table and Chairs No. 3* is also repr., n.p. Its current location is unknown.

42. See Hugh Thomson, "Art Review: Gallery One is Chamber of Horrors in Abstract," *Toronto Daily Star*, 22 August 1958; and "Comment of the Day: Dirty Canvases," *Saturday Night*

74 (25 April 1959): 5. The exhibitions were in Toronto, Canadian National Exhibition, 20 August–6 September 1958, *Exhibition of Canadian Paintings and Sculpture Arranged by the Fine Arts Committee...*, no. 199, *Prophesy*; and Art Gallery of Toronto, 21 March–19 April 1959, *The 87th Annual Exhibition of the Ontario Society of Artists*, no. 74, *Exci-Table*. *Prophecy*, as it was titled in the October 1958 Greenwich Gallery exhibition, is oil on canvas, 101.6 x 127.0 cm, collection of Nancy Hill, Toronto. *Exci-Table* is oil on canvas, dimensions and current location unknown.

43. Winnipeg, The Winnipeg Art Gallery, 7–30 November 1959, *The Fifth Winnipeg Show*, no. 62. Snow did continue to send work periodically to the Montreal Museum of Fine Arts *Spring Exhibitions*, however, in 1959, 1960, 1961, 1964, 1970. See Evelyn de R. McMann, *Montreal Museum of Fine Arts, formerly Art Association of Montreal, Spring Exhibitions 1880–1970* (Toronto: University of Toronto Press, 1988): 360.

44. Robert Fulford, "About Michael Snow," *Paintings, Sculpture, Drawings by Michael Snow* (Toronto: Greenwich Gallery, 1956): n.p.

45. Pearl McCarthy, "Art and Artists: Younger Group Rising Over Weary Sterilities," *Globe and Mail* (Toronto), 20 October 1956.

46. Hugo McPherson, "CJBC Views the Shows: The Galleries," typescript, 4 November 1956, copy in artist's file, Edward P. Taylor Research Library and Archives, Art Gallery of Ontario, Toronto.

47. Janet MacDonald, "Snow on Bay St.," *Varsity* (University of Toronto), 16 October 1956.

48. Oil on canvas, 127.0 x 152.4 cm, collection of William Finsten, Toronto.

49. Robert Fulford, "Artists in Boom-town: Young Painters of Toronto," *Canadian Art* 14 (Winter 1957): 70. *Painting 1956*, is oil on canvas, dimensions and current location unknown.

50. McPherson, "CJBC Views the Shows." *Around Red* is oil on canvas, 101.5 cm diam., collection of Michael Snow, Toronto.

51. Robert Fulford, "Triple-threat in Abstracts," *Mayfair* 30 (June 1956): 51–52.

52. Snow Fonds, box 30.

53. Both in Snow Fonds, box 37.

54. Ink on paper, 28.0 x 43.0 cm, collection of Michael Snow, courtesy S.L. Simpson Gallery, Toronto.

55. Michael Snow, Toronto, letter to Linda Milrod, Agnes Etherington Art Centre, Kingston, Ontario, 5 February 1979, in the Agnes Etherington Art Centre Archives. This, and portions of the following quotation, were published in Linda Milrod, *Pasted Paper: A Look at Canadian Collage 1955–1965* (Kingston: Agnes Etherington Art Centre, Queen's University, 1979): 17.

56. Ibid. Portions of this second part of the text have also been published in Louise Dompierre, *Walking Woman Works: Michael Snow 1961–67. New Representational Art and its Uses* (Kingston: Agnes Etherington Art Centre, Queen's University, 1983): 26.

57. Les Lawrence, "Open Up New Gallery," *Varsity*, (University of Toronto), 3 February 1956.

58. Robert Fulford, "Gallery & Studio: 'School' is Out," *Mayfair* 30 (March 1956): 52. Isaacs

had opened the Greenwich Art Shop, an art-supply and framing business, with a university friend, Al Latner, at 77 Hayter St., just west of Bay at Elizabeth St., in the late winter of 1950. (See "Announcing the Opening of Greenwich Art Shop," *The Sketch: Ontario College of Art* 4 [March 1950]: 3.) When his partner married and turned to other interests, Isaacs bought him out, and as he befriended aspiring artists from the Ontario College of Art, began thinking about opening a gallery. He took the step finally the winter of 1955–56 when he found a location around the corner at 736 Bay St., "a bright little room", as Fulford describes it, and opened with five of his stable of artists in February. The checklist of the first Greenwich Gallery exhibition is typed on Greenwich Art Shop letterhead. In addition to Fulford, above, see Dennis Reid and Michael Torosian, *Toronto Suite* (Toronto: Lumiere Press, 1989): 10–13.

59. Fulford, *Mayfair* (March 1956): 52. The two artists then associated with the Greenwich Gallery who were not included in the opening exhibition were John Gould and Paul MacDonald.

60. Fulford, *Painting, Sculpture, Drawings by Michael Snow.*

61. McCarthy, *Globe and Mail*, 20 October 1956.

62. *Pink Angel*, collection of Mr. and Mrs. Frederick R. Weisman, Beverly Hills, California; repr. in colour in Thomas B. Hess, *Willem de Kooning* (New York: The Museum of Modern Art, 1968): 52.

63. For an example of Marca-Relli's work of the period see George Heard Hamilton, "Object and Image," *Art News* 53 (May 1954): 18, repr. of *An Untitled Collage* of 1953. Louise Dompierre notes this reference in her discussion of the relationship of the 1955–56 collages to the Walking Woman Works. She relates the collages to de Kooning's famous "woman" series of drawings and paintings, however (which serves our understanding of the genesis of the Walking Woman), rather than to the mid-Forties paintings that actually suggested the idea, form and even colour treatment of Snow's collages. See Dompierre, *Walking Woman Works*: 26–28.

64. *A to Z* appears to have been shown publicly first only in February 1964 when Av Isaacs organized four evenings of screenings of Canadian experimental films at the Isaacs Gallery. It was titled *Teacups of the August Moon* on that occasion. See Barrie Hale, "The New Look In Films," *Telegram* (Toronto), 14 February 1964; and "Cuts & Splices," *Canadian Broadcaster* (Toronto), 5 March 1964.

65. Snow Fonds, box 30.

66. Fulford, *Mayfair* (June 1956): 51.

67. Ibid.

68. Medjuck and Snow, *Take One*: 7.

69. Snow Fonds, box 30.

70. Toronto, Canadian National Exhibition, 26 August–10 September 1955, *Exhibition of Paintings and Sculpture Arranged by the Fine Arts Committee…*, no. 116, as *Seated Nude*. Snow may have made changes to the painting following this showing, as it is inscribed "completed Sept 1955" on the reverse.

71. Winnipeg, Winnipeg Art Gallery, 2–15 November 1955, *The Winnipeg Show*, no. 87, as *Seated Nude*. Snow exhibited a now-lost oil in Winnipeg the following year, 4–25 November 1956, *The 2nd Winnipeg Show*, no. 85, *Nude*. Priced at $400, it must have been at least as large as *Seated Nude*, which had been priced in Winnipeg at $350, and at $300 at the CNE. It could have been a horizontal painting of a nude seated beside a table-top still-life, two drawings and notes for which survive on a sheet in Snow Fonds, box 30.

72. Fulford, *Painting, Sculpture, Drawings by Michael Snow.*

73. Medium, dimensions and location unknown.

74. Oil on canvas, 76.2 x 101.6 cm, collection of Rice Honeywell, Toronto, in the mid-Fifties.

75. Snow Fonds, box 30.

76. Michael McCordie, "Nudes Revued: Coughtry and Snow," *Varsity* (University of Toronto), 10 January 1955.

77. Alex K. Gigeroff, "Nude controversy painters outline personal attitude," *Varsity* (University of Toronto), 11 January 1955.

78. It is not clear exactly when Snow began working at Graphic. In an interview of October 1971, he recollected that Dunning "saw the show and he liked it a lot — and he thought, for some reason, that there was something to do with film. Anyway, he phoned me up and asked if I'd like to have a job working in film, which I'd never thought about before." (Medjuck and Snow, *Take One*: 7.) On the other hand, a report of the Hart House controversy the day following the opening describes both Coughtry and Snow as "now working for Graphic Associates, a Toronto motion picture studio." ("Bar 3 Offensive Nudes Mayor Asks; U. of T. Balks," *Telegram* [Toronto], 4 January 1955.)

79. The itinerary is derived from letters Snow sent to his family, with Marie-Antoinette Snow Roig, Toronto.

80. Art Gallery of Toronto, 26 February–28 March 1954, *The 82nd Annual Exhibition of the Ontario Society of Artists*, no. 82.

81. Snow, Malaga, letter to Mr. and Mrs. G.B. Snow, Toronto, 16 January 1954, with Marie-Antoinette Snow Roig, Toronto.

82. Snow, Malaga, letter to Snows and Rynards, Toronto, 3 January 1954, with Marie-Antoinette Snow Roig, Toronto.

83. One of a series of drawings, in Snow Fonds, box 17, file 9, explores ideas for a painting of passengers staring out the front windows of a packed Barcelona bus, a concept that extends the theme of the audience into the broader public realm.

84. *Notre Dame* is one of the works Snow sent home from Brussels in October 1953. See Snow, letter of 16 January 1954 already cited. Two other gouaches sent at the same time, *Moonlit House* and *The Woman and the Diamond*, were at his request submitted by his family for exhibition in Montreal, Montreal Museum of Fine Arts, 17 March–18 April 1954, *71st Annual Spring*

*Exhibition. The Woman and the Diamond* was accepted: no. 114, as *La Femme et le diamant*, and to Snow's delight was sold from the exhibition. Its current location is unknown. See Snow, London, letter to Mr. and Mrs. G.B. Snow, Toronto, 21 April 1954, with Marie-Antoinette Snow Roig, Toronto.

85. Sketchbook 10, Snow Fonds, box 17.

86. See sketchbook 12, Snow Fonds, box 17.

87. See sketchbook 11, Snow Fonds, box 17.

88. Now destroyed. It appears in some fashion photographs in Vivian Wilcox, "The Empire and the Princess," *Mayfair* 28 (February 1954): 34–41.

89. Snow, taped interview with Louise Dompierre, 4 October 1982, Agnes Etherington Art Centre, Queen's University, Kingston, Ontario, excerpted in *Walking Woman Works*: 3.

90. See "Paintings lost in Fire," *Daily Nugget* (North Bay, Ontario), 4 March 1953.

91. Excerpt from taped interview in Dompierre, *Walking Woman Works*: 3. For Martin, see David F. Ritchie, "John Martin RCA," *Antique Showcase* (October–November 1991) 27: 37–39.

92. A draft of the letter is in Snow Fonds, box 17, file 9.

93. Art Gallery of Toronto, 8 March–13 April 1952, *The 80th Annual Exhibition of the Ontario Society of Artists*, no. 96, no. 97, as *Wall Panel (No. 2)*. *Polyphony* was destroyed in the fire in his parents' home in early March 1953. Snow exhibited with the OSA again the following year: Art Gallery of Toronto, 28 February–30 March 1953, *The 81st Annual Exhibition of the Ontario Society of Artists*, no. 85, *Female*, repr. in the catalogue, n.p., mixed media on board, 38.0 x 30.5 cm, collection of Michael Snow. He also exhibited with the Canadian Society of Painters in Watercolour in 1953 and 1955.

94. "Ontario Society of Artists Uncover New Talents," *Canadian Art* 9 (Summer 1952): 170–71.

95. *The American Institute of Graphic Arts Magazine Exhibition 1951* (n.p.: 1951): 7.

96. Snow Fonds, box 25. For a full discussion of the place of music in Snow's life, see Michael Snow, ed., *Music/Sound: The performed and recorded music/sound of Michael Snow, solo and with various ensembles, his sound-films and sound installations. Improvisation/composition from 1948 to 1993* (Toronto: Art Gallery of Ontario, 1994), and for his work as a jazz musician in particular, see David Lancashire, "Blues in the clock tower" in that volume.

97. Medjuck and Snow, *Take One*: 6.

98. See *Michael Snow/A Survey*: passim.

99. M. Farber, "The Arts: Farewell to a Lady," *Time* (Canadian Edition), 24 January 1969: 17.

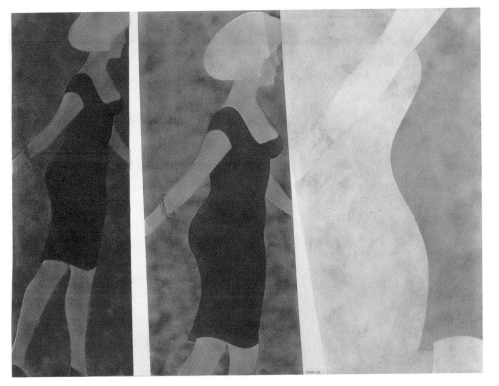

**Test Focus Field Figure** 1965
Colour Plate 1 (no. 11)
spray enamels on canvas, 152.4 x 203.2 cm
Art Gallery of Ontario, Toronto, purchase, Corporations' Subscription Endowment, 1966 (66/10)

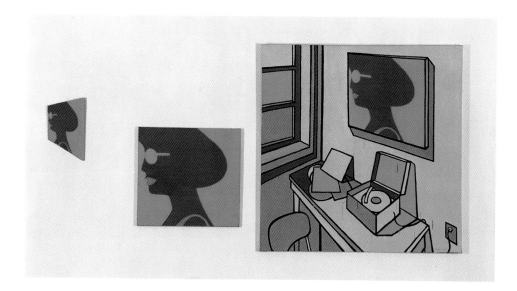

**Hawaii** 1964
Colour Plate 2 (no. 17)
enamel on two canvases, 149.8 x 149.5 cm, 71.6 x 76.1 cm;
enamel on plywood, 45.4 x 27.9 cm (trapezium); 149.9 x 309.9 cm overall
National Gallery of Canada, Ottawa, purchased 1973
(17,194.1-3)

**Half-Slip** 1963
Colour Plate 3 (no. 22)
oil on canvas, 51.0 x 152.7 cm
Burle and Louise Yolles, Toronto

131

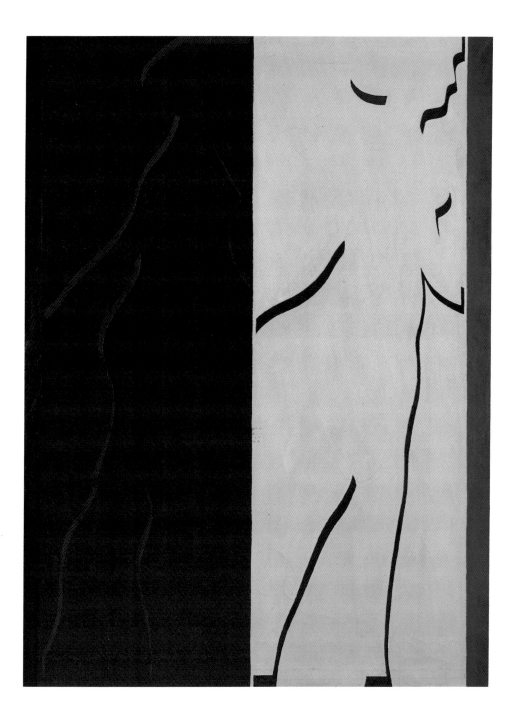

**Switch** 1963
Colour Plate 4 (no. 23)
oil on canvas, 153.5 x 114.0 cm
Geraldine Sherman and Robert Fulford, Toronto

**Noctambulation (Death Walk)** 1961
Colour Plate 5 (no. 52)
oil on canvas, 152.4 x 152.4 cm
Hirshhorn Museum and Sculpture Garden, Smithsonian Institution, Washington, D.C.,
gift of Joseph H. Hirshhorn, 1966 (66.4662)

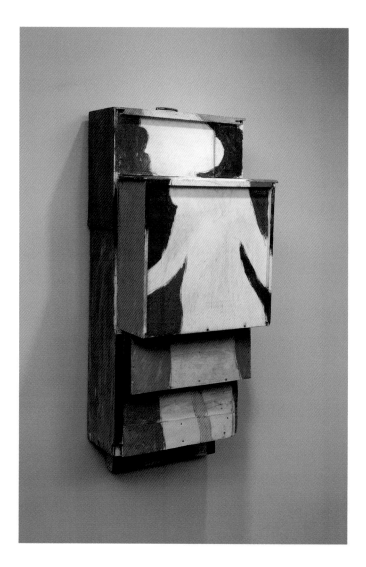

**Project**  15 July 1961
Colour Plate 6 (no. 60)
graphite and oil on plywood, timber, metal, cardboard, 105.5 x 43.8 x 34.7 cm
Michael Snow, courtesy S.L. Simpson Gallery, Toronto

**Green in Green**  November 1960
Colour Plate 7 (no. 79)
oil and lucite on canvas, 202.0 x 131.2 cm
Edie and Morden Yolles, Toronto

**Years** 1960
Colour Plate 8 (no. 86)
gouache on paper collage on painted corrugated cardboard, 89.5 x 90.7 cm
Collection Lavalin, Musée d'art contemporain de Montréal
(A92 632 C01)

**Colour Booth** 1959
Colour Plate 9 (no. 92)
oil on timber and plywood, 203.6 x 44.0 x 49.3 cm
Michael Snow, courtesy S.L. Simpson Gallery, Toronto

**Pascal/Napoleon**  April 1960
Colour Plate 10 (no. 96)
oil on canvas, 178.0 x 127.0 cm
The Isaacs/Innuit Gallery, Toronto

**Self-Centered**  January 1960
Colour Plate 11 (no. 99)
oil on canvas, 126.5 x 101.5 cm
National Gallery of Canada, Ottawa, gift of Mr. and Mrs. J.W. Strutt, Lucerne, Quebec, 1980 (23,881)

**Table and Chairs No. 1**  November 1956
Colour Plate 12 (no. 129)
oil on canvas, 71.5 x 90.8 cm
The Isaacs/Innuit Gallery, Toronto

140

**Reclining Figure** 1955
Colour Plate 13 (no. 146)
photo dyes on paper collage on board, 76.2 x 94.3 cm
Mr. and Mrs. Ray Jessel, Los Angeles, California

**Georgine**  summer 1954
Colour Plate 14 (no. 161)
gouache and graphite on card, 33.0 x 46.5 cm (sight); 35.2 x 50.1 cm (overall)
Michael Snow, courtesy S.L. Simpson Gallery, Toronto

**Colin Curd About to Play**  1953
Colour Plate 15 (no. 173)
oil on canvas, 148.6 x 79.4 cm
Art Gallery of Ontario, Toronto, gift of Sam and Ayala Zacks, Toronto, 1970 (70/253)

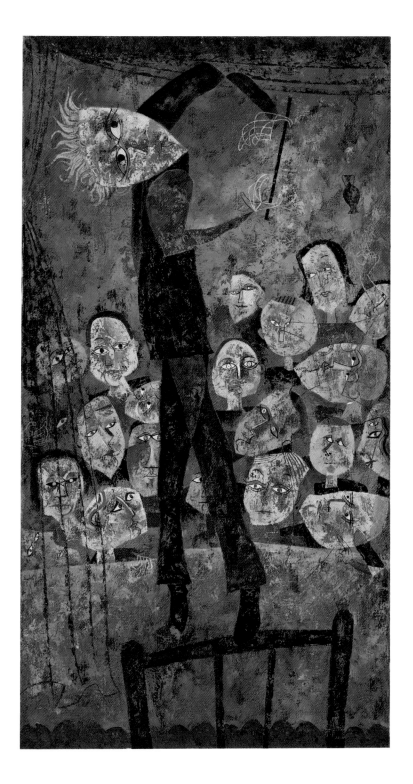

143

**Tall Panel (Wall Panel II)** December 1951
Colour Plate 16 (no. 179)
oil on panel, 63.2 x 29.2 cm
Mr. and Mrs. Ernie Herzig, Toronto

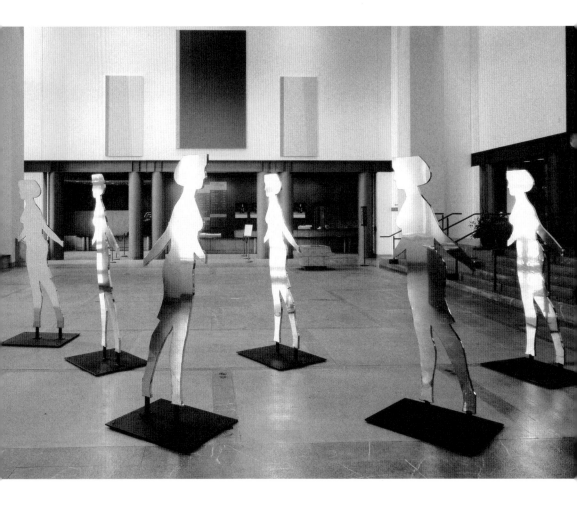

1. **Expo Walking Woman** 1967
originally eleven, now ten elements, all on patinated steel bases:
a-f. **Cut-out Figures** (above)
six elements, polished stainless steel over plywood core, each 230.5 x 91.5 x 2.7 cm
g. **Negative Figure** (top left)
brushed and polished stainless steel over plywood core, 244.0 x 91.5 x 4.0 cm
h. **Crossing Figures** (top right)
polished stainless steel over plywood core, 230.5 x 91.5 x 2.7 cm
i. **Corner Figure** (bottom left)
brushed stainless steel and cast polyester resin, 230.5 x 120.0 x 71.5 cm
j. **Stretched Figure** (bottom right)
brushed stainless steel, 231.0 x 120.0 x 244.0 cm
Art Gallery of Ontario, Toronto, gift of the Government of the Province of Ontario, 1968 (68/16.1-10)

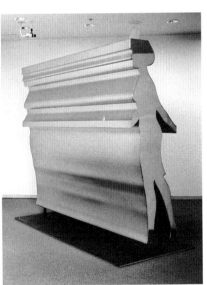

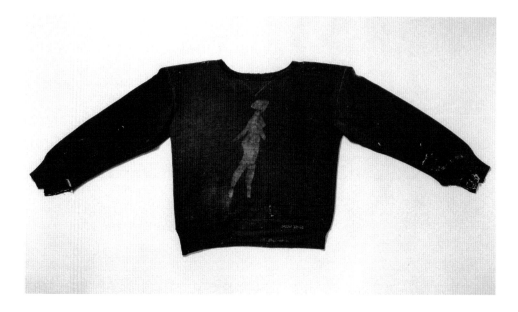

2. **Sweatshirt** 1962–66
oil on jersey fabric, 57.0 x 140.0 cm
Michael Snow, courtesy S.L. Simpson Gallery, Toronto

**148**

3. **Sending and Receiving Crosswalk and After** November 1965
acrylic on masonite and canvas, three elements, 124.5 x 42.0 x 9.5 cm, 214.0 x 71.0 cm, 4.5 x 14.5 cm,
each installed on a separate wall
Canada Council Art Bank, Ottawa (73/4-0386)

4. **Diamond**  1965 (above, left)
charcoal, red pencil and graphite on paper, 173.7 x 45.8 cm Art Gallery of Ontario, Toronto,
gift of Sam and Ayala Zacks, Toronto, 1970 (70/254)

5. **Carla Bley**  June 1965 (above, top right)
*Toronto 20* portfolio, edition of 100, number 1
photo-offset and line block on paper, 66.2 x 51.0 cm
Art Gallery of Ontario, Toronto, gift of the Jerrold Morris International Gallery, Toronto, 1966 (65/34.17)

6. **Mixed Feelings**  April 1965 (right)
acrylic on canvas, 253.5 x 150.5 cm
Vancouver Art Gallery, purchased 1967 (67.1)

7. **Village Voice**  4 February 1965 (above, bottom right)
newspaper, 45.7 x 33.6 cm
Michael Snow, courtesy S.L. Simpson Gallery, Toronto

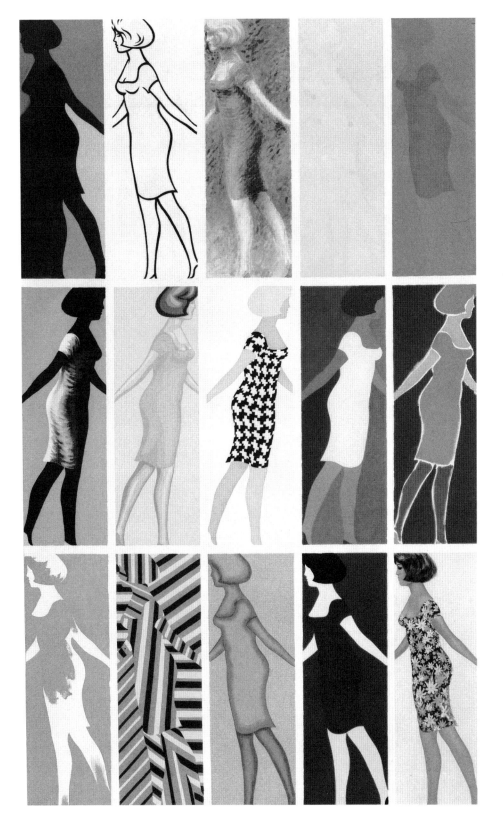

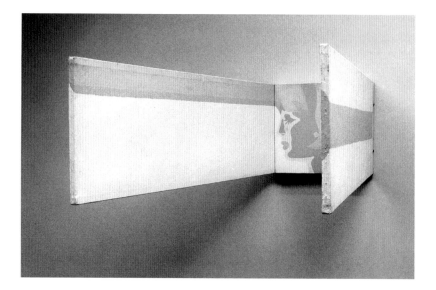

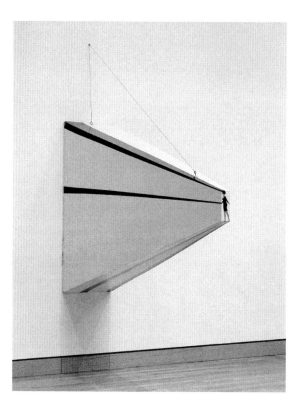

8. **Cry-Beam** 1965
enamel on canvas over wood construction, 37.0 x 70.2 x 140.5 cm
Michael Snow, courtesy S.L. Simpson Gallery, Toronto

9. **Seen** 1965
enamel on board over timber-and-plywood construction, 154.5 x 52.0 x 226.5 cm
National Gallery of Canada, Ottawa, purchased 1991 (35,346)

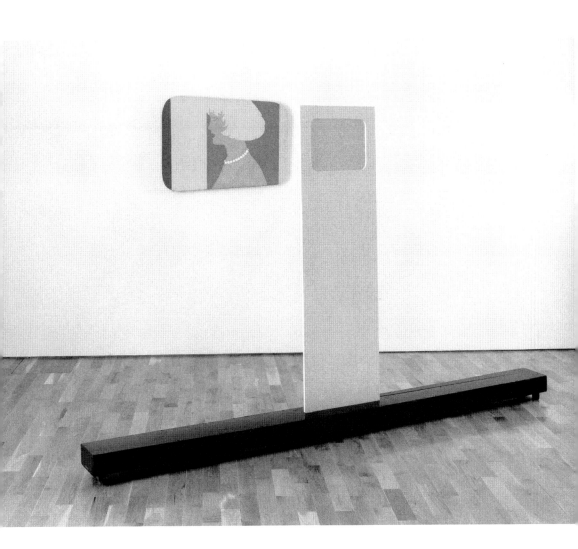

**10. Morningside Heights** 1965
two elements: enamel on timber and plywood, plexiglass, 172.7 x 290.0 x 20.5 cm;
acrylic and enamel on canvas, 67.7 x 91.0 cm
Michael Snow, courtesy S.L. Simpson Gallery, Toronto

(See colour plate 1, p. 129)
**11. Test Focus Field Figure** 1965
spray enamels on canvas, 152.4 x 203.2 cm
Art Gallery of Ontario, Toronto, purchase, Corporations' Subscription Endowment, 1966 (66/10)

153

12. **Duet** 1965
acrylic and enamel on canvas, 173.0 x 33.0 cm
Canada Council Art Bank, Ottawa (73/4-0828)

13. **Encyclopedia** 1964–January 1965
reproduction drawings, modified with black ink and opaque white, laid down on board,
varnished with acrylic resin, 245.1 x 118.1 cm
Art Gallery of Ontario, Toronto, purchased with assistance from Wintario, 1977 (77/29)

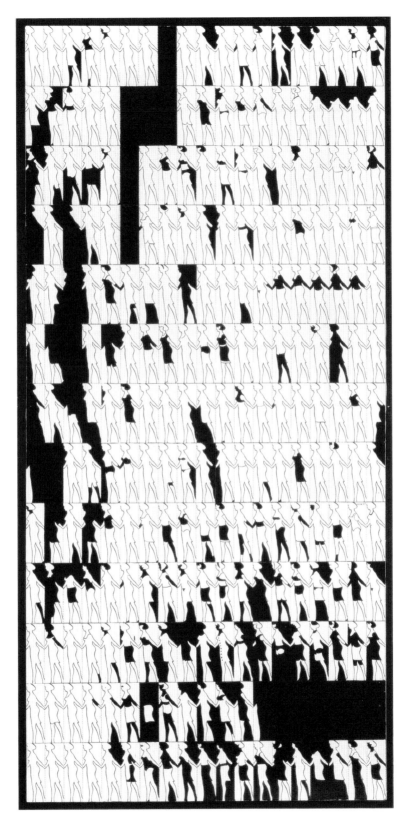

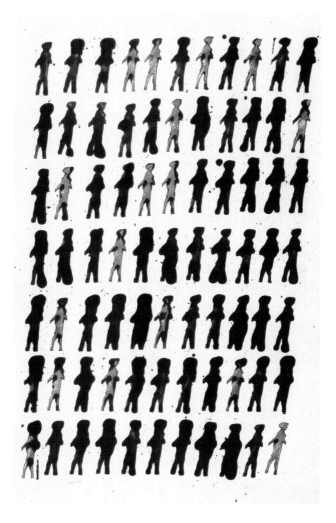

14. **Ink Walk**  1964
ink rubber-stamped on paper, 92.1 x 60.7 cm
Private collection, Toronto

15. **Places**  1964
mixed-media assemblage, including photographs; offset lithograph; paper, stamped with ink;
oil-on-paper collage, vandalized; tape; tacks; paint; wood; and acrylic sheeting 136.6 x 43.7 cm
Christopher E. Horne, Toronto

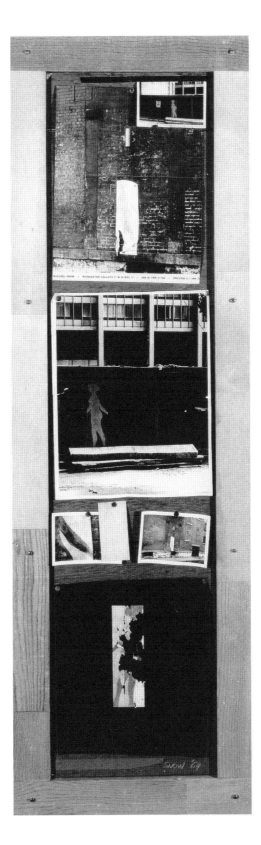

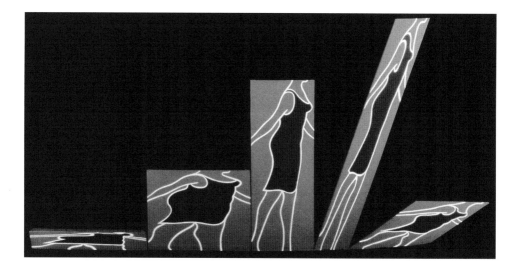

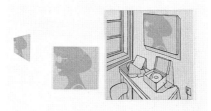

**16. Five Girl-Panels** 1964
acrylic on five canvases, 15.2 x 101.6 cm, 63.5 x 83.8 cm, 35.5 x 119.3 cm,
134.6 x 50.8 cm (rhomboid), 177.8 x 25.4 cm (rhomboid)
External Affairs and International Trade Canada (1317A, B, C, D, E)

(See colour plate 2, p. 130)
**17. Hawaii** 1964
enamel on two canvases, 149.8 x 149.5 cm, 71.6 x 76.1 cm;
enamel on plywood, 45.4 x 27.9 cm (trapezium); 149.9 x 309.9 cm overall
National Gallery of Canada, Ottawa, purchased 1973
(17,194.1-3)

**18. Register** 1964
oil, enamel and aluminum paint on timber and plywood with metal hardware, 207.5 x 63.3 x 76.0 cm
Michael Snow, courtesy S.L. Simpson Gallery, Toronto

**158**

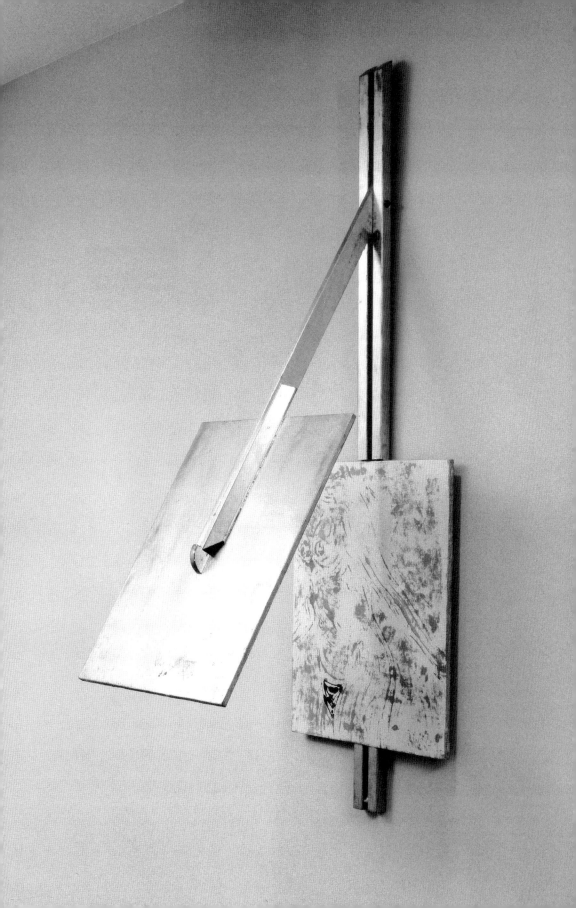

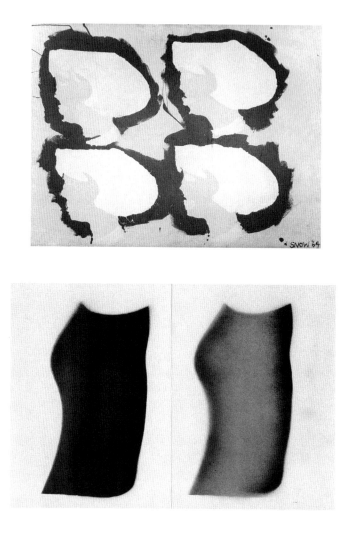

19. **The Chiffons** 1964
enamel and oil on canvas, 58.0 x 77.0 cm
Collection Lavalin, Musée d'art contemporain de Montréal
(A 92 710 P1)

20. **Two Skirts** 1964
spray enamel on board, mounted on plywood, 61.0 x 90.6 cm
National Gallery of Canada, Ottawa, gift from the Douglas M. Duncan Collection, 1970 (16,487)

21. **Shot!** December 1963
ink rubber-stamped on sixty-three sheets of paper, mounted on board, 112.1 x 71.6 cm overall
The Museum of Modern Art, New York, Inter-American Fund purchase, 1964 (295.64)

(See colour plate 3, p. 131)
22. **Half-Slip** 1963
oil on canvas, 51.0 x 152.7 cm
Burle and Louise Yolles, Toronto

(See colour plate 4, p. 132)
23. **Switch** 1963
oil on canvas, 153.5 x 114.0 cm
Geraldine Sherman and Robert Fulford, Toronto

24. **Stairs** 1963
oil on masonite, 205.5 x 52.2 cm (irregular)
Mendel Art Gallery, Saskatoon, Saskatchewan, purchased 1986 (86.5.1)

25. **Corner Piece** 1963
oil on masonite and wood, 99.2 x 44.4 x 30.3 cm
London Regional Art and Historical Museums, London, Ontario, gift of Union Gas to commemorate the retirement
of John B. Cronyn from its Board of Directors, with matching funds from the Canada Council, 1982 (82.A.5)

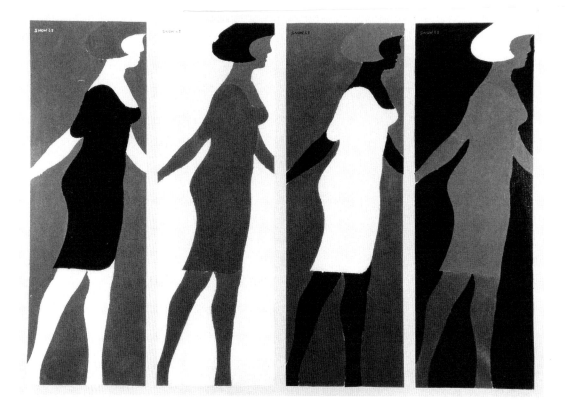

26. **Four** 1963
enamel and graphite on canvas, 162.6 x 228.6 cm
McIntosh Gallery, University of Western Ontario, London, Delaware Hall Fund, 1968 (1968.0024)

27. **Beach-Hcaeb** 1963
oil and graphite on canvas, 155.9 x 105.4 cm
McIntosh Gallery, University of Western Ontario, London, Alumni Association Fund, 1970 (1970.0043)

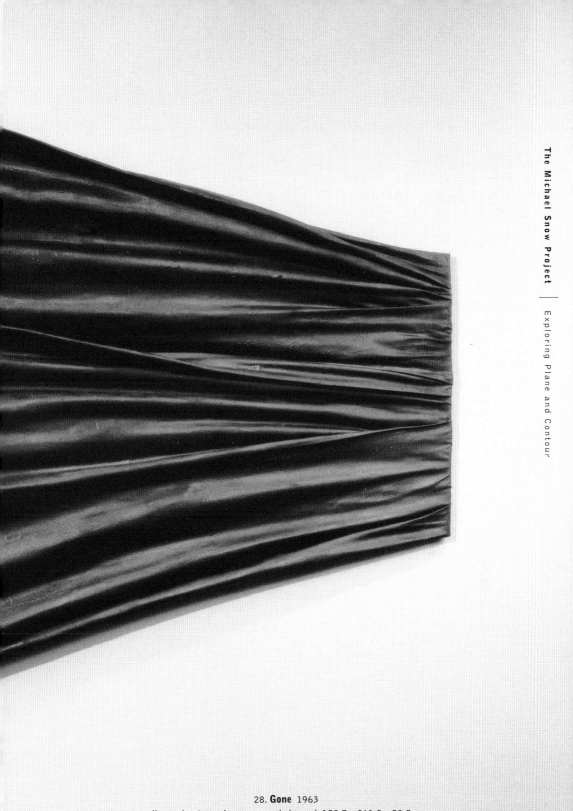

28. **Gone** 1963
oil on polyester resin, canvas and plywood, 152.7 x 261.5 x 53.5 cm
Michael Snow, courtesy S.L. Simpson Gallery, Toronto

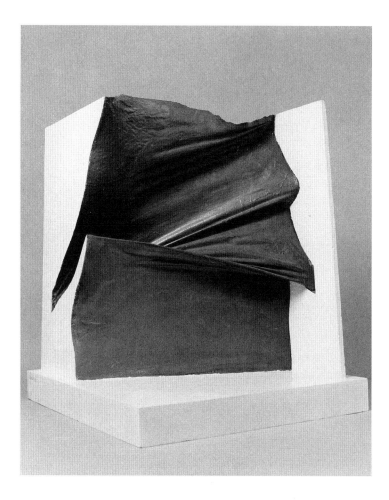

29. **Torso** 1963
enamel and polyester resin on canvas and wood construction, 73.2 x 66.3 x 60.8 cm
Macdonald Stewart Art Centre, University of Guelph, Guelph, Ontario,
gift of Alumni, Alma Mater Fund, and Wintario, 1980

30. **Interior** 1963
oil on canvas over wood construction, 150.5 x 41.8 x 23.5 cm
Michael Snow, courtesy S.L. Simpson Gallery, Toronto

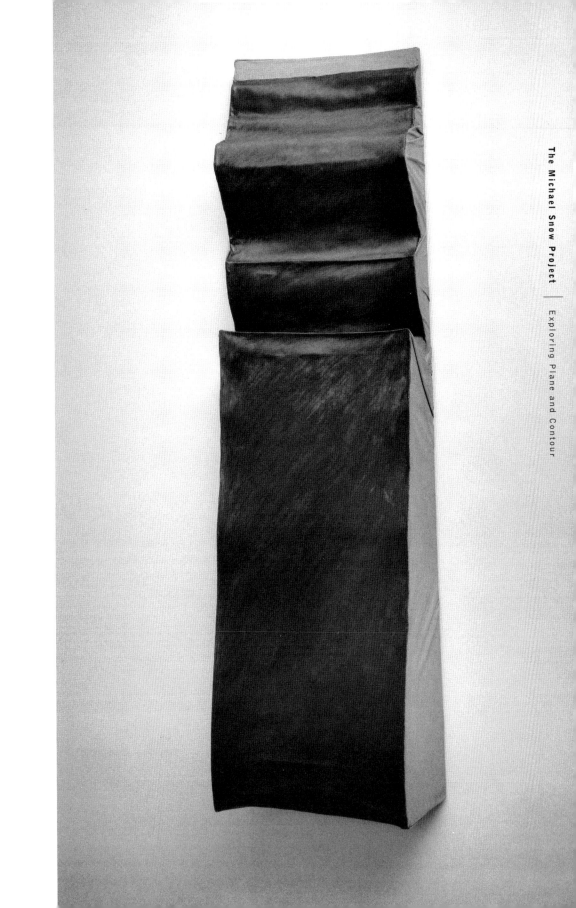

31. **Walking Woman Series #16** 1963
graphite on paper, 19.9 x 22.5 cm (sight); 21.3 x 27.7 cm (sheet)
External Affairs and International Trade Canada (987.288.1)

32. **Walking Woman Series #15** 1963 (bottom left)
graphite on paper, 25.5 x 17.5 cm (sight); 27.2 x 20.2 cm (sheet)
External Affairs and International Trade Canada (C.A.73.345)

33. **Walking Woman Series #4** 1963 (bottom right)
graphite on paper, 27.6 x 21.4 cm
Art Gallery of Ontario, Toronto, gift of Sam and Ayala Zacks, Toronto, 1970 (71/332)

34. **Walking Woman Series #4** 1963
graphite on paper, 33.0 x 57.2 cm
Owens Art Gallery, Mount Allison University, Sackville, New Brunswick, purchased 1968 (1968.127)

35. **Untitled** 1963
graphite on paper, 27.6 x 21.3 cm
Mendel Art Gallery, Saskatoon, Saskatchewan, gift of the artist, 1986 (86.4)

36. **Olympia** 1963
oil on canvas, 175.3 x 307.1 cm
MacKenzie Art Gallery, University of Regina Collection, Regina, Saskatchewan (72-11)

37. **Lights Out!** March 1963
acrylic on canvas, 96.2 x 54.2 cm
J. Ron Longstaffe Collection, courtesy the Vancouver Art Gallery

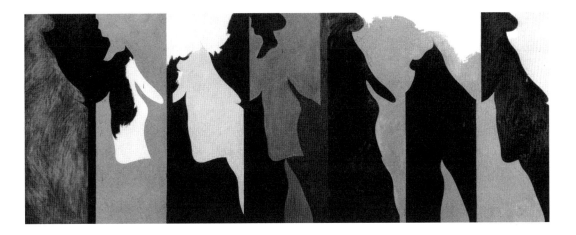

38. **Clothed Woman (In Memory of My Father)** 24 February 1963
oil and lucite on canvas, 152.0 x 386.2 cm
National Gallery of Canada, Ottawa, purchased 1966 (14,946)

39. **Sketch for "Clothed Woman (In Memory of My Father)"** 1963
graphite on paper, 27.5 x 37.9 cm (irregular)
National Gallery of Canada, Ottawa, purchased 1969 (15,690)

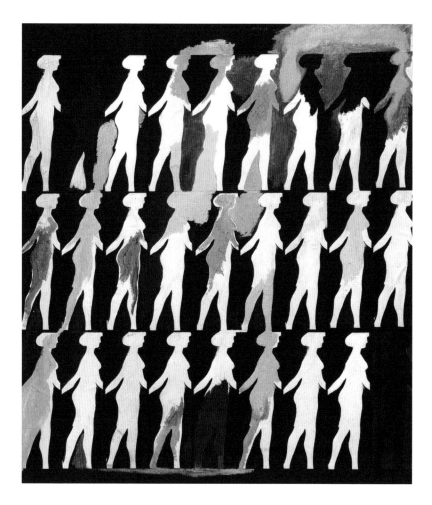

40. **27 Ladies (Women)** 1962
oil on paper collage on painted plywood, 138.7 x 121.9 cm
Hirshhorn Museum and Sculpture Garden, Smithsonian Institution, Washington, D.C.,
gift of Joseph H. Hirshhorn, 1966 (66.4663)

41. **Landscape with Walking Woman** 1962
oil and paper on an oil-on-canvas painting by J.C. Whale (1852–1905), 32.0 x 56.0 cm
Michael Snow, courtesy S.L. Simpson Gallery, Toronto

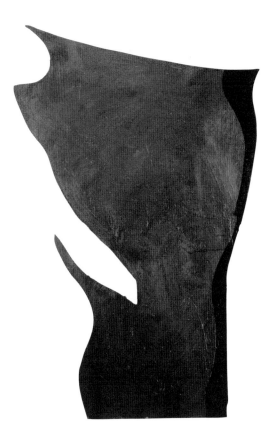

42. **Night and Wall Woman**  1962
oil on plywood, 95.5 x 62.5 cm (irregular)
Michael Snow, courtesy S.L. Simpson Gallery, Toronto

43. **Alice**  1962
weathered paper collage, 153.3 x 92.7 cm
National Gallery of Canada, Ottawa, purchased 1968 (15,455)

44. **Four to Five, June 20th, 1962** (over)
edition of 3, number 3, printed 1991
sixteen black-and-white photographs mounted on board, 68.0 x 83.3 cm overall
Art Gallery of Ontario, Toronto, purchased with donations from AGO members, 1991 (91/53)

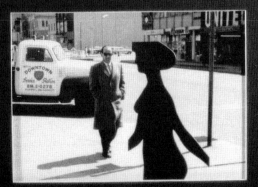

45. **Coat of Blue #1**  1962
oil on canvas, 157.0 x 53.0 cm
Collection Lavalin, Musée d'art contemporain de Montréal
(A 92 790 P1)

46. **Green Skirt**  1962
oil on canvas, 70.9 x 50.8 cm
Kathleen and Laing Brown, Vancouver

47. **Venus Simultaneous** 1962
oil and lucite on canvas, cardboard and plywood, 204.0 x 298.0 x 22.0 cm
Art Gallery of Ontario, Toronto, purchase, 1964 (63/47)

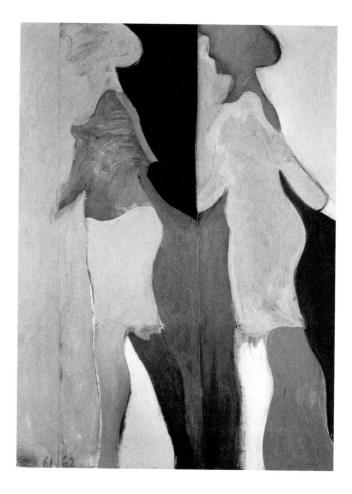

48. **61–62**  1962
oil and graphite on canvas, 152.7 x 114.5 cm
The Isaacs/Innuit Gallery, Toronto

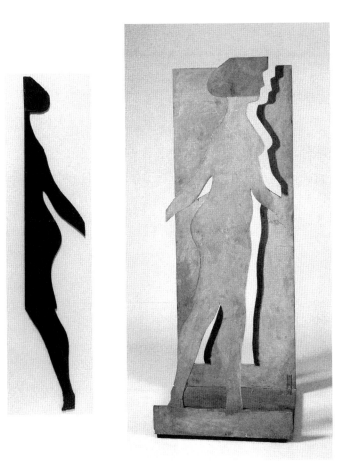

49. **Exit** November 1961
oil on cardboard, on masonite, 157.5 x 29.5 cm (irregular)
Donna and George Montague, Toronto

50. **She-scape** 1961
oil on plywood, timber and steel, 168.8 x 58.5 x 64.2 cm
Private collection, Montreal

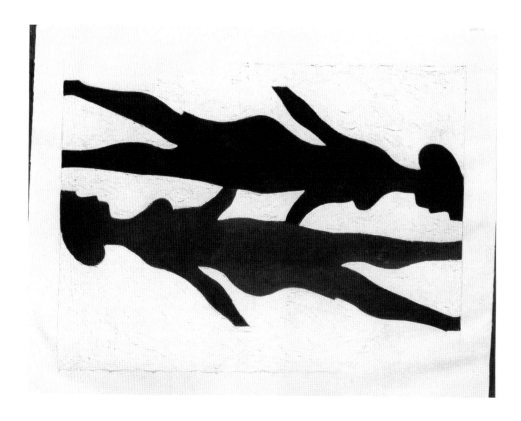

51. **A Falling Walking Woman** 1961
oil and graphite on canvas, 141.0 x 176.6 cm
Hirshhorn Museum and Sculpture Garden, Smithsonian Institution, Washington, D.C.,
gift of Joseph H. Hirshhorn, 1966 (66.4661)

(See colour plate 5, p. 133)
52. **Noctambulation (Death Walk)** 1961
oil on canvas, 152.4 x 152.4 cm
Hirshhorn Museum and Sculpture Garden, Smithsonian Institution, Washington, D.C.,
gift of Joseph H. Hirshhorn, 1966 (66.4662)

53. **Top Woman** 1961
ink and graphite with collage on folded paper, 60.6 x 64.8 cm (sight)
National Gallery of Canada, Ottawa, purchased 1973 (17,163)

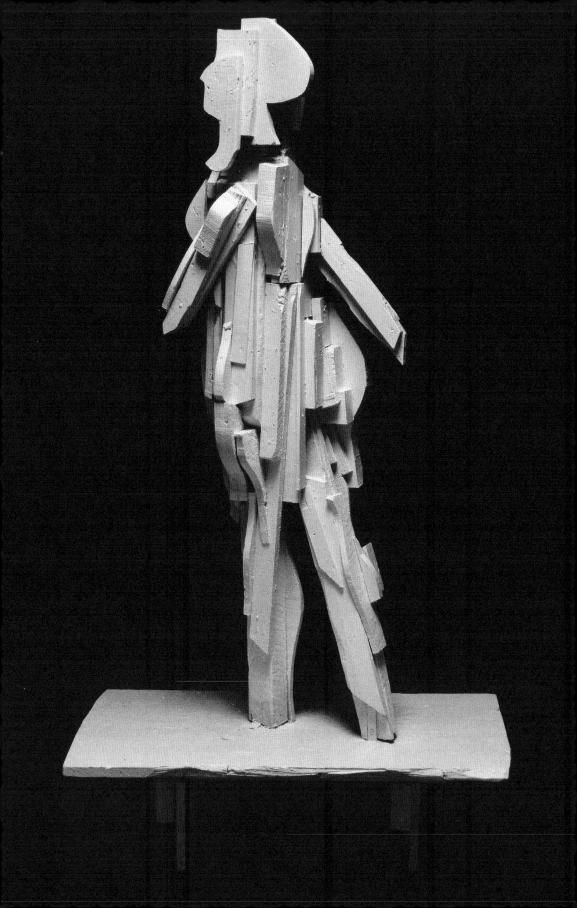

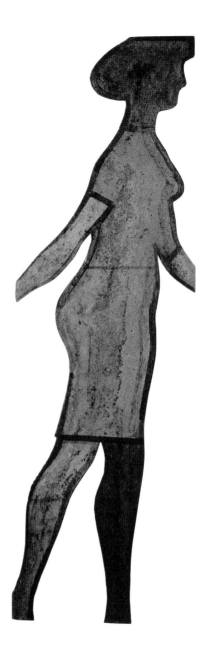

54. **Walking Woman** 1961
painted wood, 172.5 x 93.0 x 44.8 cm
Vancouver Art Gallery, purchased 1977 (77.74)

55. **Study for "Walking Woman"** 1961
graphite on paper, 20.3 x 25.3 cm
Vancouver Art Gallery, purchased 1985 (85.61)

56. **Spring-sign** 1961
weathered oil on plywood, 155.0 x 49.0 cm (irregular)
Art Gallery of Ontario, Toronto, gift of Norcen Energy Resources Limited, 1986 (86/54)

57. **Rolled Woman II** 1961
oil on paper, board and wood, cardboard tube, 72.5 x 48.8 x 6.2 cm
Leonard & Bina Ellen Art Gallery, Concordia University, Montreal,
Canada Council Special Purchase Assistance Grant, 1983

58. **Rolled Woman I** 1961
oil and graphite on canvas, latex on wood and board, cardboard tubes, 76.0 x 63.5 x 7.3 cm
Art Gallery of Ontario, Toronto, gift from the McLean Foundation, 1962 (61/61)

59. **Un-named Woman** 1961
oil on board, mounted on free-standing wooden support, 49.8 x 30.5 x 13.0 cm
Mr. and Mrs. Ray Jessel, Los Angeles, California

(See colour plate 6, p. 134)
60. **Project** 15 July 1961
graphite and oil on plywood, timber, metal, cardboard, 105.5 x 43.8 x 34.7 cm
Michael Snow, courtesy S.L. Simpson Gallery, Toronto

61. **Femetal** July 1961
oil on aluminum sheet, 122.5 x 92.4 cm
Kathleen and Laing Brown, Vancouver

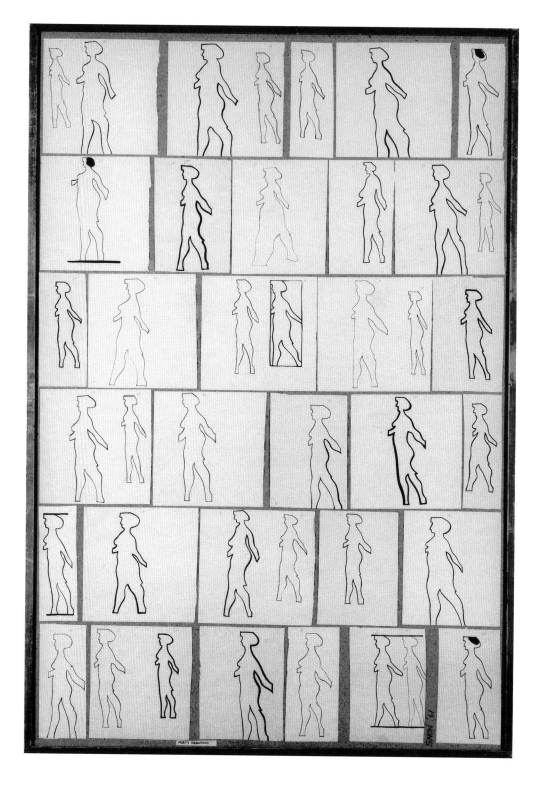

FORTY DRAWINGS

SNOW '61

62. **Forty Drawings** 1961
ink on thirty-one pieces of paper, mounted on board, 134.6 x 93.8 cm overall
Mr. and Mrs. Ray Jessel, Los Angeles, California

63. **Touched Woman** 1961
ink on folded paper, 71.0 x 51.0 cm (irregular)
Private collection, Montreal

**193**

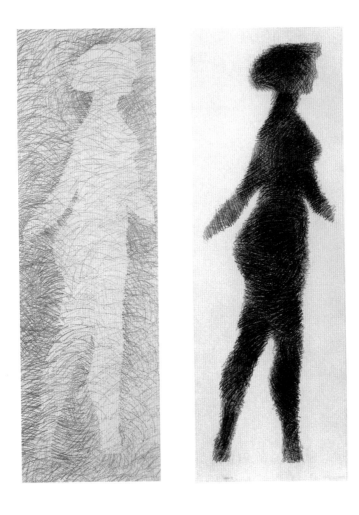

64. **Walking Woman II** 1961
graphite on paper, 170.5 x 58.8 cm
Hirshhorn Museum and Sculpture Garden, Smithsonian Institution, Washington, D.C.,
gift of Joseph H. Hirshhorn, 1966 (66.4660)

65. **Walking Woman I** 1961
graphite on paper, 170.2 x 58.4 cm
Marion Grudeff, Toronto

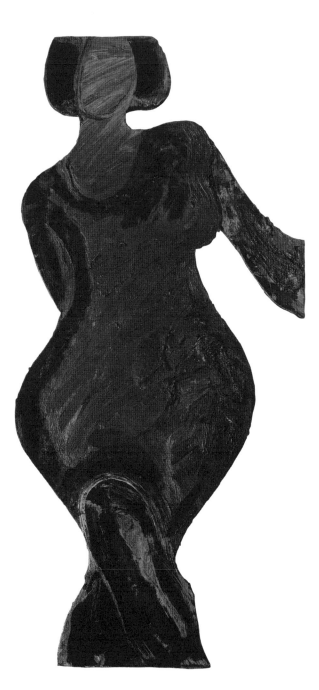

66. **Cut-out** 1961
oil on masonite, corrigated cardboard, plywood, 86.3 x 40.0 cm (irregular)
Michael Snow, courtesy S.L. Simpson Gallery, Toronto

67. **Two Walking Women**  1961
graphite on paper, 46.0 x 36.0 cm (irregular)
National Gallery of Canada, Ottawa, purchased 1975 (18,289)

68. **Studies for the Walking Woman, Three Figures**  1961
graphite on paper, 26.5 x 24.7 cm
Art Gallery of Ontario, Toronto, gift from the Peggy Lownsbrough Fund, 1984 (83/308.1)

69. **Studies for the Walking Woman, Two Figures** 1961
graphite on paper, 28.9 x 28.3 cm
Art Gallery of Ontario, Toronto, gift from the Peggy Lownsbrough Fund, 1984 (83/308.2)

70. **Untitled (Studies for the Walking Woman)** 1961
graphite on paper, 46.8 x 48.1 cm (irregular)
Robert W. Noakes, Toronto

71. **January Jubilee Ladies** 1961 (over)
chalk, gouache and paper collage on corrugated cardboard, 137.2 x 190.5 cm
External Affairs and International Trade Canada (C.C.73)

72. **Study for "January Jubilee Ladies"** 1961
graphite and coloured pencil on paper, 10.7 x 13.2 cm (sight); 19.5 x 25.3 cm (sheet)
Barbara and Murray Frum Collection, Toronto

73. **Study for "January Jubilee Ladies"** 1961
charcoal and ink on paper, 13.8 x 20.3 cm
Barbara and Murray Frum Collection, Toronto

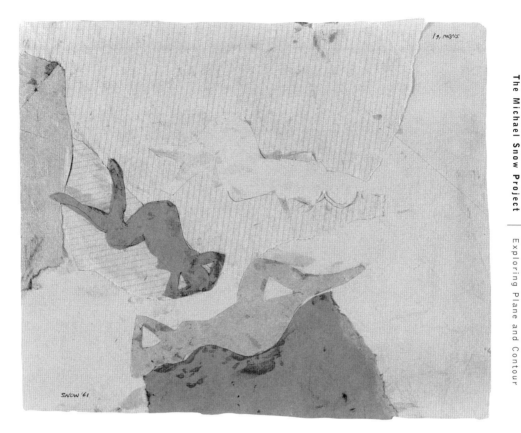

74. **Study for "January Jubilee Ladies"** 1961
gouache and paper collage on board, 28.5 x 34.5 cm
Barbara and Murray Frum Collection, Toronto

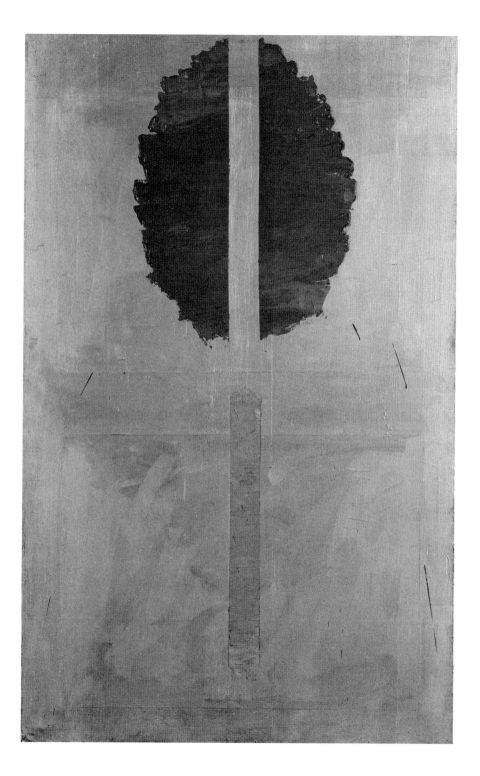

75. **Theory of Love** January 1961
oil and metallic paint on canvas, 162.8 x 101.2 cm
Art Gallery of Ontario, Toronto, gift of Sam and Ayala Zacks, Toronto, 1970 (70/252)

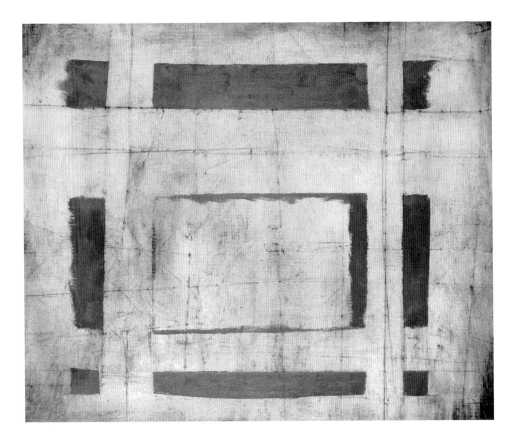

76. **Red Square**  21 December 1960
oil on canvas, 107.0 x 127.0 cm
The Toronto-Dominion Bank, Toronto (61.1.9)

77. **Before and After**  December 1960
graphite and oil on primed canvas, 177.7 x 101.2 cm
Michael Snow, courtesy S.L. Simpson Gallery, Toronto

78. **Lac Clair** December 1960
oil and paper adhesive tape on canvas, 178.0 x 178.3 cm
National Gallery of Canada, Ottawa, purchased 1967 (15,317)

(See colour plate 7, p. 135)
79. **Green in Green** November 1960
oil and lucite on canvas, 202.0 x 131.2 cm
Edie and Morden Yolles, Toronto

80. **Between**  October 1960
oil on canvas, 83.8 x 177.8 cm
Vancouver Art Gallery, gift of Avrom Isaacs, Toronto, 1983 (83.83)

81. **Two**  September 1960
oil on canvas, 101.8 x 127.0 cm
The Isaacs/Innuit Gallery, Toronto

82. **The Drum Book**  September 1960
oil and enamel on canvas, 182.7 x 152.7 cm
The Isaacs/Innuit Gallery, Toronto

83. **Nineteen Nights** February 1961
folded paper (cash receipts) with ink on graphite, on corrugated cardboard toned with watercolour, 22.4 x 66.1 cm
Michael Snow, courtesy S.L. Simpson Gallery, Toronto

84. **Title** 1960
charcoal on folded paper on board, 35.0 x 24.5 cm
National Gallery of Canada, Ottawa, purchased 1975 (18,288)

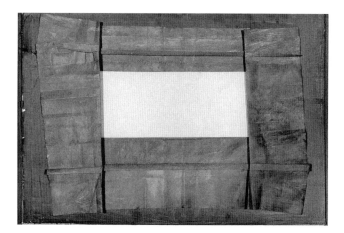

85. **A Package of Orange** 1960
oil on folded paper on painted corrugated cardboard, 62.0 x 87.0 cm
Collection Lavalin, Musée d'art contemporain de Montréal
(A 92 767 MD1)

(See colour plate 8, p. 136)
86. **Years** 1960
gouache on paper collage on painted corrugated cardboard, 89.5 x 90.7 cm
Collection Lavalin, Musée d'art contemporain de Montréal
(A92 632 C01)

87. **Blue Monk** 1960
gouache on folded paper on a free-standing wooden support, 51.5 x 38.8 x 15.0 cm
Michael Snow, courtesy S.L. Simpson Gallery, Toronto

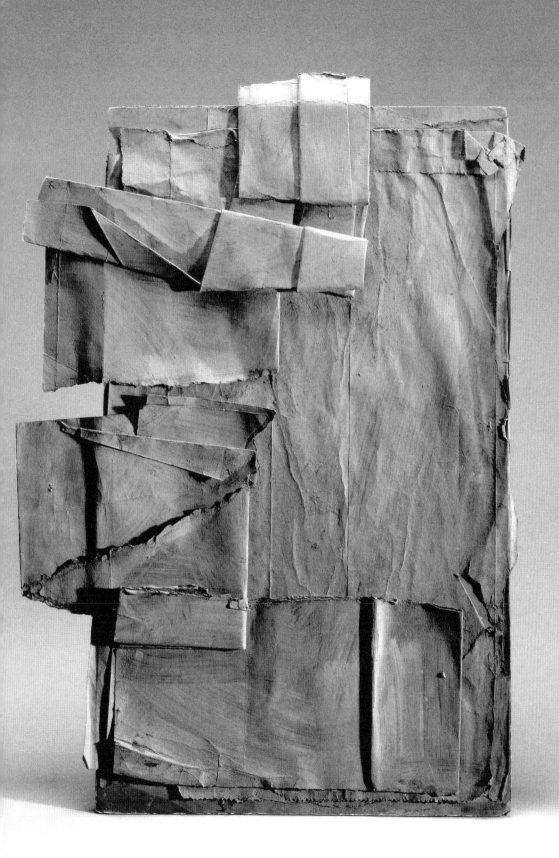

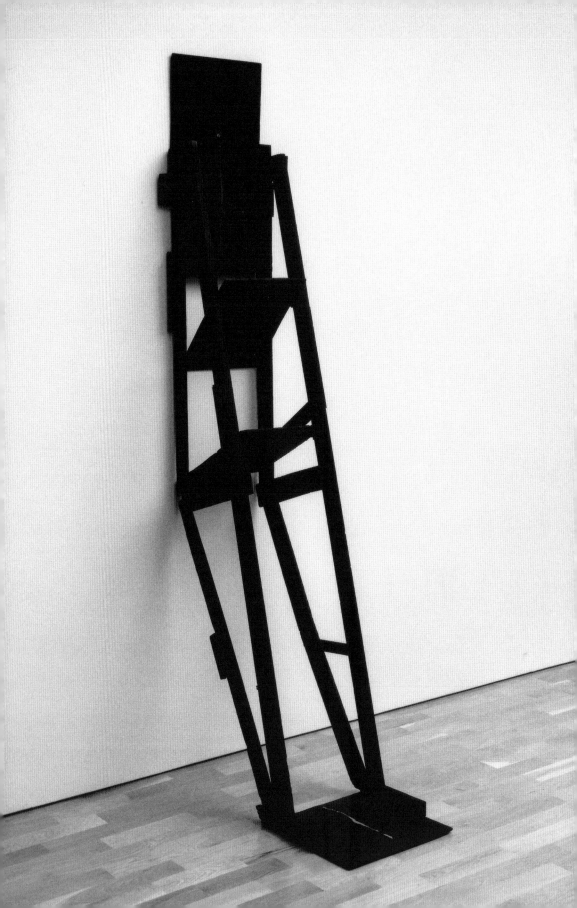

88. **White Trash**  1960
soiled folded paper on board, 71.7 x 35.8 cm
Edmonton Art Gallery, Edmonton, Alberta, purchased with funds donated by the Women's Society, 1979 (79.17.2)

89. **Quits**  October 1960 (left)
oil on timber and plywood, 223.3 x 44.0 x 92.0 cm
Michael Snow, courtesy S.L. Simpson Gallery, Toronto

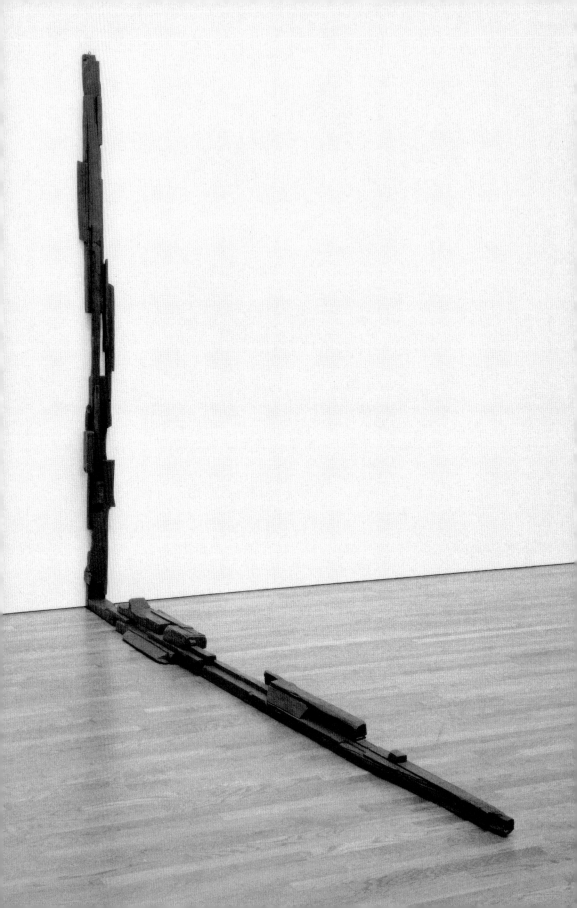

90. **Shunt** 1960 (left)
oil on timber, 264.0 x 18.5 x 335.3 cm
National Gallery of Canada, Ottawa, purchased 1970 (15,921)

91. **Studies for "Quits" and "Shunt"** 1960
green ball-point pen on paper, 29.8 x 45.4 cm
National Gallery of Canada, Ottawa, purchased 1985 (28,802)

215

(See colour plate 9, p. 137)
92. **Colour Booth** 1959
oil on timber and plywood, 203.6 x 44.0 x 49.3 cm
Michael Snow, courtesy S.L. Simpson Gallery, Toronto

216

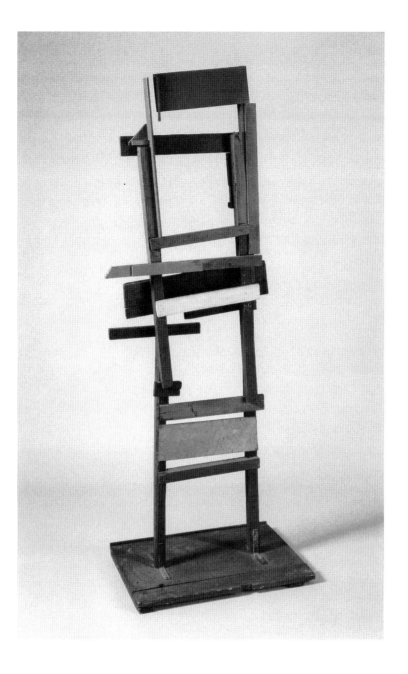

93. **A Day** 1959
oil on timber, plywood, and steel, 209.0 x 81.5 x 56.0 cm
Private collection, Montreal

**217**

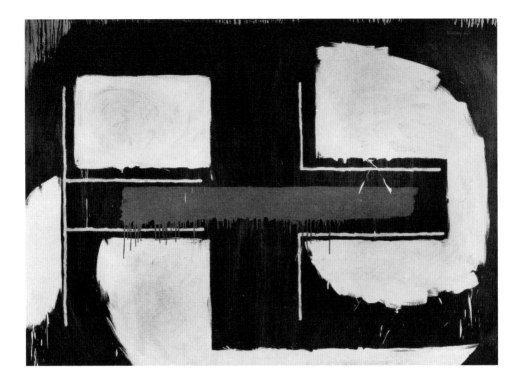

94. **Red Cross**  May 1960
oil on canvas, 127.2 x 177.6 cm
David Gladstone/Joseph Gladstone, Toronto

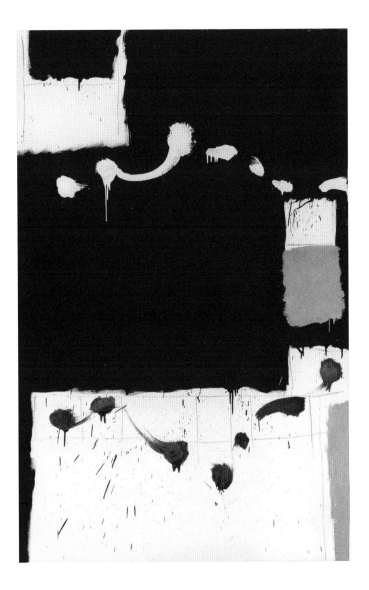

95. **Duol** May 1960
oil on canvas, 178.3 x 114.6 cm
The Estate of Signy Eaton, Toronto

(See colour plate 10, p. 138)
96. **Pascal/Napoleon** April 1960 (bottom)
oil on canvas, 178.0 x 127.0 cm
The Isaacs/Innuit Gallery, Toronto

97. **Line Situations** 1960
ink on paper, three sheets, each 21.5 x 27.6 cm
Michael Snow, courtesy S.L. Simpson Gallery, Toronto

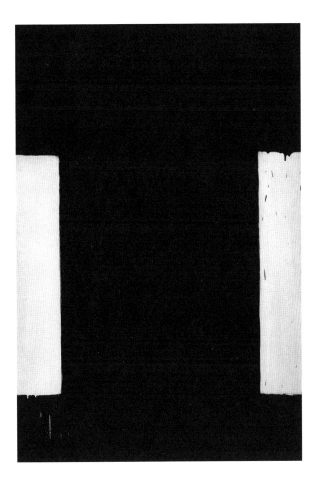

98. **Bracket I** February 1960
oil on canvas, 152.4 x 101.6 cm
Georgine Strathy, Montreal

(See colour plate 11, p. 139)
99. **Self-Centered** January 1960
oil on canvas, 126.5 x 101.5 cm
National Gallery of Canada, Ottawa, gift of Mr. and Mrs. J.W. Strutt, Lucerne, Quebec, 1980 (23,881)

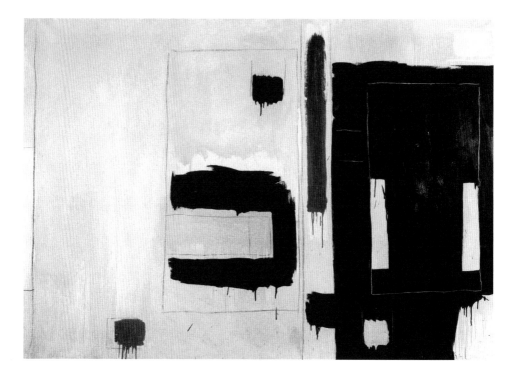

100. **Secret Shout**  January 1960
oil and charcoal on canvas, 132.0 x 190.0 cm
Larisa V.N. Pavlychenko, Claremont, Ontario

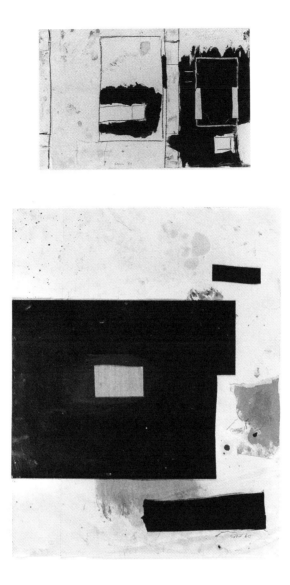

101. **Study for "Secret Shout"** 1960
coloured pencils, ink, and collage on paper, 19.7 x 29.8 cm
Barbara and Murray Frum Collection, Toronto

102. **Arrival** 1960
gouache, oil, and collage on paper, 42.8 x 33.7 cm
Private collection, courtesy Olga Korper Gallery, Toronto

**223**

103. **Painting Un-Foldage** 1959
gouache on folded and rubbed paper, 47.2 x 69.3 cm
Christopher E. Horne, Toronto

104. **Warm Scene** 1959
watercolour and collage on folded paper, 40.0 x 47.2 cm
Private collection, courtesy Olga Korper Gallery, Toronto

105. **Blues in Place** September 1959
oil and paper collage on canvas, 203.6 x 127.9 cm
National Gallery of Canada, Ottawa, purchased 1970 (15,920)

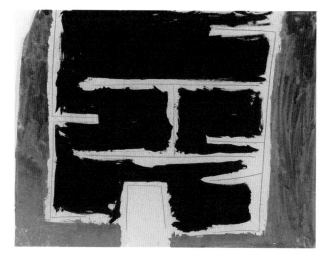

106. **Blue and Purple Drawing** 1959
gouache and ink over graphite on paper, 27.6 x 43.0 cm
Guido Molinari, Montreal

107. **Black and Blue Drawing** 1959
coloured pencil, ink and gouache on paper, 42.5 x 54.5 cm
Guido Molinari, Montreal

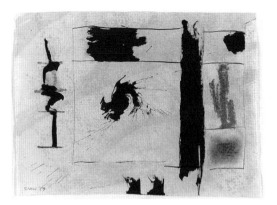

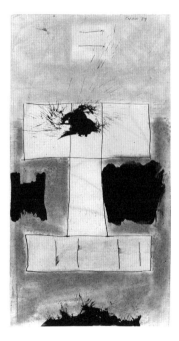

108. **Sketch for Painting** 1959
ink and chalk on paper, 19.5 x 26.5 cm
Private collection, courtesy Olga Korper Gallery, Toronto

109. **Sketch for Painting** 1959
ink and chalk on paper, 36.0 x 19.9 cm
Private collection, courtesy Olga Korper Gallery, Toronto

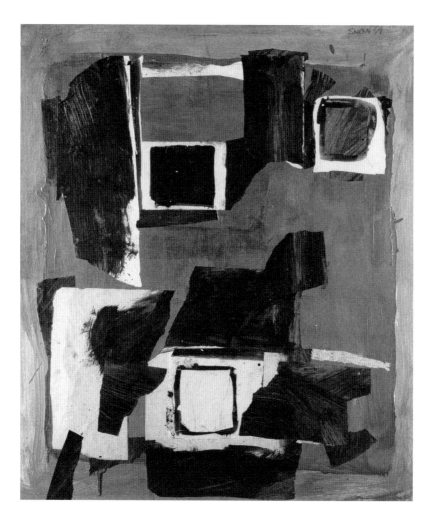

110. **Notes from the Underground**  July 1959
oil and paper collage on canvas, 82.7 x 71.7 cm
David and Jackie Gladstone, Toronto

111. **Goodbye**  July 1959
oil, paper, carbon paper and aluminum collage on veneer plywood, 69.2 x 91.0 cm
Michael Snow, courtesy S.L. Simpson Gallery, Toronto

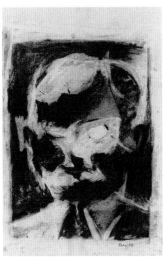
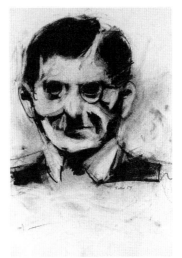
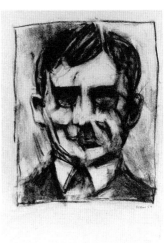

112. **Drawn Out** 1959
charcoal on paper, twenty-two sheets, each 40.6 x 27.9 cm (sight);
clipping of an offset reproduction, 11.2 x 17.1 cm (sight)
David Daniels, Toronto

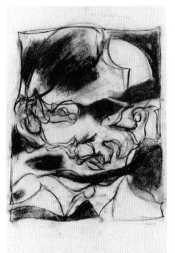

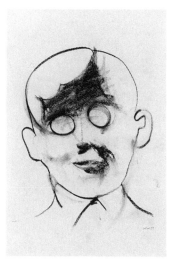

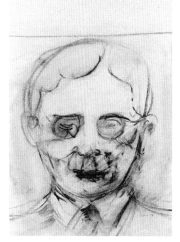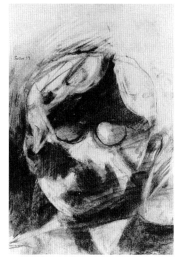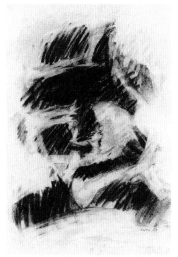

"The worst man I ever knew." That is how Burt sums up another convicted killer, Alan James Grierson.

Molly Brown loved Grierson. But he stole from her, then savagely killed her mother in another robbery.

233

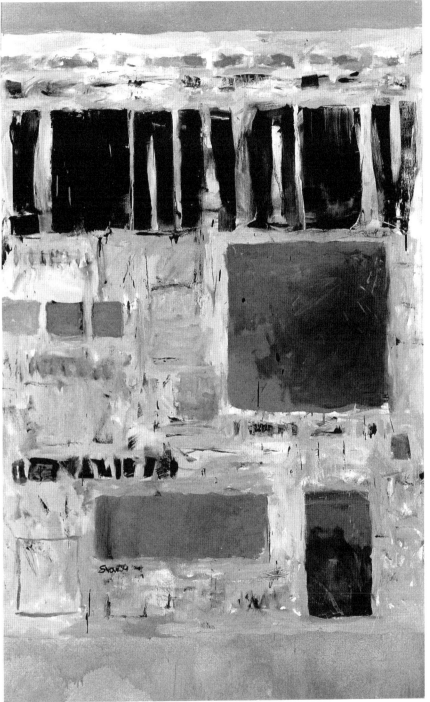

113. **News**  February 1959
oil on canvas, 165.1 x 101.6 cm
Agnes Etherington Art Centre, Queen's University, Kingston, Ontario,
gift of Ayala and Samuel Zacks, 1962 (5-76)

114. **Headline (Sketch for "News")** 1959
charcoal on paper, 31.1 x 38.1 cm
Musée d'art contemporain de Montréal, purchased 1976
(A 764 D1)

115. **Nightway** 1959 (bottom left)
charcoal on paper, 43.4 x 30.0 cm
McIntosh Gallery, University of Western Ontario, London, McIntosh Fund, 1976 (1976.0002)

116. **Theatre** 1959 (bottom right)
charcoal on paper, 41.2 x 32.3 cm
National Gallery of Canada, Ottawa, purchased 1970 (16,567)

117. **Petrograd 1917**  4 September 1958
oil on canvas, 80.5 x 127.0 cm
Art Gallery of Ontario, Toronto, gift of Walter Carsen, Thornhill, Ontario, 1971 (70/171)

118. **Detroit Blues**  3 May 1958
oil on canvas, 124.0 x 152.2 cm
Burle and Louise Yolles, Toronto

238

119. **Pencil Study for Painting** 1958
graphite on paper, 13.5 x 18.5 cm
Lynnwood Arts Centre, Simcoe, Ontario, purchase, with assistance from Wintario, 1986 (86-69-6)

120. **Pencil Study for Painting** 1958
graphite on paper, 13.9 x 19.0 cm
Guido Molinari, Montreal

121. **Pencil Study for Painting** 1958
graphite on paper, 13.9 x 18.9 cm
Guido Molinari, Montreal

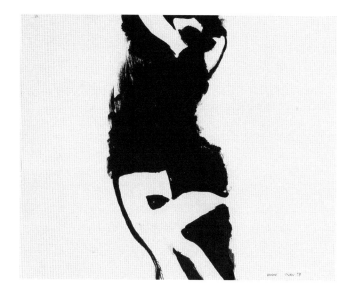

122. **White Figure I** 1958
ink over graphite with gouache and collage on paper, 20.2 x 13.9 cm
National Gallery of Canada, Ottawa, purchased 1970 (16,571)

123. **Dance** 1958
ink over graphite on paper, 35.4 x 48.9 cm
National Gallery of Canada, Ottawa, purchased 1970 (16,570)

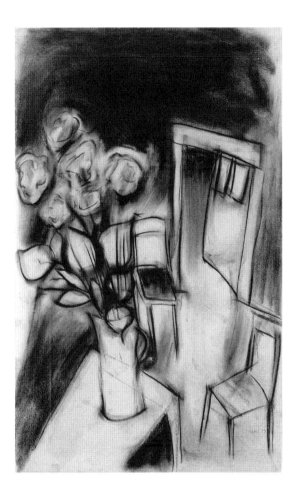

124. **Interior with Flowers** 1957
charcoal on paper, 71.2 x 43.3 cm
Michael Snow, courtesy S.L. Simpson Gallery, Toronto

**241**

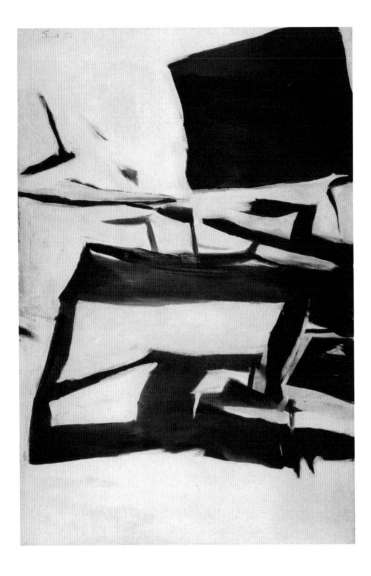

125. **Move**  July 1957
oil on canvas, 152.5 x 101.8 cm
Georgine Strathy, Montreal

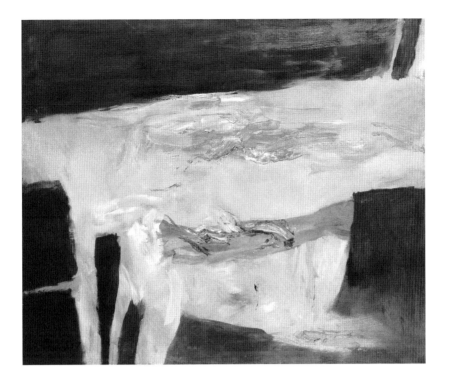

126. **Chairs** 1957
ink on paper collage, mounted on board, 48.2 x 66.0 cm
Galerie John A. Schweitzer, Montreal

127. **Sky Table** January 1957
oil on canvas, 101.5 x 121.8 cm
The Isaacs/Innuit Gallery, Toronto

128. **Blue Table and Chairs** 1957
gouache on paper, 45.0 x 62.0 cm
Collection Lavalin, Musée d'art contemporain de Montréal
(A 92 956 G01)

(See colour plate 12, p. 140)
129. **Table and Chairs No. 1** November 1956
oil on canvas, 71.5 x 90.8 cm
The Isaacs/Innuit Gallery, Toronto

130. **Interior at Dawn** August 1956
oil on canvas, 101.4 x 152.5 cm
Jessica and Percy Waxer, Toronto

131. **Leaving Blackness** summer 1956
oil on canvas, 76.5 x 122.0 cm
The Isaacs/Innuit Gallery, Toronto

132. **Three Chairs** June 1956
bronze lacquer on polyester resin and metal, on oil-painted wooden base, 12.5 x 43.0 x 25.7 cm
The Isaacs/Innuit Gallery, Toronto

133. **The Table** 1956
bronze lacquer on polyester resin and metal found objects, on oil-painted wooden base, 26.0 x 39.3 x 31.0 cm
National Gallery of Canada, Ottawa, purchased 1986 (29,333)

134. **Metamorphosis – Chair** 1955
bronze lacquer on polyester resin and metal, on oil-painted canvas-covered plywood base, 46.0 x 36.0 x 29.0 cm
Michael Snow, courtesy S.L. Simpson Gallery, Toronto

135. **Self Portrait**  1957
ink on paper, 15.9 x 25.5 cm (sight), 27.0 x 28.2 cm (sheet)
David P. Silcox and Linda Intaschi, Toronto

136. **Interior**  1957
ink on paper, 46.8 x 24.8 cm
The Montreal Museum of Fine Arts, purchase, The Saidye and Samuel Bronfman Collection of Canadian Art Fund,
1983 (Dr. 1983.2)

248

137. **Drawing** 1956
ink on paper, 22.5 x 30.1 cm
Michael Snow, courtesy S.L. Simpson Gallery, Toronto

138. **Untitled** 1956
ink and watercolour on paper, 27.9 x 28.8 cm
Geraldine Sherman and Robert Fulford, Toronto

249

139. **Two Lawnchairs** 1956
ink on paper, 27.4 x 42.6 cm
Michael Snow, courtesy S.L. Simpson Gallery, Toronto

140. **I think / Brushes should be big / and / Pens small** 1956
ink on paper, 28.1 x 43.5 cm
National Gallery of Canada, Ottawa, purchased 1970 (16,569)

141. **Two Men Swimming** 1956
ink on paper, 27.5 x 43.5 cm
Pei-Yuan Han, Montreal

142. **A Portrait of Kierkegaard** 1956
ink on paper, 27.0 x 24.0 cm (sight); 41.2 x 28.0 cm (sheet)
National Gallery of Canada, Ottawa, purchased 1970 (16,572)

143. **Reclining Figure** 1956
photo dyes on paper collage on board, 50.4 x 63.5 cm
Edmonton Art Gallery, Edmonton, Alberta,
purchased with funds donated by the Winspear Foundation, 1979 (79.17.1)

144. **Enchanted Woman** 1956
photo dyes on paper collage on board, 54.5 x 64.7 cm
The Isaacs/Innuit Gallery, Toronto

145. **Seated Nude** 1955
photo dyes on paper collage on board, 101.4 x 75.9 cm
Garth H. Drabinsky, Toronto

(See colour plate 13, p. 141)
146. **Reclining Figure** 1955
photo dyes on paper collage on board, 76.2 x 94.3 cm
Mr. and Mrs. Ray Jessel, Los Angeles, California

147. **Unseated Figure**  October 1955
photo dyes on paper collage on board, 107.1 x 76.1 cm
James Grant Laidlaw, Vancouver

148. **A Man at a Desk**  1955
photo dyes on paper collage on board, 107.1 x 76.1 cm
Private collection, Toronto

149. **A Night** 1956
ink on paper, 30.5 x 45.8 cm
Mr. and Mrs. Ray Jessel, Los Angeles, California

150. **Seated Woman** in *Sketchbook 21*, 1956
ink on paper, 30.3 x 22.5 cm
Edward P. Taylor Research Library and Archives, Art Gallery of Ontario, Toronto,
gift of the artist, 1992 (Michael Snow Fonds, box 18)

151. **Figure Drawings** in *Sketchbook 20*, 1956
ink on paper, 30.1 x 22.4 cm each sheet
Edward P. Taylor Research Library and Archives, Art Gallery of Ontario, Toronto,
gift of the artist, 1992 (Michael Snow Fonds, box 18)

152. **Untitled (Head)** December 1955
ink on paper, 30.5 x 21.5 cm
Canada Council Art Bank, Ottawa (90/1-0181)

153. **Three Figures in a Book**  November 1955
ink on paper, 35.6 x 21.9 cm
National Gallery of Canada, Ottawa, purchased 1970 (16,568)

154. **Profile** 1955
ink on paper, 68.7 x 43.4 cm
Roy L. Heenan, Montreal

155. **Seated Nude (Red Head)**  September 1955
oil on canvas, 126.0 x 80.0 cm
The Isaacs/Innuit Gallery, Toronto

**156. On the Hero Myth** 1955
oil, string on canvas board, 40.0 x 32.8 cm
Michael Snow, courtesy S.L. Simpson Gallery, Toronto

**157. Young Girl** 1955
gouache on board, 37.0 x 27.0 cm
Janice and Robert Jordan, Toronto

262

158. **Woman with a Clarinet** 1954
ink on paper, 27.5 x 21.5 cm
Donna and George Montague, Toronto

159. **The Meeting** 1954
ink on paper, 34.4 x 30.4 cm
The Montreal Museum of Fine Arts, purchase, Dr. F.J. Shepherd Bequest, 1980 (Dr.1980.2)

160. **Table Life**  1954
gouache on paper, 39.6 x 53.1 cm
Michael Snow, courtesy S.L. Simpson Gallery, Toronto

(See colour plate 14, p. 142)
161. **Georgine**  summer 1954
gouache and graphite on card, 33.0 x 46.5 cm (sight); 35.2 x 50.1 cm (overall)
Michael Snow, courtesy S.L. Simpson Gallery, Toronto

162. **The Message**  September 1954
gouache on tissue on paper, 36.8 x 44.9 cm (sight), 39.1 x 49.5 cm (sheet)
David and Adrienne Lancashire, Toronto

163. **From the Catalogue of the King's Dancers**  June 1954
gouache on tissue on paper, 35.6 x 26.3 cm (sight); 45.7 x 35.1 cm (sheet)
Michael Snow, courtesy S.L. Simpson Gallery, Toronto

164. **Clarinet Blues**  April 1954
gouache on paper, 32.9 x 43.3 cm (sight), 34.6 x 47.0 cm (sheet)
Mr. and Mrs. Roderick Rynard, Toronto

165. **Show**  April 1954
ink on paper, 31.9 x 23.8 cm
Michael Snow, courtesy S.L. Simpson Gallery, Toronto

166. **Ocul**  March 1954
ink and watercolour on paper, 51.2 x 74.0 cm
Art Gallery of Ontario, Toronto, purchase, 1970 (70/5)

167. **Natureza muerta optica**  December 1953
ink on paper, 21.0 x 28.5 cm
Michael Snow, courtesy S.L. Simpson Gallery, Toronto

168. **Studies of Cock's Head** in *Sketchbook 15*, December 1953
graphite on paper, 31.7 x 43.8 cm each sheet
Edward P. Taylor Research Library and Archives, Art Gallery of Ontario, Toronto,
gift of the artist, 1992 (Michael Snow Fonds, box 18)

169. **Jazzband** in *Sketchbook 7*, December 1953
ink over graphite on paper, 21.0 x 28.7 cm
Edward P. Taylor Research Library and Archives, Art Gallery of Ontario, Toronto,
gift of the artist, 1992 (Michael Snow Fonds, box 17)

170. **Three Nudes** 1953–54
gouache on paper, 22.6 x 30.6 cm
Michael Snow, courtesy S.L. Simpson Gallery, Toronto

171. **Man Examining a Line** December 1953–January 1954
oil on canvas, 40.6 x 45.7 cm
Art Gallery of Ontario, Toronto, gift of Mrs. Norah Vaughan, Toronto, 1993 (93/35)

172. **Man Examining a Line** November 1953
ink on paper, 28.5 x 21.0 cm
Michael Snow, courtesy S.L. Simpson Gallery, Toronto

(See colour plate 15, p. 143)

173. **Colin Curd About to Play** 1953
oil on canvas, 148.6 x 79.4 cm
Art Gallery of Ontario, Toronto, gift of Sam and Ayala Zacks, Toronto, 1970 (70/253)

174. **Studies for "Colin Curd About to Play"** in *Sketchbook 16*, 1953
graphite on paper, 46.0 x 30.6 cm each sheet
Edward P. Taylor Research Library and Archives, Art Gallery of Ontario, Toronto,
gift of the artist, 1992 (Michael Snow Fonds, box 18)

271

175. **Notre Dame** 1953
gouache on paper, 44.1 x 26.7 cm (sight), 51.1 x 38.6 cm (sheet)
Marie-Antoinette Snow Roig, Toronto

176. **Moonlit House** 1953
gouache on paper, 49.7 x 28.1 cm (sight), 56.5 x 31.8 cm (sheet)
Mr. and Mrs. Roderick Rynard, Toronto

272

177. **Blue Panel (Wall Panel V)** October 1952
oil on plywood, 38.5 x 28.9 cm
Michael Snow, courtesy S.L. Simpson Gallery, Toronto

178. **Still Life: Red Goblet**  August 1952
oil on masonite, 58.3 x 56.5 cm
Mr. and Mrs. Roderick Rynard, Toronto

(See colour plate 16, p. 144)
179. **Tall Panel (Wall Panel II)** December 1951
oil on panel, 63.2 x 29.2 cm
Mr. and Mrs. Ernie Herzig, Toronto

# Lenders

Kathleen and Laing Brown, Vancouver

David Daniels, Toronto

Garth H. Drabinsky, Toronto

The Estate of Signy Eaton, Toronto

Murray Frum, Toronto

David and Jackie Gladstone, Toronto

Joseph Gladstone, Toronto

Marion Grudeff, Toronto

Pei-Yuan Han, Montreal

Roy L. Heenan, Montreal

Mr. and Mrs. Ernie Herzig, Toronto

Christopher E. Horne, Toronto

Mr. and Mrs. Ray Jessel, Los Angeles,
California

Janice and Robert Jordan, Toronto

James Grant Laidlaw, Vancouver

David and Adrienne Lancashire, Toronto

J. Ron Longstaffe, Vancouver

Guido Molinari, Montreal

Donna and George Montague, Toronto

Robert W. Noakes, Toronto

Larisa V.N. Pavlychenko, Claremont,
Ontario

Mr. and Mrs. Roderick Rynard, Toronto

Marie-Antoinette Snow Roig, Toronto

Geraldine Sherman and Robert Fulford,
Toronto

David P. Silcox and Linda Intaschi,
Toronto

Georgine Strathy, Montreal

The Toronto-Dominion Bank, Toronto

Jessica and Percy Waxer, Toronto

Burle and Louise Yolles, Toronto

Edie and Morden Yolles, Toronto

and other private collectors

The Isaacs/Innuit Gallery, Toronto

Private collection, courtesy Olga Korper
Gallery, Toronto

Galerie John A. Schweitzer, Montreal

Michael Snow, courtesy S.L. Simpson
Gallery, Toronto

Agnes Etherington Art Centre, Queen's
University, Kingston

Art Gallery of Ontario, Toronto

Canada Council Art Bank, Ottawa

Edmonton Art Gallery

Leonard & Bina Ellen Art Gallery,
Concordia University, Montreal

External Affairs and International Trade
Canada

Hirshhorn Museum and Sculpture Garden,
Smithsonian Institution, Washington, D.C.

London Regional Art and Historical
Museums

Lynnwood Arts Centre, Simcoe

Macdonald Stewart Art Centre, University
of Guelph

Mackenzie Art Gallery, Regina

McIntosh Gallery, The University of
Western Ontario, London

Mendel Art Gallery, Saskatoon

The Montreal Museum of Fine Arts

Musée d'art contemporain de Montréal

The Museum of Modern Art, New York

National Gallery of Canada, Ottawa

Owens Art Gallery, Mount Allison
University, Sackville

Vancouver Art Gallery

# Exhibitions and Reviews

## 1955

Toronto

Hart House Art Gallery, University of
Toronto, 3–18 January 1955, *Graham
Coughtry, Michael Snow, recent paintings
and drawings.*

"Bar 3 Offensive Nudes Mayor Asks: U. of T.
   Balks." *Telegram* (Toronto), 4 January
   1955.
"Mayor Objects: Nudes Hang On." *Globe
   and Mail* (Toronto), 5 January 1955.
"One Hart House 'Nude' Is Removed:
   Artists Protest Criticism." *Telegram*
   (Toronto), 5 January 1955.
"One Hart House 'Nude' Is Removed:
   Artists Hit Back At Critics." *Telegram*
   (Toronto), 5 January, late edition.
"Hart House Nude Back Again Phillips'
   Objection Rejected." *Toronto Daily Star*,
   6 January 1955.
"Nate's Nudes Make News." *Telegram*
   (Toronto), 6 January 1955.
"One Nude Gone, Mayor Satisfied."
   *Globe and Mail* (Toronto), 6 January
   1955.
"Those 'Nudes' Will Stay Art Committee
   Decides." *Telegram* (Toronto), 6 January
   1955.
Pengelley, Mike. "Three Pics. Will Remain
   Despite Mayor's Attack Art Committee
   Decides." *Varsity* (University of
   Toronto), 7 January 1955.
"Thank You, Mr. Mayor." *Varsity* (University
   of Toronto), 7 January 1955.

"The Elected Censor." *Hamilton Spectator*,
   7 January 1955.
Friedmann, W. "Letter to the Editor: The
   Art Show at Hart House." *Globe and Mail*
   (Toronto), 8 January 1955.
Macdonald, Rose. "'Nudes or Nudes' Not
   One At Show." *Telegram* (Toronto),
   8 January 1955.
Mayor, J.B. "Letter to the Editor: The Art
   Show at Hart House." *Globe and Mail*
   (Toronto), 8 January 1955.
Slogan, Joseph. "Letter to the Editor: The
   Art Show at Hart House." *Globe and Mail*
   (Toronto), 8 January 1955.
McMordie, Michael. "Nudes Revued:
   Coughtry and Snow." *Varsity* (University
   of Toronto), 10 January 1955.
"Nude Paintings Hang On: 'Objectionable'
   Paintings Draw Crowds to HH Gallery."
   *Varsity* (University of Toronto),
   10 January 1955.
Disillusioned of Art. "Live Letters: Fearless
   Phillips." *Telegram* (Toronto), 11 January
   1955.
Gigeroff, Alex K. "Nude controversy painters
   outline personal attitude." *Varsity*
   (University of Toronto), 11 January 1955.
Le Coq d'Or. "Our Readers Write: Pauline."
   *Varsity* (University of Toronto), 11
   January 1955.
Ritchie, N. "Live Letters: Nudes Not Evil."
   *Telegram* (Toronto), 11 January 1955.
Wong, A. (S.P.S.). "Our Readers Write:
   Pursuit of Principles." *Varsity* (University
   of Toronto), 11 January 1955.

Love, Douglas (1 UC). "A Reader Writes."
    *Varsity* (University of Toronto),
    12 January 1955.
S.S. "Live Letters: A Pat For Nathan."
    *Telegram* (Toronto), 14 January 1955.
Stanton, Mrs. Renee. "Live Letters:
    Uncovering Nakedness." *Telegram*
    (Toronto), 15 January 1955.
Grad 2T5. "Letter to the Editor: Ban Evil
    and Nudes." Unidentified clipping,
    Michael Snow file, Edward P. Taylor
    Research Library and Archives, Art
    Gallery of Ontario, Toronto.
Jones, Mrs. Janet. "Letter to the Editor:
    Just in the Mind." Unidentified clipping,
    Michael Snow file, Edward P. Taylor
    Research Library and Archives, Art
    Gallery of Ontario, Toronto.

**Works Mentioned**
*Woman with a Clarinet, Wall Panel I, Wall
Panel V, At the Jazzband Ball, Colin Curd
About to Play.*

## 1956

TORONTO
Greenwich Art Shop, 1–21 February,
[*Opening Exhibition: Coughtry, Ronald, Scott,
Snow, Varvarande*]. There is a typed checklist
in the Isaacs Gallery Papers.

Lawrence, Les. "Open Up New Gallery."
    *Varsity* (University of Toronto),
    3 February 1956.
McCarthy, Pearl. "Liturgical Art in Canada
    Burns the Midnight Oil." *Globe and Mail*
    (Toronto), 4 February 1956.
Fulford, Robert. "Gallery & Studio: 'School'

is Out." *Mayfair* 30 (March 1956): 52–53.

TORONTO
Greenwich Gallery, 13 October–2 November
1956, *Paintings, Sculpture, Drawings by
Michael Snow.* There is a typed checklist in
the Isaacs Gallery Papers.

Fulford, Robert. "About Michael Snow."
    *Paintings, Sculpture, Drawings by Michael
    Snow.* Toronto: Greenwich Gallery, 1956:
    n.p.
MacDonald, Janet. "Snow on Bay St."
    *Varsity* (University of Toronto), 16
    October 1956.
McCarthy, Pearl. "Art and Artists: Younger
    Group Rising Over Weary Sterilities."
    *Globe and Mail* (Toronto), 20 October
    1956.
McPherson, Hugo. "CJBC Views the Shows:
    The Galleries." Typescript, 4 November
    1956; copy in artist's file, Edward P.
    Taylor Research Library and Archives,
    Art Gallery of Ontario, Toronto.

## 1958

TORONTO
Greenwich Gallery, 4–23 October 1958,
*Michael Snow, Paintings, also Drawings and
Sculpture.* There is a typed checklist in the
Isaacs Gallery Papers.

Duval, Paul. "Accent on Art: Canadian Who
    Liked Solitude Painted Unique 'Essence'
    Of Nation." *Telegram* (Toronto), 11
    October 1958.
McCarthy, Pearl. "Art and Artists: Abstract
    Gains in Prominence." *Globe and Mail*

(Toronto), 18 October 1958.

Fulford, Robert. "CJBC Views the Shows, Excerpts." Typescript, 19 October 1958, copy in artist's file, Edward P. Taylor Research Library and Archives, Art Gallery of Ontario, Toronto.

McPherson, Hugo. "The Autumn Season: 1958: Toronto." *Canadian Art* 16 (February 1959): 57.

### 1959

TORONTO

Art Gallery of Toronto, 20 February– 22 March 1959, *Michael Snow* in *Four Canadians*. There is a typed checklist in the Edward P. Taylor Research Library and Archives, Art Gallery of Ontario, Toronto.

Fulford, Robert. "World of Art: Snow Explores Edge of Art." *Toronto Daily Star*, 7 March 1959.

HAMILTON

Westdale Gallery, 19–26 November 1959, [*Drawings by . . . Joyce Wieland and Michael Snow*].

Kilbourn, Elizabeth. "Pianist-painter Showing Works At Westdale." *Hamilton Spectator*, 28 November 1959.

### 1960

TORONTO

The Isaacs Gallery, 13 February–3 March 1960, *Paintings. Michael Snow*. There is a typed checklist in the Isaacs Gallery Papers.

Sabiston, Colin. "Snow Best Described As Impulse Painter." *Globe and Mail* (Toronto), 20 February 1960.

Fulford, Robert. "World of Art: Canada To Enrich World Art?" *Toronto Daily Star*, 20 February 1960.

TORONTO

The Isaacs Gallery, 22 October– 10 November 1960, *Sculpture by Painters*. There is a typed checklist in the Isaacs Gallery Papers.

McCarthy, Pearl. "Art and Artists: Sculpture by Painters." *Globe and Mail* (Toronto), 28 October 1960.

Duval, Paul. "Accent on Art: From (Almost) Realism To Abstraction." *Telegram* (Toronto), 29 October 1960.

Fulford, Robert. "World of Art: Not Transferable." *Toronto Daily Star*, 29 October 1960.

### 1961

TORONTO

The Isaacs Gallery, 4–23 March 1961, *Michael Snow. Paintings etc.* There is a typed checklist in the Isaacs Gallery Papers.

Fulford, Robert. "World of Art: Cool and Playful." *Toronto Daily Star*, 4 March 1961.

McCarthy, Pearl. "Art and Artists: Art Shows Prompt Controversy." *Globe and Mail* (Toronto), 11 March 1961.

Duval, Paul. "Accent on Art: Intent and Serious." *Telegram* (Toronto), 18 March 1961.

Kilbourn, Elizabeth. "Coast to Coast in Art:

Toronto-Hamilton." *Canadian Art* 18
(May–June 1961): 184–85.

TORONTO
The Isaacs Gallery, 20 December
1961–9 January 1962, [*Dada*]. There is
a typed checklist in the Isaacs Gallery
Papers.

Fulford, Robert. "World of Art: Anarchy."
    *Toronto Daily Star*, 23 December 1961.
———. "Everybody Wants to Get Into
    the Act." *Toronto Daily Star*, 6 January
    1962.
Sanouillet, Michel. "The Sign of Dada at the
    Isaacs Gallery, Toronto." *Canadian Art*
    19 (March/April 1962): 111.

## 1962

TORONTO
The Isaacs Gallery, 15 March–3 April 1962,
*Michael Snow*. There is a typed checklist in
the Isaacs Gallery Papers.

Fulford, Robert. "World of Art: Snowgirl."
    *Toronto Daily Star*, 17 March 1962.
Duval, Paul. "Accent on Art: Feminine
    Flavor for New Shows." *Telegram*
    (Toronto), 24 March 1962.
Fulford, Robert. "World of Art: How Not
    To Buy." *Toronto Daily Star*, 31 March
    1962.
Kilbourn, Elizabeth. "Michael Snow at the
    Isaacs Gallery." *Canadian Art* 19
    (May–June 1962): 178.
———. "Painter-Sculptors." *Canadian Art* 19
    (July/August 1962): 272–75.
———. "Art and Artists: 1962 — Bang and

Whimper." *Toronto Daily Star*, 5 January
1963.

TORONTO
Art Gallery of Hart House, University
of Toronto, 9–28 October 1962, *An exhibi-
tion of drawings by Michael Snow and Joyce
Wieland*.

Richardson, Doug. "Art: Snow in the
    Gallery." *Varsity* (University of Toronto),
    19 October 1962.

## 1963

MONTREAL
Montreal Museum of Fine Arts, April 1963,
*William Kurelek and Michael Snow*. There is a
typed checklist in the library of the Montreal
Museum of Fine Arts.

Ayre, Robert. "Humanity and Trash In
    Gallery XII." *Montreal Star*, 20 April
    1963.

## 1964

NEW YORK
Poindexter Gallery, 28 January–15 February
1964, *Michael Snow*. There is a typed check-
list in the Poindexter Gallery Papers.

Edgar, Natalie. "Reviews and previews: New
    Names This Month: Michael Snow." *Art
    News* 62 (February 1964): 18.
Preston, Stuart. "Bring the Past to the Bar of
    the Present." *New York Times*, 2 February
    1964.
Judd, Donald. "In the Galleries: Michael
    Snow." *Arts Magazine* 38 (March 1964):

60–61; reprinted in *Donald Judd, Complete Writings 1959–1975, Gallery Reviews, Book Reviews, Articles, Letters to the Editor, Reports, Statements, Complaints.* Halifax, New York: The Press of the Nova Scotia College of Art and Design, New York University Press, 1975: 120.

Fulford, Robert. "On Art: some Canadian painters — like Michael Snow — have to quit Canada." *Maclean's* 77 (7 March 1964): 55.

TORONTO

The Isaacs Gallery, 22 April–11 May 1964, *Walking Woman Works, Michael Snow.* There is a typed checklist in the Isaacs Gallery Papers.

Hale, Barrie. "World of Art: Poetic Ingenuity." *Telegram* (Toronto), 18 April 1964.

———. "World of Art:Snow Show Brilliant." *Telegram* (Toronto), 25 April 1964.

Kilbourn, Elizabeth. "Art and Artists: Snow's achievement." *Toronto Daily Star,* 25 April 1964.

Kritzwiser, Kay. "At the Galleries: T-Shirts Painted for Show." *Globe and Mail* (Toronto), 25 April 1964.

Hale, Barrie. "World of Art: Another Gallery Returns." *Telegram* (Toronto), 2 May 1964.

Kilbourn, Elizabeth. "Art and Artists: Opposites…." *Toronto Daily Star,* 2 May 1964.

Malcolmson, Harry. [Untitled.] *Telegram* (Toronto), 2 May 1964.

Hewlett, Bruce. "The Readers Write: No Hands." *Telegram* (Toronto), 5 May 1964.

Kilbourn, Elizabeth. "Art and Artists: Action Painting." *Toronto Daily Star,* 9 May 1964.

Harris, Marjorie. "The Snow Man's Woman." *Commentator* 8 (June 1964): 14–16.

Rockman, Arnold. "Letter From Toronto." *Canadian Art* 21 (July–August 1964): 243–44.

<div align="center">1965</div>

TORONTO

The Isaacs Gallery, 8–27 January 1965, *Interim Works by Four Artists.* There is a typed checklist in the Isaacs Gallery Papers.

Hale, Barrie. "Art and Artists: Biggest Christmas Yet." *Telegram* (Toronto), 9 January 1965.

Kritzwiser, Kay. "An Interim Report on Four Artists." *Globe and Mail* (Toronto), 9 January 1965.

Russell, Paul. "From Pop to Gouache." *Varsity* (University of Toronto), 15 January 1965.

Malcolmson, Harry. "Art and Artists: Isaacs' Four, Onley, Sita and Morton." *Telegram* (Toronto), 16 January 1965.

Ferry, Anthony. "Going to the Galleries: More Uncertainties." *Toronto Daily Star,* 23 January 1965.

TORONTO

The Isaacs Gallery, 12–31 March 1965, *Polychrome construction: Judd, Weinrib, Burton, Rayner, Snow, Wieland.* There is a typed checklist in the Isaacs Gallery Papers.

"Constructivist art." *Globe and Mail* (Toronto), 13 March 1965.

TORONTO
York University, Glendon Campus, 1–26 October 1965, *Michael Snow Retrospective 1965*. A checklist with an essay by Elizabeth Kilbourn was published.
Also shown at Kingston, Agnes Etherington Art Centre, Queen's University, 2–28 November; Windsor, University of Windsor, 4–30 December; Waterloo, University of Waterloo, Gallery of the Theatre of the Arts, 4–31 January 1966.

"Art Notes." *Telegram* (Toronto), 25 September 1965.
Hale Barrie. "Art and Artists: Michael Snow Retrospective." *Telegram* (Toronto), 9 October 1965.
"Drawings and Paintings: Gallery Exhibit Stars Two-woman Show While Snow's Woman Walks On and On." *Kingston Whig-Standard*, 8 November 1965.
"Art Show At Centre." *Windsor Star*, 11 December 1965.
"What does a sky-scraper see? Other sky-scrapers." *Windsor Star*, 11 December 1965.
"Art and Artists: Storm Warnings Flap Again For Show at U. of W. Gallery." *Kitchener-Waterloo Record*, 22 January 1966.

NEW YORK
Poindexter Gallery, 7–31 December 1965, *Michael Snow*. There is a typed checklist in the Poindexter Gallery Papers.

Einfrank, Aaron. [Untitled.] *Telegram* (Toronto), 8 December 1965.
Malcolmson, Harry. "Art and Artists." *Telegram* (Toronto), 24 December 1965.
Johnston, Jill. "Reviews and Previews: Michael Snow." *Art News* 64 (January 1966): 16.
Goldin, Amy. "In the Galleries: Michael Snow." *Arts Magazine* 40 (February 1966): 65.

1966
TORONTO
The Isaacs Gallery, 6–25 April 1966, *Michael Snow Walking Woman Works*. There is a typed checklist in the Isaacs Gallery Papers.

Kritzwiser, Kay. "At the Galleries: Snow's Walking Woman walks again." In another edition: "Walking Woman Works: Snow's complex world." *Globe and Mail* (Toronto), 9 April 1966.
Malcolmson, Harry. "Two Outstanding Exhibitions this Week." *Telegram* (Toronto), 16 April 1966.

LONDON, ONTARIO
20/20 Gallery, 18 October–6 November 1966. *Snow*. There is a typed checklist in the Isaacs Gallery Papers.

Crawford, Lenore. "Canadian artists open 20/20." *London Free Press*, 19 October 1966.
Henry, Dave. "Snow — 20/20's First A Success." *Gazette* (London), 21 October 1966.

## 1967

VANCOUVER

The Vancouver Art Gallery, 5–29 January 1967, *Michael Snow Walking Woman Retrospective 1963–66*. A checklist was published.

Watmough, David. "Artist Shows His Wit." *Vancouver Sun*, 5 January 1967.

Lowndes, Joan. "Spotlight on Art: The man behind Walking Woman." *Vancouver Province*, 6 January 1967.

Fulford, Robert. "Two parties at once with Michael Snow." *Toronto Daily Star*, 7 January 1967.

Rosenberg, Ann. "Vancouver: Michael Snow Walking Woman Retrospective 1963–1966, Vancouver Art Gallery." *artscanada* 25 (February 1967): artscan section, 4.

Watmough, David. "Walking Woman Man Talks." *Vancouver Sun*, 13 February 1967.

## 1970

TORONTO

Art Gallery of Ontario, 14 February–15 March 1970, *Michael Snow/A Survey*. A catalogue with essays by Dennis Young, Robert Fulford, Richard Foreman and P. Adams Sitney was published.

Youngblood, Gene. "Intermedia: Falling Walking Snow." *Los Angeles Free Press*, 2 January 1970.

Youngblood, Gene. "Icon and Idea in the World of Michael Snow." *artscanada* 27 (February 1970): 2–14.

Andrews, Bernadette. "Art: Michael Snow." *Telegram* (Toronto), 14 February 1970.

Kritzwiser, Kay. "At the Galleries: An exhaustive survey of Snow at AGO." *Globe and Mail* (Toronto), 14 February 1970.

Lord, Barry. "Art: Walking Woman never looked so good." *Toronto Daily Star*, 14 February 1970.

Englebright, Anne. "Gallery arrayed in woman motif." *Daily Ryersonian* (Ryerson Polytechnic Institute, Toronto), 26 February 1970.

Allegre, Christian. "Michael Snow, un architecte de la perception." *Le Devoir* (Montreal), 14 March 1970.

Mendes, Ross. "Thinking man." *Canadian Forum* 50 (April–May 1970): 63.

Young, Dennis. "Letter to the Editor: Michael Snow." *artscanada* 27 (June 1970): 63–64.

Paradis, Andrée. "Michael Snow: Les démarches d'une opposition." *Vie des Arts* 59 (summer 1970): 58–59.

Michelson, Annette. "Toward Snow: Part I." *Artforum* 9 (June 1971): 30–37.

## 1983

KINGSTON, ONTARIO

Agnes Etherington Art Centre, Queen's University, 29 January–4 March 1984, *Walking Woman Works: Michael Snow 1961–67. New Representational Art and its Uses*. A catalogue with essays by Louise Dompierre, Peter Morris and Michael Snow was published.

Also shown at Ithaca, New York, Herbert F. Johnson Museum of Art, Cornell University, 16 November–23 December 1983; Halifax, Nova Scotia, Dalhousie Art Gallery,

Dalhousie University, 31 May–1 July 1984;
London, Ontario, London Regional Art
Gallery, 15 July–26 August 1984; Victoria,
British Columbia, Art Gallery of Greater
Victoria, 13 September–21 October 1984;
Toronto, Art Gallery of Ontario,
3 November 1984–13 January 1985.

Hutchison, Bill. "Walking Woman man."
    *Kingston Whig-Standard*, 28 January
    1984.
Mays, John Bentley. "Walking Woman
    returns." *Globe and Mail* (Toronto),
    11 February 1984.
Grenville, Bruce. "Art in its proper place."
    *Kingston Whig-Standard*, 18 February
    1984.
MacDonald, Scott. "Reviews: Ithaca,
    Michael Snow, 'Walking Woman Works
    1961–67,' Herbert F. Johnson Museum of
    Art." *Artforum* 22 (May 1984): 91–92.
"Snow's 'Walking Woman' on exhibit at Dal
    gallery." *Halifax Mail Star*, 31 May 1984.
Barnard, Elissa. "'Walking Woman' retro-
    spective overpowering or just plain fun."
    *Halifax Mail Star*, 8 June 1984.
Laurie, Peter. "Snow exhibition offers over-
    dose of famed image." *London Free Press*,
    4 August 1984.
Hume, Christopher. "Walking Woman
    triumphs." *Toronto Star*, 17 November
    1984.
Mays, John Bentley. "'It's often necessary,'
    Snow says, 'to define your own direc-
    tion'." *Globe and Mail* (Toronto),
    1 December 1984.
Dault, Gary Michael. "Snow's Angel, The
    Bachelor Stripped Bare by His Bride(s)."

*Vanguard* 14 (April 1985): 24–26.

## 1986

TORONTO
The Isaacs Gallery, 22 March–11 April 1986,
*Michael Snow Paintings, Sculpture, Works on
Paper 1959–1960*. There is a typed checklist in
the Isaacs Gallery Papers.

## 1988

TOKYO
Hara Museum of Contemporary Art, 22
October–4 December 1988, *Michael Snow*.
A catalogue with essays by Pierre Théberge
[in French and Japanese] and Michael Snow
[in English and Japanese] was published.

Silva, Arturo. "Michael Snow Retrospective
    At The Hara." *Daily Yomiuri* (Tokyo),
    27 October 1988.
Thoren, Barbara. "From Snow's eclectic
    palette." *Japan Times* (Tokyo),
    30 October 1988.
Terry, Edith. "Conflicting views of contem-
    porary art crop up in Japan." *Globe and
    Mail* (Toronto), 7 November 1988.
Morishita, Akihiko. "Michael Snow, cen-
    tered around the series: 'Walking
    Woman', The Structure of Dualistic
    Opposition." *Bijutsu Techo* 41 (January
    1989): 170–77. [In Japanese.]

## 1989

TORONTO
The Isaacs Gallery, 3–23 June 1989, *Michael
Snow 'Drawn Out' 1959*.

# Additional Bibliography

## 1951
*Canadian Art* 8 (summer 1951): cover.

## 1953
"Paintings lost in Fire." *Daily Nugget* (North
    Bay, Ontario), 4 March 1953.

## 1956
Fulford, Robert. "Triple-threat in Abstracts."
    *Mayfair* 30 (June 1956): 51–52.

## 1957
Fulford, Robert. "Artists in Boom-town:
    Young Painters of Toronto. *Canadian Art*
    14 (Winter 1957):68–71.

## 1958
*Canadian Architect* 3 (April 1958): cover.
*Mayfair* 32 (August 1958): cover.
*Imperial Oil Review* 42 (October 1958): cover.
Hubbell, Liz. "Snow: impressionist."
    *Gargoyle* (University College, Toronto),
    19 December 1958.

## 1959
[Bowser, Sara.] "An Interview With Michael
    Snow." *Canadian Architect* 4 (April 1959):
    74–76.
"Dirty Canvases." *Saturday Night* 74 (25
    April 1959): 5.
*Canadian Architect* 4 (June 1959): cover.
Fulford, Robert. "Jazz Painter." *The Royal
    York Magazine* 1 (June 1959): 26–27, 35.
*Canadian Architect* 4 (July 1959): cover.
*Canadian Architect* 4 (August 1959): cover.

Fillmore, Patricia Lamont. "Canadian Art
    for Your Home." *Canadian Homes and
    Gardens* 36 (September 1959): 13–25, 62,
    64–66, 68–71.

## 1960
Parmelee, Helen. "Meet the Avante-Garde
    Artists." *Telegram* (Toronto), 24
    September 1960.
Snow, Michael, illustrator. Raymond
    Souster. *Place of Meeting: Poems
    1958–1960.* Toronto: Gallery Editions,
    [1960].

## 1961
Fulford, Robert. "Snow." *Canadian Art* 18
    (January-February 1961): 46–47.
"Michael Snow." *evidence* 2 [spring 1961]:
    n.p.

## 1962
Snow, Michael, illustrator. Phyllis Gotlieb.
    *Who Knows One? Poems by Phyllis Gotlieb.*
    Toronto: Hawkshead Press, 1961/62.

## 1963
Rockman, Arnold. "Same Woman, But In
    All Shapes And Sizes." *Toronto Daily
    Star*, 6 July 1963.
———. "Michael Snow and his Walking
    Woman." *Canadian Art* 20 (November–
    December 1963): 345–47.

## 1964
Hale, Barrie. "The New Look In Films."

*Telegram* (Toronto), 14 February 1964.

"Cuts & Splices." *Canadian Broadcaster* (Toronto), 5 March 1964.

Kritzwiser, Kay. "At the Galleries: Plaster Goalie Dominates Stratford Show." *Globe and Mail* (Toronto), 27 June 1964.

Lord, J. Barry. "In Search of the Figure in Canadian Painting: The New Figure." *Canadian Art* 21 (July–August 1964): 200.

Holstein, Jonathan. "New York's Vitality Tonic for Canadian Artists." *Canadian Art* 21 (September–October 1964): 270–79.

Hutchison, Gail. "This Woman Walked Right Into Michael Snow's Life." *Canadian Weekly* (Toronto) (24 October 1964): 18–19.

### 1965

Thomas, Ralph. "300 flee from far-out film." *Toronto Daily Star*, 5 April 1965.

Cohen, Nathan. "Politicians and players." *Toronto Daily Star*, 7 April 1965.

Kilbourn, Elizabeth. [Untitled.] In *Michael Snow Retrospective 1965*. Toronto: York University, 1965: n.p.

### 1966

"Ten Artists in Search of Canadian Art: Michael Snow, 1929–." *Canadian Art* 23 (January 1966): 62–63.

Pike, Dave. "The Snows go...Where the action is." *Telegram* (Toronto), 8 February 1966.

Kritzwiser, Kay. "Sculptures for Expo/2 win $30,000 contest." *Globe and Mail* (Toronto), 1 April 1966.

Hale, Barrie. "Ontario's choice for Expo 67 sculpture." *Telegram* (Toronto), 1 April 1966.

"Provincial government buys $24,000 sculpture." *Toronto Daily Star*, 1 April 1966.

Arthur, Paul. "Art and Architecture — a confused situation?" *Canadian Art* 23 (July 1966): 12–14.

Michener, Wendy. "Where's The Walking Woman Walking? To The Bank." *Maclean's* 79 (3 September 1966): 16–17, 39–40.

"Michael Snow." *Allied Arts Catalogue* 1 (October 1966): 46.

### 1967

Foreman, Richard. "New Cinema Festival at Jewish Museum." *artscanada* 25 (April 1967): artscan section, 9.

Kay Kritzwiser. "What's so special about New York? Ask an artist." *Globe and Mail* (Toronto), 15 April 1967.

"Design for Competition. *Globe and Mail* (Toronto), 18 May 1967.

"A Peep Show." *Toronto Daily Star*, 27 May 1967.

Malcolmson, Harry. "Sculpture. Disappointments at Expo." *Saturday Night* 82 (July 1967): 43.

Fulford, Robert. "These hippies have no guts." *Toronto Daily Star*, 29 August 1967.

Snow, Michael. "Michael Snow." In *Statements: 18 Canadian Artists*. Regina, Saskatchewan: Norman Mackenzie Art Gallery, 1967: 86–88.

### 1968

Cameron, Dorothy, ed. "Michael Snow."

*Sculpture '67*. Ottawa: National Gallery of Canada, 1968: 12.

Mekas, Jonas, and P. Adams Sitney. "Conversation with Michael Snow." *Film Culture* 46 (Autumn 1967, published October 1968): 2–4.

"Letter From Michael Snow, 21 August 1968." *Film Culture* 46 (Autumn 1967, published October 1968): 4–5.

### 1969

"7 questions + 1 on Michael Snow at The Isaacs Gallery." *artscanada* 26 (April 1969): 30–31.

### 1970

Foreman, Richard. "Right Reader." In *Michael Snow/A Survey*. Toronto: Art Gallery of Ontario, 1970: 62.

Fulford, Robert. "Apropos Michael Snow." In *Michael Snow/A Survey*. Toronto: Art Gallery of Ontario, 1970: 11–13.

Sitney, P. Adams. "Michael Snow's Cinema." In *Michael Snow/A Survey*. Toronto: Art Gallery of Ontario, 1970: 79–84.

Snow, Michael. "Michael Snow: A Family History." In *Michael Snow/A Survey*. Toronto: Art Gallery of Ontario, 1970: 10.

Young, Dennis. "Origins and Recent Work." In *Michael Snow/A Survey*. Toronto: Art Gallery of Ontario, 1970: 15–16.

### 1972

Hale, Barrie. "Introduction." *Toronto Painting: 1953–1965*. Ottawa: The National Gallery of Canada, 1972: passim.

Snow, Michael. "Michael Snow." In William Withrow, *Contemporary Canadian Painting*. Toronto: McClelland and Stewart Limited, 1972: 113.

Withrow, William. *Contemporary Canadian Painting*. Toronto: McClelland and Stewart Limited, 1972: 114–120.

Medjuck, Joe, and Michael Snow. "The Life & Times of Michael Snow." *Take One* 3 (January–February 1971, published April 1972): 6–12.

Hayum, Andree. "Information or Illusion: An Interview with Michael Snow." *Review* (New York) 72 (winter 1972): 55–60.

### 1973

Reid, Dennis. *A Concise History of Canadian Painting*. Toronto: Oxford University Press, 1973: 290–91, 293, 298–300.

### 1974

Lord, Barry. *The History of Painting in Canada: Toward a people's art*. Toronto: NC Press, 1974: 211–15.

Sitney, P. Adams. "The Films of Michael Snow." In Annette Michelson, ed. *New Forms in Film*. Montreux, Switzerland, 1974: 109.

———. *Visionary Film. The American Avant-Garde*. New York: Oxford University Press, 1974: 418. This is a slightly edited version of the above.

### 1976

Godsell, Patricia. *Enjoying Canadian Painting*. Don Mills, Ontario: General Publishing Co. Limited, 1967: 220–22.

Snow, Michael. "Michael Snow: A letter to Alvin Balkind from Michael Snow, April 1976." In Alvin Balkind. *17 Canadian Artists: A Protean View*. Vancouver: The Vancouver Art Gallery, 1976: n.p.

### 1977

Hale, Barrie. "The Inventions of Michael Snow." *Toronto Daily Star* (The Canadian Magazine), 1 January 1977: 4–7.

### 1978

Snow, Michael. "The Mermaid Inn: Crushed Cookies Make Crumbs liberates swing. Cuts its pulse." *Globe and Mail* (Toronto), 1 April 1978.

Théberge, Pierre. "Sept Films et 'Plus Tard'." In *Michael Snow*. Paris: Musée National d'Art Moderne, Centre Georges Pompidou, 1978): 7–9.

### 1979

Théberge, Pierre. "Michael Snow. Summary of his Life and Work." In *Michael Snow*. Lucerne: Kunstmuseum Luzern, 1979: 9–16. [English and German versions of the preceding text.]

———. "Leven en werk." In *Michael Snow*. Rotterdam: Museum Boymans–van Beuningen, 1979: 5–7. [Dutch version of the preceding text.]

### 1980

Cornwell, Regina. *Snow Seen. The Films and Photographs of Michael Snow*. Toronto: PMA Books, 1980: 4–9, 64–66.

### 1983

Burnett, David, and Marilyn Schiff. *Contemporary Canadian Art*. Edmonton: Hurtig Publishers Ltd., 1983: 92–94.

Dompierre, Louise. "Solid Color Space Ladies." In *Walking Woman Works: Michael Snow 1961–67. New Representational Art and its Uses*. Kingston, Ontario: Agnes Etherington Art Centre, Queen's University, 1983: 21–58.

Morris, Peter. "Snow Place for a Lady: The Early Films of Michael Snow." In *Walking Woman Works: Michael Snow 1961–67. New Representational Art and its Uses*. Kingston, Ontario: Agnes Etherington Art Centre, Queen's University, 1983): 61–64.

Snow, Michael. "A Lot of Near Mrs." In *Walking Woman Works: Michael Snow 1961–67. New Representational Art and its Uses*. Kingston, Ontario: Agnes Etherington Art Centre, Queen's University, 1983: 18–19.

### 1985

Abley, Mark. "Art: Seeing Things." *Saturday Night* 100 (October 1985): 65–66, 68–69.

### 1987

Snow, Michael. "Michael Snow." In Joan Murray, ed. *The Best Contemporary Canadian Art*. Edmonton: Hurtig Publishers, 1987: 160–61.

### 1988

Fulford, Robert. *Best Seat in the House, Memoirs of a Lucky Man*. Toronto:

Collins, 1988: 90–96.

Reid, Dennis. *A Concise History of Canadian Painting*. 2d ed. Toronto: Oxford University Press, 1988: 299–303, 308–10, 379.

Snow, Michael. "Artist's Statement." In *Michael Snow*. Tokyo: Hara Museum of Contemporary Art, 1988: n.p. [In English and Japanese.]

———. "Marcel Duchamp." *Brick* 34 (Fall 1988): 34–35. Also in *Brushes with Greatness*. Toronto: The Coach House Press, 1989: 43–47.

Théberge, Pierre. "Michael Snow, la réalité et les apparences." In *Michael Snow*. Tokyo: Hara Museum of Contemporary Art, 1988: n.p. [In French and Japanese.]

## 1990

Burnett, David. *Masterpieces of Canadian Art From The National Gallery of Canada*. Edmonton: Hurtig Publishers, 1990: 176–79.

## 1992

MacDonald, Scott. "Michael Snow." In *A Critical Cinema 2: Interviews with Independent Filmmakers*. Berkeley/Los Angeles/Oxford: University of California Press, 1992: 51–76.

Philip Monk

# Around
# Wavelength

## The Sculpture, Film
## and Photo-Work of Michael Snow

## from 1967 to 1969

# Around Wavelength

Philip Monk

## I. Side Seat: A Retrospective Look at Michael Snow

In late 1969, stimulated by the occasion of a retrospective of fifteen years of his work at the Art Gallery of Ontario, Michael Snow reviewed his career by producing the catalogue as an artist's book. *Michael Snow/A Survey* "was an attempt to use the records of my life and work which I had (in the form of snap-shots, family photos and photos of and texts about my work) to compose a *new work*."[1] This notion of a retrospective look using the materials of past productions was further playfully exemplified in Snow's 1970 film *Side Seat Paintings Slides Sound Film* as a complement to the catalogue.[2] The film "reproduces" a typical artist's slide lecture on Snow's paintings from 1954 to 1965, which one sees as if arriving late (one always arrives, historically, late) and so is afforded only an oblique view — the "side seat" of the title. The film, of course, is not only this dry review; it is a transformation of one medium and set of works into another made of the elements composing the title: "What especially interested me was the transformation of media: painting to slide projection to sound-film and that the core 'raw' material was something that I had already 'personalized' for another purpose. The intention was that the transformation should put the spectator in the present experiencing the sound-film 'through' the past of the paintings and slides."[3]

The intervening period between Snow's last "painting" of 1965 (the quotation marks are his) and its duplication in *Side Seat Paintings Slides Sound Film* is the subject of this exhibition. The film exemplifies two concepts operative in the present exhibition and catalogue: the retrospective look of *Side Seat* is not only a looking back, it is also a looking through one medium into another, which already individually interweave levels of presentation and representation. In the present case, the look back is ours, not Snow's, but we reproduce that initial gesture of Snow's at a greater distance; and the looking through is not the transformation of one body of material into another, but a retrospective seeing of works through each other's shared structures and mutual influence. (Our looking back is different still in that the presence Snow writes about — experiencing the past through images in the present — cannot be recreated here simply through the offering of past works to our current view, for there is no actual transformation of medium here. Representation in writing is one thing, which the catalogue attempts; re-presentation in exhibition is another. In the latter, we are dealing with the presence of the original works outside of their own time of making and first presentation. This complicated play of presence and absence, though, makes up many of the challenging dilemmas *and* subjects of Snow's works and writings.)[4]

Looking is circumscribed, nonetheless. While the 1994 exhibitions at the AGO (apart from that at The Power Plant) virtually replicate the one of 1970 in terms of the period of the works, if not number,

shown, those specifically from 1967–69 are *now* separated from the presentation of the earlier works by the very gestures we find in the sculptures, films and photoworks of that period themselves.[5] In its narrow scope, *Around Wavelength* functions as an *aperture* to separate its works from the wide concerns featured in the comprehensive exhibitions that bracket it, while acting at the same time as a hinge between them. Focusing on its moment then, the current presentation narrows attention to the limiting conditions of work produced by Snow for his 1968 exhibition at the Poindexter Gallery in New York and his 1969 Isaacs Gallery exhibition in Toronto where new works supplemented those of New York. (The 1970 AGO exhibition added the rest of the sculpture, photographic works and films of the current exhibition.)

This notion of the aperture defining the exhibition within the Michael Snow Project as a whole mirrors what took place in Snow's work of that period. These works concentrated their apparatus on the function of viewing in order to make sight visible. They effectively put an end to the images of the Walking Woman, filtering perceptual and conceptual themes to their more purified essence, before Snow's themes broadened out again to wider image practices during the 1970s.

Sculpture played the dominant role in these commercial exhibitions, but while those two exhibitions are the core of this one, sculpture was not conceived apart from Snow's concurrent work in film and interest in photography, which themselves defined the shape sculpture would take. Prior to Snow's main activity in photography evident during the 1970s, sculpture assumed the role of perceptual investigation. At that time, Snow focused the apparatus of his work on the actual acts of viewing: reducing the figurative element (yet actively incorporating the body of the spectator) by using the camera as a model and the frame as a principle device. This was sculpture to be seen through as much as to be looked at.

While the camera and its framing device offer the model for sculpture, the camera's product — the still or "moving" image — found its analogy in the viewing experience of the spectator. Photography proper was not part of these exhibitions in 1968 and 1969, with the exception of that integral to the sculpture *Atlantic*. In our case, each photographic work has been chosen to indicate a type of investigation consistent with Snow's sculpture of 1967–69 but which differs from his subsequent investigations initiated from 1970 on.

The absent presence in the space of exhibition here, and speculative hinge of the exhibition, is Snow's filmwork, particularly the film that made his fame, *Wavelength*. The planning of *Wavelength* during 1966 signalled the Walking Woman's demise (although *Wavelength* could be thought the last Walking Woman work) and set out the complex themes that would be explored, in the cases where they were more apt (or perhaps led to more interesting transformations), in the specific media of sculpture or photography. While the original exhibition contexts seem to highlight sculpture in the concept of this exhibition, film is integral to it: hence the title *Around Wavelength*. This title can be read as what spatially, in the case of the present exhibition, groups itself around *Wavelength* or as what sets the historical context ("around the time of *Wavelength*"), even as what succeeds it in time, as if influenced by it as well. Around the *time* of

**Side Seat Paintings Slides Sound Film** 1970
20 min., colour
Art Gallery of Ontario

Wavelength, moreover, should remind us also of the durational effects Wavelength introduced to Snow's work.

If Wavelength is the key to the demise of one body of work, and the initiation of another, an artist's thinking is too complex to let one work stand as the determination of all that follows. Working in a variety of media, Snow was enough of a modernist to let each medium determine its own effects. Nonetheless, Wavelength, in its devotion to the insubstantialities of time, light and sound, plays an inordinate role in this catalogue and exhibition in that it is the counterpart to everything that is stable and static in museum presentations.

## II. "See it my way."

Michael Snow: Sculpture, Poindexter Gallery, New York
January 27–February 16, 1968

Michael Snow, together with Joyce Wieland, both already established on the Toronto art scene, in 1962 moved to New York City. Although they continued to visit Toronto and exhibit at the Isaacs Gallery there, the cultural milieu of New York would provide the background for Snow's work as an artist and his orientation towards filmmaking. Snow's stay in New York from 1962–1971 coincided with the breakdown of the Abstract Expressionist aesthetic and the rise of the competing ideologies of Pop and Minimal art, the latter fully consolidated as a new aesthetic with its Postminimal and Conceptual offshoots by the time of Snow's 1968 Poindexter exhibition. Snow's two bodies of work produced during his residency in New York, then, would roughly coincide with and perhaps be influenced by Pop art (the Walking Woman Works) and Minimal art (the predominantly sculptural works under consideration here). Yet, the first series was started by Snow in Toronto, with the important proto-conceptualist photographic Four to Five, 1962, being one of the last works produced there, and his own film Wavelength was seen to have contributed significantly to the Minimalist aesthetic of duration. (In fact, the shape of temporality would be recognized as one of Snow's contributions to film practice.)

In reality, the period was not as clear as its justified paths of development make it appear to be retrospectively. Donald Judd, one of the major proponents of the "reductive" art of Minimalism that was to become so dominant in influence, sug-

---

A note on the illustrations: In keeping with the re-presentational nature of the exhibition, I have chosen to document the works in this section of the catalogue only by photographs contemporary to the works' making. As much as these documents allow, they are used to recreate the original presentations (the Isaacs Gallery exhibition) and to "re-enact" some of the works' perceptual effects (the Poindexter Gallery presentation). In the latter case, the camera is the perfect observer of these self-enclosed systems, documenting the effects its own apparatus inspired.

gested in 1964 rather how productively messy (and open) the situation actually was. On the perceived dominance of a by then exhausted Abstract Expressionism in New York, Judd wrote: "In 1960 there were several unpredicted shows, and things began to be complicated again.... The history of art and art's condition at any time are pretty messy. They should stay that way. One can think about them as much as one likes, but they won't become neater; neatness isn't even a very good reason for thinking about them. A lot of things just can't be connected.... The change from the relatively uniform situation of 1959 to the present diverse one did not suddenly occur with pop art in the 1961–62 season."[6] And so Michael Snow's Walking Woman Works should be seen not as an unpolished variation of American Pop art but as his own response to the situation of painting in the late 1950s and early 1960s.[7]

In the text "A Lot of Near Mrs." written in 1962-63, Snow noted: "Problem of originality: invent a subject."[8] In the aftermath of the grand existential themes of Abstract Expressionism, young artists (painters still) asked themselves this same question, one of content, and ultimately, an issue of what to paint. The young Jasper Johns provided one influential solution in his mid-to-late 1950s paintings of flags and targets, with their co-existence of image and object, which would so strongly inflect the developments of both Pop art and the Minimalist serial painting of the 1960s.[9] Donald Judd's answer to this problem of *painting* was a turn to a three-dimensional art that was neither painting nor sculpture, a shift in art practice that would lead to Minimalism and which he began to describe in "Local History" and more fully articulated in the complemen-

tary article "Specific Objects."[10] The Walking Woman would be Snow's obvious solution, a closed form whose content is an open-ended series of transformations of media and investigation of perception through art's presentational formats and representational practices.

The dimensional form that some of Michael Snow's Walking Woman Works took — such as *Torso*, 1963, which Judd earlier had reviewed in 1964 ("I like the three-dimensional pieces best."[11]) — ensured his inclusion in Judd's list of artists whose works shared some of the characteristics of the new art he was defining. "The new work obviously resembles sculpture more than it does painting, but it is nearer to painting."[12] So starting with painting, the jump to Snow's abstract sculpture from 1967 on should not seem so radical, if we think that the Walking Woman Works' real subject was perception, whether confined within a two-dimensional representation or concretized in a three-dimensional object. The concerns of the Walking Woman series actually had more in common with the phenomenological and perceptual issues of Minimal and Conceptual art as they later developed than their painterly appearance and Pop association suggest.[13] The aim here is not to review the Walking Woman series, only insofar as certain works specifically prefigure the apparatus and concerns of the later sculpture. For example, framing is the dominant device in *Morningside Heights* and *Sleeve*, while the zoom of a camera is implied in *Test Focus Field Figure*, all paintings and constructions of 1965, the last year (until 1978) Snow devoted to painting.

The Pop art exhibitions of the 1961–62 exhibition season mentioned by Judd were followed by a second assault of younger

generation artists on the aesthetics of Abstract Expressionism in the first exhibitions of what generally became known as Minimal art, in 1963–64. Snow's first New York exhibition at the Poindexter Gallery took place in this context, opening right after the closing of Donald Judd's first Minimal works displayed at the Greene Gallery. Robert Morris's monochrome primary forms followed at the Greene Gallery later that year.[14] These two exhibitions by Morris and Judd can be taken really as the defining moment, not just for Snow's work, but for the development of art of the period as a whole. Between his first Poindexter exhibition in 1964 and his third in 1968 more than Snow's art would change. Minimalism became the name for what could only be called a cognitive-aesthetic shift in the thinking about and practising of art. The broad, epoch making movement of Minimalism, which included and transformed the practices of sculpture, film, music, and dance, is the proper milieu of Snow's work. The period provoked an intense dialogue between art and theory, the latter which was written mainly by the artists themselves. To Judd's already mentioned "Specific Objects," we note Robert Morris's "Notes on Sculpture I & II" of 1966 and Robert Smithson's "Entropy and the New Monuments," 1966, among others, and the critic Michael Fried's counter-article "Art and Objecthood" of 1967 attacking the confrontational, theatrical, and durational qualities of the Minimalism Fried labelled literalist art.[15] Fried's article was published a month after the first screening of *Wavelength*, and that film and Snow's succeeding sculpture of the Poindexter exhibition would surely have come under Fried's strictures for provoking these very characteristics.

It is no wonder, then, that P. Adams Sitney, when in 1969 attempting to situate Snow's filmwork in the intellectual milieu of its time, would place Snow firmly in the context of the new temporal arts:

"A constellation of 'performing' artists, working out of New York, share a broad aesthetic base with Michael Snow. A brief *resumé* of the formal concerns they have in common might illuminate a context for Snow's art and lead us to a definition of his achievement in the cinema. I am thinking of the musicians La Monte Young, Terry Riley, Steve Reich, and Philip Glass, the dramatist Richard Foreman, and the dancers Yvonne Rainer, Meredith Monk, and Deborah Hay.... These artists tend to use *duration,* repudiate psychology, and retard and elongate the few actions they employ. Their materials are consistent (not diversified); extensive repetition is common, and where it is not found, one can expect stasis."[16] (While Snow has expressed his interest in Johns and Oldenburg, his friendships and associations were with artists of another milieu, aesthetically and artistically — filmmakers such as Ken Jacobs and Hollis Frampton, musicians/ composers Roswell Rudd, Steve Reich and Philip Glass, sculptors such as Carl Andre and Richard Serra. Snow's first associations were more with the film and music world ["The real influence on Joyce and me after we moved to New York {'62} was just Jonas {Mekas} and the amazing existence of the Cinematheque."[17]] and his lasting influence and recognition in New York would be within film and not art, although his films were documented and debated and were of influence in the artworld.)

While Snow's last Walking Woman painting was *Test Focus Field Figure* of 1965,

the image that ended his *Side Seat Paintings Slides Sound Film*, the actual last Walking Woman work, contemporary with the making of *Wavelength*, was the outdoor sculptural ensemble made for the Montreal World's Fair (Expo 67). *Expo Walking Woman* consisted of eleven stainless steel figures in various dispositions and perceptual distortions spread through the grounds of the Ontario pavilion, partly as directional devices. The nature of this large commission extended the themes of the Walking Woman longer than they were actually effective:

"I gradually stopped using the Walking Woman exclusively after I did a big sculpture exposition at Expo 67, which I worked on in '66 and showed in the summer of '67. That was something that was finished before it was done in the sense that it was a designed thing and a summation of certain ideas of *objectness* that I'd been thinking out. It was a big sculptural composition in stainless steel. It had a lot to do with reflections; so it really had an image aspect." But in the context of this comment, he continued: "I was thinking over *Wavelength* for a long time. It was really quite important to me."[18]

*Expo Walking Woman* brings full circle and closes the book on the idea of dispersal initiated and documented in *Four to Five*. In substantiating the notions of sequence and seriality, it is a compendium of a number of the perceptual and representational themes explored in the Walking Woman series. Given it was Snow's summation of certain ideas of *objectness* should make us think that it shares characteristics with the purely sculptural works he would exhibit less than a year later at the Poindexter Gallery. Yet, it is still the shape and outline of the Walking Woman that determines the sculptural effects as that shape solidifies space as it is "moved" from one position to another to objectify a mass or as it is subtracted in the same way from a solid mass. The reflective nature of the stainless steel, which gave the sculptures their other "image aspect," and the movements of the spectator in the ambient space offering itself for reflection, however, were taken up by Snow as material and content for his Poindexter sculpture.

The 1968 Poindexter exhibition consisted of only four sculptures, but each tells of the changes not only to Snow's work but to the ambitions of the period's art in general. The installation photographs show the pressure the new sculpture began to put on architecture, taking the architectural container of the gallery to be part of the context of a piece and its larger framing device. By consequence, the spectator is absorbed in the process to which all the ambient conditions of display contribute such as space, light, and movement. Robert Morris's description of this new sculptural aesthetic in his "Notes on Sculpture," published in *Artforum* in 1966, established some of these conditions that apply to Snow's sculpture as well:

"The better new work takes relationships out of the work and makes them a function of space, light, and the viewer's field of vision. The object is but one of the terms in the newer aesthetic. It is in some way more reflexive because one's awareness of oneself existing in the same space as the work is stronger than in previous work, with its many internal relationships. One is more aware than before that he himself is establishing relationships as he apprehends the object from various positions and under varying conditions of light and spatial context.... Some of the new work has

expanded the terms of sculpture by a more emphatic focusing on the very conditions under which certain kinds of objects are seen. The object itself is carefully placed in these new conditions to be but one of the terms."[19] Of course, theory here is also a means of justifying one's own work as much as arguing against other sculptor-theorists: Donald Judd and Robert Smithson, for instance, come to mind. Nor is the description of new practices complete. Nevertheless, Morris sums up some of the conditions of Snow's sculpture without exhausting his special contributions. He recognizes, as well, in an insight not peculiar to him alone, that "the experience of the work necessarily exists in time."[20]

The sculptural objects in the Poindexter exhibition are hybrid: they are as much to be looked through as to be looked at. Thus, they literalize the "emphatic focusing" Morris mentioned, not only by directing the conditions under which objects are seen but by making the objects themselves into viewing machines, literally incorporating the view of the spectator into their form and scopic apparatus. The movement of the spectator in Snow's sculpture is as often displaced by sight through a piece as much as physically around it. The view of the spectator is regulated, even constrained, making the sculptures the reverse of those of the *Expo Walking Woman*, which were stable while the viewer was mobile.

Each of the works — they are all from 1967 — is more than a conventional sculpture, being an apparatus of sorts that directs vision and complicates its procedures. Simply described, *In Place* (later titled *Site* for the 1969 Isaacs exhibition and finally *Sight* for the 1970 Art Gallery of Ontario exhibition, under which name it is

now known) is a type of view finder. *First to Last* and *Scope* function basically as periscopes while *Blind* is a complex focusing device.

*First to Last* had already been exhibited (under the title *First, Last*) in Toronto in 1967 in the outdoor exhibition *Sculpture '67*. In an interview for the catalogue, Snow said: "For the last three or four years [i.e., from the period of the making of his 1964 film *New York Eye and Ear Control*], I have been influenced by films and by the camera. When you narrow down your range and are looking through just that small aperture of the lens, the intensity of what you see is so much greater."[21] What is seen is something that the artist sets up but does not control, much as in the taking of a photograph, a process Snow had earlier described and documented in *Four to Five* as the "development of events-for-capture."[22] Unlike photographs, what is captured here is not fixed, rather what is registered for view is the chance flux of events. This mechanism of aperture and view parallels Snow's continuing interest in the dualism of activity and stasis that runs through his work and is "iconically" evident as early as the painting *Lac Clair*, for instance.[23] This duality is not rigidly framed as an either/or opposition. The frame's function here is not to draw limits defining the border of an artwork so as to ideally separate it from the world by its frame, but to break down those hierarchies between, for instance, inside and outside. Here the frame itself is a tool to place the formalized space of the art gallery in question as happened in Conceptual art and to an extreme in Earthworks. (The photograph is an exemplary model: by its indexical nature its makes reference to an outside.) The range of what is seen or its

seeing *procedures* are varied in Snow's works, however, for what is the point of producing more than one sculptural apparatus that functioned like the camera's aperture, itself a simple optical mechanism?

The sculptures for the Poindexter exhibition had to be carefully planned for the space (the Poindexter Gallery being an uptown brownstone) and the gallery was measured to determine sizes and relationships. Nowhere is this clearer than in *In Place*, which had to be designed to fit the window facing the street. The polished aluminum side of *In Place*, seen from the street, blocked the view into the gallery. Its interior face of a scored black plastic sheet, acting like a viewfinder, directed a view, so that the flux of events outside the gallery became part of the work's contents. The changes in the title of this piece (the double homonymic inflection inherent in "site," more so than in "Sight" especially) reflect its nature as a sighting device that functions only in a locale. (Snow toyed with calling this piece *56th St.* after the location of the gallery.) Moreover, the piece cannot be taken in at a glance: one must pass from outside to inside to fulfill its function. Even the two sides of its surface emphasize that constraint, opening and closing itself to a view, as Annette Michelson wrote: "The aperture totally absorbs the tiny fraction of wholly extraneous visual material through it; it is all somehow drawn into the total composition of the surface, absorbed into its linear pattern, its accident and irregularity tamed, as it were, to the uses of geometry. Turning around to the other side of the surface, peering through the slot which breaks its even, unarticulated, glistening aluminum surface, punctuated only by occasional bolts, we perceive the total

unassimilability of the scene beyond it."[24]

Dealing with eyesight alone and not the body, *In Place*, nonetheless, frustrates viewing, as the unassimilability that Michelson mentions. But as the bolted aluminum and slotted eyehole bring to mind armoured vaults and trucks, so the body is brought into play by negation. This association — and latent threat — is not fortuitous. Coupled with the work's other constraints, it makes of *In Place* a highly charged psychological situation that theatricalizes seeing. Hilton Kramer, reviewing the show in the *New York Times*, said Snow's works made the space reminiscent of a "chic concentration camp," and such terms filter through all the contemporary journalistic reviews. Michael Snow himself thought of calling the succeeding Isaacs exhibition "Protective Measures" and his notes show him running through possibilities of titles along these lines that add psychological overtones to what seem merely playful perceptual pieces.[25] While *In Place* opens itself to the outside by bringing it into the gallery by the operations of the aperture, ironically, at the same time, it seems psychologically to protect us from the street.

Entering the gallery and engaging these "playful" sculptures that invoke the participatory spirit of Happenings, we perhaps leave ourselves vulnerable, but from what on the street do we need to protect ourselves? As much as we are subject *of* our own look, we are also subject *to* these viewing machines, to the views that they allow. When we peer through them, blind to what else is around us, we are also the subject of *another's* look. *Scope*, for instance. *Scope* operated much like a periscope laid on its side, and is constructed as such. Its stainless steel and mirror fabrication,

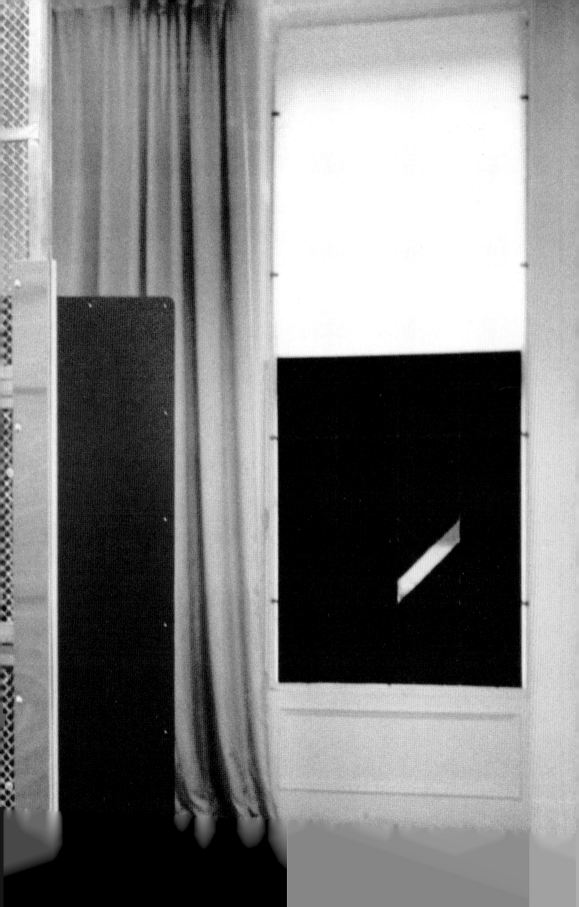

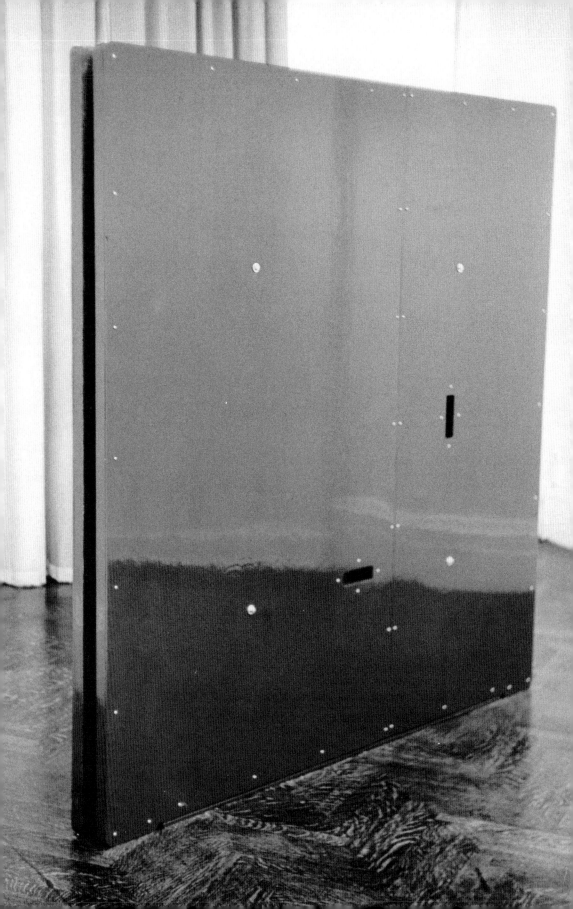

**Michael Snow: Sculpture**
**Poindexter Gallery, New York**
**January 27–February 16, 1968**

like *In Place*, allowed the viewer to see whatever passed by the other end; and if nothing was captured there, as if in a closed-circuit dialogue with oneself, one's own face was dimly reflected back by the stainless steel sheet attached to the wall in front of the other aperture. (Snow originally questioned what should be located there: the room, a painting, a photograph, or itself. One photograph shows the scope, tautologically, being reflected back into itself.) Thus engaged and blinkered, we put ourselves on view for others. So Snow thought in a series of sketches (and in an actual other performance) where he staged the apparatus in front of an audience and added "periscope play," making of the mechanisms *Scope* sets up, as in *In Place*, a play between public and private.[26]

*First to Last* combines features of *In Place* and *Scope*. As a free-standing wall, this sculpture obstructs sight as much as it obscures it. For while our view through *First to Last* makes it a periscopic device as well, looking is now frustrated in various ways and perversely directed elsewhere by means not so obvious as *Scope* where we recognize from the shape of the device where our gaze is to be thrown. The periscopes in *First to Last*'s viewing slots direct the eye not *through* the piece but, unexpectedly, in other directions, to the floor or ceiling — or sky, as in its original outdoor installation. Like *Scope*, *First to Last* is a scopic apparatus but it is constructed so that its internal functions dictate the external. (The aluminum inner walls that narrowly face each other in *First to Last* act as mirrors, emphasizing its tautological or self-reflexive character.) "This sculpture is so internal that it feeds on what is external. It composes by the very limitations it imposes."[27] In so directing the totality of vision, the limitations it imposes exhaust vision. (Notes reveal that Snow considered calling this piece by the titles "Sum" or "Total.")

This trajectory from *In Place* to *Scope* to *First to Last* complicates the process of perception: from pieces that seem merely to be interested in framing and in the dynamics of activity and stasis set up thereby (*In Place* and as redirected to a lesser extent, *Scope*), to devices that bring us into view (*Scope*), to self-sustaining or tautological "machines" (*First to Last*) that ask us to examine their operations. Admittedly, all these sculptures share these characteristics to a degree. While all are framing devices of Duchampian derivation, they are also sculptural objects that take up space. They are optical machines that bring the body into consideration. Combining the two functions makes them interactive: they invite a participation both physical and visual.

This dual engagement is most active in *Blind*, a work that draws us in both physically and optically. *Blind* is made of a series of steel mesh screens of different gauge of opening and orientation. One can pass back and forth between the channels of the screen experiencing the sculpture spatially while also putting oneself on display for another: as that body recedes back from plane to plane, we use this figure to judge depth (the reverse of the painting *Test Focus Field Figure*). But the parallel screens accomplish this function on their own. They draw us optically back and forth through this space by means of the interaction of the meshes which establish different focal planes, thus making *Blind* function as a continuous zoom (causing the planes of the screens to foreshorten in space); as a large focusing device our eye adjusts, lock-

ing in place a particular focal plane; or even as the iris of a camera as the interplay of the meshes narrows or opens the different apertures.

Snow considered calling *Blind* by the title "Snow Storm" recalling for us the formal role his name — and biography — often had in the choice of subjects. But here the title would have added the realistic reference of a blizzard for the density and optical sparkle of its perceptual effects caused by the meshes' interplay. The final title still retains an autobiographical relevance, in that his father went blind, a factor that attuned Snow to the mechanisms, obscurities and anomalies of sight.[28] (The optical effects are similar to a complementary photographic work he did title *Snow Storm, February 7, 1967*, which substitutes the density of falling snow photographed through a barred window of his Chambers Street studio for the visual overlap of levels of mesh.)

The back and forth, "to-and-fro" characteristic we observe in *Blind* — uniting the body walking back and forth to the optical shifts from front to back — is a factor operating in all the pieces. In *In Place*, it is what passes by as seen through its slot, but also in what the aperture brings from outside into the gallery as an image. In *Scope* it is the dialogue that takes place from the two ends of the piece as well as the mirroring shuttle back and forth between the viewer and his or her own reflection. This visual displacement of the viewer's image — as a doubling or ghost of the self proper to the photographic image — is in contradistinction to the physical displacement sculpture invokes in asking us to see it from all sides, or, in this case, from both ends. The aperture both frames *and* captures: as we are captured so is an image, analogous to the photographic print. The physical constraint of the sculpture is a means to make us focus on sight; in doing so our sight is channelled, displaced from our place to another, and, in reply, an image is transposed from its site to ours. Movement of the viewer and transposition of the image are analogous here in their potential and actual displacements.

"See it my way," by which I title this section is drawn from a reference in Snow's notes and suggests the modernist artist's function of changing vision or directing it to new sources. Such is the Cagean strategy of breaking down traditional hierarchies by opening our view to the things around us, those chance, everyday events in real space and time brought into focus by the apertures of Snow's apparati. We could just as well read the phrase as a threat: "see it my way — *or else*." To the physical and perceptual we must also add a psychological dimension of constraint. Snow's notes are filled with sketches and plans for sculptural machines for viewing, but the self-reflexivity implied in limiting vision to observable conditions is not always of an epistemological order here. These sighting devices constrain vision through the common model of the perspectival cone, as if those lines of sight were literalized and beyond which, thus blinkered, we could not stray. The scopic field for Snow is possessive (as well as sexual: compare the sight-lines incorporated into the painting *Seen*, 1965; although clothed in this example, the naked female body in the male gaze is a model of vision), so he not only constrains our bodies with these machinic sculptures, but he also possesses our sight (a "temporary possession," however) by directing it.

In constraining body and diverting sight, these sculptures partake of the per-

319

**Snow Storm, February 7, 1967** 1967
Black and white photographs, enamelled masonite
121.9 x 121.9 cm
National Gallery of Canada, Ottawa

verse obdurateness that is a not so subtle undercurrent of Minimal art. We recognize the performative aspect Minimalist sculpture shared with dance. But there is something that goes beyond its possession of space and confrontation with the viewer, which Michael Fried criticized and from which one can trace the origins of Performance and Body art, such as that by Vito Acconci and Dennis Oppenheim. (Robert Morris is an emblematic figure here, passing between performance and sculpture in the early sixties.[29] As with the framing device, Duchamp can be seen as the inspiration for all these physical and optical constraints brought to bear in Minimalism and its derivations in various ways and through diverse media exemplified by artists such as Jasper Johns, Robert Morris, and Bruce Nauman. This is the "optical" Duchamp of *To be looked at from the Other Side of the Glass with One Eye,*

*Close to, for Almost an Hour,* 1918, but also the "performative" Duchamp of the suggestion "Establish a society in which the individual has to pay for the air he breathes [air meters; imprisonment and rarefied air, in case of non-payment simple asphyxiation if necessary [cut off the air].") While Minimal art seemingly is an art without content, the space of confrontation between work and spectator, in which the spectator is forced to participate, psychologizes the space in such a manner it becomes a social situation. It is in this charged space that all the unresolved social turmoil of the mid-sixties race riots, civil rights agitation and Vietnam war unconsciously surfaces.[30] This is not an arbitrary suggestion: Snow toyed with titling the Poindexter exhibition "Public Private Paranoid Visual Art" and, however ironically, thought of calling the Isaacs exhibition "Protective Measures."

### III. Shaping Time, Shaping Space: Wavelength

"Quite obviously there's Snow sculpture before *Wavelength* and Snow sculpture after *Wavelength*." So wrote Gene Youngblood in 1970 and such is the conjecture of this exhibition.[31] Yet, the material of this conjecture, called sculpture here, pursues its medium in as pure a way as possible for Snow, as does film. Both utilize the body and eye, and what is specific to each may be general to the other.[32] Snow was enough of a modernist that he sought to keep media independent. He attempted to discover latencies within media obscured by what was shared across them. What gets "mixed" are not media but levels of presen-

tation and representation. (The complex dialectic between presence and absence of the photograph makes it an apt model for investigation, which is why it is so dominant in Snow's work in film, sculpture and, obviously, photoworks themselves.) So the statement or premise should read instead, there's Snow work before *Wavelength* and Snow work after *Wavelength*. In that it concludes one body of work and introduces another, we ask of *Wavelength* the summation it implies for the rest of his work.

*Wavelength* has been one of the most influential and written about of experimental films. Since in so many of those

commentaries, Snow's statement for the Experimental Film Festival of Knokke-le-Zoute in Belgium, in which he won first prize in 1967–68, is also quoted, it makes sense to repeat it in full here:

"*Wavelength* was shot in one week in Dec. '66 preceded by a year of notes, thots, mutterings. It was edited and first print seen in May '67. I wanted to make a summation of my nervous system, religious inklings, and aesthetic ideas. I was thinking of, planning for a time monument in which the beauty and sadness of equivalence would be celebrated, thinking of trying to make a definitive statement of pure Film space and time, a balancing of 'illusion' and 'fact', all about seeing. The space starts at the camera's (spectator's) eye, is in the air, then is on the screen, then is within the screen (the mind).

"The film is a continuous zoom which takes 45 minutes to go from its widest field to its smallest and final field. It was shot with a fixed camera from one end of an 80 foot loft, shooting the other end, a row of windows and the street. This, the setting, and the action which takes place there are cosmically equivalent. The room (and the zoom) are interrupted by 4 human events including a death. The sound on these occasions is sync sound, music and speech, occurring simultaneously with an electronic sound, a sine wave, which goes from its lowest (50 cycles per second) to its highest (12000 c.p.s.) in 40 minutes. It is a total glissando while the film is a crescendo and a dispersed spectrum which attempts to utilize the gifts of both prophecy and memory which only film and music have to offer."[33]

Most commentators selectively unpack this statement according to theoretical need or argument, or they catalogue the discrepancies between statement and fact, few

considering the consequences, however, of each aspect of Snow's summation — especially the "religious." *Wavelength*, however, is his second filmic summation. Michael Snow's first film (discounting his seven minute animation *A to Z* of 1956), *New York Eye and Ear Control* of 1964, assembled its diverse materials towards a definitive statement. Subtitled "A Walking Woman Work," *New York Eye and Ear Control* attempted for film the encyclopedic summation pursued according to medium in the rest of the painting and sculpture of that same series.[34] Snow said, "This film contains illusions of distances, durations, degrees, divisions of antipathies, polarities, likenesses, compliments, desires. Acceleration of absence to presence. Scales of 'Art' — 'Life', setting-subject, mind-body, country-city pivot. Simultaneous silence and sound, one and all. Arc of excitement, night to daylight. Side, side then back then front. 'Imagined' and 'Real'. Gradual, racial, philosophical kiss."[35] While these dualities — black-white, figure-ground, motion-stasis, sound-silence, city-country, men-women, etcetera, that range in nature and theme as classes and events from abstract, formal, and metaphorical to social — structure the film, the figure of the Walking Woman herself, as in the static painting and sculpture, is a device to judge phenomena as presented and represented in film space *and* time. A static image of an active gesture, the Walking Woman here is the passive element that makes the field active or that makes us active in the field, i.e., viewing the material of this film experience.[36] The Walking Woman, however, is not the main actor; that role is reserved for what is most active and determining in this black-and-white film: light, or, rather, light-duration. While the Walking Woman

322

form is used analytically to contrast foreground-background, positive-negative figure-ground relationships, among others, and is the anchor of different types of camera shots, Snow would instead abstract the conditions of his next film (*Wavelength*) from the long static shots of its planar outline in differing lighting and exposure conditions (such as the long shot on the lower Manhattan rooftop where the sunrise changes the exposure of the image from under-to-overexposed). These "elements" of light and duration would find their consummate shape in *Wavelength*.[37]

(Abstracted from the polarities listed above, the nascent forms light-duration assumed at this stage relate *New York Eye and Ear Control* to Warhol's earliest films of 1963–64: the lightstruck ends, the long takes emphasizing the literal duration of camera time, in particular.[38] According to P. Adams Sitney, Warhol's contribution to structural film that shortly followed his first films was his "temporal gift ... duration." He suggested "Warhol must have inspired, by opening up and leaving unclaimed so much ontological territory, a cinema actively engaged in generating metaphors for the viewing, or rather the perceiving, experience." Sitney thought that *New York Eye and Ear Control* was "architectonically naïve.... However, Snow's primary weakness here becomes the central strength of his later work: the vision of a simple situation permeated by rich philosophical implication, which *duration* elaborates."[39])

Film answered a desire for Snow that his paintings could be seen in time: that the lateral or spatial seriality found in paintings such as *Olympia*, 1963, *Encyclopedia*, 1964–65, or *Mixed Feelings*, 1965, for example, be controlled in time;

that the theme and variation motif common to jazz find its equivalency and be played temporally, rather than the spatiality of one thing after another that was the ideal of Minimalist sculpture.[40] Insofar as *Wavelength* fulfilled this desire for serial variation in duration, it could be argued to be still a Walking Woman work. (Her image, pinned to the end wall of the loft, is in range of the target of the zoom.)

In the twenty-seven years since its first screening, *Wavelength* has accumulated many different readings and interpretations following upon the theoretical debates of avant-garde film. My concern here initially is not to enter these debates — since I claim no expertise or theoretical position — but to recall the first interpretations that set the parameters for future reconsiderations or reconfirmations. These figure around *Wavelength*'s celebrated zoom and the film's purported narrative structure.

*Wavelength* came at the confluence of two streams, one from the world of American experimental or underground film and the other from the New York artworld, which Snow bridged, and they found their most powerful exponent united in one individual — Annette Michelson. Michelson, however, was not the first to champion the film or Michael Snow. The film's epoch-making character was heralded by P. Adams Sitney as exemplary of a new film form, "structural film." Writing of Michael Snow (taken to be "the dean of structural film-makers") and George Landow, Hollis Frampton, Paul Sharits, Tony Conrad, Ernie Gehr, and Joyce Wieland, Sitney claimed "Theirs is a cinema of structure in which the shape of the whole film is predetermined and simplified, and it is that shape which is the primal impression of the film."[41] Whether or

not this founding claim is accurate — and it was Snow's film *Wavelength* that led Sitney to these formulations — is not the issue here, rather, Sitney saw structural film as fulfilling "the great unacknowledged aspiration of the American avant-garde film" which he took to be "the cinematic reproduction of the human mind."[42] Elsewhere Sitney claimed "*Wavelength*...comes to constitute a mode of philosophical thought," thus bridging film to contemporary artists' conceit that art was a philosophical activity.[43]

"There is a metaphor recurrent in contemporary discourse on the nature of consciousness: that of cinema." So writes Annette Michelson, concurring with Sitney, in the opening line to her 1971 article on Snow; and she continues: "And there are cinematic works which present themselves as analogues of consciousness in its constitutive and reflexive modes, as though inquiry into the nature and processes of experience has found in this century's art form, a striking, a uniquely direct presentational mode. The illusionism of the new, temporal art reflects and occasions reflection upon, the conditions of knowledge; it facilitates a critical focus upon the immediacy of experience in the flow of time.... Epistemological inquiry and cinematic experience converge, as it were, in reciprocal mimesis."[44]

In our anti-foundational, and consequently anti-epistemological times, such a statement on the epistemological claims of art at least has to be situated in its own time.[45] These claims orient Michelson to a limited — though powerful — description of the events of *Wavelength*, and while their phenomenological basis is of its moment, the consequences of her description and interpretation probably continue today.[46]

Michelson isolates one characteristic of the zoom and the superimpositions that occur therein to establish her argument: "The camera, in the movement of its zoom, installs within the viewer a threshold of tension, of expectation.... Now the effect of these perceptions is to present the movement forward as a flow which bears in its wake, contains, discrete events: their discreteness articulates an allusion to the separate frames out of which persistence of vision organizes cinematic illusion. Above all, however, they create, through the slow focussing in time, through relentless directionality, that regard for the future which forms an horizon of expectation. We are proceeding from uncertainty to certainty, as our camera narrows its field, arousing and then resolving our tension of puzzlement as to its ultimate destination, describing, in the splendid purity of its one, slow movement, the notion of the 'horizon' characteristic of every subjective process and fundamental as a trait of intentionality. That steady movement forward, with its superimposition, its events passing into the field from behind the camera and back again beyond it, figures the view that 'to every perception there always belongs a horizon of the past, as a potentiality of recollections that can be reawakened; and to every recollection there belongs as an horizon, the continuous intervening intentionality of possible recollections (to be actualized on my initiative, actively), up to the actual Now of perception'." The consequence: "And as the camera continues to move steadily forward, building a tension that grows in direct ratio to the reduction of the field, we recognize, with some surprise, those horizons as defining the contours of narrative, of that narrative form animated by distended temporality, turning

324

upon cognition, towards revelation."[47]

Narrative form, then, is what Snow restores to film. Against its destruction and concomitant perpetuation of a disjunctive, fractured space represented by Stan Brakhage's films, "Snow has redefined filmic space as that of action.... The film is the projection of a grand reduction; its 'plot' is the tracing of spatio-temporal *données*, its 'action' the movement of the camera as the movement of consciousness.... *Wavelength*, then in a very special sense was an 'eye-opener', as distinguished from both the hypnagogic vision of Brakhage and the stare of Warhol. Snow, in re-introducing expectation as the core of film form, redefines space as ... essentially 'a temporal notion'."[48]

Michelson's argument hinges on expectation and while one cannot doubt the overwhelming determination of the zoom on our fascination, the superimpositions themselves perhaps play roles other than that of exemplifying phenomenological horizons. Actually, they are infrequent and appear only late in the film. There is one very brief flash superimposition of an earlier point of the loft space as if a reminder of that passage but it is so quick we cannot establish where it was in the passage and it occurs well past the death; the telephone call is the occasion for *immediate* flashbacks, not later recalls; and close to the end there is a projection forward so that a gap opens up between the two images of the wave photograph. Michelson's endeavor to define a new category of temporal arts by overemphasizing an epistemological and phenomenological reading of the work collapses the space of viewing and the time of the filmic experience to that of the movements of consciousness. A too reciprocal mimesis takes place here, dis-

counting the objectivity of our position *outside* the film observing the "pure" orders Snow constructed and analysed in *Wavelength*.[49] Adducing this experience as narrative oriented future discussion of the film to the normalizing role of dominant cinema, condemning *Wavelength* to a role of critique or simply condemning it — for its self-same narrative devices.[50]

The human events that could be construed as elements of a narrative series do not naturally link together and each cannot, as is generally thought, be taken to be a realistic standard from which deviations are made or traditional narrative undermined. Although the immediate entry of figures into the space gives an impression of realism ("The room is shot as realism."), already there are fluctuations in the image, a flash frame, and colouration of the image caused by filters or gels, which Snow labels "intimations of other ways of seeing the thing, until the first real break is when the image is totally negative."[51] One could say, rather, that the figures moving the heavy bookshelf into the loft simply establish the depth of the space, which appears more foreshortened than its actual eighty foot length, and through which the zoom will have to travel for forty-five minutes. (We do not yet know that the hierarchy of action is to be displaced, with the zoom assuming a more significant role than the human actors and that the actors will be no more important an event than the light fluctuations.)

The second human appearance and episode similarly is an initial means to deconstruct elements that make film, in particular, image-sound relationships, as initiated and analysed in *New York Eye and Ear Control*. So far the film has been in sync sound. Now with the shutting of the

window (unnaturally closing out the street sound as happens so often in commercial film in passages outside to inside, or room to room and thus setting up one consideration of an "inside"/"outside" as well as sound/silence construction) music from the radio is ascendant. When one of the women walks back through the space, her footsteps are not heard. Yet when the radio is turned off, sync sound returns and we hear the footsteps of the second woman who makes the same exit behind the camera. (Street sound returns even though the window is not re-opened.) The use of this particular song playing on the radio, the Beatles' "Strawberry Fields Forever," moreover, allows the first colour fluctuations caused by filters to be seen as referential, the rose-like tones exemplifying what is sung in the lyrics pointing to its own "unreality."

"Off-stage" sound is used to announce the third human event: the entry of the man who collapses and dies in front of the camera. This "typical" scene of dramatic construction — a death — is already denaturalized by the fact that even before we see him enter the frame the time of his movement passes (through different stocks of film and takes) from day to a twilight effect of grainy filmstock to night. Here, once again, the human intervention seems to be a prop the zoom relentlessly rolls over.[52] And now the colour and light fluctuations assume another referential role as reflection of inner states.

The zoom now having passed over the body, the fourth event occurs, which is linked through dialogue to the body in the space. A woman enters presumably from the same location but the sync sound of her walking corresponds now only to the visible depth of field as if what we have passed through by means of the zoom — and in which the body "exists" — is no longer in our presence. The telephone call that makes reference back to the body is followed closely on the woman's exit by flashbacks, literally, a series of flashes in black and white as if ghostly traces of the *immediate* past action. (During this scene, strong shadows of the figure are thrown against the wall, paralleling the separation between the two Walking Woman cut-outs above her, anticipating her own ghostly apparitions, and the out-of-sync images of the waves soon to appear.)

Each of these incidents is subject to immediate question as to their constructed reality or to what Michael Snow calls levels of belief. In the reality of film, they are not of a different order than the abstract or light events that interrupt; they are not the realistic counterpart to the materialist demonstration of medium to follow that then puts that *construction* of reality in doubt.[53] It was in doubt from the start since the only construction of reality here is the film. Similarly, Michelson's concentration on expectation limits the film to one order of reality, that of intentional consciousness, without allowing other orders and levels of events — the "dispersed spectrum" of the film — to be considered. (It is as if the later philosophy of Wittgenstein, a philosophical source for Snow, was not considered in favour of the phenomenology of Husserl as a resource for reading this film.) With the proviso that Snow calls *Wavelength* "metaphysics" and *New York Eye and Ear Control* "philosophy,"[54] the former is like the latter in that different orders and classes of events construct it:

"Now: one of the subjects of or one of the things *Wavelength* attempts to be is a

326

'balancing' of different orders, classes of events and protagonists. The image of the yellow chair has as much 'value' in its own world as the girl closing the window. The film events are not hierarchical but are chosen from a scale of mobility that runs from pure light events, the various perceptions of the room, to the images of the moving human beings. The inert: the bookcase that gets carried in, the corpse, as seen, dying being a passage from activity to object. Inertia. It is precise that 'events *take place*.' The various kinds of events imply or demonstrate links which are, more or less, 'stories.' We tend to make a strong human event link between the death and the phone call. It is the beginning of what we conventionally call a 'story.' Before the man dies or after he dies the 'story' changes levels and one 'reads' relationships. His entry (He is not seen. Behind you?) is announced/preceded by breaking glass, etc. sounds as well as image-colour fluctuations. The sound is 'representational,' 'realistic' as he is seen, walks in, dies. This is against the 'abstract' sine-wave glissando. When he dies the 'realistic' sound stops and is now seen. The colour-image waves which on other occasions are sensed as light events tied to what-is-happening-to-the-room (?!) belief are now sensed as ripples of life-heart struggles or the reverberations of hitting the floor. It is a very involved subject to try to write about. The 'story' is on different levels of belief and identification."[55]

That one thing after another happens does not necessarily comprise a narrative: Snow's desire for serial variation does not restore narrative and its forms of cinematic identification. The anti-narrative spatiality of Judd's "one thing after another" is made temporal in *Wavelength*.[56] The zoom is the

temporal vehicle or medium in which events can happen, just as the space is its analogue for human actions. Michelson, in claiming "Snow has re-defined filmic space as that of action" and that the film is a "grand reduction" itself reduces the film to an aim — to get to the end of the space of the loft where tension and expectation, "the core of film form," are resolved in the conclusion of the still image of the sea. (The implications of that climax, however, are left unresolved or even unnoted, as Sitney points out in his criticism of Michelson's view.[57] Moreover, once the film is seen and our expectations are satisfied the film no longer would have any future aesthetic effect for us if we already knew the outcome of the zoom.) "It is precise that 'events take place'," and yet these events which take place during forty-five minutes of time are precisely what is lost in Michelson's scenario, perhaps because they are, only — light.

What creates equivalences in this film ("beauty and sadness of equivalence"; setting and action "cosmically equivalent"; "balancing of 'illusion' and 'fact'") is what makes film — light. The medium of light makes the presentational medium of film and therein all things are equal. In that all "things" are light here, the film *Wavelength* concerns itself with the *representation* of light in time. Notes reveal that *Wavelength* started as a much different film, although the room and the zoom were constant throughout.[58] In all cases, room and zoom were vehicles for the events that take place. As with his sculptures, Snow "set up a system or container which could both shape the fortuitous and give it place."[59] *Wavelength*, as I have suggested, is the last Walking Woman work in that it fulfilled Snow's desire to make a work on/of

327

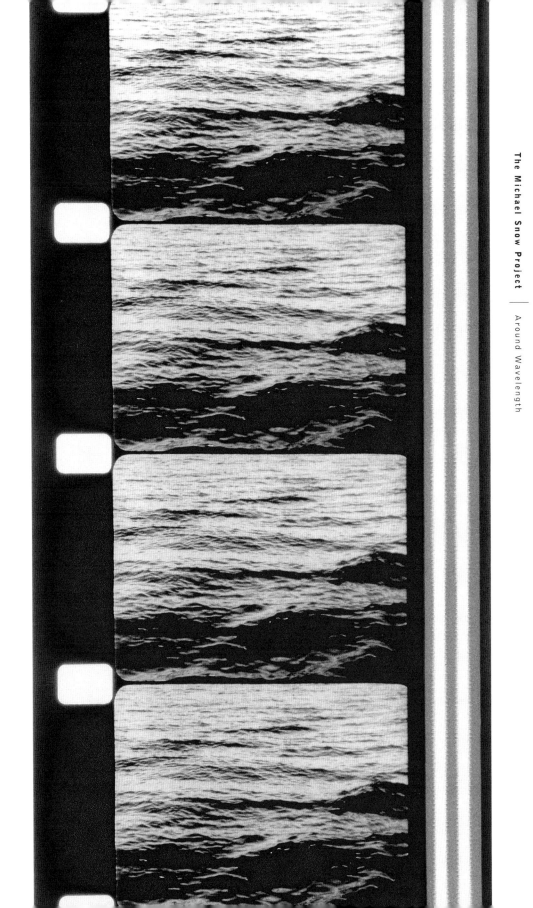

variation. "Don't paint use light to make variations," Snow wrote in his notes; but clearly the historical issues of painting were still in his mind. In attempting "to make a definitive statement of Pure space and time, a balancing of 'illusion' and 'fact'," Snow had the model of painting and Cézanne in particular before him. So he told Jonas Mekas and P. Adams Sitney in both his *Film Culture* interview and letter.[60] But he also deleted this ambition from a draft for his Knokke-le-Zoute statement: "In painting since Cézanne 'space' has been a subject of art and has to do with a balance of 'illusion' and 'fact'. I wanted to do this for film with light not paint."[61] Light, then, for Snow becomes the medium for what is pure in "pure Film space and time."

Space in film is formed by coloured light thrown onto a ground that is the screen (itself a framed rectangle). Thus, light functions much as the "abstracted" brushstrokes of a Cézanne painting, hovering between material and representation, fusing an illusionistic space by recognizable visual clues common to any photographic medium. While what makes the image still is only light, what is real as light is emphasized by what is pertinent to film — flash frames, filters, visible splices — but above all by time, the duration brought about by projection. What film adds uniquely to the spatial representation it shares with both photography (a dimensional space constructed by the lens) and painting is duration.

The loft space delineated by the zoom of *Wavelength* was chosen to exemplify, mirror or map out the space of film and seeing: Snow said the film was planned to be "all about seeing." We have to follow that space as it diminishes, not only to experience variation, but to discover what Snow thinks are the pure orders of filmic

presence and representation, illusion and fact. (Painting allows us to enter its picture plane at any place and proceed in any direction outside any hierarchy of relationship. Film's ordering of space is otherwise directed by temporal succession and *Wavelength* in particular by the diminishment caused by the zoom.) Snow described this space for us: "The space starts at the camera's (spectator's) eye, is in the air, then is on the screen, then is within the screen (the mind)."

The representational space of the film seems perspectival, but is actually, nearly, conical, mirroring the throw of the projector's beam. The zoom does not move through the space along perspectival lines of sight but advances maintaining a planar construction of viewing: "It's all planes, not perspectival space," said Snow.[62] The jerkiness of movement, rather than smooth transition, emphasizes this construction, all the more abstract since the zoom cannot be duplicated naturally by the eye. The light variations, especially those caused by filters or gels, actually reinforce this planar construction. (Delimiting the other end of the loft, the windows close off the space of the zoom but still envelop the street in the optics of the lens, and they are the most immediate means by which colour difference is seen. As clear frames light projects through, analogous to the projector itself, colour thereby achieves all its vibrancy and transparency through the windows otherwise muted and transformed by the colours in the space itself. The window panes thus act as a complex mediator between inside and outside, moreover, functioning like a projector in one direction or operating akin to the zoom lens in foreshortening the façades of the buildings opposite in another). All these planar reinforcements

are "projections" of the actual "unseen" individual frames of the filmstrip themselves as they compose the seeming diminishment of space when run together (the illusion of movement of the zoom) — the nature of the filmic enterprise Snow described as the "frame by frame truth and the running together illusion."[63] The balancing of illusion and fact is this accomplishment, in that film is both representational and durational.

Moving through the space of Michelson's "grand reduction" or Sitney's "story of the diminishing area of pure potentiality," we arrive at the full frame still photograph of the waves.[64] We have to arrive there, not because it is the climax and passage to a transcendental realm, but because it returns us to the very materials and terms of illusion and fact Snow started with. The film had to end on a still on that flat plane of the screen replicating the material of a beginning, with the *difference,* however, that temporality makes: the single frame still image/s projected in time.[65] At the end, a still image, which we know to be a spatial illusion (the photograph in our reality is "opaque" not "transparent"), is rendered on and reduced to the flat two-dimensional plane of light. It is maintained there even after the sound track ends, only to be dissolved through turning the image out of focus, finally transpiring as white light on a flat screen. *Wavelength* concludes on this "frame by frame truth" the image reveals to us at the end of our passage through film time.

The "metaphysical" moment of penetration for Sitney ("The metaphysical culmination of *Wavelength* had been the moment of breaking through the photographic surface."[66]) or material exhaustion of space for Michelson (material in the sense that an optical apparatus exhausts the "space" of the film) is marked rather by the revelation of the original terms of film in the moment that the two cones coincide on, or are reduced to, the plane of the screen — the material conical throw of the projector and the illusionistic space of the loft that mirrors it — collapsed into the full frame still image. This is the logical conclusion of the shape of the film as the consequence of the zoom. But the film does not end here. We do not pass through the image, after all the zoom stops there, but we enter into another durational space or state that the image brings about, which Snow reveals is just as endemic to film space and time.

Of course, in that there are different levels of order in this film, being a summation of Snow's "nervous system, religious inklings and aesthetic ideas," the end of the film and the image of the waves can be made a metaphor and Snow talked many times of the waves being an image of continuity: "The photograph of the waves is an implication of a kind of total continuity for everything and not just that simple incident."[67] P. Adams Sitney, I think, was the closest of the first commentators in taking *Wavelength* at Michael Snow's word as elaborated in his Knokke statement and *Film Culture* interview and letter, especially in considering the transcendental implications of Snow's summation. He agreed with Snow that "metaphysics (for Snow, the religious and apperceptive dimension and the locus of paradoxes) ... is the specific domain of *Wavelength*." He criticized "Michelson's brilliant analysis of the film [because] it does not account for its transcendental aura, which emerges," he believes, "from the tension between the intentionality of the movement forward

and the superhuman, invisible fixity of the tripod from which it pivots," and from that between the glissando and natural sound which are climaxed "in the final eerie plunge from the flat wall into the illusionary depth of the motionless seascape."[68]

Snow's "religious inklings," perhaps are no more than a general sense of continuity allied to a notion of fate for which film is suited and around which *Wavelength* is *purely* constructed.[69] Referring to *Wavelength*, Snow has written: "From the beginning the end is a factor. In the context of the film the end is not 'arbitrary'; it is fated. And past the end it should have ripples. The wave photograph; waves are the visible registrar of invisible forces. Because it is (at first) seen as flat (on the wall) it makes a total spatial ending for the film at the same time as an image it implies continuity."[70]

This statement in itself points to the levels of comprehension each moment of the film must balance: perhaps here is the paradoxical locus Sitney calls "metaphysical." But in the reality that the film maintains, here and now in its viewing situation, as in all his films Snow constructs image-spectator relations which are also "attempts to suggest the mind to a certain state or certain states of consciousness. They are drug relatives in that respect." The transcendence Snow speaks of for *Wavelength* is specific to those elements that compose the film: light and time. "*Wavelength*...is more transcended by light-time," Snow claimed.[71]

Another reading of the film, then, would attempt to link what is rendered in its common elements of light and time, concentrating in different ways on the new rhythms of time, light and sound as they shape our viewing. In other words, the "shape" of *Wavelength* is more than its exhaustion of space. (Shape would be measured along the rhythm of light and sound breaks.) Not only would expectations change (now measured along the rhythm of non-human events) but also the way the film has been structured in descriptions around the human events. If we then divorce our viewing of the film altogether from the human actions as a four-part structuring of the film corresponding to those actions (as the film is usually analysed in commentaries and which cannot account, like Michelson, for the conclusion, which is beyond the human), we can begin to reconstruct *Wavelength* around other types of events. A four-part division of the film can still be maintained with the human actions figuring now only as particular moments within overall duration. (A more detailed breakdown aligned to classes of variations would follow the changes in rolls and stocks of film and processing.)

The first section of the film sets out general relations and expectations, but not a duality between realism and materialism. The alternation between actors and empty space by no means prejudices us in favour of the human activity we expect to follow (or not). The empty space maintains its own presence through the durations when nothing (human) happens. Already that space has been interrupted by flash frames and fluctuations. After the radio sequence a whole repertoire of effects is established by means of superimposed filters or plastic gels, generally yellow during this sequence (the colouration during the film progresses from warm to cool, in wavelength from light to water), flashes, rapid alternations between filters and back to the space, some emphasizing, at one moment, the interior and, at another, the world outside the

studio. (These alternations introduce us to one of the themes of an inside/outside dichotomy and reveal the effects to which the windows are put as they emphasize the inside of the room or the street outside with its façades and passing trucks, at one moment transparent, at another as opaque and reflective as the walls — or screen.)

The passage to the second part of the film, "the first real break," illustrating that there was an equivalency between the seemingly different "realistic" and "abstract" events depicted, is made through a transition to a negative image. The transition is not made easily, however. There seems to be a struggle through hesitating flashes of white light to attain this state, as if a passage was being made through light from one *threshold* to another (thresholds that will be enacted in different ways between the parts of the film).[72] Once again the "same" repertoire of effects is catalogued through colour filters, only now in negative with similar alternations between inside and outside. The negative image offers a new reality, however abstracted, and sculptural form to the space. (Even the bookcase, its compartments mimicking the panes of the windows, finally is clearly visible.) A drone, Snow's sine-wave glissando, commences with the negative image, replacing that of the "realistic" street sound, and continues to the end of the film as the zoom's abstract complement.

The third section begins after the negative sequence has ended in a few frames of white light, caused by clear leader, returning the loft to a positive image, now tinted green and in which varying transformations continue to take place. The room changes, bathed in a glowing aqueous white light in which the yellow chair

beside the desk and underneath the photographs takes on added prominence. This sequence passes from day to night intervened by the break-in and death. Intervened only — the zoom, continuing to pass over the body, brings the yellow chair all the more to attention. The sequence ends, fading to black (in opposition to the transitions in white earlier) only when the frame begins to encroach on the image of the chair, which suggests from the moment the chair came to prominence that all objects, including the human body were subsumed to the same class of event: that of the inert object. (The death is not the climax to be resolved in a denouement that concludes a classic four-part dramatic construction.)

If the third part of the film is dominated by the objectivity of the chair, the fourth part, in contrast to the third (as part two contrasted to the positive image of part one), is devoted to representations of the photographic image, although this is not immediately apparent as the end of the wall seems to float before us through a white haze. But as the wave photograph commands the centre of the wall (as it has done since the beginning of the film), so photography sets in place the various operations of human action depicted. Another day to night passage occurs here, now artificially introduced by pure black frames. The phone call is the occasion for various "out-of-sync" images to supervene, such as those between figure and shadow or the ghost image of the flashbacks and the past reality of their subject, both of which mirror the slippages the wave photograph more obviously will introduce. (The telephone call is, as well, a representation, a verbal flashback, of a past action.) The very images of the Walking Woman above the wave photograph are accurate templates for

us to judge any slippage of the image. At the point when the wave photograph begins to dominate the ground by its centrality, still framed by a wide border of white wall and window moulding around it, it announces its end in an anticipatory dialogue with itself (casting its "shadow" before it). A larger ghostly image of the photograph appears while the image of the present location of the zoom remains constant and clear. The zoom motion then tracks that of the larger ghost image, maintaining the scale of the earlier image, until it marries its own image in depth. Here an inversion occurs whereby the large image surfaces through in all its black and white reality. Now the wave image dominates the screen and quickly fills it.

The zoom ends here, edging slightly into the photograph, but the film does not conclude. Reaching the photograph does not end the film but subject the image and audience to different dimensions of temporal experience of (by means of) the photograph. After having reached a peak, the glissando slides up and down, then, after the image of the waves has been held on the screen for a long time, ends, while the image is held silently for an equal time before being tuned out of focus.

Beyond the activities of its human actors, image, light, sound, and time resolve here as the pure motivations of the cinematic apparatus to which the zoom and glissando have led us: "It is a total glissando while the film is a crescendo and a dispersed spectrum which attempts to utilize the gifts of both prophecy and memory which only film and music have to offer."

The temporal dimension of prophecy and memory are brought forth by the zoom and glissando apart from any human motivation in the film. The contradictory appeal to "the immediacy of experience in the flow of time" as an intentionality of consciousness mirrored by the viewer as an analogy to the actions of the film is belied by the construction of the film. (Yet abstraction and motivation are related: "Within that I played/improvised with plastics and filters while shooting, feeling it out but bearing in mind certain prior considerations: their relation to the human events [announcing/echoing etc.], when they should perhaps be most pure...."[73]) The temporal structure of announcements and echoes means that the film is never fully present as much as the intensity of the effects of its inter-frame rhythms, the relentless drive of the zoom, and the shrillness of the glissando subject the viewer. But this viewer, as well, is subjected to new conditions brought about by a move towards temporal structure. As such the identifications sustained by both mythopoetic film and Abstract Expressionism in corresponding passages to structural film and an allied Minimalism no longer hold and enter a contradictory moment for the subject/viewer. This would account for first interpretations and subsequent revisions of *Wavelength* as well as for the discomfort, perhaps, that the dialectic of presence and absence enacted through a dualism of human and inhuman brought about by representations made by a machine — the camera apparatus — produced for the viewing subject. These representations within a temporal structure of announcements and echoes would make *Wavelength*, then, surprisingly, allegorical. Announcements and echoes would not adhere to the intentional structure of consciousness where a "reciprocal mimesis" would make the film symbolical in

structure but to an allegorical mode which "always corresponds to the unveiling of an authentically temporal destiny."

The nature of *Wavelength*'s construction, of frame following frame, the relationship between one slightly differentiated sign and another in a film that attempts to end after its passage in the recognized but differential conditions of its origins "necessarily contains a constitutive temporal element; it remains necessary, if there is to be allegory, that the allegorical sign refer to another sign that precedes it. The meaning constituted by the allegorical sign can then consist only in the *repetition* (in the Kierkegaardian sense of the term) of a previous sign with which it can never coincide, since it is the essence of this previous sign to be pure anteriority.... Allegory appears as a successive mode capable of engendering duration as the illusion of a continuity that it knows to be illusionary." "Whereas the symbol postulates the possibility of an identity or identification, allegory designates primarily a distance in relation to its own origin, and, renouncing the nostalgia and the desire to coincide, it establishes its language in the void of this temporal difference. In so doing, it prevents the self from an illusory identification with the non-self, which is now fully, though painfully, recognized as a non-self."[74]

The engendering of a new mode necessarily enfolds a past aesthetic and so we expect to find the symbolical and allegorical mixed in the intentions and interpretations of this film. The allegorical mode only, however, can envelop in its constructions the levels that must be balanced in this film, some contradictorily, and the summations that must be resolved as much as they express on the part of the artist conflicting nostalgia and desires.

## IV. Autonomic Art

Michael Snow: Sculpture, The Isaacs Gallery, Toronto
January 15–February 3, 1969

Snow's exhibition at the Isaacs Gallery in Toronto reprised that of the Poindexter Gallery a year earlier, including its four works *Blind*, *Scope*, *First to Last* and *In Place*, now titled *Site*. The presentation in Toronto added *Atlantic*, made in 1966–67 before any of these works (significantly, through the period Snow was thinking about and making *Wavelength*) and subsequent works that continued Snow's theme of framing (*Portrait*, 1967, *View*, 1968) and those that broached new conceptual territory (*Aluminum and Lead*, 1968), as well as more ephemeral works that took the space of installation as their compositional device, such as *Long Distance (for Wendy)* and *Piano*, both 1969. Photography on its own was yet absent, except by implication or influence and as part of the sculpture *Atlantic*.

Though comprising many of the same works, the exhibition in Toronto had a different reception, function and meaning for *Canadian* art than it would or did in New York. In New York, the work would be seen as the continuing articulation of a Minimalist aesthetic shared by many

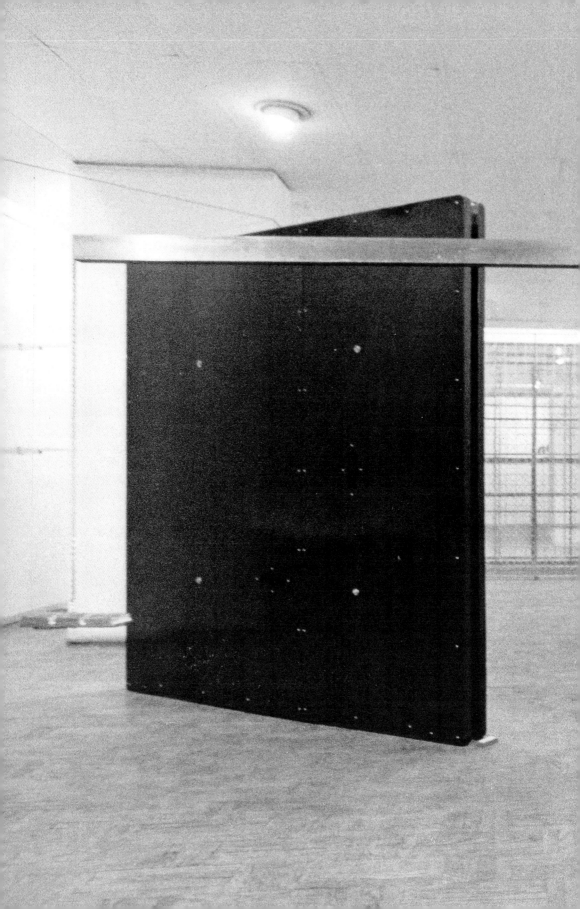

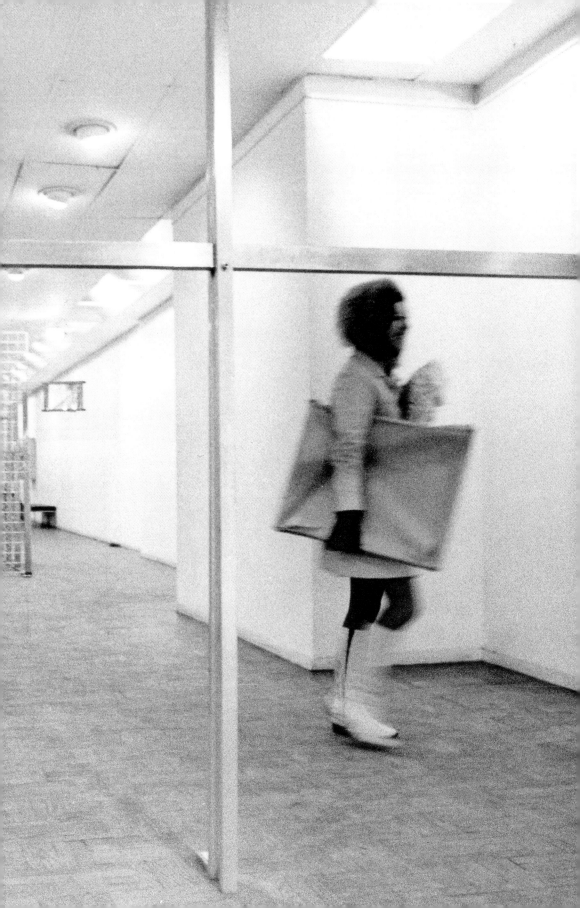

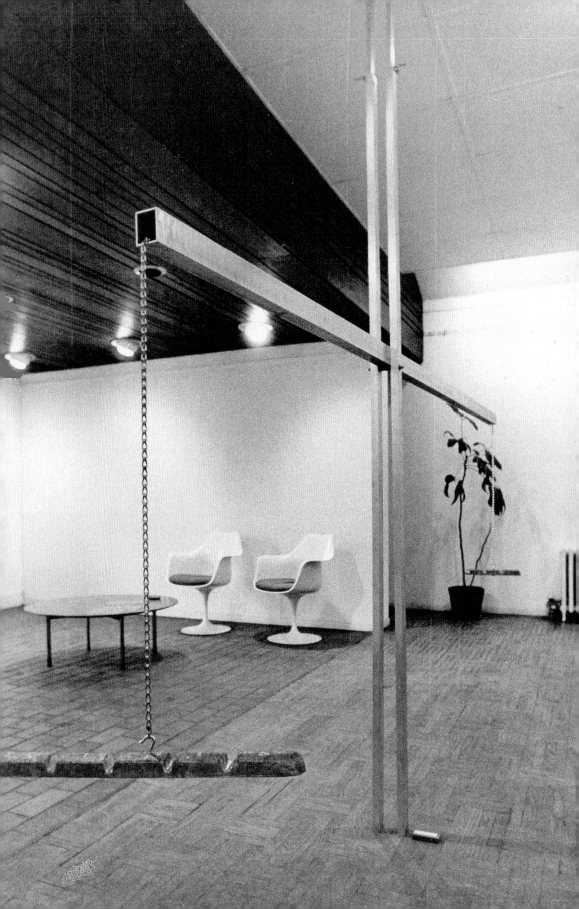

**Michael Snow: Sculpture**
**The Isaacs Gallery, Toronto**
**January 15–February 3, 1969**

artists, but it would not necessarily have stood out on its own, or it may been seen more in relation to *Wavelength*. In Toronto, where Snow was known primarily for the Walking Woman, and not, for instance, for his film *Wavelength*, his sculpture was seen as a departure from his own work and that of his past association with the Isaacs' group of painters. But this work was also very much a confirmation of the direction a generation of younger sculptors were taking — Karl Beveridge, Royden Rabinowitch, and David Rabinowitch especially — in their Toronto exhibitions of 1968 and 1969 and can be taken as a marker of a new orientation in Canadian art. Reviewing the Poindexter exhibition for a Toronto newspaper, Harry Malcolmson recalled *First to Last*'s exhibition in *Sculpture '67*: "*First, Last* was so contrary to the flow of the sculpture at the City Hall exhibition as not to be comprehensible." By the next year, this would no longer be the case.[75]

The Isaacs exhibition included works made over what was more than a two year period and thus in the context of those sculptures from the Poindexter exhibition introduced a seemingly new direction to past concerns. While works such as *Portrait* and *View* seem to further economize the theme of framing and hardly seem sculptural at all, they are closely related conceptually and structurally to a new direction of Snow's sculpture exemplified in *Aluminum and Lead* and, indeed, to his future photographic works. Snow's sculpture trailed off after this exhibition and, aside from continuing major work in film, his visual art of the seventies was devoted to photography. The last sculptures, actually two complementary works, *Membrane* and *432101234*, both from 1969, were first shown in his 1970 retrospective, and this particular practice would not reassert itself until his 1982 sculpture exhibition at the Isaacs Gallery, although many of those works had their origins in notes of this earlier period. During the period covered by the 1969 Isaacs exhibition, Snow worked on the films *Wavelength*, *Standard Time*, 1967, and ←→, 1968–69. In fact, after this exhibition, by his own testimony, Snow distanced himself from being an artist in favour of being seen as a filmmaker as he was then recognized, culminating with *La Région Centrale* in 1971, as the major influence in experimental film. The film ←→, or *Back and Forth* as it is also known, was Snow's main filmic effort after *Wavelength* (*Standard Time* being really a study of various camera movements and image-sound relations preparing for it). The clarity of structure and different concern for materiality Snow pursued in ←→ was brought to bear in the new sculptures as well.

*Aluminum and Lead* greeted visitors as they entered the Isaacs Gallery, as if, in its difference from Snow's past sculpture, setting the parameters for re-viewing the earlier works made for the Poindexter exhibition (or, like *Portrait*, made at the same time) along Snow's new lines of interest. The title, *Aluminum and Lead*, itself describes both basic elements of the sculpture, with its grammatical conjunction mimicking by its position in the title the function of balance in the piece. *Aluminum and Lead* is simply that: a balanced construction of unadorned and untransformed materials, lead ingots and aluminum extrusion, the weight of the lead played against the structural strength of the aluminum. Reduced here to the basic elements of simple utilitarian materials and architectonic

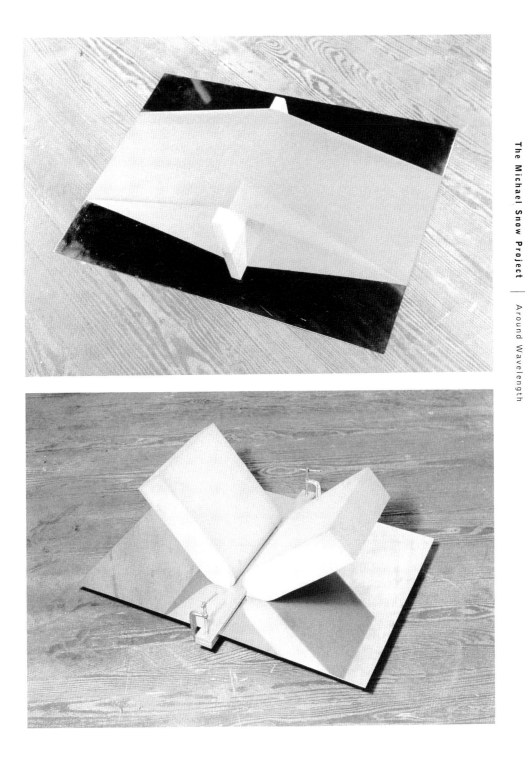

**Membrane** 1969 (top)
Chromed steel, wood, rubber
9.5 x 48.9 x 67.3 cm
S.L. Simpson Gallery, Toronto

**432101234** 1969 (bottom)
Chromed steel, aluminum, sponge rubber
33.0 x 48.9 x 67.3 cm
Peggy Gale, Toronto

←→ 1968–69
50 min., colour
Art Gallery of Ontario

form held in tension and compressed between floor and ceiling, the sculpture partakes of "the human intervention of architecture" thus relating itself to the rectangle and framing device of the earlier sculpture. But it is more than this as well. As in *First to Last*, the work "composes by the very limitations it imposes." *Aluminum and Lead* is a closed system that draws its construction from the potentialities of its materials and situation, and that shows itself by its clarity of making — it is all there for the seeing. This procedure is the principle for *Membrane* and *432101234* as well, where the constraint that in the past was applied to seeing now is given over to materials, the operation and procedural effects of which are offered to observation.

In retrospect additionally this can be seen to be a principle of the framing pieces such as *Portrait*. Interviewed for the Isaacs exhibition, Snow replied: "*First, Last* and especially *Portrait* also *View* also *Aluminum and Lead* are held together by equalizing tensions. In *Portrait* each set of two bars is forced against both the opposite walls or door-jamb and against one another and in addition are held there by being clamped *together*. This makes a kind of compressed point of stasis or rest. All the forces involved have an equal part in maintaining the form which you are seeing. I think this is very clear, very simple, very sculptural, very necessary and very important. The forms are made from forces but they are fixed."[76]

The articulation of a clear conceptual structure that displayed the conditions of the work's making as effects to be realized in the viewing of the work was applied, moreover, as a working procedure for future photography, a procedure displayed as its indexical signs of making in *Authorization*, 1969. The photographic

works included in the present exhibition, while grouped as a medium here, have different affiliations. None were shown actually in the Poindexter or Isaacs exhibitions. *Snow Storm, February 7, 1967* was first shown in a Canadian group show in Europe at the time of the Poindexter exhibition and closely relates to the works in that exhibition, especially *Blind*. *Authorization*, *Press*, *8 x 10*, *Tap*, all from 1969, were first shown in *Michael Snow/A Survey*, and *Untitled Slidelength*, 1969–71, found its context at the Bykert Gallery in New York in 1971, in a group of other photographic works outside the purview of this exhibition. The fact that most of these photoworks date from 1969 suggests the beginning of Snow's more dominant orientation to photography during the seventies, but they are all more closely aligned to the concerns of the sculpture here than to the photographic practice to develop. The one earlier photographic piece, *Snow Storm* from 1967, is as sculptural as the other contemporary work that incorporates photography, *Atlantic*, both relating to the earlier concerns of the Poindexter sculpture.

"I am working to use photography in a very enclosed way so that there is nothing outside the work itself that is used in the photograph . . . as in certain kinds of painting which have an autonomy of their own."[77] So said Snow in reference to such self-referential work as *Authorization*. *Authorization* is the record of its own making, as if in dialogue with itself through the process of its self-fabrication. The step-by-step process is clearly demonstrated: the artist shoots a polaroid of a framed rectangle taped to a mirror; that slightly out of focus print (since the focal point is the reflection of the artist) is placed within that frame and a new shot

**Authorization** 1969
Black and white polaroid photographs,
tape, mirror, metal
54.5 x 44.5 cm
National Gallery of Canada, Ottawa

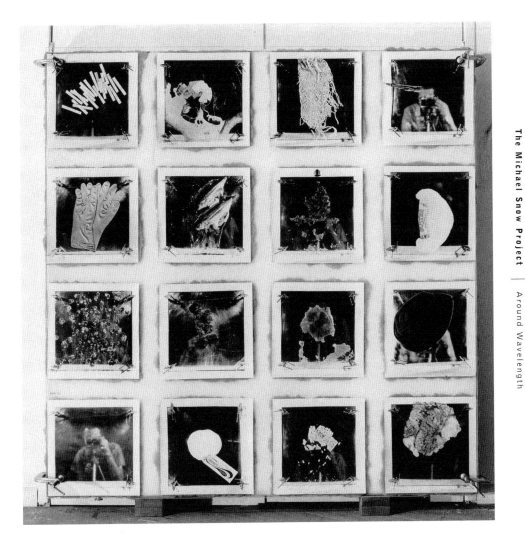

**Press** 1969
Black and white photographs, plastic, metal
182.9 x 182.9 x 25.4 cm
Dr. & Mrs. Sydney L. Wax, Toronto

**8 x 10** 1969 (over)
80 black and white photographs
Each: 20.3 x 25.4 cm
S.L. Simpson Gallery, Toronto

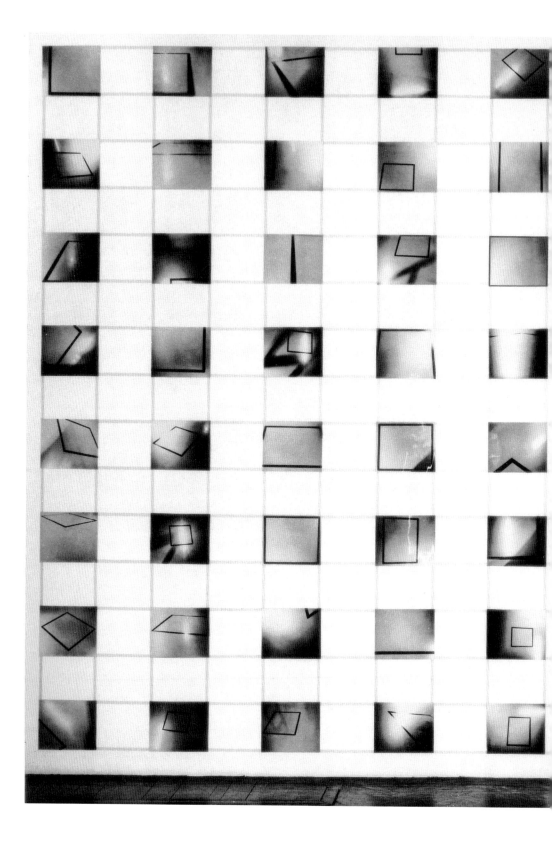

**Tap** 1969
Framed black and white photograph,
framed typewritten text on paper, tape player,
speaker, wire and sound tape
106.8 x 156.3 cm; 65.1 x 40.0 cm;
48.3 x 38.1 x 25.4 cm
National Gallery of Canada, Ottawa

TAP (PART THREE)

THE "DRUMMING " SOUND WHICH YOU HAVE HEARD,ARE HEARING,WILL HEAR
OR PERHAPS WONT EVER HEAR I MADE BY TAPPING MY FINGERS AGAINST A MICROPHONE
WHILE MOVING IT OVER THE TAPE RECORDER TO MAKE A BIT OF FEEDBACK.I THEN MADE
A LOOP OF A SELECTION FROM THE RESULTING TAPE.THERE IS A LARGE BLOWUP OF A
PHOTOGRAPH OF THE ABOVE PROCEDURE WHICH YOU MAY HAVE SEN OR WILL SEE ETC. ITS
SUPPOSED TO BE HANGING SOMEWHERE IN THIS BULDING.THE TAPE AND THE PHOTO WERE
MADE IN FEBRUARY 1969 AND THIS IS BEING TYPED ON MARCH 14 1969.JOYCE WIELAND
SNOW AND I TOOK THE PHOTOS WITH A MIRANDA 35MM. CAMERA,AN 8"x10" PRINT FROM
THE SELECTED NEGATIVE WAS MADE BY "MODERNAGE" ON 48TH STREET AND THE 6'
X40" BLOWUP WAS MADE BY "INDEPENDANT" ON 42ND STREET. IT COST $36.00.

I WANTED TO MAKE A COMPOSITION WHICH WAS DISPERSED,IN WHICH THE
ELEMENTS WOULD BE BE COME UPON IN DIFFERENT WAYS AND WHICH WOULD CONSIST OF
1.A SOUND,2.AN IMAGE, 3.A TEXT,4.AN OBJECT, 5.A LINE, WHICH WOULD BE UNIFIED
BUT THE PARTS OF WHICH WOULD BE OF INTEREST IN THEMSELVES IF THE CONNECTIONS
BETWEEN THEM WERE NOT SEEN (BUT BETTER IF SEEN).ONE OF MANY ADDITIONAL CONSID_
ERATIONS WAS THAT IT BE PARTLY TACTILE,BODY_MADE THO USING MACHINES.TYPEWRITING
IS A VERY SIMILAR FINGER TAPPING TO THE WAY THE TAPE WAS MADE AND I THOUGHT THAT
PERHAPS I SHOULD MAKE A COMPLEMENTARY OBJECT BY FINGER TAPPING BUT FINALLY DECID
ED TO SHOW THE LOUDSPEAKER AS THE OBJECT,AS A "FOUND" ELEMENT WHICH SPREADS
THE "CREATED" ELEMENT.THE SPEAKER IS JUST A CHEAP PORTABLE SPEAKER I GOT ABOUT
FIVE YEARS AGO AND I CONSIDERED "INCLUDING" IT MORE BY PAINTING IT,PERHAPS I
WILL,AT THIS WRITING IT IS DARK BROWN,ITS ORIGINAL COLOR.RATHER THAN CHANGE THE
"GIVEN" COLOR OF THE SPEAKER OR ITS SHAPE I DECIDED TO CONTINUE THE COLOR.THIS
AND THE PHOTO ARE BLACK AND WHITE AND THE WIRE IS BLACK.SINCE THE BROWN SPEAKER
"FRAMES"THE SOUND I USED THE SAME BROWN IN FRAMING BOTH THIS AND THE PHOTO.THE
FRAMES ARE ALSO RECTANGULAR "LOOPS".THE LINE,WHICH OF COURSE,PROPERLY SPEAKING
IS ALSO AN OBJECT I DECIDED TO COMPOSE THROUGH WHATEVER BUILDING THE PIECE IS
IN.IT PARTLY "COMPOSES"ITSELF ACCORDING TO ITS OWN NATURE BUT IT EVENTUALLY
"DISAPPEARS" TO THE TAPE RECORDER WHICH IS NOW(?) PLAYING THE TAPE SO THAT IT

(THE WIRE) HAS A"SPREAD" WHICH IN ITS OWN TERMS HAS SOME SIMILARITY TO THE
ACOUSTICAL SPACIAL SPREAD OF THE SOUND,EVENTUALLY DISAPPEARING.I DECIDED AGAINST
SHOWING THE PLAYBACK TAPE RECORDER BECAUSE THE SOURCE OF THE SOUND AT THIS TIME
AND HISTORICALLY IS HERE DESCRIBED AND IN THE PHOTO ,PICTURED.IN A SENSE THE BLA
CK LINE (CARRIER OF THE SOUND) DISAPPEARS TO HERE (TEXT) TO THE PHOTOGRAPH (IMAG
E) BOTH OF WHICH ARE "TRACES"OF IT AND TO THE ACTUAL (HIDDEN) TAPE RECORDER.

THIS PIECE IS AN ATTEMPT TO,AMONG OTHER THINGS,DO SOMETHING MANIPUL_
ATIVE WITH MEMORY DEVICES:TAPE RECORDER,CAMERA,TYPEWRITER.IT IS NOT a "MIXED_
MEDIA" OR COLLAGE_ASSEMBLAGE PIECE,NOR IS IT THEATRE.AS IS PROPER TO THE USE
OF THE ABOVE DEVICES IVE ATTEMPTED TO USE MEMORY AS AN ASPECT OF THE WORK.I HAVE
MADE SEPARATED OR "DISPERSED" COMPOSITIONS SINCE 1961,SOME OF THEM HAVING PARTS
ON DIFFERENT CONTINENTS BUT WITH THE EXCEPTION OF CERTAIN PERFORMANCE PIECES
(EG. "RIGHT READER" 1965) AND FILMS (SIMULTANEOUS IN ELEMENTS AND SITE) THE
PARTS were ALWAYS IN THE SAME MEDIUM,INVOLVED, IMAGES ONLY (IF THATS POSS
IBLE) OR WORKED IN AN IMAGE TO OBJECT SCALE.

"TAP" IS A KIND OF STILL SOUND MOVIE MAP.THE WAYS IN WHICH THE DIFFERE
NT ELEMENTS OCCUPY SPACE ARE INTERESTING: THE SOUND FILLING IT,HAVING A SOURCE
BUT NO DEFINITE "EDGES",THE LINE ,READING BACKWARDS,THREADING AND CARRYING THE
SOUND AND HAVING AN UNSEEN END,THE IMAGE FLAT ,TWO DIMENSIONAL,THIS FLAT,BLACK,
LINEAR,SMALL,IN YOUR EYES AND IN YOUR MIND.

Michael Snow

MICHAEL SNOW

**Untitled Slidelength** 1969–71
80  35mm colour slides
S. L. Simpson Gallery, Toronto

taken; the process repeats until the frame is full and this final record is tucked into the upper corner of the mirror frame. While the artist initiates — or authorizes — the process, the work has a life of its own, tautological, as the mirror and the camera mimic each other. (The work is authorized almost as a readymade, in that the conditions are chosen to make themselves: a "solo for polaroid and mirror," Snow referred to it in his notes) But an image is transferred, much as in *Scope*, and the author of the image, as the taker of the photograph, cannot be separated from the work. This self-referentiality is not solipsistic, however: the conditions of making have to reveal something of its material properties, here, the camera apparatus and the indexical nature of the photograph.

Conditions of presentation match conditions of production so that now in *Press*, which similarly reflects the artist taking the photographs (but in a way that does not show a step-by-step temporal progression), the manner of shooting the image becomes the means of its presentation. In *Press*, various things — eggs, fish, spaghetti, etcetera — have been squeezed (pressed) between a sheet of plexiglass and stainless steel sheet, photographed upright, and the ensuing photographs then have been assembled, pressed themselves under a plexiglass sheet secured by the same type of clamp. In squeezing things into a flat plane, the work literalizes the transformation of three-dimensional objects into the two-dimensional plane of the photograph (as if photography exerts a pressure on those things photographed, the film technique of a dolly or tracking shot Snow would literalize in his films *Breakfast (Table Top Dolly)*, 1976, and *Presents*, 1980–81). The record of this compression is equiva-

lent to the material tension of a sculpture such as *432101234*.

*Untitled (Slidelength)*, 1969-71, belongs to a different category of photographic works that utilize slides. While these works are on the perimeter of my concerns, having been produced mainly in 1970, they do investigate image, light and sound relationships as if traces of *Wavelength*. In that they use the resources of different media and mechanisms of recording and projection, however, they further pursue interests beyond that of *Wavelength*. Moreover, they combine media, as in *Sink* and *A Casing Shelved*, both 1970, or one medium is transformed within another, as in *Side Seat Paintings Slides Sound Film*. *Untitled Slidelength*, with its pure light events and photographic references to *Wavelength*'s loft absent of any of its human actors, could be thought to be a purified coda for that film. It takes the mechanism of the carrousel slide projector and the material of the 35mm slide to its purified essence: "It's really a pure slide piece, a coloured light, colour-field and time composition."[78] As a meditation through another medium on the facts and illusions of *Wavelength*, *Untitled Slidelength* shares with these other manipulations of the slide medium the temporal control of light and image, the legacy of *Wavelength*.

*Authorization* and *Press* both incorporate the body or rather image of the body of the artist, and the viewer at least can find his or her reflection in *Authorization* as the immediate presence of viewing after the fact of making (and as the chance element of a structured event). But the two-dimensional nature of the photograph maintains its traditional static relation to the spectator. Film, photography, and sculpture each situates the body in various ways. In film all movement is within the

film frame as a result of the camera activity, whether the zoom of *Wavelength* or the panning of ←→, while the viewer is stationary. In sculpture, it is the reverse with the spectator moving around a static object. Even though the spectator can move back and forth in front of it, no aspect of a photograph changes. Any implied movement of the body or embodied eye, and any temporality, has to be introduced to the image by evidence of *process*. Such is the case in *Authorization* and *Press*, and in *8 x 10* as well, a work about framing that does not let us look through it but makes its framing infinitely flexible as an *object* of photography itself and thus forces us to change our relations to it moment by moment, image by image, and by making us move across its wide wall expanse as well. This is also the case for *Tap* as it is the one photographic work that literally makes us walk to experience its three parts, composed of a photograph, a text and a recording.

The percussive tapping we hear on the recording of *Tap* returns us to ←→, a film about which Snow has said "←→ is percussion and *Wavelength* is song."[79] If *Wavelength* can be seen to envelop the Poindexter and related sculpture within its concerns, ←→ provides the framework for those new works of the Isaacs exhibition. In fact, Snow took ←→ to be sculptural in its particular shaping of space and fusing of image, flattening the space through a blur of light caused by speeding up the motion of the pan, the basic camera device of the film. (This camera operation makes the pivot of the metronomic pan function much like the constructive elements of the sculptures *Aluminum and Lead* and *432101234*.)

## V. Time, Light, Sound

"For me, film is a coming together of things previously separated in my work. Sculpture and film both represent my coming to terms with formerly scattered elements. One is thoroughly static and solid, something you can hammer together, and the other is light, sound and time, a fusion of pretty fugitive things. The structuring of time and the duration of things interests me as well as the realization of total time-shapes that have a beginning and end."

"While still an Artist (capital A) the effect the film [*Wavelength*] had on other people has been helping me realize myself as perhaps essentially time-light-sound poet."

— Michael Snow[80]

In making *Wavelength* a "time monument," Snow shaped our sense of temporality through the relentless progression of the zoom over a forty-five minute period. If he hyperbolized the zoom, he hypostatized the conclusion by holding the still image of the waves on the screen, retaining it long enough that it sustains both the glissando and an equal period of silence. In maintaining this image, not only did he return the film to its originating constituents, but he contrasted seemingly different states of time, or rather he opened to view a new sense of time and interrogation of the photographic

**Atlantic** 1967 (detail)
Metal, wood, photographs, arborite
171.1 x 245.1 x 39.9 cm
Art Gallery of Ontario

image. Earlier, the long take of the Walking Woman on the rooftop in *New York Eye and Ear Control* lent itself to this new ontological relation Sitney defined for Warhol's early films, and in Snow's film the changing exposure of the image drew us to observe variable photographic-perceptual effects. In *Wavelength*, the photographic image was slowly brought forward by the zoom until it merged with the screen, but it already existed in the space of the loft tacked to the end wall as a constant reminder, perhaps, of film's photographic character.

The dichotomy between the still and moving image is played out fully in Snow's 1969 film *One Second in Montreal* which extrapolates from *Wavelength*'s conclusion. Here a succession of still images alone composes this silent film. *One Second in Montreal* is made of thirty-one shots of varying length, thirty-one off-set photo-lithographs of Montreal parks under snow sent to the artist in 1965 as part of a sculpture competition. These nondescript urban scenes, even less visually compelling due to the poor quality of their original printing, do not really maintain a hold on our attention as the individual shots are held for longer and longer periods. About mid-way through this film, projected, as with Warhol's early films, at sixteen frames per second (rather than the customary twenty-four), the shots begin to shorten to a different rhythm and we find with the change of tempo a change in our expectation as we begin to scan the images with a new sense of urgency. We have fallen, almost unaware, beyond boredom and the discomforts of the body, under the fascination of time. "You have to be able to live with what's happening for a certain length of time in order to begin to understand it. It is literally made with lengths of time."[81]

As a concluding work to this exhibition, *One Second in Montreal* brings us full circle to one of the earliest, equally hybrid works, *Atlantic*, itself a sculpture incorporating thirty still images of the waves that appeared in *Wavelength*. These multiple images of the sea — each slightly different from the others, but not immediately so, their distinctness eroded by the stainless steel funnels that separate them, yet through reflection unite them in continuity as well — give the work a cinematic effect. Stilled images, their crashing waves resonate a ghostly silence. Silent stills, representations, their very presence seems to call for what would give them life, their opposite — the *illusion* of movement and sound.

*Atlantic*, exactly, is not a film but a static object. *We* move around it, side to side and back and forth, following and discovering another movement, that of the camera, one inhuman presence having recorded another: the sea. The camera has changed its angle in recording, and as those images are stacked one above the other we read this optical shift in the "space" of the photographic representation. More than an allusion to the persistence of vision that composes film, these splayed out multiple images, the same yet different, enfold together, in the play between presence and absence (the nature of a photograph), the real time of our presence and of the past of recording. Not in an instant, however; the work is static while our experience is insistently durational. Of course, what stands between past and present is this work, an object *and* a representation, just as the camera intervened for the artist, blinding him in the moment of the closing of the aperture, the pure presence of that instant mediated by a tool and repeated, mechanically, over time.

**One Second in Montreal** 1969
20 min., black and white
Art Gallery of Ontario

This work of art is the complex site of enquiry of an apparatus, more than a century and a half old, the camera and its photographic image (whether static or durational as in film) that has distilled the issues of representation as the paradoxical play of presence and absence. Michael Snow's career has proven to be a long meditation on the camera and the photograph. Nowhere was it initiated so clearly as in the camera-related works — sculptures, films, photoworks — included in this exhibition. Snow does not aim simply for an image, nor is the camera a simple apparatus, a tool for observation that would make his concerns merely epistemological. He wants to make sight visible through his sculptures, yes; but as sight is embodied, the whole human drama of existence enters (of memory and presentiment, of time and fate) somehow condensed in the fragile image, process and paradoxical product of the photograph. Whatever sense of temporality accompanies the image, whether that image is still or in motion, somehow seems to define something about the human being. All the more paradoxical, insofar as the play between presence and absence that defines our temporal sense is derived from a machine — the camera — and its representation is an optical-chemical product — the photograph. What defines the human is given over to the inhuman, moreover, as the end that Snow traditionally names this sense of temporality: "fate."

In its combination of sculpture and photography and in its allusion to cinema, *Atlantic* can stand as an emblem for the works of this period. Produced in 1966–67, it shares its origins with the planning and making of *Wavelength*, the film being a summation of his "nervous system, reli-

gious inklings, and aesthetic ideas," whose last frames end on a similar image of waves, that image of continuity which passes through Snow's work and is of autobiographical note.

"*Wavelength*, some four years old, is now a celebrated film, a turning point for many in the history of the medium as in the maker's own development.... The film is a masterwork, a claim hardly to be seriously contested at this point in film history." So wrote Annette Michelson in 1971, and she repeated a similar claim in 1978: "The film ...broke upon the world with the force, the power of conviction which defines a new level of enterprise, a threshold in the evolution of the medium."[82] It is hard for us coming from the other direction in time to recover the force of the film's assault on the mythopoetic context of avant-garde film of its moment, except through such testimonials. Repeated screenings show the film to sustain an aesthetic force; the more repeated, the rhythms of this "time monument" begin to assert themselves. For us, *Wavelength* must take its context in the development of Michael Snow's other work in film, sculpture and photography. Obviously, *Wavelength* played a role of summation according to Snow, but in not ending a career, it shared influences, of the camera apparatus, for instance, across Snow's other media. Amongst the repertoire of effects the film established, however, its most lasting influence was its powerful assertion of temporality in the investigation of conditions of the photographic image.

**Manual** 1970
58.8 x 57.8 cm
Offset lithograph
Art Gallery of Ontario,
gift of the artist, 1970

# Notes

### 1. Side Seat: A Retrospective Look

1. From the manuscript "About Side Seat Paintings Slides Sound Film" dated 1978 in the Michael Snow Fonds in the E. P. Taylor Research Library of Art Gallery of Ontario. All references to Snow's notes and sketches in the text pertain to this archive. The catalogue referred to is *Michael Snow/A Survey* (Toronto: Art Gallery of Ontario and The Isaacs Gallery, 1970). The exhibition took place Feb. 14–March 15, 1970. Also see the print *Manual*, 1970, which uses the 1970 catalogue as a physical object to transform photographically into another work.

2. *A Casing Shelved*, an autobiographical "talking picture," also from 1970, has a retrospective structure.

3. Snow, "About Side Seat…"

4. On the notion of a retrospective look for curatorial practice, see Philip Monk, "In Retrospect: Presenting Events," *Parachute* 46 (March–May 1987): 11–13, and the Preface to Philip Monk, *Ian Carr-Harris: 1971–1977* (Toronto: Art Gallery of Ontario, 1988), 6–7. *Around Wavelength* continues the curatorial conjecture set out in that earlier exhibition.

5. While the present exhibitions survey the same period, needless to say, they are separate and operate under different curatorial criteria. Together, though, *Exploring Plane and Contour, Around Wavelength* and The Power Plant's *Embodied Vision* provide a "retrospective" survey of Snow's work, without following the retrospective format.

### 2. "See it my Way"

6. Donald Judd, "Local History," *Complete Writings 1959–1975* (Halifax: The Press of the Nova Scotia College of Art and Design and New York: New York University Press, 1975), 149, 151.

7. Annette Michelson points out the (positive) differences to American Pop art: "Conceived and executed largely during the years of Pop, these works neither offer the polish nor the sensuousness of the work of the major American Pop artists. The irony and sensuousness of media images and plastic materials to be found in Lichtenstein and Warhol are absent from these works. Lushness of surface, intensity of color are also lacking, as are the kinds of irony available in the use of consecrated images — familiar labels, packages and such. The series does, on the other hand, explore in a fashion that parallels the Americans, the possibilities of a single basic figure, of its serial organization or variational play effected by change of context. They explore much more radically and extensively, however, the contrast between pictorial and sculptural space, modes and degree of representation and variety of materials." Annette Michelson, "Toward Snow," *Artforum*, 9: 10 (June 1971): 35.

8. Michael Snow, "A Lot of Near Mrs.," in Louise Dompierre, *Walking Woman Works: Michael Snow 1961–67* (Kingston: Agnes Etherington Art Centre, 1983), 18.

9. "I like work of Johns, Oldenburg, Dine, partly because apparently they came to similar conclusions arising out of the accomplishments of the great senior New York painters." Snow, "A Lot of Near Mrs.," 19. Duchamp, mentioned in these notes as well, should be reserved as an influence on both Johns and Oldenburg and particularly on Snow. He is mentioned as well as Johns and Oldenburg in a list of other influences which include Duke Ellington, Mondrian, Matisse, John Cage,

371

Jan Vermeer, Bach, Jimmy Yancy, Joyce Wieland and Paul Valéry. Snow, "Letter from Michael Snow," *Film Culture* 46 (Autumn 1967; published October 1968): 5.

10. Donald Judd, "Specific Objects," *Complete Writings*, 181–89.

11. Judd, *Complete Writings*, 120; originally published in the March 1964 issue of *Arts Magazine*.

12. Judd, "Specific Objects," 183.

13. In an interview for the 1969 Isaacs Gallery exhibition, Michael Snow established precedents in his earlier abstract painting and sculpture for his later post-Walking Woman sculpture:

"Did work that had to do with framing (masking), with seeing through, with window relationships, also balances between activity-stasis like the painting *Lac Clair* and sculptures that partly derived their form from room relationships like *Shunt* (wall to floor and vice versa). *Window*, a construction which was in the so-called Dada show at Isaacs, has probably the clearest connection as far as 'in terms of visual perception'." "7 questions + 1 on Michael Snow at The Isaacs Gallery," *artscanada* 26: 2 (April 1969): 30.

14. Donald Judd: Greene Gallery, December 17, 1963–January 11, 1964 ; Snow: Poindexter Gallery, January 28–February 9, 1964; Robert Morris: Greene Gallery, December 1964–January 9, 1965. Mention should also be made of Frank Stella's exhibitions at Castelli in 1960, 1962, and 1964.

15. Michael Fried, "Art and Objecthood," in Gregory Battcock, ed. *Minimal Art: A Critical Anthology* (New York: Dutton, 1968), 116–47. Originally published in the June 1967 issue of *Artforum*.

16. P. Adams Sitney, "Michael Snow's Cinema," in *Michael Snow/A Survey*, 79. On the relationship between dance and Minimalist art practices, see Yvonne Rainer, "A Quasi Survey of Some 'Minimalist' Tendencies in the Quantitively Minimal Dance Activity Midst the Plethora, or an Analysis of Trio A," in Battcock, *Minimal Art*, 262–73.

As part of the Whitney Museum's "Anti-Illusion: Procedures/Materials" exhibition, "Four Evenings of Extended Time Pieces" took place between May 21–27, 1969, with compositions and extended time pieces by the composers Philip Glass and Steve Reich and artists Bruce Nauman and Richard Serra; Snow's ←→ and *One Second in Montreal* were premiered there May 21. Sitney wrote the article "The Avant-Garde Film: Michael Snow" after these performances claiming: "In fact, the influence of recent avant-garde dance (Yvonne Rainer, Deborah Hay, Meredith Monk) in both theory and practice on the events in ←→ cannot be ignored. Each activity is a rhythmic unit, self enclosed, and joined to the subsequent activity only by the fact that they take place in the same place." *Changes*, 3 (June 1969): 15, 28. Richard Foreman wrote on Snow's films in relation to Philip Glass's compositions in "Critique: Glass and Snow," *Arts Magazine* 44: 4 (Feb. 1970): 20–22. Steve Reich also wrote an unpublished commentary on *Wavelength* which is in the Michael Snow Fonds. On the dynamic interrelationships of the arts in the early 1960s, see Barbara Haskell, *Blam: The Explosion of Pop, Minimalism and Performance 1958–1964* (New York: Whitney Museum of America Art, 1984). For a more specific study of one artist, however, whose connections to dance and performance illustrate this period, see Maurice Berger, *Labyrinths: Robert Morris, Minimalism, and the 1960s* (New York: Harper & Row, 1989).

Annette Michelson was the major theorist of the new "temporal arts." For her summation of this period in the context of Snow's work, see "About Snow," *October* 8 (Spring 1979): 111–25.

17. Snow, "Letter from Michael Snow," *Film Culture*: 5. Snow lent his studio to "free jazz" musicians such as Cecil Taylor, Albert Ayler, Archie Shepp. Snow brought together Albert Ayler, Don Cherry, John Tchicai, Roswell Rudd, Gary Peacock, and Sonny Murray as an ensemble to

provide the soundtrack for *New York Eye and Ear Control* which was also released as a record.

18. Jonas Mekas and P. Adams Sitney, "Conversation with Michael Snow," *Film Culture* 46: 3. "The most developed of the 'dispersed' compositions was the 11 part steel composition I did mostly in '66 for Expo '67 in Montreal. The 11 variations were scattered over large area, couldn't all be seen at once. One came upon them. This was the last walking woman work." Snow, "Letter from Michael Snow," Ibid.: 5.

19. Robert Morris, "Notes on Sculpture," in Battcock, *Minimal Art*, 232, 234. Originally published in *Artforum* as "Notes on Sculpture, Part II," October 1966.

20. Morris, 234.

21. Snow in Dorothy Cameron, *Sculpture '67* (Ottawa: Queen's Printer, 1968), 12. "*First, Last* comes from the window pieces that I did beginning three years ago. This business of framing derives from a series running from the first 'Walking Woman' paintings (where the figure was framed, cut-off) to the last highly polished 'Walking Woman' sculptures at Expo (which framed within themselves the reflected outside action). But both here and in the window pieces I am interested merely in *framing* itself. This piece is a kind of absolute that frames things that are fortuitous.... Any chance thing can suddenly appear in it: whatever is going on on either side or in the sky.... This sculpture is so internal that it feeds on what is external. It composes by the very limitations it imposes."

Fifteen years later in written interview response, Snow elaborated on his fascination with the camera apparatus:

"My attention was directed to the camera as a director of attention from considerations of Art itself being (in another situation) a director of attention. Similarly cameras both intensify and diminish aspects of normal vision and they 'set apart' those aspects for possible examination. By the object-memory which they produce (photos, films, tape), they give a locus for and evidence of selection, of choice. The rectangular camera frame/mask, of course, continues the human intervention of architecture and sets up the possibility of a perhaps edifying dialogue between the rectangle and all its specifically human content with the nature (that might be) pictured through the camera or in the rectangular result. That the photographer/viewer is hidden in this architectural paradigm also becomes interesting.... The result of framing in photography is always a fragment, making the camera potentially analytical, an epistemological tool. That's to say (to repeat?) that out of the universal field, knowledge isolates, selects and points out unities or differences which were not previously evident. Identification, definition is a matter of limits, of recognition of limitations, bounds, boundaries. There are ways of indicating the depth of implication of this human viewer instrument between us and the rest of the universe. Lenses extend, expand or contract vision (abstract it) in both the optical and chimerical senses. I'm interested in the way that the products of cameras are ghosts of their subjects. Less than dessicated, wonderful as the relic is, it has (almost) only two dimensions. Still photographs are suffused with nostalgia seconds after their taking/making. Cinema ghosts are more active, Flying Dutchmen.

"I don't know why I became interested in these things. It gradually became evident to me that more was to be done in this area, that I was especially interested in time, that I might learn something about it, myself and what-it-all-means...." "Michael Snow and Bruce Elder in Conversation," *Cine-Tracts* 17 (1982) reprinted as "A Conversation," *Afterimage* 11 (Winter 1982–83): 34–35. Of interest is the notion of ghosts which has relevance to my discussion of *Scope* below.

For an interview on the camera related work, see Pierre Théberge "Conversation with Michael Snow," *Michael Snow* (Lucerne: Kunstmuseum Luzern, 1979), especially p. 17.

22. "Opposites. Film I'm working on seems to concern itself with the poetry of juxtaposition of the static and dynamic, absence, presence, development of events-for-capture = art series of photographs taken in Toronto April '62." Snow, "A Lot of Near Mrs.," 19.

23. See note 13.

24. Michelson, "Toward Snow," *Artforum*: 33.

25. "I'd thought fleetingly of calling it *Protective Measures*, which is more or less relevant too, but is also only an aspect." "7 questions + 1…," *artscanada*: 30.

The reference to Kramer's "the atmosphere of a chic concentration camp" is taken from "Farewell to a Lady," *Time* (Canadian Edition), Jan. 24, 1969: 17. See also the title to a review of the Isaacs exhibition by Gail Dexter, "Sculpture makes gallery something like a prison." *Toronto Daily Star*, Jan. 16, 1969: 40.

On the Poindexter exhibition: "Seen from the street the piece [*In Place*] looks like a section of a Brinks armored car with a peculiarly shaped gun slot." John Perrault, "The Act of Seeing," *Village Voice*, Feb. 8, 1968: 19.

On one sheet of notes, Snow tried out titles such as: "storm cage, blizzard cage, concentration storm," and on another: "blizzard concentration, blizzard cage/jail/prison, storm camp, surveillance."

26. In 1965, as an "advertisement" for an upcoming Walking Woman exhibition at the Poindexter, Snow performed *Right Reader* at the Filmmakers Cinemateque. See *Michael Snow/A Survey*, 62, for photographs and a text on the performance by Richard Foreman, and Dompierre, *Walking Woman Works*, 12, 14, for Snow's comments. The year Snow constructed *Scope* he also staged a performance with himself and Joyce Wieland involving communication through mirrors of actions repeated by the participants but partly hidden from the audience.

In a different context in the interview "A Conversation," *Afterimage*: 49, Snow unites the names Heraclitus and Sartre after his discussion of *Sight*, the two names being an intriguing philosophical conjunction operative in the work: what is seen — the Heraclitian flux; what is being seen in the look of the other — our viewing. See Sartre's situation of being at a keyhole, in "The Look," *Being and Nothingness* (New York: Philosophical Library, 1956), 259 ff.

27. Snow in *Sculpture '67*, 12.

28. Titles in Snow's notes that unite perceptual effects to his name or its associations include: "inside winter, storm cage, blizzard cage, concentration storm, snow storm, blizzard concentration, blizzard prison, storm camp."

"My father, who was a surveyor then civil engineer during most of his life had only one eye, then lost the sight of his other eye during my teens, which made us both very interested in vision." "A Conversation," *Afterimage*: 36.

On the self-referentiality of Snow's work, see Philip Monk, "Colony, Commodity and Copyright," *Vanguard* 12: 5–6 (June 1983), reprinted in Philip Monk, *Struggles with the Image* (Toronto: YYZ Books, 1988), 95–99.

Hollis Framptom made a film, titled *Snowblind*, using the optical effects of *Blind*.

29. "Literalist sensibility is theatrical because, to begin with, it is concerned with the actual circumstances in which the beholder encounters literalist work…. The theatricality of Morris's notion of the 'nonpersonal or public mode' seems obvious: the largeness of the piece, in conjunction with its

nonrelational, unitary character, *distances* the beholder — not just physically but psychically. It is, one might say, precisely this distancing that *makes* the beholder a subject and the piece in question … an object. … But the things that are literalist works of art must somehow *confront* the beholder — they must, one might almost say, be placed not just in his space but in his way." Fried, "Art and Objecthood," 125, 26, 27. On Morris, see, Maurice Berger, *Labyrinths: Robert Morris, Minimalism, and the 1960s.*

30.  The political climate in which a film such as *Wavelength* could be seen and criticized in the period is revealed in the leaflet distributed at the Knokke-le-Zoute festival at which Snow won the $4000 first prize:

"FIGHT AGAINST THE OPEN AND THE UNDERGROUND AMERICAN IMPERIALIST AND CINE-IMPERIALIST AGGRESSION ALL OVER THE WORLD.

"The international capital recruits its boys: Gaevert-Agfa lends them a roll of filmmaterial and pays the one who is most obedient with 4000 US dollars: every meter film showing a naked ass out of the metropoles keeps silence about a burned body in Vietnam making more profit than 4000 US dollars." etc. The statement is reproduced in P. Adams Sitney, "Report on the Fourth International Experimental Film Exposition at Knokke-le-Zoute," *Film Culture* 46: 6.

On the other hand, consider a later evaluation of the political function of film — albeit a particular notion of politics: "Despite the lack of any evident political signified (as though such an 'evidence' could furnish criteria), Snow's films are politically insistent in their question of the cinematic institution of the subject in film, their question of another subjectivity — material, heterogeneous, in process —, of a film that *makes a body.*" Stephen Heath, "Film Performance," *Questions of Cinema* (Bloomington: Indiana University Press, 1981), 129.

### 3. Shaping Time, Shaping Space: Wavelength

31.  He continues: "And since he's been concerned almost exclusively with process and perception, one can say that the film work has qualitatively improved the sculptures." Gene Youngblood, "Icon and Idea in the World of Michael Snow," *artscanada*, 27: 1 (Feb. 1970): 10.

32.  Of Snow's many comments on this subject, a contemporary one suffices: "I tend to make sculpture that is sculpture, and films that are films, and I don't want to see them both together. I think each should have power enough within its own medium to be of interest. The term 'mixed media' is often used to describe a kind of impressionism and I'm more interested in the specific than the general." Snow in *Sculpture '67*, 12. Also see note 34.

33.  Michael Snow, "A Statement on *Wavelength* for the Experimental Film Festival of Knokke-le-Zoute," *Film Culture* 46: 1.

34.  " … since I started to get a clear idea of what seemed of interest in film — since '63, I guess it was, or when I made *New York Eye and Ear Control* in '64 — it seemed to me that some elements of the medium have possibilities of content of their own that have only been used for some other purposes, in a way …" George Csaba Koller, "Interview with Michael Snow," *Cinema Canada*, 4 (Oct.–Nov. 1972): 51.

35.  Michael Snow, in *New York Filmmakers Cooperative Catalogue.*

36.  Within the active-passive opposition, the camera-eye substituting for the viewer and filmmaker is active while the Walking Woman is passive, subject to different optical and perceptual

conditions, including hanging, burning, being run over. This structure repeats itself in the treatment of the "actors," the women passively compared to the "ideal" cutout of the Walking Woman, while the men — those who make up the jazz ensemble — are individuated in portraits.

37. "[Most other films] don't use the material. They use the mechanism, but they don't use *duration* and they don't use *light* for the qualities and contents that are possible from using those things as the actual material of the medium. The material of the medium isn't, you know, showing somebody killing somebody, or whatever the usual subjects are; the material is shaping light and shaping time, and that's what you do when you make a film." Snow, interviewed in Koller, *Cinema Canada*: 51.

38. "*Eye and Ear Control* was finished summer '64 and sometime late fall saw first Warhols: *Henry Geldzahler* and others at the New Yorker which I very much admired. I was amazed at the coincidences, I mean shocked, to my thinking in *Eye and Ear*. I not only used lightstruck ends, there are a set of 'portraits' and the time sense is similar. To continue the amazement I later read about *Empire*. In *Eye and Ear* there is a dawn sequence which is much shorter than I'd intended but it is essentially the same thought.... The differences are of course vast as well. When I started thinking, jotting notes for *Wavelength* it occurred to me that it might be a little like *Empire*. It didn't come from there tho. The similarities are partly the background of our thinking which came from the issues of the painting world: Oldenburg, Jasper Johns, Duchamp." Snow, "Letter from Michael Snow," *Film Culture*: 5.

39. P. Adams Sitney, "Michael Snow's Cinema," 82; *Visionary Film: The American Avant-Garde* (New York: Oxford University Press, 1974), 412. These polarities are what makes the film "philosophical" in its analytical character: "For him *New York Eye and Ear Control* analyses modes of action, philosophy being a curriculum extending from ethics to logic, but excluding metaphysics." Sitney, 420.

See Youngblood on the film's relation to Warhol: "*Wavelength* is post-minimal because, thanks to cinema, it can deal empirically with illusion, that is, a wider range of vision than usually is engaged in the plastic arts. It is post-Warhol because it confronts the illusory nature of cinematic reality; it presents not only 'pure' time and space, but also *filmic* time (fragmented) and space (two-dimensional, nonperspectival). It is more metaphysical than Minimal. *Wavelength* is a romantic movie." Gene Youngblood, "Michael Snow: *Wavelength*," *Expanded Cinema* (New York: Dutton, 1970), 126–27. Youngblood's description of *Wavelength* is very inaccurate. Descriptions of *Wavelength* vary in accuracy. The fullest representations are those by Regina Cornwell, *Snow Seen: The Films and Photographs of Michael Snow* (Toronto: PMA Books, 1980), 60–79, superseded by Bruce Elder, *Image and Identity: Reflections on Canadian Film and Culture* (Waterloo: Wilfrid Laurier University Press, 1989), 188–213. In citing only Michelson's and Sitney's descriptions below, I am concentrating on the first interpretations that set the context for and reception of *Wavelength*.

40. "The walking woman thing was a whole sort of variation which is related to jazz. The theme and variation thing. And while I was doing them I was thinking that maybe a lot of the paintings I did should be seen in time — that there should be a serial display of the variations. That was one of the things that preceded *Wavelength*. This idea of having the variations follow each other in time is like jazz, or any music. *The Goldberg Variations* especially." Snow interviewed in Joe Medjuck, "The Life & Times of Michael Snow," *Take One*, 3:3 (Jan.–Feb. 1971): 8.

41. Sitney, *Visionary Film*, 407. "*A structural film creates its primal impression with its overall shape. Wavelength* hyperbolizes this form: not only is its shape its primary impression, but that shape appears before the viewer from the very first minute of the film. In other 'structural films' the shape becomes evident at the end of the first viewing. In fact, the lucid shaping of *Wavelength* first led me to consider

the existence of a new formal category; the article referred to ['Structural Film'] emerged out of that consideration." Sitney, "Michael Snow's Cinema," 80.

For reconsiderations of structural film and Sitney's role, see Paul Arthur, "Structural Film: Revisions, New Versions, and the Artifact," *Millenium Film Journal* 1:2 (Spring–Summer 1978): 5–13; and "Structural Film: Revisions, New Versions and the Artifact. Part Two," *Millenium Film Journal* 4:5 (Summer–Fall 1979): 122–34; David E. James, *Allegories of Cinema: American Film in the Sixties* (Princeton: Princeton University Press, 1989).

42. Sitney, *Visionary Film*, 408. For a critique of this view of Sitney's and Michelson's, see Constance Penley, "The Avant-Garde: Histories and Theories," *Screen* 19: 3 (Autumn 1978), reprinted in Penley, *Future of an Illusion: Film, Feminism and Psychoanalysis* (Minneapolis: University of Minnesota Press, 1989), 31–37.

43. Sitney, "Michael Snow's Cinema," 79. Also see the statements by Jonas Mekas: "Philosophical cinema? Can there be such a thing?…A philosophical cinema, a treatise on the essence of reality, that's what Snow's films are to me." "A Note on Michael Snow, written in a Minnesota Snowstorm," *Take One*, 3:3 (Jan.–Feb. 1971): 12, reproduced in Pierre Théberge, *About Thirty Works by Michael Snow.* (Ottawa: National Gallery of Canada, 1972), 7–8. This view was common among the Minimalist and Conceptual artists: for example, Michelson writes typically of Robert Morris: "An enterprise of this kind is critical in each sense we commonly attach to the word, and in one other; its fullest comprehension commands recognition of the singular resolution with which a sculptor has assumed the philosophical task which, in a culture not committed on the whole to speculative thought, devolves with a particular stringency on its artists." "Robert Morris — An Aesthetics of Transgression," *Robert Morris* (Washington: The Corcoran Gallery of Art, 1969), 7.

44. Michelson, "Toward Snow," *Artforum*: 30.

45. Among others, refer to this critique in Richard Rorty, *Philosophy and the Mirror of Nature* (Princeton: Princeton University Press, 1979). (We will have to ask ourselves in relation to this film what today constitutes "conditions of knowledge" which is more an issue of representation and power now than one of epistemology.)

46. For instance, Bruce Elder repeats this claim from the opening lines of "Michael Snow's *Wavelength*," in *Image and Identity*, 188–213.

47. Michelson, "Toward Snow," *Artforum*: 31. The quotation in Michelson's text is from Husserl's *Cartesian Meditations.*

48. Michelson, "Toward Snow," *Artforum*: 32. In 1979, as the promised part 2 of her 1971 "Toward Snow" article, Michelson revised her views on *Wavelength* in light of the "apparatus" debates that took place in French film theory by reconsidering Snow's restoration of narrative space as confirmation of the transcendental subject. "He had, in fact, by restoring and remapping the space of perspective construction, reestablished its center, that place which is the space of the transcendental subject. *Wavelength*, then, appeared as a celebration of the 'apparatus' and *a confirmation of the status of the subject*, and it is in those terms that we may begin to comprehend the profound effect it had upon the broadest spectrum of viewers — especially upon those for whom previous assaults on the spatiotemporality of dominant cinema had obscured the subject's role and place. The spectator for whom that place was obscured — and threatened — by the spatial disorientations of, say *Dog Star Man*, (a space purely optical and a temporality of the perpetual present) could respond, as if in gratitude, to Snow's apparently gratifying confirmation of a threatened sovereignty." "About Snow," *October* 8 (Spring 1979): 118.

Whether or not this refers to her own spectatorship, its sleight-of-hand revisionism obscures the role Michelson played in her original phenomenological reading of *Wavelength*. Nevertheless, Baudry's discussion of the ideological basis of cinema in the replication of Renaissance perspectival construction through the optics of the lens is pertinent to both the zoom and the space of *Wavelength* (as are his comments and therefore implicit critique of Michelson on "the constituting transcendental function to which narrative continuity points"). Michelson, at least, maintains that Snow subjected these norms "to constant analytic transformation.... The depth and integrity of the perspective construction is at every point subjected to the questioning and qualification imposed by the deployment of anomalies as differences within the spatiotemporal continuum." "About Snow": 118. For further discussion of this space, see note 62.

For Baudry see, Jean-Louis Baudry, "Effets idéologique de l'appareil cinématographique de base," *Cinéthique* 7–8 (1970): 1–8. Translated as "Ideological effects of the basic cinematographic apparatus," *Film Quarterly* XXVIII: 2 (Winter 1974–75). Also "Le dispositif," *Communications* 23 (1975): 56–72; translation "The Apparatus," *Camera Obscura* 1 (Fall 1976): 104–26. Both articles are reprinted in Theresa Hak Kyung Cha, ed., *Apparatus* (New York: Tanam Press, 1981), 41–83, from which the Baudry reference above comes: 32.

Bruce Elder has taken Baudry's critique of the phenomenological subject film confirms, ironically, for *positive* application to Snow's films: see his "Snow's Transcendental Self," and "The Transcendental Self, *La région centrale*, and Idealist Thought," *Image and Identity*.

49. By changing to a panning motion of the camera from side to side in ←→ rather than a zoom in depth as in *Wavelength*, Snow rid the later film of any mistaken identification and absorption of the spectator in the "depth" of the space of the image. Discussing the space of ←→, Snow wrote: "You aren't within it, it isn't within you, you're beside it. ←→ is sculptural, because the depicted light is to be outside, around the solid (wall) which becomes transcended/spiritualized by motion-time whereas in *Wavelength* it is more transcended by light-time." Snow, "Letter from Michael Snow," *Film Culture*: 4.

In a recent interview on *Wavelength* Snow warned the interviewer of a too mimetic attraction and participation, which the interviewer called "existential": "I'm not so much interested in depicting — although my work is representational — as in making a kind of phenomenon that's as much itself as you are. And it doesn't necessarily have to take you into it — it's just that it has its own strength and you're here and it's there. With regard to my films, for instance, you don't really disappear into them in the same way you might with a fiction film because there's an objective level that remains, I think, in watching them." "Michael Snow in Conversation with John Massey," *C Magazine* 38 (Summer 1993): 19.

50. Such has been the ambiguous role Snow and *Wavelength* have played for the British Structural/Materialist filmmakers/theorists such as Malcolm Legrice and Peter Gidal. For a review of these interpretations see Michael O'Pray, "Framing Snow," *Afterimage* 11 (Winter 1982–83): 51–65. For an exchange between Gidal and Michelson on her Snow article, see "Foreword in Three Letters," *Artforum* 10:1 (Sept. 1971): 8–9. Michelson's reference to Manny Farber's review of *Wavelength*, "Film," *Artforum* 7:5 (Jan. 1969): 70–72, reprinted in *Negative Space: Manny Farber at the Movies* (New York: Praeger, 1971), 250–55, and the narrative space of action is central to their exchange.

For a discussion of the the diegetic rather than narrative production of *Wavelength*, see Noël Burch, trans. and ed. Ben Brewster, *Life to those Shadows*, Berkeley: University of California Press, 1990), 255–59.

51. "Conversation with Michael Snow," *Film Culture*: 3.

52. Snow's comments on murder in note 7 seem to pertain to this incident and may be the reason for the choice of this particular type of event for the film for the structural expectations it sets up in commercial film that are not met here. In fact, as the zoom relentlessly passes over the body, we even forget that it is there as it passes out of the frame, until it is recalled to us by the telephone call. In the reality of the film, the glissando carried more of the traditional role of building climax as it accompanies the zoom both reinforcing the relentless plotting of a fated sense of time. "It's the movement of time, which is inexorable. It is fated. And fate is really a proper subject for films. Since their end is already in their beginning, to work with fate is very apropos." "Michael Snow in Conversation with John Massey," *C Magazine*: 21. "…the medium of cinema, it seems to me, is quite properly concerned with fate. I mean, what is a more appropriate content for a medium that is a temporal structure that's determined?…The whole element of fate that's in Agamemnon too, it's in all these things; it's in cinema. I hope it's in all my films. The mystery of going and not knowing where you're going, but the way is predetermined." Snow interviewed in Jonathan Rosenbaum, "Snowbound: A Dialogue with a Dialogue," *Afterimage* 11: 68.

53. Elder, for instance, makes too much of this opposition in *Wavelength*, "Michael Snow's *Wavelength*," 189–90. Speaking of his 1980–81 film *Presents*, Snow said: "Then, within each of the 2 major sections, there are fluctuations of emphasis from the 'concrete/materialist' to the 'naturalistic/realist'. In my own monologues about my work, I call these changes in 'type of belief'." Snow and Elder, "A Conversation," *Afterimage*: 43. Also see Snow's comments to Rosenbaum on the equalization proper to film and in his *Presents*. "Snowbound": 68.

54. "If *Wavelength* is metaphysical, *Eye and Ear Control* is philosophical and ◄—► will be physics." Snow, "Letter from Michael Snow," *Film Culture*: 4.

55. Snow, "Letter from Michael Snow," *Film Culture*: 4.

56. See Regina Cornwell's description of *Wavelength*'s zoom in its relation to the structural principles of Minimalism, *Snow Seen*, 73–4.

57. See Sitney's comments on Michelson quoted below.

58. For instance Duke Ellington and then a nude woman in a room were considered subjects. Asked by Sitney, "Which part of the concept of *Wavelength* came first?," Snow replied: "The zoom. I was searching for the place for a long time and I didn't know where it started or where it went. It was just the idea of a long zoom." "Conversation with Michael Snow," *Film Culture*: 3.

59. Snow, "Letter from Michael Snow," *Film Culture*: 5.

60. "It is attempting to balance out in a way all the so-called realities there involved in the issue of making a film. I thought that maybe the issues hadn't really been stated clearly about film in the same sort of way — now this is presumptuous, but to say — in the way Cézanne, say, made a balance between the colored goo that he used, which is what you see if you look at it in that way, and the forms that you see in their illusory space. That whole issue in film has been touched on by lots of people, that it's light, and it's on a flat surface, and it's also images. A kind of space that seems natural to it is maybe conical, but flattened. I can't explain how that seems proper. But it's something to do with that and that (Snow indicates first the flat of a screen with his palm and then the conical projection beam with both hands): the beam and the flat surface." "Conversation with Michael Snow," *Film Culture*: 3. "I mentioned Cézanne in a comment about the illusion/reality balancing act in painting. Tho many others painters have worked out their own beautiful solutions to this 'problem', I think his

was the greatest and is relevant because his work was representational. The complicated involvement of *his perception of exterior reality, his creation of a work which* both *represents* and *is* something, thus his balancing of mind and matter, his respect for a lot of levels are exemplary to me. My work is representational. It is not very Cézannesque tho. *Wavelength* and ←→ are much more Vermeer (I hope)." Snow, "Letter from Michael Snow," *Film Culture*: 5.

61. A second version has: "An ambition: to make a definitive statement of pure film space. Huge generalizations in painting since Cézanne's masterpiece 'space' has been a 'subject' of painting, having to do with a balancing of 'illusion' and 'fact'. I wanted to do this for film with light not paint as 'representational' not as 'abstract' art."

62. Snow, "Letter from Michael Snow," *Film Culture*: 5. For an unique, corrective analysis of the role of the zoom, see William C. Wees, "Prophecy, Memory and the Zoom: Michael Snow's *Wavelength* Re-viewed," *Cine-Tracts* 4: 2–3 (Summer-Fall 1981): 78–83.

That *Wavelength*'s deep space does not follow perspectival construction but is composed of many orders perhaps gives it a special place in the apparatus debates referred to in note 48. Jean-Louis Comolli discusses the role of deep focus in the construction of verisimilitude in early film through the constitutive codes of perspective and its historical effacement: "It is by the transformation of the conditions of this credibility, by the displacement of the codes of cinematic verisimilitude from the plane of the impression of reality alone to the more complex planes of fictional logic (narrative codes), of psychological verisimilitude, of the impression of homogeneity and continuity (the coherent space-time of classical drama) that one can account for the effacement of depth." All these codes seem in question in *Wavelength* partly through the theatricalization of the zoom of the camera placed high on its tripod, which both strengthens the belief in the image at the same time that it dramatizes the space: "This is why cinematic deep focus does not slip into the 'naturalness' of linear perspective, but inevitably stresses that perspective, accentuates it, indicates its curvature, denounces the visual field it produces as a construction, a composition in which there is not simply 'more real' but in which this more visible is spatially organised in the frame, dramatised. Deep focus does not wipe out perspective, does not pass it off as the 'normality' of vision, but makes it readable as coding (exteriorisation of the interiorised code); it de-naturalises dramatises it." Jean-Louis Comolli, "Machines of the Visible," in Teresa de Lauretis and Stephen Heath, eds. *The Cinematic Apparatus* (New York: St. Martin's Press, 1980), 130, 137. Also see, Comolli, "Technique and Ideology: Camera, Perspective, Depth of Field," originally published in 1971 in *Cahiers du Cinéma*, reprinted in *Film Reader* 2 (January 1977): 128–40.

63. Snow, "Letter from Michael Snow," *Film Culture*: 5. "*Wavelength* was trying to be aware of the fact that films are made up of single frames." "Michael Snow and John Massey in Conversation," *C Magazine*: 24.

64. Sitney, *Visionary Film*, 413.

65. One of the characteristics of the zoom Wees concentrates on in *Wavelength* is constancy of the photograph in the centre of the frame due to the optical mechanics of the zoom. "Presumably this is why Snow says that from the beginning of the film, the end is 'fated.' The end is visibly present in the beginning: a grey spot precisely in the centre of the projected image. There is no 'choice' but for the end to increasingly manifest itself through the photograph's increasing size.... Thus it is that *Wavelength*'s zoom permits us to perceive, cinematically, that interpenetration of beginning and end ... It is also in this way that the interpenetration of space and time is made visible. As the zoom is the 'cause,' so is the photograph the 'effect.' It is the visible evidence of a telescoping of centre and periph-

eries, time and space, beginning and end. Hence the particular significance in the fact that the film is centered on the photograph throughout. The photograph is literally the center of the film's projected image from begining to end, and at every moment it embodies, in Snow's phrase, 'prophecy and memory'…." On the concluding image, where the zoom stops because the photograph cannot be penetrated by the optics of the zoom as the room has, Wees offers a different opinion from mine: "Although there is nothing more that the zoom lens can show us, the film does not end on a dead center of exhausted perception. The spatial flattening produced by the zoom does not, finally, affirm the flatness of the photograph/screen, but, instead, releases a qualitatively different sense of depth than that we had experienced as long as the wall provided a 'ground' for the photograph and pre-vented our experiencing the photograph's 'infinity.' By the same token, the film does not simply reduce itself to the materiality of the screen and the flat image projected on it. It ends by suggesting that its materiality is not 'the end' at all. At least, that is what I take to be the implications of the 'flat-tening' effect leading to, and being superceded by, the perception of 'infinite' depth, and the increas-ingly blown-up image of the photograph being erased by a final vision of pure, unobstructed light. Where the film ends, the imagination is encouraged to carry on, free of material constraints." Wees, "Prophecy, Memory and the Zoom," *Cine-Tracts*: 81, 82.

66. Sitney, *Visionary Film*, 423.

67. "Conversation with Michael Snow," *Film Culture*: 3. "*Wavelength* starts wide and goes to one thing which has wide implications. As far as the space in the image is concerned, that's what it does….

Q: By wide, do you mean spatially?

S: Yeah, and in terms of references." Snow interview with Jonathan Rosenbaum, *Film Comment* (May–June 1981): 36–37.

68. Sitney, *Visionary Film*, 420-21., "Discovered the high angle to have lyric God-like above-it-all quality." Snow, "Letter from Michael Snow," *Film Culture*: 5.

69. "My own fairly obsessive attempts at resolving existential problems have always started from an attempt at realising a specific concrete/materialist base. Successive seeming clarifications in my philosophy as in many others always head to Mystery. I'm not a 'literary' philosopher but, if we are here to name everything, it all has to build to a Transcendental Signifier. Out of facetious humility, I'm 'religious'." "A Conversation," *Afterimage*: 41. "I think if you don't recognize that certain kinds of examinations of reality bring you to a stage that asks for metaphysics, you're being stupid." Rosenbaum, "Snowbound," *Afterimage*: 75

70. Simon Hartog, "Ten Questions to Michael Snow," *Cinim* 3 (Spring 1969): 3-4, reprinted in Peter Gidal, ed. *Structural Film Anthology* (London: British Film Institute, 1976), 37.

71. Snow, "Letter from Michael Snow," *Film Culture*: 4.

72. "…I've been trying to give some attention to how 'one thing leads to another' or more accurately: 'the ways in which one action leads to another'." Snow, "Passage," *Artforum* 10:1 (Sept. 1971): 63.

73. "Letter from Michael Snow," *Film Culture*: 5.

74. Paul de Man, "The Rhetoric of Temporality," *Blindness and Insight* (Minneapolis: University of Minnesota Press, 1983), 206–07, 226. "The dialectical relationship between subject and object is no longer the central statement of romantic thought, but this dialectic is now located entirely in the tem-poral relationships that exist within a system of allegorical signs. It becomes a conflict between a con-

ception of the self seen in its authentically temporal predicament and a defensive strategy that tries to hide from this negative self-knowledge." Ibid., 208. An allegorical interpretation of *Wavelength* would account, for instance, for Michelson's own troubling revision from her 1971 to her 1979 article (see note 48). De Man's article, first published during this period in 1969, expresses the conflicts within the film that Michelson could not recognize: see her "Art and the Structuralist Perspective," a 1969 lecture published in *On the Future of Art* (New York: Viking, 1970), 37–59. De Man's essay was a resource for Sitney. "The structural film — and *Wavelength* may be the supreme achievement of the form — has the same relationship to the earlier forms of the avant-garde film that Symbolism had to its source, Romanticism. The rhetoric of inspiration has changed to the landscape of aesthetics; Promethean heroism collapses into a consciousness of the self in which its very representation becomes problematic; the quest for a redeemed innocence becomes a search for the purity of images and the trappings of time. All this is as true of structural cinema, as it is of Symbolism." *Visionary Film*, 417.

## 4. Autonomic Art

75. Snow's prior exhibition at the Isaacs Gallery in 1966 was still Walking Woman Works and he had a retrospective of the series at the Vancouver Art Gallery in 1967. At Expo '67, his Walking Woman was well represented by its function as a public sculpture at the Ontario pavilion.

For a review of the situation of sculpture in Canada, see Philip Monk, *Robin Collyer* (Toronto: Art Gallery of Ontario, 1993), 16–17, 89 n. 2. That year, 1967, also saw the publication of Canada's first major art history, J. Russell Harper's *Painting in Canada*, its title indicating clearly the obstacles sculpture would have to overcome to bring Canadian art into line with the defining work done elsewhere.

Harry Malcolmson, "Michael Snow — after Walking Woman," *Toronto Daily Star*, Feb. 10, 1968: 34.

76. "7 questions + 1...," *artscanada*: 30–31.

77. Robert Fulford, "Apropos Michael Snow," *Michael Snow/A Survey*, 11–12.

78. Théberge, *About 30 Works by Michael Snow*, 37.

79. Snow, "Letter from Michael Snow to Peter Gidal on the film *Back and Forth*," Gidal, *Structural Film Anthology*, 51.

## 5. Time, Light, Sound

80. Snow quoted in Jud Yalkut, "*Wavelength*," *Film Quarterly* 21:4 (Summer 1968): 51. Snow, "Letter from Michael Snow," *Film Culture*: 4.

81. Snow quoted in "Michael Snow: A Filmography," *Afterimage* 11 (Winter 1982–83): 10.

82. Michelson, "Toward Snow," *Artforum*: 30, 32; "About Snow," *October*: 113.

# Exhibition List

## Sculpture

1. *Atlantic* 1967
   Metal, wood, photographs, arborite
   171.1 x 245.1 x 39.9 cm
   Art Gallery of Ontario, Purchase, 1980
2. *First to Last* 1967
   Painted wood, aluminum, glass
   208.5 x 208.5 x 15.2 cm
   Art Gallery of Ontario, Purchase, 1985
3. *Sight* 1967
   Aluminum, engraved plastic
   142.2 x 106.7 cm
   Vancouver Art Gallery, purchased with
   funds from the Vancouver Foundation
   Endowment and the Canada Council
4. *Scope* 1967
   Stainless steel, mirrors
   2 elements: 175.3 x 396.2 x 91.4 cm
       137.2 x 71.1 x 27.9 cm
   National Gallery of Canada, Ottawa
5. *Blind* 1967
   Painted aluminum and steel
   243.8 x 243.8 x 243.8 cm
   National Gallery of Canada, Ottawa
6. *Portrait* 1967
   Aluminum
   Variable dimensions:
   approximately 60.9 x 91.4 cm
   Private collection
7. *Aluminum and Lead* 1968
   Aluminum, lead
   Height adjustable, cross bar 304.8 cm,
   lead ingots 53.3 and 33.0 cm
   Art Gallery of Ontario, Purchase, 1969
8. *View* 1968
   Plastic, steel cable
   55.88 x 76.2 x 7.62 cm
   Mrs. Peter MacLachlan, Toronto
9. *Membrane* 1969
   Chromed steel, wood, rubber
   9.5 x 48.9 x 67.3 cm
   S.L. Simpson Gallery, Toronto
10. *432101234* 1969
    Chromed steel, aluminum, sponge rubber
    33.0 x 48.9 x 67.3 cm
    Peggy Gale, Toronto

## Photography

11. *Snow Storm, February 7, 1967* 1967
    Black and white photographs,
    enamelled masonite
    121.9 x 121.9 cm
    National Gallery of Canada, Ottawa
12. *Authorization* 1969
    Black and white polaroid photographs,
    tape, mirror, metal
    54.5 x 44.5 cm
    National Gallery of Canada, Ottawa
13. *Press* 1969
    Black and white photographs, plastic, metal
    182.9 x 182.9 x 25.4 cm
    Dr. & Mrs. Sydney L. Wax, Toronto
14. *8 x 10* 1969
    80 black and white photographs
    Each: 20.32 x 25.4 cm
    S.L. Simpson Gallery, Toronto
15. *Tap* 1969
    Framed black and white photograph,
    framed typewritten text on paper,
    tape player, speaker, wire and sound tape
    106.8 x 156.3 cm; 65.1 x 40.0 cm;
    48.3 x 38.1 x 25.4 cm
    National Gallery of Canada, Ottawa
16. *Untitled Slidelength* 1969–71
    80 35mm colour slides
    S.L. Simpson Gallery, Toronto

**Films**

17. *Wavelength* 1966–67
    45 min., colour
    Art Gallery of Ontario
18. *Standard Time* 1967
    8 min., colour
    Art Gallery of Ontario

19. ←→ 1968–69
    50 min., colour
    Art Gallery of Ontario
20. *One Second in Montreal* 1969
    20 min., black and white
    Art Gallery of Ontario

## Selected Bibliography

### Catalogues

Cameron, Dorothy. *Sculpture '67.* Ottawa: Queen's Printer, 1968.

Dompierre, Louise. *Walking Woman Works: Michael Snow 1961–67.* Kingston: Agnes Etherington Art Centre, 1983.

*Michael Snow.* Lucerne: Kunstmuseum Luzern, 1979.

*Michael Snow/A Survey.* Toronto: Art Gallery of Ontario, 1970.

Smith, Brydon. *Michael Snow/Canada.* Ottawa: National Gallery of Canada, 1970.

Théberge, Pierre. *About Thirty Works by Michael Snow.* Ottawa: National Gallery of Canada, 1972.

### Books

Cornwell, Regina. *Snow Seen: The Films and Photographs of Michael Snow.* Toronto: PMA Books, 1980.

Elder, Bruce. *Image and Identity: Reflections on Canadian Film and Culture.* Waterloo: Wilfrid Laurier University Press, 1989.

### Reviews

POINDEXTER GALLERY, 1968:

A., J. "Michael Snow," *Art News* 67:1 (March 1968): 54.

Malcolmson, Harry. "Michael Snow — after Walking Woman." *Toronto Daily Star* (Feb. 10, 1968): 34.

N., R. "Michael Snow." *Arts Magazine* 42:5 (March 1968): 63.

Perrault, John. "The Act of Seeing." *Village Voice* (Feb. 8, 1968): 19.

ISAACS GALLERY, 1969:

Andrews, Bernadette. "Distorted reflections from sculptor Snow." *The Telegram* (Toronto) (Jan. 15, 1969): 61.

Dexter, Gail. "Sculpture makes gallery something like a prison." *Toronto Daily Star* (Jan. 16, 1969): 40.

"Farewell to a Lady." *Time* (Canadian edition) (Jan. 24, 1969): 17.

Kritzwiser, Kay. "The Shades of Snow's Walking Woman still walks." *The Globe and Mail* (Toronto) (Jan. 18, 1969): 26.

"7 questions + 1 on Michael Snow at The Isaacs Gallery." *artscanada* 26:2 (April 1969): 30–31.

### Film Criticism

*Afterimage* 11 (Winter 1982–83). Special issue "Sighting Snow." Includes: Hamlyn, Nicky. "Seeing is Believing: *Wavelength* Reconsidered.": 22–30; Snow, Michael, and Elder, Bruce. "A Conversation.": 32–49;

O'Pray, Michael. "Framing Snow.": 51–65; Rosenbaum, Jonathan. "Snowbound: A Dialogue with a Dialogue." 66–76.

*Film Culture* 46 (Autumn 1967; published October 1968). Includes Snow, Michael. "A Statement on *Wavelength* for the Experimental Film Festival of Knokke-le-Zoute." 1. Mekas, Jonas and Sitney, P. Adams. "Conversation with Snow,." 1–4. Snow, Michael. "Letter from Michael Snow." 4–5. Lamberton, Bob. "Wavelength." 5–6.

Farber, Manny. "Film." *Artforum* 7:5 (Jan. 1969): 70–73.

———. "Film." *Artforum* 8:5 (Jan. 1970): 81–82.

Gidal, Peter. "Back and Forth." Gidal, Peter, ed. *Structural Film Anthology*. London: British Film Institute, 1976: 45–9.

Hartog, "Ten Questions to Michael Snow." *Cinim* 3 (Spring 1969): 3–4; reprinted in Gidal, Peter, ed. *Structural Film Anthology*. London: British Film Institute, 1976: 37.

Mekas, Jonas. "A Note on Michael Snow, written in a Minnesota Snowstorm." *Take One* 3:3 (Jan./Feb. 1971): 12; reprinted in Théberge, Pierre. *About Thirty Works by Michael Snow*. Ottawa: National Gallery of Canada, 1972: 7–8.

Noguez, Dominique. "On *Wavelength*," in *Michael Snow*. Lucerne: Kunstmuseum Luzern, 1979: 93–108.

Sitney, P. Adams. "The Avant-Garde Film: Michael Snow." *Changes* (New York) 3 (June 1969): 15, 28.

———. "Michael Snow's Cinema." *Michael Snow/A Survey*. Toronto: Art Gallery of Ontario, 1970: 79–84.

———. "Structural Film." *Film Culture* 47 (Summer 1969): 1–10.

———. "Structural Film," *Film Culture Reader* New York: Praeger, 1970: 326–48.

———. *Visionary Film: The American Avant-Garde*. New York: Oxford University Press, 1974.

Snow, Michael. "Letter from Michael Snow to Peter Gidal on the film *Back and Forth*." Gidal, Peter, ed. *Structural Film Anthology*. London: British Film Institute, 1976: 50–1.

Wees, William C. "Prophecy, Memory and the Zoom: Michael Snow's *Wavelength* Reviewed." *Cine-Tracts* 4:2–3 (Summer-Fall 1981): 78–83.

Yalkut, Jud. "*Wavelength*." *Film Quarterly* 21: 4 (Summer 1968): 50–52.

Youngblood, Gene. "Michael Snow: *Wavelength*." *Expanded Cinema*. New York: Dutton, 1970, 122–27.

## Articles

Foreman, Richard. "Critique: Glass and Snow." *Arts Magazine* 44:4 (Feb. 1970): 20–22.

Michelson, Annette. "About Snow." *October* 8 (Spring 1979): 111–25.

———. "Toward Snow." *Artforum* 9:10 (June 1971): 30–37.

———, and Gidal, Peter. "Foreword in Three Letters," *Artforum* 10:1 (Sept. 1971): 8–9.

Michael Snow, "Passage," *Artforum* 10:1 (Sept. 1971): 63.

Youngblood, Gene. "Icon and Idea in the World of Michael Snow." *artscanada* 27:1 (Feb. 1970): 2–14.

## Interviews

Koller, George Csaba. "*La Région Centrale*/Michael Snow." *Cinema Canada* 4 (Oct.-Nov. 1972): 51–55.

Medjuck, Joe. "The Life & Times of Michael Snow." *Take One* 3:3 (Jan./Feb. 1971): 6–12.

Snow, Michael and Massey, John. "Michael Snow in Conversation with Michael Snow." *C Magazine* 38 (Summer 1993): 17–24.

Louise Dompierre

# Embodied Vision

The Painting, Sculpture, Photo-Work,
Sound Installation, Music, Holographic Work, Films
and Books of Michael Snow

from 1970 to 1993

# Embodied Vision

Louise Dompierre

Louise Dompierre is the Associate Director and Chief Curator, The Power Plant, Contemporary Art Gallery at Harbourfront Centre

## Looking Back Now

Walking through the exhibition — or, at this early stage, writing my way through it — in the imagined presence of the works, I find myself in constant touch with the past, re-living history. The sense of familiarity that emerges as I make my way through that past is, perhaps, as strong as the sense of disorientation I experience as I am about to try to explore its depth. It feels, somewhat, like re-visiting a large urban park or even a forest and not being quite sure how to proceed. There is, of course, a path, which others have followed and which I could take as well. At the same time, however, there is also the pleasurable temptation to look at the park in a new way. This, of course, is not without risks. I know, ahead of time, that I will occasionally slip back onto the path, enough, perhaps, to avoid losing my sense of direction entirely. At the same time, however, I also know that I do not want to avoid the delight of trying to look at things from a slightly different perspective.

As I make my way through the woods, I recognize some old landmarks. I also notice things I had never paid attention to before. While this is happening, I am also aware that there will be sights that I will ignore and others to which I will never even pay attention. In the end, although I will try to see as much as possible, to take it all in, in one full experience, I realize that there will be many things that will escape me. And that I will have to come again and again to look at the park. But what is the meaning of pleasure if it is not this?

## Passage: *Venetian Blind* and *Egg*

A way, perhaps, to begin this reflection would be to imagine ourselves in Venice, in 1970, and to focus our attention on Michael Snow's *Venetian Blind* (1970). The work consists of twenty-four photographs — snapshots, in fact — organized in a grid pattern in four rows of six. Each of the photographs is a close-up of the artist's face, eyes closed in the glare of the sun, set against the shimmering water surrounding Venice. Like most of Snow's titles, *Venetian Blind* is a visual pun emphasizing a rapport between a "blinding" sun, the eyelids and common house curtains known as "Venetian blinds". More importantly, perhaps, *Venetian Blind*, allows a glimpse into the artist's inner state.

389

For that reason alone it deserves attention.

One of a series of "self-portraits" by Snow, *Venetian Blind* structurally recalls such early works as *Four to Five* (1962) and the well-known *Atlantic* (1966). Like these two works, *Venetian Blind* draws from the notion of seriality and repetition emphatically to assert the image and draw attention to it. What makes this work unusual, however, is that it tends to allow speculation as to the artist's emotional state. Snow has rarely opted to focus upon himself or others in such a manner. And it is debatable whether this work allows such analysis. However, no other work similarly captures the feeling of euphoria, perhaps, that Snow might have experienced at this particular time in his life.

The 1970s began in earnest for this Toronto artist at the very beginning of that decade. Early that year, on 14 February to be precise, he was honoured by a major retrospective exhibition at the Art Gallery of Ontario. Organized by the curator Dennis Young, the exhibition was summed up in the following way by the American film critic and author Gene Youngblood: "The show amounts to a revelation, and Snow is recognized at last as one of the most important aesthetic sensibilities guiding us into the final third of this millennium."[1] Even then, this was no exaggeration. Snow was and has remained one of the inspiring figures of our times.

In June 1970 Snow found himself in Venice representing Canada at the prestigious international exhibition known as the Venice Biennale. At about the same time, *Aluminum and Lead* — a work acquired by the Art Gallery of Ontario in 1969 — was "chosen by the Government of Japan to represent Canada in the Expo Museum of Fine Arts, Osaka, Japan, 1970."[2] Although only forty-one years of age and still living in New York, Snow certainly could be said to have reached the peak of his career, at least in Canadian terms. On the face of it, it also looked as if the old adage had worked and that, indeed, "New York had made him."

In truth, matters were more complex than that. Certainly, the international acclaim accorded to *Wavelength* — the winner of the grand prize at the Fourth International Experimental Film Festival competition, Knokke-le-Zoute, in 1968 — did him no harm. As Annette Michelson observed, "the film ... broke upon the world with the force, the power of conviction which defines a new level of enterprise, a threshold in the evolution of the medium."[3] However, it should equally be noted that, despite the fact that he lived abroad, Snow had been a constant presence in Canada. In addition to the many exhibitions of his works that were held at the Isaacs Gallery on Yonge Street in Toronto, his work was also shown in several other institutions across the country. These not only afforded critics, such as Robert Fulford, and curators, such as the Art Gallery of Ontario's Dennis Young, and Pierre Théberge, of the National Gallery of Canada, the opportunity to gain a good understanding of his work, but provided an opportunity for Snow to continue to be seen as a full participant in the Canadian art scene. It should come as

Egg 1985

390

no surprise, therefore, that the maker of such masterful works as the Walking Woman series (1961-67) and *Wavelength* should be the focus of such attention at home, at the Canadian Pavilion in Venice, and in Osaka, Japan.

There is a current belief — based on the notion that retrospectives effect a sort of closure, or, at the very least, are perceived as doing so — that such exhibitions should be saved for later in an artist's career. If there is any basis to that view, it is hard to see how it applies to the career of Michael Snow. Certainly, there is no evidence to suggest that his 1970 exhibition at the Art Gallery of Ontario was detrimental to him in any way, neither curbing his creativity nor diminishing his opportunities to exhibit. The reverse, in fact, might be said to be true. Presented with a unique opportunity to reflect upon his broad accomplishments to date, Snow seemed to have been propelled into the most productive years of his career. This fact began to manifest itself the very year that those events were taking place.

Also in 1970, in addition to completing such works as *Venetian Blind*, *A Casing Shelved*, *Sink*, and *Crouch, Leap, Land*, Snow also worked on *La Région Centrale*, a film of epic proportions and a landmark in his career. Common to these and other current projects was Snow's growing interest in camera works. As the artist pointed out, "For the last three or four years, I have been influenced by films and by the camera. When you narrow down your range and are looking through just that narrow aperture of the lens, the intensity of what you see is so much greater."[4] In this context, *Venetian Blind* can also be seen as a bridge between the artist's early photographic works and his largely photo-related practice of more recent years.

*Venetian Blind* is a photographic essay attempting to capture time in its minute variations. Structurally, the work indexes slices of time in an effort to bring out every nuance of a particular instance. While changes can be apprehended on the artist's features, they are more strikingly reflected in the background. The face tends to suggest one time and place. The background, on the other hand, shows distinct variations in the positioning of the subject. In fact, each photograph acts as a different memory of almost the same action. Within an instant of time, and by means of the simple act of self-portraiture, the complexity of time and the relatedness of its various constituent parts are here concisely represented within an almost simultaneous past, present and future.

What is also interesting to note is that while it is evident that the artist is holding the camera, his back is also turned against the landscape, pointing to the fact that the camera is selecting the views against which the artist is represented. In fact, it could be said that the artist is in the way of the well-known tourist views behind him. The practice of making self-portraits that go beyond the conventions of self-portraiture (*Authorization*, 1969) as well as the idea of giving

autonomy to the camera — as he also did in *La Région Centrale* — could be said to characterize his work at about this period.

At the same time, however, the work equally emphasizes the inter-relatedness of Snow with the environment surrounding him. The artist is seated between the sun (frontally) and the Venetian landscape (background). In fact, the image shows him in between, caught in nature, a heaven of peace, one might presume, from the hectic and febrile activity of the Biennale.

The sense of staging that characterizes this work echoes the stage-like feeling that the city of Venice itself possesses. Venice is a city of the past with almost no space left in which to manifest the present. That Snow chose it as backdrop to his own emphatically asserted "presence" re-emphasizes the notion of "plural time" on which *Venetian Blind* plays. Furthermore, staging, the acknowledged role of nature in the shaping of the work, as well as the indexical structure of the photo-graph, are some of the characteristics that form the basis of further inquiries by Snow during the Seventies. *Egg*, a holographic self-portrait, created some sixteen years later for Expo '86, held in Vancouver, exhibits a related sense of *mise-en-scène* and similarly encapsulates time in one of its minute manifestations.

Within the installation of Snow's work at The Power Plant, *Venetian Blind* is hung behind *Egg*, a work that acts as the anchor to the exhibi-tion. If *Venetian Blind* marks the beginning of the Seventies, *Egg* imparts a sense of magic and drama that characterizes Snow's other-wise highly controlled practice of more recent years.

*Venetian Blind* begins with and in the Real. The event is an actual one in an identifiable environment. That fact or that occasion has then been subjected to a process of translation through the medium of photography. This transformation, while seemingly representing the Real, points to the impossibility of actually doing so. For which is "the" moment? At one level, the twenty-four images are this moment. At the same time, however, the various backgrounds — as well as the changing light on the artist's features — indicate that there were instants in between which were not recorded. Seemingly exhaustive in the way it appears to seize every nuance of a single event in time, the work simultaneously reveals the Real as a complex and multi-faceted entity that the camera can only begin to approximate. In fact, *Venetian Blind* is posed between what can be represented and what cannot; it is an inquiry into the parameters of the photographic process. More impor-tantly, the work is a search for the knowledge that this same process can impart. This is the subject of *Venetian Blind*.

With *Egg*, on the other hand, we soon become engaged by a ghost-like figure that appears and disappears as we move back and forth in front of the image. Intrinsically linked to the use of the holographic medium, this positive/negative quality places the Real in the position of being constantly denied by the ghost-like, disappearing image of

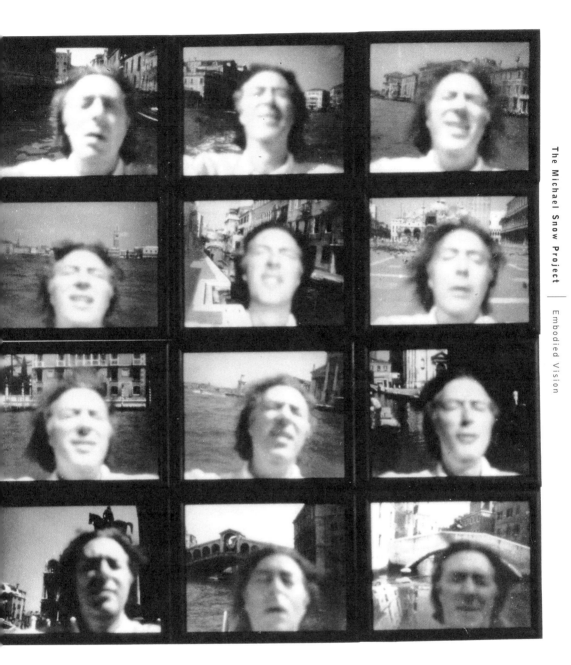

the artist. Through this play of contrast, reality exists only in denial and as a momentary, fleeting presence, its being emerging as magically as it disappears. This disconnected, transformed, fictionalized and altered space is the space where most of Snow's work functioned during much of the Seventies and the Eighties. In fact, in this period, the space of representation tended to begin in an already transformed or re-constructed Real, conveying an increasing sense of remoteness, of a world in fragments, and one that feels distanced through the mediation of the image and through other devices. With the Nineties, or close to that decade, there would seem to be yet other changes and indications of a rapport of a different order with the world. In these more recent works, the body becomes a disembodied presence, at once objectified and the embodiment of traces of meaning.

These facts tend to point to a clear transformation in Snow's apprehension of the world in this period. From an attempt at seizing and analysing — often through a photographic and deconstructive process — the immediate world that surrounds him, Snow has gradually acknowledged the impact of the image in our apprehension of the Real, and the gradual disintegration of a commonly shared or holistic world view.[5] Over time, and long before they became widely addressed issues, the role of the image in shaping an understanding of reality, and other factors contributing to an articulation of *différance*, mark Snow's artistic practice. If, initially, his inquiries lead him into examining a world of objects and/or their representation, this changes with the Eighties. In that decade, a distanced sense of humanity — one that was caught in a virtual world (*The Spectral Image*, 1986) and trapped within devices of its own making (*Redifice*, 1986) — distinguished Snow's production. By the Nineties, humanity comes face-to-face with a world of representation (*Derma*, 1990, and *Conception of Light*, 1992).

Over the years, much has been said about Michael Snow's inquiries "into modes of seeing, recording, reflecting, composing, remembering and projecting."[6] Usually, these inquiries have been associated with "an intensive exploration of the particular functions of the photographic process...", or of the medium within which the artist happened to be working at the time.[7] Snow himself has encouraged this view. As he said: "I am working to use photography in a very enclosed way, so there is nothing outside the work itself that is used in the photograph."[8] Associated with this mode of analysis is the idea that, as "we can decode [the] work by tracing back in time the sequence of [its] making", so do we reach an understanding of the meaning of the work.[9] While this view of Snow's process is not, by itself, inaccurate, it does tend to limit and reduce his artistic project. On the one hand, it situates it within a field of understanding that tends to restrict critical discussion to formal properties alone. On the other hand, it also tends to confine such an analysis to the arena of art itself, leaving out a broader cultural basis of understanding.

**P.29** 1979 (left)
**Midnight Blue** 1973-74 (right)

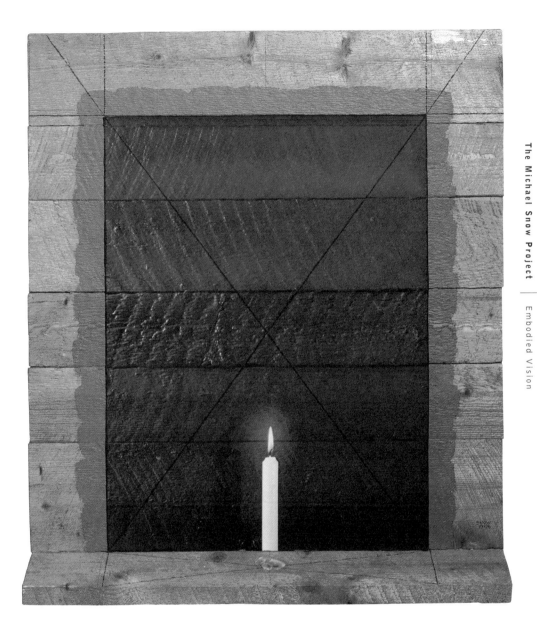

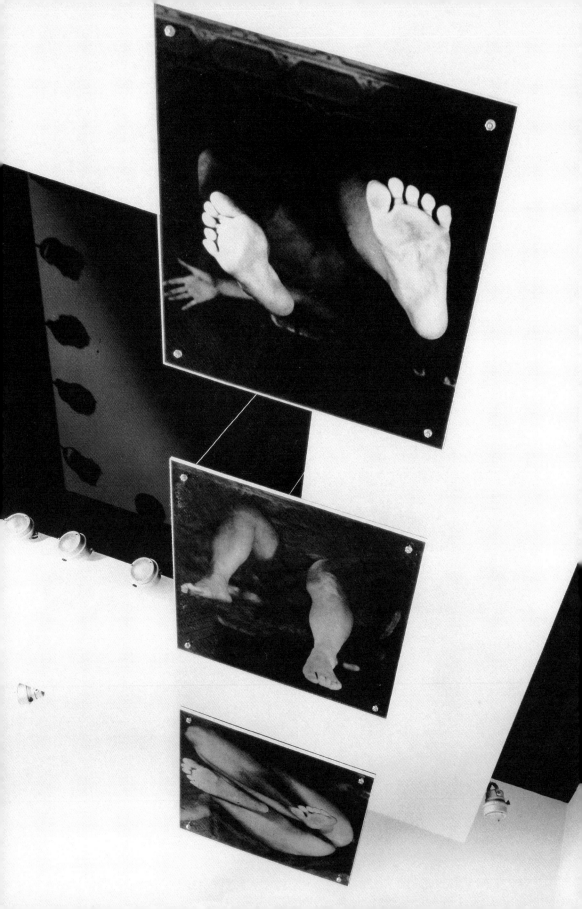

Snow's ideas reach beyond this. In fact, during the Seventies, Eighties and Nineties, they can be said to parallel related developments in post-philosophy. Andrée Hayum is one of several critics who began expanding the context of understanding of Snow's work when, in *Film Culture*, she described his activities as a "treatise on the difficulties of knowing".[10] Snow himself, when pressed on the question of meaning, admits that "I've always hoped that I and the spectator might benefit from my own attempt to apprehend and invoke a *participation mystique* with the nature of the 'reality' being presented by the little things I do and be led to extrapolate (emotionally or intellectually) that situation to the larger situation to which it belongs".[11]

Michael Snow takes nothing for granted. Working from the immediate environment in which he lives and functions, his project involves an analysis of the nature of reality, of its "truth" or realness and our/his relationship/perception of it through the use of various media. Snow analyses the language of the media he works with "to analyze thought and the reality represented in thought".[12] During the period under discussion, this project shared the intellectual preoccupations of many post-philosophers — post-structuralism, post-analytic philosophy, hermeneutics and critical theory — whose ideas have been summed up as inquiries into "questions of truth and reason."[13] Within this context, the Austrian linguistic philosopher Ludwig Wittgenstein, with whose thoughts Snow was familiar, is seen as a predecessor. But it is within the particular and contemporaneous "reflection on the conditions of knowing and understanding", and the gradual understanding of the impossibility of representing the world, that Snow is best understood.[14] With Snow, as with many contemporary philosophers, there is no "naked given," and the object of knowledge is always seen and perceived as part of a text.[15] It is the complexity of the world and of our place within it, as well as the impossibility of representing it, that forms the core of his researches. If, at times, Snow appears to attempt to objectify the world in a formal sense — and indeed, he is making *objects* — most of his works address the very impossibility of doing so. What his inquiries explore are the nuances, even the gap, between this so-called process of objectification and the actual world as we think/feel we perceive it.

The idea of a de-centred subject, the questions of the status of the image and its relationship to the Real, the role of the image in the shaping of identity and understanding, the reliance on techniques of reproduction in the making of art objects, and, finally, the denial of the notion of the creating subject and its replacement by the idea of the artist as *auteur*, are some of the key ideas and practices that characterize Snow's approach, and which were shared by many artists, locally and internationally, in the period under discussion here.[16] There are, however, some basic and essential differences in the way in which Snow enacts these processes.

First of all, his ideas and the themes in his work derive from a very private world of experience. Snow's project does not involve the examination of the social, political or cultural forces that constitute subjectivity. Rather, his analyses involve looking at the factors that contribute to the way that we construct (that is, represent) the world, and the various ways in which reproductive means, such as photography, assist in the process. From this perspective, Snow's distinction is twofold: on the one hand, his early reliance on the photographic medium and his recognition of it as a key means of representing the world has opened the way for much of the work that has been done since; and, on the other hand, because his work deals with such a basic yet contemporaneous need of understanding our world and the way we retain it through representation, his work rises above the specific determinations of particular trends.

*Egg*, which is located at the borderline of illusion and reality, exemplifies some of those ideas. Simultaneously film, photography, and sculpture — or situated between all three — *Egg* blends the tangible with the intangible. In front of the framed yet fugitive portrait of the artist stands a frying pan sitting on a dark display-case. If *Venetian Blind* insisted on recording minute variations of an actual experience, *Egg*, by contrast, is a statement about the inevitable gap between representation, however "real" it might momentarily appear, and actual objects. Snow attempts to bridge that gap — just as, in *Venetian Blind*, he attempted to record "the" moment — by having the egg-yolk sit at the very edge of representation and the Real, in a zone that can almost be apprehended mentally and represented only through illusion. Snow's statement is emphasized by his use of the hologram and the almost tangible tri-dimensional quality of that medium. Furthering this tension between the Real and illusion is the image of the artist in an everyday outfit. Dressed in his characteristic checkered shirt, Snow performs a delicate yet ordinary task, but one which, like art itself, involves the transformation of one substance into another. More importantly, perhaps, through this portrait which, metaphorically, shows the artist as the "maker," we are reminded of how the "'subject' and 'object' mutually determine one another".[17] This understanding is often reflected in Snow's work in the manner in which he frequently refers to his own history through the use and selection of objects he owns and which form part of his private world. *Venetian Blind* might, as I pointed out earlier, ambivalently sit between self-expression and objectification. With *Egg*, however — and generally within Snow's practice — this notion is clearly displaced.

## Em(body)ing Vision

*Venetian Blind* and *Egg* mark a distance in time, through the artist's own body. Snow's reliance on the human body — whether his own, that of others and/or a body in representation — to question the con-

tent and explore the parameters of representation can be traced throughout his career. A line, for instance, can be drawn between such works as *Venetian Blind*, *Crouch, Leap, Land* and *Conception of Light* (1992).

*Crouch, Leap, Land* consists of three black-and-white photographs under plexiglass which document three stages of body movement: crouching, leaping and landing, all in the nude. These movements are recorded from below, and must be viewed in the same manner; the camera sees that which would be difficult to see normally, unless the actions were performed on a transparent surface above the viewing subject. In fact, without the staging and the recording of these acts, it would be difficult for the eyes to retain this action in its details. On this level, but in a much more compressed manner, the work reminds us of Eadweard Muybridge's analytical photography. It equally brings to mind *Venetian Blind* in the strategic framing of consecutive moments of an action in time. Here, however, the notion of the image as a "frozen instant" is emphasized by the sense that the body is falling through space, or that it is retained in space only through the freezing of the image. Similarly, here the notion of framing is clearly partial. In fact, in one photograph, the feet are firmly pressed on/in the surface of the image, while the rest of the body disappears into almost total nothingness. The sense of depth that the images convey — and this play between presence and imagination — contrasts vividly with the minimal and thin surface of each of the images as we apprehend them in the space. The work emphasizes the ability of the camera to capture and hold movement and to describe human form in some of its stages of transformation. More importantly, the work draws atten-

tion to the ability of the camera to hold a memory distinct from what the eyes can see and hold normally. This quality is, of course, further emphasized by the fact that the camera is indiscrete, in that it reveals parts of the human anatomy usually hidden from public view. However, what could be perceived as voyeuristic (that is, an act scrutinizing parts of the human body for erotic speculation), is here counterbalanced by the clearly documentary mode of the work. This characteristic, and Snow's well-established practice of framing the body in action, is con-textualized, in the exhibition, through the placement of *Crouch, Leap, Land* near a number of Walking Woman Works and, in particular, *Sleeve* (1965). These earlier works, which acted as windows opening up onto the form of a woman walking, draw attention to the continuity in Snow's practice of viewing and analysing human form in movement. The Walking Woman Works, in fact, represent an important transitional phase in Snow's career, marking the passage from his early production to his maturity as an artist. However, with Walking Woman Works, Snow began with a cut-out figure and proceeded to replicate this form in various media. By contrast, here, he photographically translates an actual body in motion, suggesting within each of the images of the

Pages 402-403 and 406-407
**Conception of Light** 1992

three-part work its gradual disappearance and the fact that it seems to be held in the air by the surface of the image. This approach tends to emphasize the control exercised over the body by the camera. For it is the camera that memorizes acts and shapes perception in a way that would otherwise be lost to human experience.

*Crouch, Leap, Land* should also be considered within the context of Snow's more recent *Conception of Light*, a 1992 installation work, in which the artist's camera has focused on the ocular iris, as both the subject and form of representation. The resulting work consists of two round-shaped objects, disembodied and taken from two different sources since one eye is blue and the other brown. The eyes, which are installed face-to-face can be seen as two flat globes or maps of the world. Like these devices, onto which are recorded intrinsic natural marks that serve to identify and mark location, the eyes similarly hold signs of individual identity that would normally go unnoticed, were they not, as here, magnified so that they can be scrutinized. Alike yet different, united through their form yet also separated in space, they look at one another without seemingly seeing. This work is remarkable: at the same time that it fascinates, it generates a deep sense of unease. The extreme magnification of such a minute and vulnerable organ destabilizes our sense of relationship to it. And as much as the extreme size of the eyes claims attention, their lack and loss of expression suggests a deep sense of loss. They stand almost as the lone surviving parts of human form: subjects in representation, as much as subjects of representation.

"Embodying vision" clearly refers to the works just discussed. This title, however, is meant to encompass more than works carrying obvious references to the body. In fact, it is also meant to address a range of issues of representation that includes not only the self and human form but also a range of objects within the world. In particular, the title is meant to speak to how, materially and at an interpretive level, the work embodies and manifests the position of the author and his particular perspective on the world in which we live.

**A Plural Self**

In retrospect, it becomes clear that one of the immediate results of the Art Gallery of Ontario's survey was that it led Snow to the examination of a range of issues probing the gap between the self and its representations. Through the exercise of having a survey of his work and the necessary selective process that this entails, it might have become clear to the artist that the exhibition highlighted only some aspects of his work, however comprehensive it was. In fact, that it constructed him in a particular way. The book he created on that occasion was to become yet another form of representation of the self and a space of reflection about the complexity of the act of representation. *Michael Snow/A Survey*, which was designed by Snow and is, in fact, a survey

**Sink** 1970 (top)
**Watercolours** 1979 (bottom)

**Blue Blazes** 1979 (left)
**Door** 1979 (right)

of the life of the artist Snow from his perspective, introduces personal history or biography as an integral element of artmaking. The book also draws attention to the role of nature in his life and work. More importantly, the book is a statement about voice and the many voices through which the self can be represented and apprehended.

The life that the book depicts is full, layered, complex, and as playful as it is meditative. From this rich field of experience, individual works emerge as related yet concise and distinct statements from that to which they are made to relate. Like the image of the island on the cover of the book, some carry references to the Real. At the same time, however, they also hold layers of meaning that clearly distinguish them from the world from which they are made to appear to emerge.

Throughout the book, the life of Michael Snow, his youth, adolescence and adult life, his private and public moments, are recalled through numerous engaging (and often amateurish) snapshots. These spontaneous images stand in strong contrast to the more controlled quality of the professional reproductions of the work. At the same time, however, both sets of images insist on a rapport between the two distinct areas of activities. To begin with, the book opens with a view of nature: a small island on a lake surrounded by mountains (the cover). It is immediately followed by a photograph of an abstract painting of Snow's entitled *Lac Clair* (National Gallery of Canada, 1960). That same cover image, viewed from different perspectives, re-occurs throughout the book, clearly indicating its role in the shaping of the work and the artist's sensibility. *Lac Clair* certainly occupies a position within the abstract movement that was predominant at the time. However, the relationship drawn between a reproduced natural site barely marked by signs of civilization and an informed dilution of this site through painterly abstraction, insists on the distillation of a personal experience and the fact that art is not produced in a separate compartment that is isolated from life. In a subtle and non-dogmatic way, this insistent image poetically proposes an alternate perspective, and one that stands in contrast to the more isolationist and professional-looking images of the book.

Also included in *Michael Snow/A Survey* are snapshots showing the artist, his family, even his ancestors, at various stages in the story of his life. We see him at the beach, at the airport, on picnics, playing music, at parties and with his artworks. If the book succeeds in emphasizing the role of nature in the artist's life and work, it also draws attention to personal history and subjectivity and their equally important roles.

A most interesting aspect of this document is a map listing the content of some of the snapshots that describe Snow's history. This map, which is located at the beginning of the book, away from the images themselves, informs without interfering with the images and

the range of associations that could be drawn from them. In other words, it dispels the fiction that the images might generate, while, at the same time, letting the fiction be, if and when we look at the non-annotated pages. This map is immediately followed by a series of car-toons — in fact, a series of early works and another level of fiction — bringing out the humorous dimension in Snow's work and the tone in which some parts of this book were assembled.

The multi-faceted Snow, however, is represented not only visually but throughout the texts. These many voices — Robert Fulford, Dennis Young, Richard Foreman and P. Adams Sitney — unveil yet other ways of reading Snow. This notion of plurality in the shaping of identity through the medium of an exhibition catalogue is carried over in the use, manipulation and diversity of the typefaces. The text is sometimes overprinted, printed upside down or so reduced that a magnifying glass is needed to read it. These strategies become yet other means of emphasizing how complex the self is and how it is even more com-plexly difficult to attempt to represent it.

In *Michael Snow/A Survey*, art, life and fiction are constantly juxta-posed and interwoven, a statement drawing attention to the artist's multi-levelled vision and the fact that this vision is embodied at all three levels. If Snow does not project himself in the work or use his work as a means of self-expression, at the same time he recognizes that his ideas emerge from numerous and even obscure sources. The picture one gets, in the end, is complex and arresting, both in its generosity and its silences. It is simultaneously an artist's book, an exhibition catalogue, a biography and even a fantasy of sorts: revealing yet also simultaneously mystifying. At another level, the book manages to reflect a playful, seemingly candid, yet private Snow. The relation-ship of the Real or of actual events with their re-construction through representation is one of the many ideas that Snow was to explore during the Seventies.

Other works addressing related issues include, for instance, *Side Seat Paintings Slides Sound Film* (1970), *Sink* (1970) and *Untitled Slidelength* (1969-71). *Side Seat Paintings Slides Sound Film* consists of a film projection of slides of the artist's works. A commentary by the artist accompanies the projection. This work, like the book *Michael Snow/A Survey*, relies on reproductions, that is, it exists in a zone at one remove from the Real or the actual artworks that the slides repre-sent. Like the book, the work also takes this notion further. Here it re(presents) this content yet again through the medium of film. Furthermore, the notion of transformation effected by both the photo-graphic and film images is emphasized by two factors. On the one hand, no matter how the viewer is seated, he or she sees a distorted image. Secondly, a distorted sound accompanies the image. As Snow has pointed out: "It [*Side Seat Paintings Slides Sound Film*] came out of doing my book, A Survey.... And also the whole retrospective thing

A Wooden Look (detail, over)

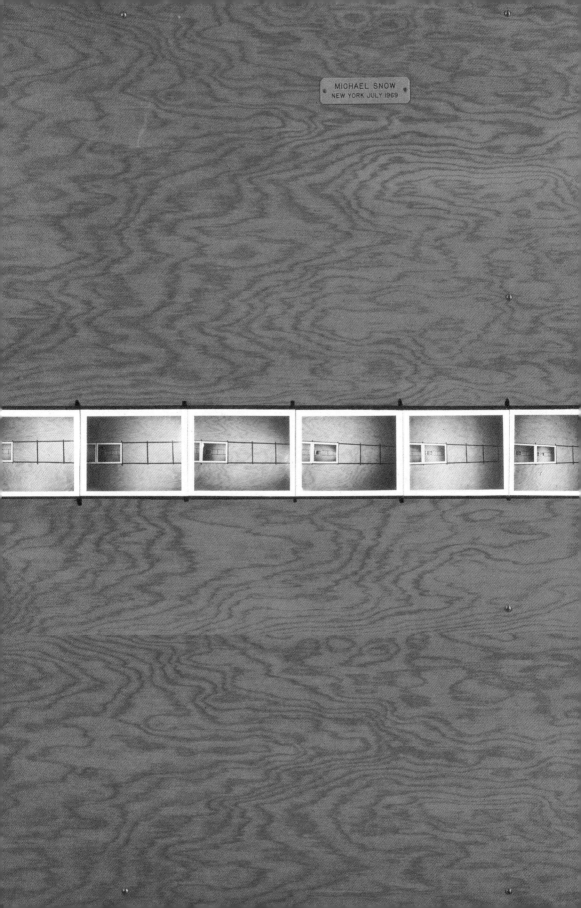

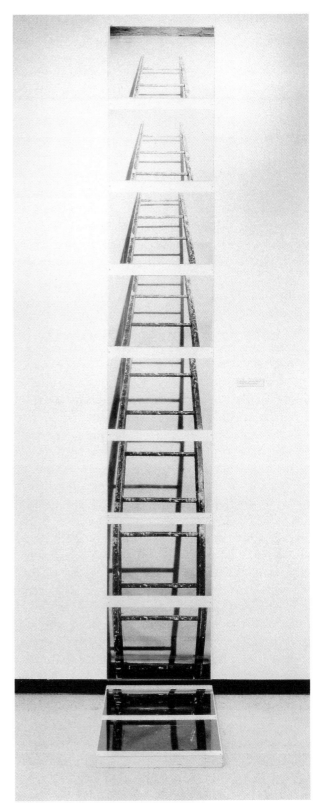

**A Wooden Look** 1969 (top)
**The Squerr (Ch'art)** 1978 (bottom)
**Of a Ladder** 1971; reprinted 1981 (right)

that made me look back at my work for the first time. I was interested in using the records of old materials for new works. The book uses still photos. The film uses slides."[18]

With these pieces, Snow not only reconstructs new works from old material — a strategy that characterizes the Seventies and came to be known as diaristic art — but he shows how representation throws a different perspective on that which is being represented. While the material used in the construction of his book illustrated how different materials became voices in the construction of subjectivity, here actual voice and the formal qualities of the moving image make us aware of the distortion that occurs when art is transposed from its originary status into slides and film, and that this distortion is taken further still through vocal and presentational modes, and even further still, should this process be maintained. This idea and corollary thoughts were to remain leading considerations in Snow's artistic project.

**In the Wild of Nature**

Before pursuing this thought, however, it might be worthwhile to con-sider *La Région Centrale*. This film, which at first might appear to be disconnected from Snow's other projects of this period, is in fact closely related both to them, both at the level of its theme and in terms of the artist's inquiries into the status of the image, the relationship of the image to the Real, and how images shape reality.

By this date, through the making of other films, Snow had become fully aware of the meaningful role that the camera could play. As he said, "camera movement has generally been allied to the dictates of the story and the characters being presented and follows what has been assumed to further these things eg. [*sic*] someone leaves the room, the camera follows the action. I give the camera an equal role in the film to what is being photographed."[19] By relying on a machine (made by Pierre Abbeloos but conceived by himself), Snow decided to let the camera record "freely" without subjecting it to the dictates of the plot. With this decision, he not only resolved to allow the camera to play a role, but he also seemingly abandoned his role as director.

In actual fact, however, by pre-determining both the role and the possibilities of the machine, Snow remained in control of the event. This event takes the form of a dialogue between the theme of the work, its wild-ness, and the mechanism of its representation. In this work, the camera becomes almost as "wild" as nature itself. Beginning, on the one hand, with an actual landscape and, on the other, with a robotic (i.e., quasi-wilful) camera, Snow lets the subject and the mechanism of its representation function almost freely together. This dual yet linked activity results in making us more aware of the role an object such as a camera takes in the shaping of objects and their meaning in representation.

*Crouch, Leap, Land* and *La Région Centrale* could be said to relate to one another through a contrasting strategy. Both, in the end, become a demonstration of the fact that, with or almost without human interference, the camera still retains the ability to transform the Real.

## A Plural World

With works such as *Log* (1973-74), *Midnight Blue* (1973-74) and *Glares* (1973), and other pieces executed in this period, Michael Snow concentrates on measuring and making the viewer aware of the various levels of difference between actual objects and their representation. He does so with almost scientific precision, yet without forfeiting humour or any of the engaging appeal that most of his work possesses. In *Log*, for example, in which an actual log is placed next to a photographic representation of that same object, the gap between the two objects becomes the space of reflection. Both objects are marked — the photographic object through the spacing in between the images, and the log itself through plexiglass inserted into cuts — in such a way as clearly to direct our attention to these fragments and to the transformation process that occurs through the photographic act. The two objects are measured, one against the other, standing side-by-side, saying, in fact, the same thing but in totally different languages. The result is quite telling: the log is radically transformed by and in the photographs. In this work, the photographic composition is as close to a mental construct of a log as it is to an actual log, the distance between the three being just as great.

The fact that the camera not only distorts objects in representation but can be made emphatically to state that fact through the positioning of the lens in its recording of the object is made clear with *Glares*. With this work, Snow began with a frame holding a white surface marked with black lines shaped in the form of a grid. At the top of the frame sat a light-fixture. He then photographed the individual sections of the frame from different angles, that is, not always in a position directly parallel to the object. Each photographic image was then inserted in its place in the grid and frame. The resulting work, with the light-fixture still sitting at the top of the frame, becomes a composite object marking not only different moments in time but also embodying its photographic representation in various versions. The actual space is also the support/frame of its represented space, usually from a different perspective than what it actually is. It is clear that, should the original object stand empty, directly in front of us — or as a blank, lined surface, as it originally was — we would be confronted by a series of voids or white surfaces. As it is, the space is filled with an image containing references to its own frame, and generally to the space around the outlined inner frames, which draws attention to the role of the camera in its recording of the object.

The play between the actual and representation is further empha-

**Log** 1973-74 (detail, Page 420)
**Glares** 1973 (Page 421)

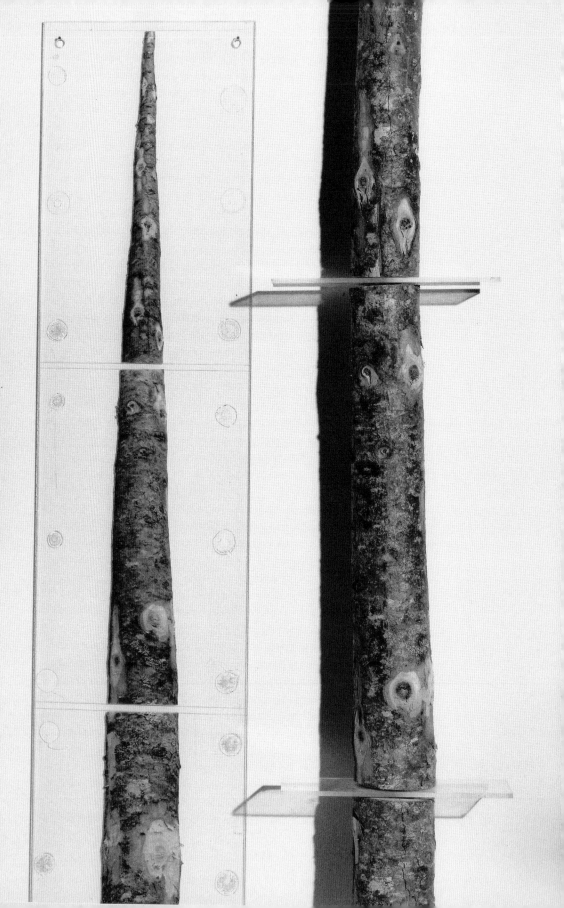

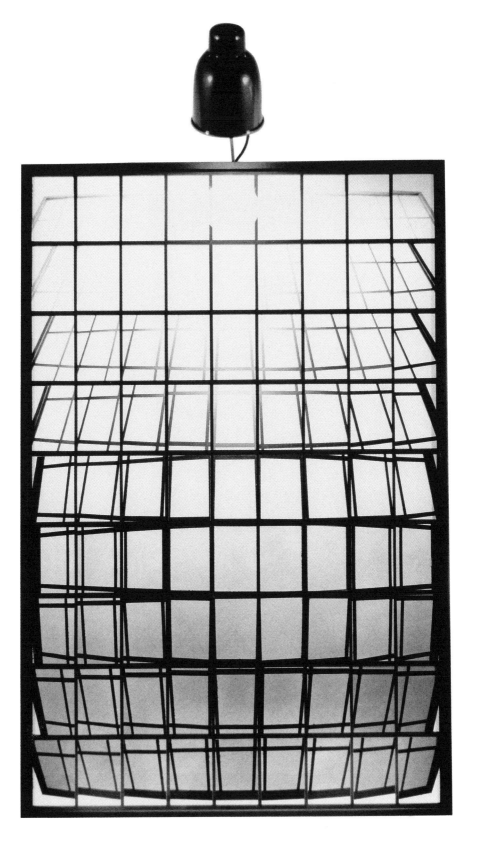

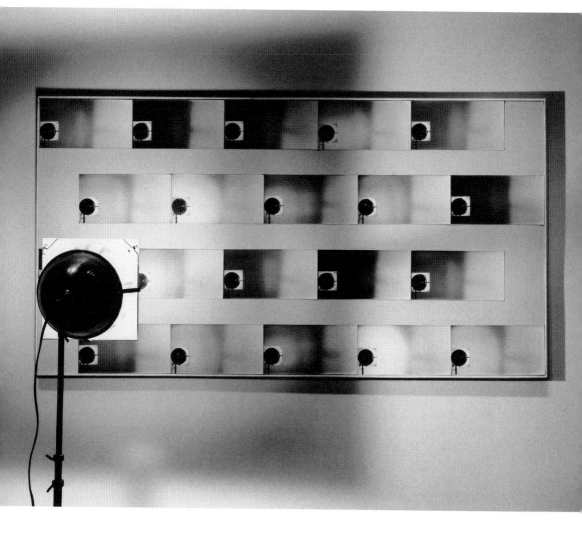

sized by the light of the lamp, which reflects onto the images, and the frame at the top. That same light is recorded in the image drawing a link between the original actual light, the recorded/distorted light of the photographs, and the current light that illuminates the object as we view it. *Glares* is neither the actual object nor a total representation, but a composite of both and an object that draws a rapport between an actual past, its reconstruction through photography, and the act of reception. If we think of photography as a process that selects and transfers re-shaped fragments of the world into a new frame, *Glares* mimics that process but replaces the new frame back into the actual frame, blending the re-shaped fragments of the world within the Real. Works such as this one actually embody the dialogue between reality and illusion.

In contrast, with *Light Blues* the artist began with a blue rectangle in front of which stood a floor-lamp. He then photographed this installation using different colour-gels. Once printed, the images were placed on the blue rectangle — the rectangle thus becoming the support for its multi-layered and multi-coloured self. At the same time, the work also reached another level of representation through the blending of the actual with representation. Furthermore, as in *Glares*, this work emphasizes the role of light in transforming the Real. This is reiterated by the fact that a gel also covers the light standing in the actual space, transforming the images even further. As viewers, we are given to consider a fragmented Real. Also, and most importantly, a Real transformed through its own representation. Finally, the work demonstrates how the Real, in the form of the floor-lamp, itself can become an agent of transformation.

*Midnight Blue* simultaneously draws attention to a particular shade of blue, to the notion of time, and to the idea of a certain mood, all of which are represented in some form in the work. Through these devices and references, the work speaks to the almost total displacement of the Real — that is, of an actual object — in favour of an image that has recorded a phase in the object's moment of disappearance. What remains of the activity that took place is a lump of wax lying beneath the represented candle, an area of lighter blue paint that surrounds the photographic image in an irregular shape, and a framing of natural wood that encloses the latter area and the whole composition. In this work, Snow makes it clear that the represented candle, that is, the photographic image, is of another order than that which was photographed. Here, representation not only clearly transforms the Real — the blue colour of the actual background and the blue background in representation are different — but only captures a momentary phase of the Real, as is demonstrated by the spent candle. The photograph is the memory of an instant and a partial recording in the life of the candle. This exists within a space which itself contains a memory (the spent candle). The actual remains of the candle (or its

memory) are set against a photographic memory of itself in a space that simultaneously refers: a) to the *now* (the instant we look — the actual wood); b) to the *now* transformed in representation (the blue painted wood), an act that occurred prior to our looking; and c) to the *then* which has memorized that space, again in our absence. The intersecting lines that run over all three different grounds (natural wood, the painted and the represented surface) further enhance the distance between the various stages of representation, holding them together in the act of reception yet still making visible the Real and the memorized distance between them. In all of this there is no actual candle, no object in the Real that can be compared with either the memorized one or its remains. This not only points to the distortion that occurs through photography; at a metaphorical level, it also can be seen as an allusion to the way human memory tends to transform facts and events.

*Log*, *Glares*, *Light Blues*, *Midnight Blue*, and some other works of this period mark a transition from a consideration of an object in the Real to its transformation and eventual disappearance through photography. Simultaneously working from an actual object, translating it through the medium of photography and using the photographic object to transform the Real, Snow replaces or displaces the Real through the image. In the end, all that is left is, on the one hand, a trace or a sign of a Real that once was, and, on the other, a photographic construct. This process not only speaks to the role of the image in the shaping of perception but, given that a single object can exist in several photographic interpretations, it suggests that there is no single truth to that object. That there are, in fact, as many possibilities for that object to become, and meanings to be assigned to it, as there are possibilities of recording an object through an image.

This notion of plurality, and the associated thought that there is "no naked given" — ideas which have been discussed here in relationship to everyday objects — were soon to gather strength, particularly in terms of television. This medium came to be seen as the medium *par excellence*, primarily responsible for conveying a fragmented, hence distorted sense of the world. Television's practice of reporting fragments of events taking place in various parts of the world — and generally only the spectacular aspects of those events — was soon understood as a medium of distortion. Similarly, its process of translating events came to be seen in the same way that the photographic camera presents a version of an object and not the object itself. Both the photographic and the film image contribute, in the end, to dissipate a holistic understanding of the world.

What is interesting to note is that, while Snow has never seen himself as a critic of television or of the other media, he nonetheless conveyed an early awareness of their tendency to transform or process the Real, and did so when awareness of this phenomenon was restricted

to a very few. By first casting doubt on the ability of the camera to represent the Real, Snow soon displaced the Real with the image, acknowledging the difficulty of knowing reality. This was to lead to considerations of the Real as a multi-faceted entity, a thought that eventually resulted in the acknowledgement of the fact that reality could not be represented or, at least, that the Real existed in a zone other than in its representation.

One of the ironies of critical discourse is that, while it has become increasingly aware of its own process of "fabricating thought," it still tends to need to rely on such constructions in order to sustain interest. To state that, at about this point in Snow's career, a profound change was occurring is, in some ways arbitrary. In this particular instance, given the nature of Snow's work, it would be ironic not to highlight this arbitrariness. As pointed out above, there are works that indeed do tend to suggest that such a change was happening. At the same time, however, the manner in which this trajectory is shaped for the purpose of discussion here might tend to imply a deliberate act. Like anyone involved in serious research, Snow often proceeds intuitively and moves back and forth and sideways in developing his work. To insist otherwise oversimplifies his working method. Let me only say, then, that a pro-found change occurs at about this period in relationship to the ideas discussed here. At the same time, however, it should be clear that parallel processes of thought, not expanded upon here, evolved in Snow's work, which could be discussed from other perspectives — the nature of light, for example, in his work — that might suggest a turning point at another moment in time.

### Interlude

*Interludes suggest an in-between space and a time marking distance within a single event, such as a performance. Such a "space" is inserted here to draw attention to the important role of music in Snow's life and to the exhibition itself, in which a similar space of reflection has been created. In a small room, in The Power Plant's upstairs gallery, it is possible to hear selections from Snow's music performances and to realize, with some degree of privacy, the extent of the role of music in his career. Because we are so used to compartmentalizing human activities, we often tend to think of Snow the musician as other than Snow the visual artist or Snow the filmmaker. To rectify this oversight to some extent, not only does the exhibition make space for such a room, but it also includes a soundwork,* Hearing Aid *(1976-77), which runs through the spaces downstairs.*

**Field** 1973-74 (above)
**Field** (detail, right)

*From this perspective, the exhibition attempts to bring together all aspects of Snow's career.*

*Elsewhere in this exhibition, it is also possible to reflect on Snow's public commissions. These are made present through photographic reproductions. However, as some of these commissions are located in Toronto, it is also possible to view them in actuality, thus further expanding the physical and contextual space of the exhibition.*

## Distorted World

Before turning to works that carry increasing evidence of a distancing process from the Real, it might be helpful briefly to allude to *Two Sides to Every Story* (1974). This work, as its title indicates, states the ambivalence of any action in the Real. As such, it suggests a shift of emphasis from works that explore more forcefully the recording/transforming of the Real through various reproductive mechanisms. With *Two Sides to Every Story*, Snow exposes the fiction of the film image by breaking with the illusion of film as a window onto the world. Of more pertinence here, perhaps, is the fact that the film object speaks to the complexity and duality of points of view.

Projected *recto-verso* on a thin, two-sided screen are a series of actions that have been filmed simultaneously by two cameras facing one another. In order to absorb it all, the viewer must walk around the work. This walk or movement inevitably carries with it the gradual realization that the object cannot be taken in all at once. That, in fact, each time we leave one side to look at the other, we are left with only a memory of the former. The story goes on in our absence. No matter how much we try, a gap always remains, and this despite the thin, hence vulnerable surface, that divides the two sides. If *Two Sides to Every Story* refers to an actual world, that world remains, at the same time, intractable in yielding its total truth.

Snow was further to explore this notion of dualism in such works as *Cover to Cover* (1976) and *Shade* (1979). The first is an artist's book in which Snow is simultaneously the subject/object of the "plot" and its author. As in *Two Sides to Every Story*, Snow's actions are recorded by two cameras. Usually, these two sides to the story are recorded on the back front and back of a leaf. If, in this instance as in the later *Shade*, it is easier to apprehend both sides, the work still places an emphasis on the necessity for double-sided considerations. Simultaneously biographical and analytical, the book explores the conventions and the potential of the book medium. These formal concerns, as well as Snow's inquiries into the nature of representation, were reiterated in relationship to *"Rameau's Nephew" by Diderot (Thanx to Dennis Young) by Wilma Schoen*, a film he worked on from 1972 to 1974. As he

**Shade** 1979

**Plus Tard** 1977 (installation view, above)
**Plus Tard** (details, right)

said, "its 'dramatic' development derives not only from a representation of what may involve us generally in life but from considerations of the nature of recorded speech in relation to moving lightimages of people.... Echoes reverberate to 'language', to 'representation' in general, to 'representation' in the sound cinema, to 'culture', to 'civilization'."[20] This was re-emphasized by Regina Cornwell in *Afterimage*, when she wrote, "Running through Snow's *Rameau's Nephew* is a philosophical discussion about reality, appearance, illusion, representation, verisimilitude..."[21]

At the time that he was completing *Rameau's Nephew*, Snow turned to abstraction. *Red*, which was executed in 1974, is (as its title indicates) a dye-transfer print of the fifth Polaroid photograph of a red field, in which four photographs are lying face up. These four elements are recordings, first, of a red field, then, in stages two, three and four of the work, of a red field with one, two and three photographic images recorded on its surface. In its final state, the work is a construct of recordings of photographs in a red field whose positions have been slightly altered each time a new photograph was taken. Initially, when the first image was recorded, the object of the recording was clearly nothing except a red surface. As the work progressed, this red field/surface became the container of actual objects which served to record themselves. At this level, the work constructs a referential Real out of "nothing." The content or subject consists of an abstract image, a reference to painterly abstraction or to a diluted sense of the world. In clear contrast to such works as *Glares*, for instance, where the referent is an actual object, that is, a frame with a light at the top, here the referent is not really identifiable and results in no more than a diffused sense of the world. With *Red 5*, representation no longer exists in reference to the Real, but creates a Real out of a removed and distanced conception of it.

A number of other works pursued this idea during this period. In 1977 Snow made *Multiplication Table*, in which he began with a photographic enlargement of a sketch for a table. The enlargement was made to the exact dimensions of the table, were it to be built. Resting on the drawing of the table is a pencil that is clearly out of proportion with the drawing. In other words, even though the drawing has been magnified, the pencil still appears too large in relationship to it. Through the same process of photographic enlargement, Snow simultaneously makes representation approximate the Real (the magnified drawing of the table), while also distorting it (the pencil resting on the drawing of the table). This work begins with a concept, a drawing on paper of an actual table or the idea of what a table could be, and transforms this concept into a life-size approximation of the Real. Yet, even when this is done, our relationship to the work remains suspended between two worlds. In other words, that which approximates the Real (the table) is thrown off by the "real" (the pencil), and vice-versa.

*Plus Tard*, also completed in 1977, similarly begins in representation. This time, Snow decided to work with painterly representation. The work is a record of an installation of paintings by members of the Group of Seven at the National Gallery of Canada. Camera in hand, Snow photographed the paintings in a way that suggests the manner in which a film camera might capture these paintings. The resulting work is a visual re-interpretation, another level of representation, of an already twice-interpreted reality. If the suggested movement of the camera might recall ←→ *(Back and Forth)* or even *La Région Centrale*, here the difference lies with the space of representation itself. In these earlier films, the Real is what was being translated. In *Plus Tard*, Snow no longer works from the Real but with various translations of it.

However, as in *Multiplication Table*, the work also introduces actual elements. Here, in addition to the paintings, other elements such as the room itself, with exit signs, doorways and the floor, are integrated into the work. This forces us to look at these objects and signs as part of the representation. In fact, their integration is so total that they become an integral part of the images. This work not only refers to artistic intention in our understanding of the world, but also points to the effect of time (the title) and on the means used to interpret art. The images are, at once, a memory, a record of a reconstruction of the world and a re-recording of the experience of both.

*Rendezvous* (1979) depicts a neatly (if somewhat garishly decorated) waiting-room, such as can be found almost anywhere, from dental or medical offices to small country hotels or motels. Despite the difference in patterns between the carpet that covers the floor and the upholstered furniture, there is an attempt — humorously unsophisticated — at colour-coordination. This idea of an all-coordinated interior is carried over into an abstract painting that hangs on the wall next to the door.

The title is intriguing. For there is no one in the room. So what is the "rendezvous" suggested by the title? The work implies a narrative, yet all that we are presented with is the locale for a narrative to be developed. This locale appears to have been drawn from the "real." However, as we examine the work closely, we distinguish textural differences between the painting and the rendering of the rest of the space. This suggests two different sources of imagery. In fact, the work is a photographic reproduction of a postcard onto which the painting has been added.[22] Postcards such as this one are often used to sell the idea of visiting such an establishment, assuming, of course, that this is a motel or hotel. Furthermore, paintings are often acquired by such establishments for no purpose, other than to decorate the walls and match the furniture. Is the rendezvous Snow alludes to here one between art and the corporate collector? Of more relevance, perhaps, to this present discussion is the fact that the work explores the distance and difference between two elements: the reproduced room

Snow '79

and the added painting. The reproduced room is a reconstruction of an actual room in the same way that the painting extracts from the Real. Both suggest a fictional space, but at a twice-removed level from the Real in the case of the room itself. Viewed this way, the "rendezvous" or the implied narrative exists between various stages of abstraction. These abstract worlds — the reproduced room and the painting — however, also function at one further level removed from the Real. In other words, the narrative space implied here will not enact itself in actual acts but takes place conceptually. This work takes us into what at first appears to be a stage-set for the development of a real plot in real time. In fact, what is plotted is enacted conceptually and at invisible levels. One might ask, when looking at this work, "What happens when painterly abstraction meets photographic abstraction?" This, I believe, is the rendezvous that Snow is talking about. It also happens to be the kind of question that both illustrates and emphasizes our disconnection from reality.

*iris-IRIS* (1979), like *Rendez-vous*, similarly relies on a postcard to inquire into suspended narratives. The work consists of two large square surfaces positioned side-by-side. On the left-hand section of the work, three key elements form the basis of the "plot": a slightly unmade bed, a bedside table with a burning cigarette sitting in an ashtray, and a pile of what appears to be postcards. Finally, a small postcard hangs on the wall above and between the bed and the table. A lone and identical postcard, located in exactly the same position as the one on the left, adorns a blank surface on the right-hand side of the work. However, while the image on the right is an actual postcard, the left-hand image is integrated within the photographic rendering of the room.

As Snow has said of *iris-IRIS*, the work "tries to contain a set of pyramidal stages of readings of different times and places with (an attempt at) almost measurable temporal distances from the concrete here and now to remote theres and thens. Trying to make the inevitable nostalgia of photos palpable. First; [*sic*] the work is two equal sized squares side by side. One panel includes a postcard of Mont Blanc on a painting (wall?). The other is a photo of a bedroom somewhere which shows the same (?) post card [*sic*] same size on the same wall (painting?) in the late afternoon (?) light. The self-referentiality of this work might keep a spectator moving around in a perception/thought cycle."23

The title *iris-IRIS* suggests, as Snow points out above, a visual/physical/conceptual play on the act of apprehending the same object in different contexts and times. The postcard is already an object of "memory." The work creates a series of almost pyramidal situations which result in the further distancing of the actual experience of having seen Mont Blanc, to looking at a reproduction of it in a postcard format, to its further contextualization into a different

*Rendez-vous* 1979

**Chair-Back** 1978 (above)
**Waiting Room** 1978 (right)

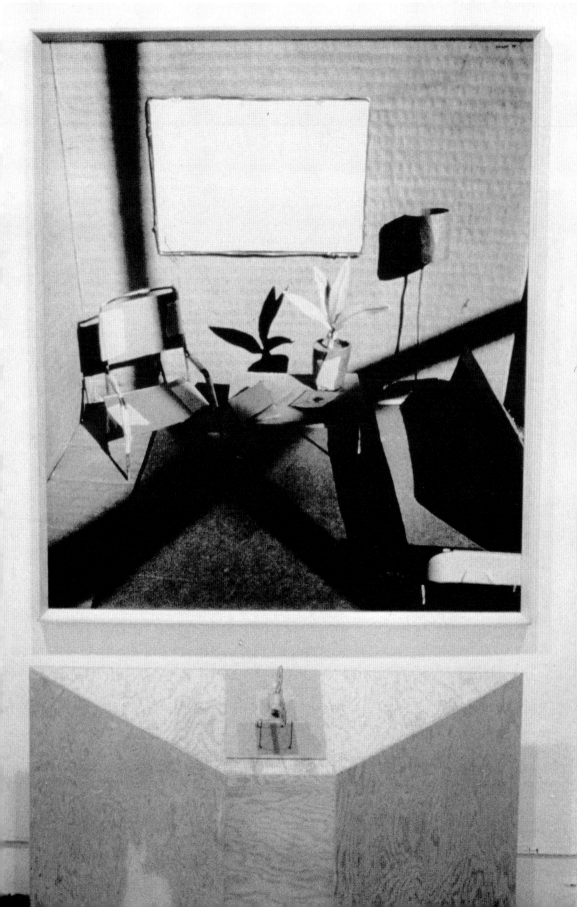

environment at a different time.

It is interesting to note, however, that the work on the right appears to give a near-actual experience of the site, while in fact all that we experience is a postcard on a blank surface, a remote and removed experience of observing Mont Blanc. This is juxtaposed to a "plot" — the postcard seemingly being at the centre of a narrative caught in mid-development. The burning cigarette implies a human presence temporarily absent from the room. Furthermore, the insistence on the postcard — it is present everywhere and in multiple versions of itself — leads us to question its presence. Inevitably, this results in the assumption that it is at the basis of the plot and the reason behind the person's departure. But however much we may ponder upon this it leads nowhere. All we can turn to is the right-hand side of the image. This is the "evidence," an act: the act being none other than memory or the re-construction of an experience through an image of a place at a certain time. Here again, we are asked to conceptualize what, at first, appears to be a very descriptive situation.

At the same time that he was developing these narrative-based works, Snow also executed a series of flame-based works such as, for example, *Black Burn Back* (1979) and *Blue Blazes* (1979). These works appear to revert to referencing an actual occurrence, that is, the burning of a substance. In fact, what the works refer to is the product of this burning process. This suggests more than the disappearance of the Real; by recording it photographically (that is, by turning it into an object), Snow imprints its disappearance in memory, albeit in distorted form. The flames are the result of burning, the last sign of an object before its total disappearance. Here, too, as elsewhere in the work of Michael Snow on the eve of the 1980s, we find ourselves within a ever-evanescent world, and one that is increasingly difficult to hold on to.

## Gates to the Future

By the early 1980s, Michael Snow had achieved and maintained a prominent position both in Canada and abroad. In fact, if anything, his reputation had grown even further and farther afield. In Canada, the decade began with the presentation of *Michael Snow* at the Montreal Museum of Fine Arts (13 December 1979 to 3 February 1980). The exhibition, which had opened at the recently completed Centre Pompidou in Paris in December 1978, had then travelled to Rotterdam, Bonn and Munich before closing in Montreal. As Regina Cornwell remarked in *Artforum* in 1979, "The exhibition, celebrating the influence of the camera on Snow's art as a whole since 1967, consists of 30 visual works and one sound piece."[24] It was an ambitious project and one that helped to enlarge the spectrum of understanding of Snow's activities. Until then, Snow had been primarily known in Europe as a filmmaker.

The year 1980 also saw the publication, and the launching in both Toronto and New York, of Regina Cornwell's *Snow Seen: The Films and Photographs of Michael Snow*, the first book-length analysis of an important aspect of Michael Snow's work. Snow was also included in *Pluralités*, organized by the National Gallery of Canada in Ottawa, and in *10 Canadian Artists in the 1970s*, a project organized by the Art Gallery of Ontario, two exhibitions that generated a lot of interest at the time.

During this decade, Snow was also the recipient of prizes, awards and honours of various sorts. These included the award for "The Best Experimental Film" from the Los Angeles Film Critics' Association for the film *So Is This*; the Order of Canada; and an Honourary Doctorate from the Nova Scotia College of Art and Design. Finally, an exhibition of the artist's work opened the new 49th Parallel Gallery in New York, a Canadian Government– sponsored space that exhibited contemporary works by Canadian artists.

However, despite the success that continued to mark Snow's career, there was a noticeable change in what probably can best be described as the artist's apprehension of the world around him. By the Eighties, Snow's photographic work, which, apart from his films, continued to represent the focus of his activities, existed almost totally within a suspended and reconstructed sense of space. More than ever, these fragmented views of the world, which, until then largely focused on objects but which, from now on, were also to include human forms, propose an understanding of the world as one that is driven and conditioned by the image.

In fact, in this period, human references are not only far more frequent, but, as the decade advances, an increasing sense of unease about "being-in-the-world" tends to prevail. It is a world, to some extent, in chaós, and difficult to convey and capture in its diversity. More than ever, it is a world caught in "representation" and shaped by it. This sense of a gap between us and what surrounds us, this inability, perhaps, to reach beyond how the world is pictured to us, was to culminate in a return to painting by 1990. *Derma*, which is a relatively small canvas depicting a diminutive, naked, bald man, his back turned to the viewer, is a good example of what was happening in the work of Michael Snow at the time. Facing this man and us is the surface of an immense abstract field. Nothing remains in his world, in this canvas, except this reduced individual standing against a world in representation, which also happens to act as a wall. Despite his attempt at scrutinizing the surface of the painting — inviting us at the same time to do so — he is also hindered from going further into his exploration by representation itself, and the fact that he is so close to the work that he can only see a minute part of its surface. Even touch does not allow him to begin to navigate this overwhelming sea of signs, which is far bigger and wider than his diminutive self seems capable of ever undertaking.

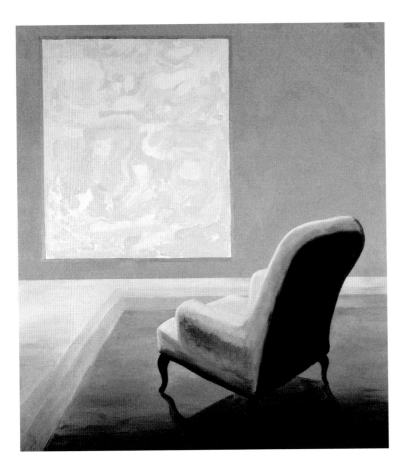

**H.M. is Supposed to Have Said** 1991 (above)
**Imposition** 1976 (right)

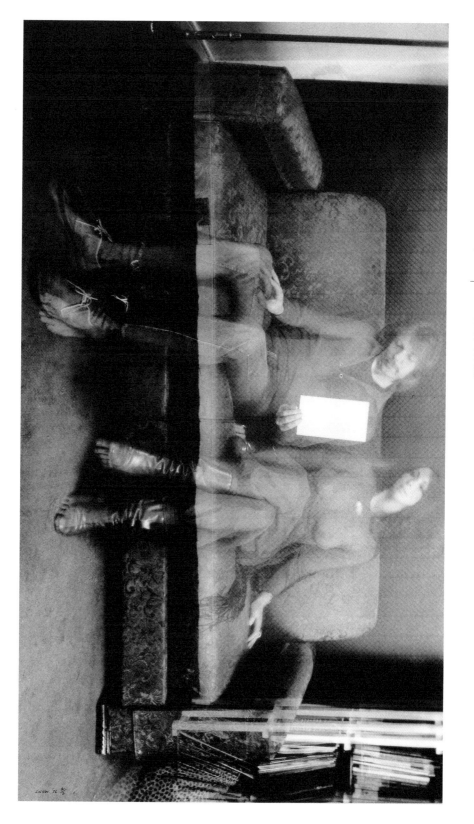

SNOW 76

**Une nuit d'amour** 1963 (above)
**Sleeve** 1965 (installation view, right)
**Sleeve** (detail, Page 449)

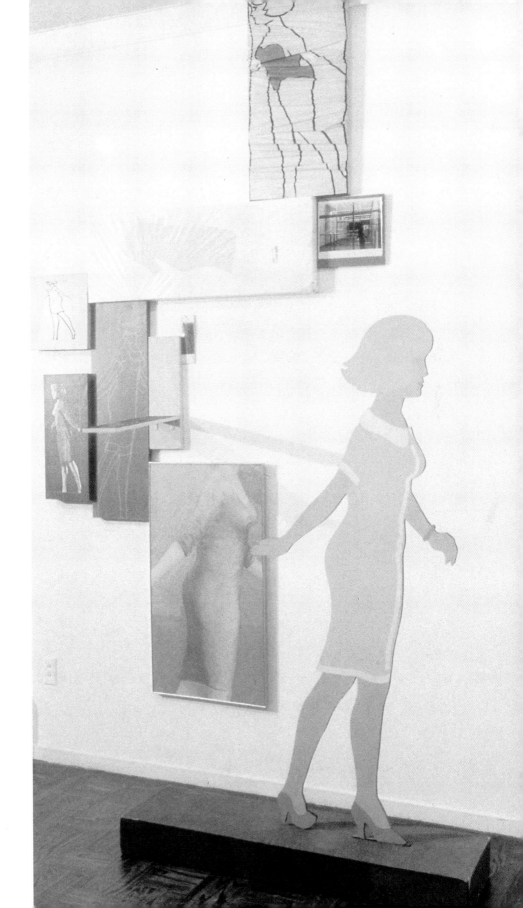

Earlier in the decade, Snow had begun a project that would convey this same sense of remoteness, of this wall, in fact, that stands between us and the world, this time through the passage of one's experience of the world to one's own progeny. Entitled *Quintet* (1984), the work consists of a photograph of a man holding a child over and within (that is, sharing the surface of) a rather second-rate painting of a nude figure. Obviously, this work talks about art and its reception, about reproduction and representation and about sexuality and sexual difference. However, apprehension and understanding of these questions and issues are clearly offered to the child through representation or at a once-removed level from the Real, however close the child and his father are physically made to be involved in this process.

This sense of an elusive reality, of a reality difficult, almost impossible, to grasp, first communicated itself, as I have pointed out earlier, at the beginning of the decade on the occasion of an exhibition of Snow's work at the Galeries Gilles Gheerbrandt in Montreal, in which the flame paintings occupied an important place. Regina Cornwell reported, "as I walked into the Galerie Gilles Gheerbrandt in Montreal in mid-January, in my first glance over the exhibition of new Snow works all dating from 1979 I caught sight of four large photographs of flames...."[25] It might not be an exaggeration to say that, at a symbolic level, these works can be seen as marking the disappearance of our world, of a world that can be grasped simply and in a holistic manner.

However, before pursuing these thoughts, it might be helpful to consider a group of sculptures that the artist executed in 1982. At one level, these works can be said to effect a reconnection with reality. Perhaps in reaction to the direction his work was taking, Snow worked on a body of sculptures which, as Christopher Dewdney remarked, were for the most part "generated purely from the properties of vision".[26] These sculptures included such works as *Sighting*, *Monocular Abyss*, *Seated Sculpture* and *Zone*. Within the context of Snow's career, a link can be established between these recent works and a series of sculptures (*Scope* and *Blind*, for example) that he executed directly after the Walking Woman Works. This rapport resides at the level of visual perception. Generally speaking, the sculptures are like viewing devices or apparatuses which involve the viewer's participation in the act of viewing. A striking aspect of the 1982 sculptures is their tendency to bring forth a very pragmatic sense of the world, a sense that stands in strong contrast to the elusive quality of the world as conveyed in the photo-based works. In fact, these new works function almost by opposition, while simultaneously emphasizing Snow's complex perception of the world at this particular time. *Monocular Abyss*, for example, invites the viewer to consider the abyss or total, pure, unadulterated darkness. *Sighting*, on the other hand, focuses the eyes on the wall. With *Core* — also made at this time — a large, precarious-looking tower of clay, which similarly exhibits a highly tactile quality, brings us face

**Quintet** 1984 (top)
**Derma** 1990 (bottom)
**Bees Behaving on Blue** 1979 (over)

451

**Zone** 1982 (above)
**Stereo** 1982 (right)

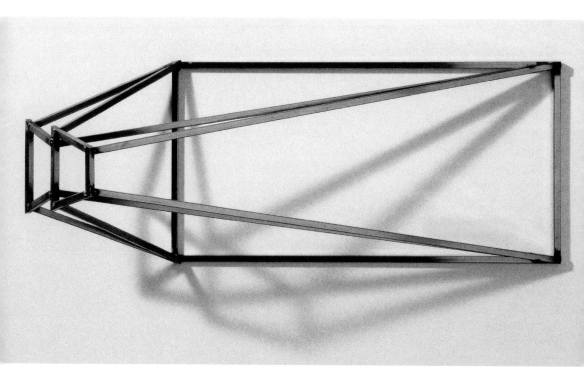

**Sighting** 1982 (above)
**Monocular Abyss** 1982 (right)

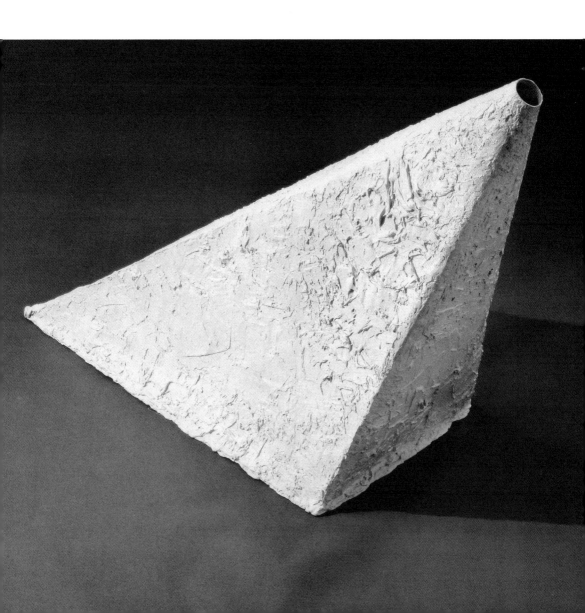

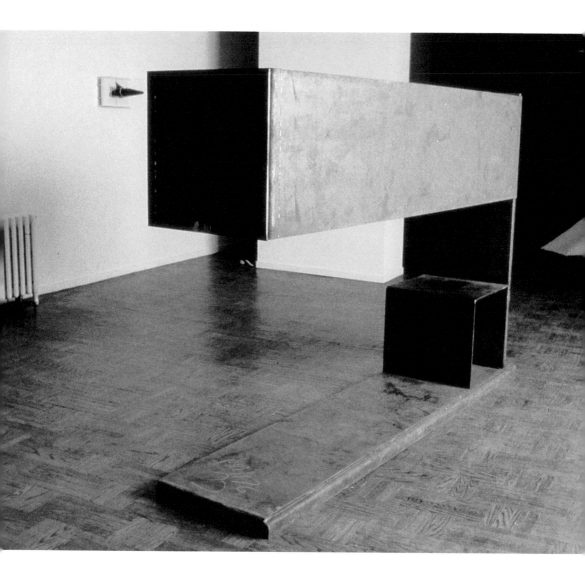

to face with the "almost impossible," since the work is probably the largest clay work ever made. Yet, despite its overwhelming size and the flaws that occurred in the firing process — it is, indeed, a Tower of Babel — the work exudes "presence."

For various reasons, these works have not been the focus of much critical attention, and, when they were, they were not always well-received.[27] This may be explained by the fact that they tend to be lacking in "ecstasy" or drama and to favour "analysis," two terms that well described Snow's production in this period, and which Snow himself was to use to refer to his own work.[28] On the other hand, if we consider the direction of Snow's practice until now, it is easy to understand his need to reconnect in a very tangible way with the world and to try to surmount, perhaps, the gulf that seems to be expanding in his apprehension of objects.

A related process occurred after the making of the Walking Woman Works, when Snow proceeded to produce a series of sculptures or viewing apparatuses. With the Walking Woman Works, Snow framed a representation of a woman using a paper cutout as a device to render that figure. As a result of this process, the figure was twice, sometimes three times removed from the Real (e.g. *Sleeve*, 1965). The sculptures that followed this tended to be like frames onto a real world. These passages between reality and representation, provided by framing-devices of various kinds, tend to appear at regular intervals in Snow's career. No doubt they are a means for Snow to pull back somehow and measure, in the Real or against the Real, how far his analytical process has taken him.

At another level, the direct contact of the artist's hands with artistic materials, which the making of some of Snow's Eighties sculptures required (especially *Core* and *Monocular Abyss*), can also be seen as a means of feeling the Real and of working with something tangible. This sense of manipulation is one that was to recur in some other works during the Eighties, although with a different purpose in mind. Among such works (to be discussed below) are *Meeting of Measures* (1983), *Race* (1984) and *The Audience* (1989).

At more or less the same time that he was working on these sculptures, Snow pursued his inquiries within the photographic medium. *Still-Living (9 x 4 Acts, Scene One)* is a suite of *mise-en-scènes* in which miscellaneous objects are the actors and the still-life the èsite of the micro-enactments. The work consists of thirty-six dye-transfer miniature images organized in groups of four on nine pages. Each of the pages contains four different versions of the staging of a wide range of objects, including bananas, nails, axes, etc. In fact, re-grouped in this work is a diversity of objects, both familiar and unfamiliar, that simultaneously refer to outdoor and indoor activities of all sorts, and which both affirm and expand the visual vocabulary relied upon to by Snow.

**Seated Sculpture** 1982

There are almost as many levels at which these groupings function as the range of elements used in making them is broad. Overall, the work reaches far beyond formal considerations. As Snow has pointed out, "The mode is the still life tradition of arrangements of objects but these images contain many objects, events and allegorical implications never before brought together on the same stage."[29]

*Meeting of Measures* is also a photographic image encompassing references both to a re-constructed Real and to the actual. The image has two elements: a box containing a large number of small plasticine human figures and, on top of that box, a foot which, by contrast to the figures, appears gigantic. The work which, at one level, clearly refers to measures of various kinds, also suggests an overpopulated, chaotic and vulnerable world, yet a world made vulnerable not by outside forces but by human presence itself. The foot is an image of an actual foot, while the mass of human beings is alluded to by plasticine figures suggesting two orders in the world: those in control and those others, who, toy-like, are subjected to superior forces.

What functions as a binding element between *Still-Living* and *Meeting of Measures* is the staged quality of the works. This sense of performance can also to be found in both *The Spectral Image* and *The Audience*. Beginning around 1985 and continuing for about four years thereafter, Snow became involved in the development of two major and multi-levelled commissions that took him away from the solitude of his studio to his involvement with, and his directing of, various teams of people. The first project, *The Spectral Image*, was developed for Expo '86 in Vancouver. The other, *The Audience*, consists of a permanent, integrated, two-part sculptural element on the façade of Toronto's SkyDome stadium.

*The Spectral Image*, which was installed in a former machine shop in Vancouver, consisted of a broad range of holographic works which were integrated within the architectural space of the building and positioned in such a way as to direct the viewer's walk through the exhibition. In this exhibition, Snow took into account every single element. As he said, "Here there is an aesthetic inclusion of the actual space of the exhibition, the gallery itself, modified by light and sound. Within this space the nature and placement of the sculpture, photos and holograms has been considered in a way which makes it all part of a single sculptural experience but which contains details within details down to the tiniest elements within the holograms."[30]

In other words, *The Spectral Image* became a world unto itself and a space where *Egg* — discussed at the very beginning of this essay — loomed ghost-like in a virtual world, a world that simultaneously advanced and receded from our view, an intangible world yet a world whose presence was intensely felt. To accomplish this, Snow turned to holography. As he explained, "Working with photography and film led me to working with holography. With this medium I've tried to create

Still-Living (9 x 4 Acts, Scene One) 1982

**Race** 1984 (above)
**Meeting of Measures** 1983 (right)

465

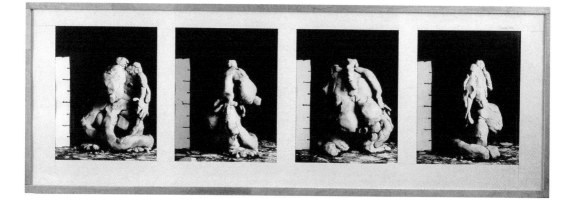

**Location, Date, Size, Weight, Materials, Condition** 1983 (above)
**Handed to Eyes** 1983 (right)

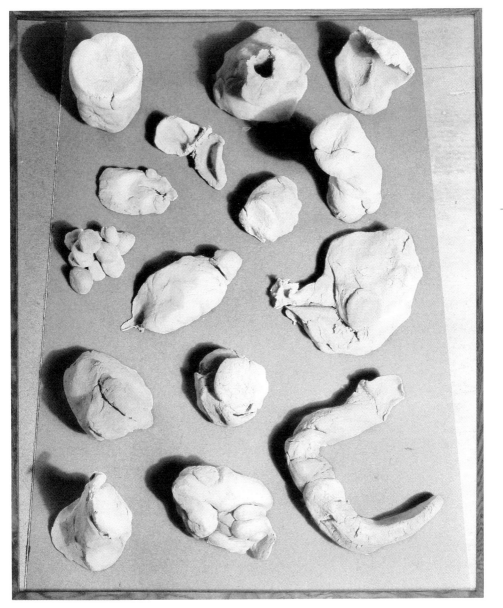

spatial situations that are otherwise impossible. The strangeness of a frozen event and the almost-palpability of a ghost is part of the spatial/temporal experience...."[31] *Egg* was not the only remarkable work in this series. The project also included *Redifice*, undoubtedly the most complex work in the Expo '86 exhibition.

*Redifice* consists of an extremely large construct with many windows opening onto scenes of various sorts which are thematically linked by the reference to the colour red. Snow himself has compared or extended the meaning of the work by drawing a relationship between its shape and colour with such elements as an operating room, a highrise building, a theatre and a classroom. In other words, *Redifice* is a complex, a space in which many events take place at many levels. It is a theatre of life in the postmodern world. Its interior is chaotic, while the many windows that adorn its surface order the presentation of the dramas or the representations of various sorts that occur within. The box is the device that both distances us and enables us to enter into the various rooms. Its role is an attempt at holding all these various types of experiences together, for otherwise there is a strong sense that this complex might fall apart. For what does a suicide and a still-life, birds and a fire-extinguisher have in common, apart from their redness, and the fact that they are all part of our world?

*Redifice* was first shown in the context of works that emphasized both this sense of the "unreal Real" while simultaneously and fleetingly conveying a sense of three-dimensionality. Taken together, the works assumed the shape of a fantastic, almost hellish world, transposing everyone and everything into a virtual condition.

No sooner was this major project completed that Snow began work on the SkyDome project. The challenge of creating a work for a building such as Toronto's domed stadium was no small one. A massive grey concrete form, almost as broad as it is tall, the SkyDome is considered an engineering feat, especially in view of its curved movable roof, which allows *plein air* activities. But if this building is an achievement in soundness of construction and utility, the same cannot be said of its appropriateness for the siting of an artwork. That Snow was capable of defeating the elephantine thrust of such a structure and creating a work that stands out while being fully integrated into the site, at the same time remaining true to his own artistic concerns, says it all in terms of his ability as an artist and his experience with public commissions. Already this had been made clear with his work at the Eaton Centre in Toronto, and it was to be reaffirmed in Washington, D.C. However, the SkyDome work is, to my mind, the most outstanding of his public commissions.

Of primary importance to our discussion here is the fact that the work re-emphasizes Snow's concerns with issues of representation. The subject of the SkyDome work is an audience. At the level of its theme, the work represents a study of gesturing spectators. There is

**Redifice** 1986 (installation view, right)
**Redifice** (details, over)

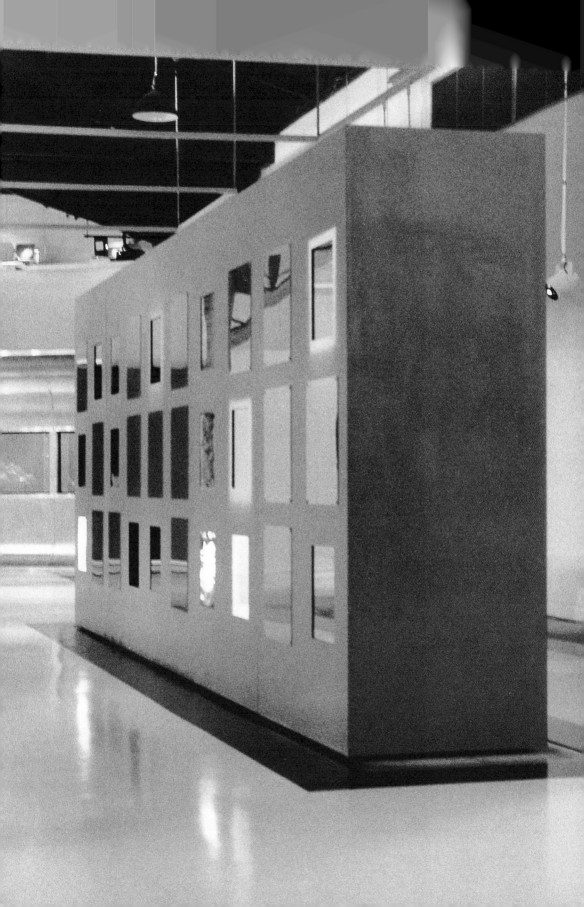

a cartoon aspect to the figures and a sense that they have been shaped in clay, an approach Snow also used in *Meeting of Measures*. This emphasizes the *mise-en-scène* quality of *The Audience*, a staging of reconstructed human beings who look upon and appear to react with a real audience. Here, in a sense, is a world totally turned upon itself. While Snow's work gradually acknowledges the role of the image in shaping our perception of the world, in *The Audience* this acknowledgement goes one step further. Representation is, in a way, anthropomorphized, both mirror-like and pro-active, to the point that it becomes *the* element that shapes our reactions to the world around us. Or, put another way, it is ourselves looking at a representation of ourselves, having, perhaps, lost the ability to experience without representation.

Some have objected to *The Audience* on the basis that it "mocks" the spectators it portrays. To my mind, while the colourful, somewhat rude, highly expressive tone of this work is in keeping with its subject, it needed, in fact, to go that far in order to provoke the viewer, to be the representation that takes on the role of a live audience in order to get the results it was seeking. Without it, the work would only function conceptually and thus would have failed. As it is, it almost takes Snow's inquiries into representation, and into this sense of a world totally conditioned by representation, to what might well be its fullest extent.

*The Audience*, after a brief return to painterly considerations and the making of such works as *Derma*, brings us back to *Conception of Light*, a work discussed at the beginning of this essay: the two disembodied eyes looking at without seeing one another. The fact that one of Snow's own eyes (blue) has been used to make this work also brings us back full circle to *Venetian Blind*, created some thirty-two years earlier.

*Venetian Blind* posed Snow in relationship to the photographic camera. Here, Snow's body — that is, a fragment of it — is posed in representation "eyeing" another representation. That the other eye is none other than that of his wife, Peggy Gale. makes this statement even more poignant. The "drama" enacted here is one we all face. Where are we but in representation? Is there any truth to what we see? What is represented as truth? Has representation become more "real" — it is certainly more actual — than the Real? And from here, to where?

It is questions such as these, questions that scholars and artists alike continue exploring, that emphasize better than any other argument the ongoing relevance of Snow's work. Snow, in fact, is unsurpassed anywhere and by anyone in the way in which he manages, generally with humour, to challenge contemporary thinking.

## Looking Ahead

My walk is over, at least for now. As the summer ends and this text is brought to a conclusion, Snow will be returning from his summer

retreat somewhere in the midst of nature. March, however, will bring to life some of the ideas that I was able to gather here during the summer. Ahead of time, I know that the lived experience of the works, their mutual dialogue and placement in the exhibition, will reveal yet other sites of reflection and new constellations to ponder upon.

There is never any summing up or, as Snow said, there are *Two Sides to Every Story*. However, as I walked through the park, some thoughts clarified themselves. That Snow's work is shaped by formal concerns, or by his interest and desire fully to explore the possibilities of the medium he happens to be working with, is beyond question. However, this consideration is equalled, if not surpassed, by his deep awareness of some of the key issues that have confronted our world in recent decades. Most importantly, the idea of a fractured world, of a world increasingly out of reach and shaped by the various media we rely upon to translate it, has been a leading consideration in his work in recent years.

In fact, this concern with issues of representation takes us back to the moment in the early Sixties when Snow conceived his first Walking Woman. As much as this body of work summed up the key concerns of artists at that period, and in many ways denoted a far more informed and in-depth understanding of those issues than most, his work of the Seventies, Eighties and Nineties exhibits a similarly deep grasp of the issues artists are grappling with at this point in our history. There is no question that Snow will continue doing so for many years to come.

### Endnotes

1. Gene Youngblood, "Icon and Idea in the world of Michael Snow", *artscanada* 28, no. 140-141 (February 1970): 2.

2. Ibid.

3. Annette Michelson, "About Snow", *October* 8 (Spring 1979): 113.

4. Michael Snow, quoted by Brydon Smith, ed., in *Michael Snow/Canada* (Ottawa: National Gallery of Canada 1970), p. 19. Catalogue for the XXXV International Exhibition of Art, Venice, 24 June to 31 October 1970.

5. K. Baynes, J. Bohman and T. McCarthy, *After Philosophy: End or Transformation?* (Cambridge, Mass. and London, England: The MIT Press, 1991) (fifth printing), p. 319. This is referred to in the context of an analysis of Hans-Georg Gadamer's thoughts. Both an analysis of and a reflection on "postmodern" or post-philosophy, this book has largely been drawn upon here to contextualize Michael Snow's ideas in the period under discussion, and in an attempt to expand this discussion beyond the field of art itself.

6. Annette Michelson, "Toward Snow", *Artforum* 9 (June 1971): 37.

7. Amy Taubin, "Doubled Visions" *October* 4 (Fall 1977): 33.

8. Michael Snow, quoted in Taubin, ibid: 35.

9. Ibid.: 33.

10. Andrée Hayum, "A Casing Shelved", *Film Culture*, no. 56-57 (Spring 1973): 87.

This was reiterated perhaps even more forcefully by Nicky Hamlyn in her discussion of *Wavelength*: "It is therefore more appropriate to talk about the film not as a quasi or fragmentary narrative, or documentary or bio-pic or whatever, but as a debate on *doubt*, which explores the relationships between what we think we see, what we can know from those perceptions and what we actually see." (Nicky Hamlyn, "Seeing is Believing: Wavelength Reconsidered", in "Sighting Snow", *Afterimage*, no. 11 [Winter 1982-83]: 24.)

11.  Snow, quoted by Bruce Elder, in "Michael Snow and Bruce Elder in Conversation", *Ciné-Tracts*, no. 12, issue 17 (1982): 16.

12.  Michael Dummett, quoted by Baynes *et al.*, *After Philosophy...*, p. 187.

13.  *Ibid.*, p. 2.

14.  *Ibid.*, pp. 10, 4, 5. For instance, "the idea that there is a true meaning to be discovered is rejected on the grounds of the essential undecidability of meaning" (p. 10).

15.  *Ibid.*, p. 5.

16.  These issues are well-known ones and have been broadly discussed in recent years. Two books address some or all these issues: Hal Foster, ed., *The Anti-Aesthetic: Essays on Postmodern Culture* (Port Townsend, Washington: Bay Press, 1983), and Hal Foster, *Recodings: Art, Spectacle, Cultural Politics* (Port Townsend, Washington: Bay Press, 1985).

17.  This thought is attributed to Hans-Georg Gadamer in Baynes *et al.*, *After Philosophy...*, p. 320. It was soon to become a widely accepted view, and many post-philosophers re-emphasized it in different ways — for instance, Karl Otto Apel, who pointed out that "His or her verbal behavior [subject] must also be interpreted by the community of investigators, and this interpretive moment can never itself be displaced by objectivistic investigation." (Ibid., p. 246.)

18.  Snow, quoted by Simon Field in "Michael Snow: A Filmography", in "Sighting Snow", *Afterimage*, no. 11 (Winter 1982-83): 12.

19.  Snow, in a manuscript proposal to the Canadian Film Development Corporation, March 1969, p. 2. This text, which has often been reproduced, was first published in *About 30 Works by Michael Snow* (Ottawa: National Gallery of Canada, 1972), an exhibition organized for The Center for Inter-American Relations, New York.

20.  Snow, quoted by Field in "Michael Snow: A Filmography": 17.

21.  Regina Cornwell, in *Afterimage* 7, quoted in ibid.

22.  Cornwell, "Michael Snow: The Decisive Moment Revised", *artscanada* (April/May 1980): 6.

23.  Snow, quoted by Elder, in "Michael Snow and Bruce Elder in Conversation": 17.

24.  Cornwell, "Snow-Bound Camera", *Artforum* 17 (April 1979): 42.

25.  Cornwell, "Michael Snow: The Decisive Moment Revised": 1.

26.  Christopher Dewdney, "Michael Snow: The Isaacs Gallery", *Vanguard* (February 1983): 36.

27.  Gary Michael Dault, "Michael Snow: The Isaacs Gallery", *Vanguard* 13 (May 1984): 31.

28.  Snow, quoted by Elder, in "Michael Snow and Bruce Elder in

**Recombinant** in Snow's Toronto studio, 1992

Conversation": 17.

    29.  Snow, "Artist's Statement", *Michael Snow* (Tokyo: Hara Museum of Contemporary Art, 1988), n.p.

    30.  Snow, quoted in Gilles Rioux, "Michael Snow, Holographe/Holographer", *Vie des Arts* 31 (June 1986): 27.

    31.  Snow, "Artist's Statement", n.p.

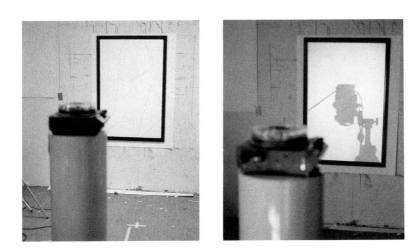

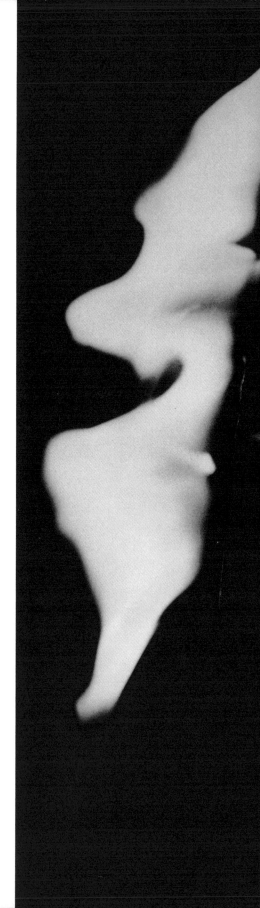

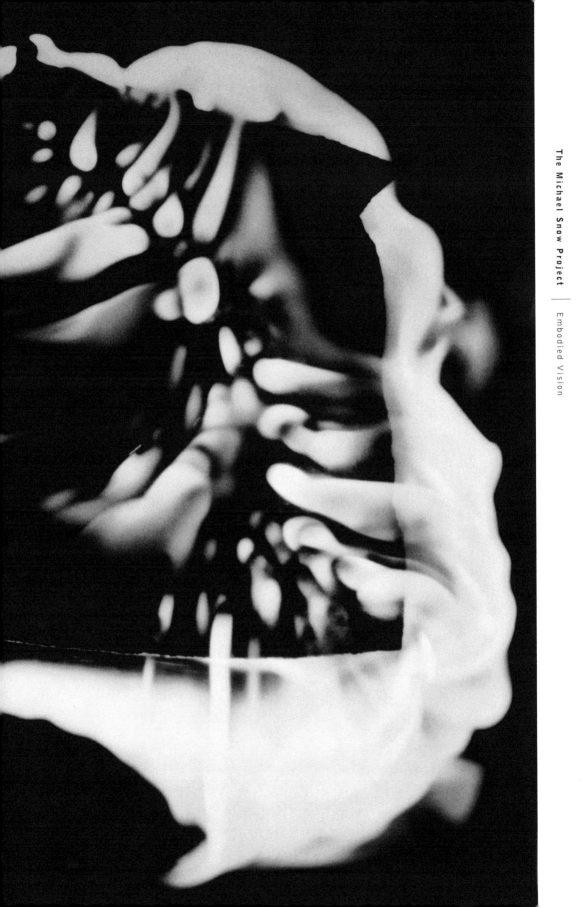

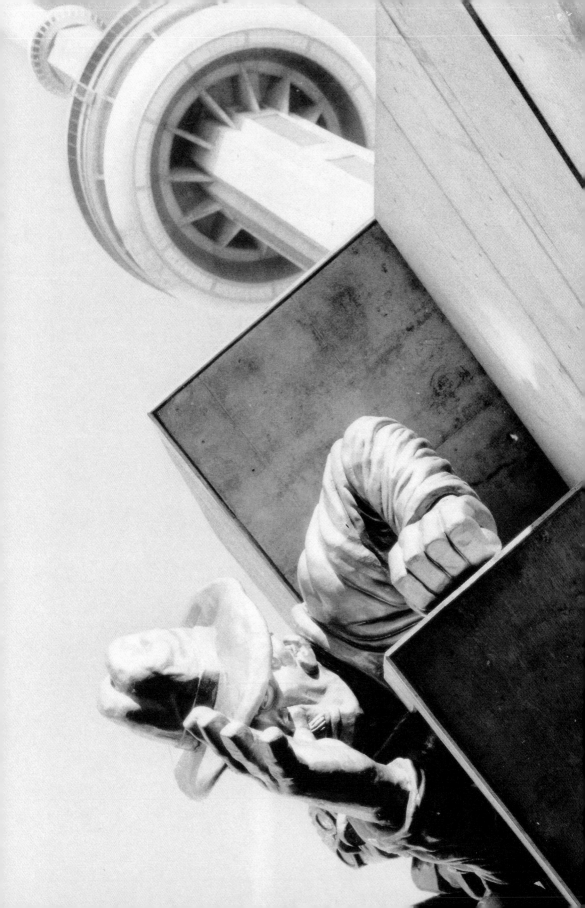

# Michael Snow: The Public Commissions

Richard Rhodes

The past century has been a century of museum art in the West. Reputations have been established on the basis of studio works circulating in private and public collections. This geography of reception has left little room for public-commission art. It has been the age of the indoor object under an institutional roof, with not much room for things delivered in the open air of public spaces.

In this context, commission work is an off-centre, marginalized type of art production. It no longer conforms to an ideal image art. We have seen no Sistine Chapels for Picasso, Louise Nevelson or Vito Acconci, only occasions for commission works that gild the edges of a career. This extraneous aspect is the status of the genre. It is largely an uncontextualized, windfall art, measurable usually only by the time it buys for artists to make other work that falls more easily within the modern story of art. If we were to draw a graph to illustrate the trajectories of different types of art over the century, there would be the public commission: at the end of a smoothly descending curve of relevance.

This diminishment is paradoxical. Despite its slide in importance, there continues to be a profusion of public commission work. "One-percent" programs adopted throughout Europe and North America set aside budgets for this kind of project. Since the 1970s, refurbished downtowns have been the sites, both indoors and out, of hundreds of competition calls for murals, reliefs, fountains, etc. But despite the boom, there is no credit in the thought that this work performs a major imaginative function. It is an amenity, nothing more.

The reasons for the stranded effect of this art evolve out the lowered expectations for it. These expectations are linked to tacit assumptions about the nature of art and its place in history. In this sense, public commission work is a victim of its own prior success. It is still sentimentally thought of in terms of its former central place within a grand heroic tradition. This was a form of art once in service to the Church, the Monarchy and the State. It was an adjunct partner to prevailing ideologies and belief systems.

In the twentieth century the surviving model of this monumental idea of public art was the great failed art of Soviet Agit-Prop. Here was an art that, despite its compromises with a cynical totalitarianism, left an image of re-imagined possibilities for the modern state. It was an

479

ambitious art linked to momentous historical events, and it held the promise of a new, radical script for the future with an imaginative energy that is still sustained, seventy-five years later, in the surviving drawings and photographs. Whether Tatlin's vast legislative capitol, built as a towering spiral, or El Lissitsky's *Proun Rooms*, this art declaimed its activism. It became synonymous with all of the young, serious faces that figured in the related poster campaigns, faces seen from below so that they looked like giants, peering off into a higher realm.

So what happens when the set changes and the inspired backdrop rolls away? The new public art is caught in its own circumstantial history and presents a different kind of image, with different actors. We see developers in suits standing in front of scale models of new head offices or shopping malls, shaking hands with artists in shirts who have just signed six-page contracts to decorate the lobbies. This is not a particularly compelling image of art; it lacks the subtexts of will, or inspiration, or lonely meditation, that are behind the idealistic conception of artmaking that we still carry with us. But this is an art cut loose from those romantic models of meaning. It is an art that is mired in the real world, a *pro forma* practice grounded in hard facts, such as the political pressures of municipal building bylaws, or the stress-capacities of poured concrete. Beyond this, it is also brokered throughout by extraneous interests, by the handlers who represent the developers, the city, the neighbourhoods and the watchdog committees of "professional standards."

The resulting image of public art is somehow more viable to a commercial narrative than to an aesthetic one, and in large part this is why public art has been the subject of so little critical energy. Within a contemporary framework, it has never seen the deep articulation that has been directed towards object art, standing without theory and without the constant revisions of purpose and interpretive need. No, public art's terrain is too confusing. There are too many players, too many projects, too many inherent compromises. It appears as if it is an art that is missing the comprehensive sense of deliberation that one sees in museum art. Despite the financial energies that hover about public work, the practice itself is an accidental marvel. It seems somehow a passive art — as if it was detached from any deep sense of need.

Museum and gallery art is, of course, linked with its capacities to represent such needs. It has a value predicated on possession, on ownership, and hence on its relation to a private viewer. This situation has evolved over the centuries but certainly, in the modern era, it is linked with deep modern drives for spectacularly individuated things. The art attaches to a conceptual world of resistance in which the art figures as an escape-valve from the homogenizing pressure of mass culture. Its meaning stems from the creation of an imaginative space that exists as a zone apart, functioning as a metaphoric parallel to

the inner psyche, a window onto private space through which a viewer can look to see the evidence of a self. With this at stake, the tacit liberal assumption holds the fate of art to be a kind of extension or flag for human fate.

With this steep set of expectations, it is no wonder that, given its generally blunt, unprotected staging, public art seems to play in a different arena than its museum or gallery equivalent. It is without the context of continuity within abstract historical thought that art institutions can so easily manifest through their architecture and their collections. This "outsiderness" explains public art's marginality, its dull aesthetic visibility. But, at the same time, it is not as if there is no ironic rebound into the art world that generates this condition for public art.

This is a professional world which is discovering that the high liberal view of art is not constant. Ideas about the purpose of art are subject to art's use, to patterns of expectations that come from beyond the museum world. Ours is a time when the meaning of art is often negotiated from a presumption of its exclusivity, both by its audience and by its practitioners. The reputation of high art has become ambivalent and uncertain, a fact mirrored by the institutions themselves as they re-gear to put a new, interactive, happy face on the museum experience. As a result, we have seen square-footage get rewritten in terms of entertainment rather than edification or meditation. The new museum is supposed to be "open" and it is, but the long and short of it is that this openness threatens the instinctual closures on which the meaning of art traditionally has been made.

With this ambivalence in the air for art in general, museum and gallery art may conceivably find itself sharing public art's marginality as a common ground. It is a real challenge, as public art knows, to contextualize art practice into a fluid, low- profile, ideological space. This is why it is perhaps more interesting not to think of public art as some lesser form of art production but rather as a harbinger of the receptive space into which contemporary art is headed. This space is a space on the other side of deep, long-term care, where there is muddle and confusion about the role of art because of an intuitive understanding that meaningful public space has disappeared into the airwaves, into an equation of broadcast licenses and cable reception fees.

Public art knows the idea of leftover public space intimately. It is an art that by its urban roots faces a largely transitory, if not predominately indifferent, audience. It can hover above, or hug the wall in a parody of invisibility or shyness or shame. The actual perception of the work is comprised of glancing passes, peripheral views or surprised confrontations. This is work with only a fractional foothold on the consciousness of its viewers, placed usually within a transit zone that channels movement from one more meaningful site to another

Government of Canada Building 1978 (details)

more meaningful site. As work, it decorates the way. It is an art of passage, its commission usually predicated on the assumption that the place of placement would otherwise be an experiential void.

When artists turn to public work, then, this fact means that they face a different context. While some might look at this production in terms of its success or failure to translate the achievements of a museum practice, it seems to me that more fruitful attention might be paid to the relation between the work and its site-limitations, and to the ways in which the work has had to adapt to compromises in its effect and meaning, as these in themselves are the significant zones of meaning for any contemporary art.

With Michael Snow, however, it is no easy job to stay clear of the themes and influences of his museum work when considering his public work. Here is an artist who has manoeuvred his production through every media in the repertoire of contemporary art, shifting from painting and sculpture into photography and film — even into holography. The curve of Snow's career is a curve away from fixity, especially the fixity of one idea of what an art object can be. It is a career in which, through the years, images of sea and flame and revolving moons have figured as signs to show that in this work there is no urgent quest for final arrival. Snow's wry, involuted stagings of representation have a way of folding different sets of visual and material fact into another.

The ultimate thematic frame for Snow's work is its destabilizing of any phenomenological status. It is work that shows a wisdom about the flux at the end of things. In his best-known film, *Wavelength*, a relentless camera zoom ends focused within the borders of a tacked-up picture of ocean waves, a conclusion that seems to laugh back at the forty-five minutes that came before, where every expectation was built on the suspense of the zoom and its likelihood of ending on a single point of closure and resolution. This work, and others, makes one aware that here is an art that would seem to understand, even predict, the predicament of unravelling contexts, an art that would find in public art's floating status a natural extension of its ongoing interests.

But there has to be a beginning — and what is interesting, if we start at Snow's beginning as a maker of public art (a commission of eleven Walking Woman Works for the Ontario Pavilion at Expo 67 in Montreal in 1967) — is that we see that the working opportunities of a public practice were in fact a spur to push his still-forming museum practice into more complex territory. The initial Walking Women were an open-ended series of paintings and multi-media works predicated on changes of colour and scale to a template shape that showed the curvaceous silhouette of a woman, stepping figuratively out into a booming and permissive new social world. Phrased in a profusion of "styles" within the shape of the contour, these were multi-media works that played on variations of sameness. The series incorporated fantasies of difference into a comedy of appearances that

skimmed across the look of the 1960s.

The Expo commission could easily have been only an extension of this work. But the literal fact of several million viewers for the commission subtly reshaped the serial project and its thematic concerns. Snow decided to create a piece that would no longer exist just within an image-realm, no longer be just a speculation or game with a representation of sameness. Here, sameness — or mass identity — would be a fact; it would become a condition into which the art would disappear as eleven stainless-steel figures stood dispersed as an installational parody of visitors moving through the exhibition space. Choosing polished stainless steel as a sculptural material was a mark of how Snow wanted these new Walking Woman Works to step beyond their other-media sisters.

With the work's neutral surface, any colour on the surface would be acquired colour, reflected from the summer shirts and dresses of the women and men wending their way through the pavilion. And while I have no memories of these sculptures from my own teenage visits to Expo, it seems to me now that, with the press of the crowds, they likely were more often than not invisible: surrogates of the people who moved alongside them, works capable 'at a distance' of generating confusion as to what — or, better yet, who — they were. This collapse of the art object into the real world around it is not a general dimension of the other works; but here, along with some other deliberately ephemeral works, it shows as a development of the capacity of the Walking Woman series to generate meaning. In response to the practicalities and pressure of a commission, the Expo commission brought underlying tensions of anomie into thematic play with a silhouette image of the woman, a case of Walking Woman stepping out bearing the existential load of her flesh-and-blood model.

This may push the point of difference between one set of Walking Woman Works and another, but all of Snow's public commissions are marked by this kind of uniquely circumstantial focus. Abstract considerations and references are largely set aside in the public works in favour of literal, site-specific demonstrations. The prime example of this is an enormous commission which Snow received in 1978, for a new Government of Canada building located in North York, north of the Toronto city limits. In many respects, this was an ideal commission, in that the architects approached the artist early in the design process and gave him a chance to devise works before final layouts were set. In the end, twenty separate pieces were placed throughout the building: in the entrance foyer, the elevators, the floors, the ceilings, the offices, their windows, even some washrooms.

These were photo-pieces, like the ones Snow showed throughout the 1970s at Toronto's Isaacs Gallery. But where the gallery works spoke to aspects and habits of perception within an art context through metaphoric images of creation — doors, projectors, flames — the

**Flightstop** 1979 (above, detail)
**Flightstop** (over, detail)

**Flightstop** (installation view)

Government of Canada Building works are distinguished by their direct and literal application to the perceptual framework of the site.

In the entrance lobby, for instance, Snow built a new capital for one of the concrete columns that dominate the space. Consisting of a tilted plane, topped with a photographic enlargement of view of one of the other columns, the work is angled in such a way that it disappears, seemingly becoming part of a general view, when the right perspective "gelled." This playful tone continues throughout.

In another space is a large, wall-mounted photographic enlargement of a keyhole to a broom-closet. It is hung around the corner from a miniaturized image of the door itself, so that walking along this particular hallway is like an *Alice in Wonderland* adventure.

In a men's washroom, Snow inset a photograph of a urinal into a bank of mirrors. The effect was that someone standing at the sink, looking into the mirrors, would have to negotiate the difference between the photographic image of a urinal and the actual reflection of urinals that showed in the mirror.

With certain windows, glued transparencies played with the visible visual elements and the perspective of the view. One substituted an archival photograph through which to see the skyline of new development in the city. These were all works that stuck to what was close at hand. They were incitements to play, incitements in a clerical office for bureaucrats to stop and think not just about the paper coming across their desks but about the views outside the window or up the escalator.

This is a commission meant to be discovered. It works on a system of lapsed revelation, and its conceptual energy makes it not only a major project but a major work of contemporary Canadian art. The commission glories in an idea of an innocent set on enjoying a visual here-and-now during nine-to-five office hours. Its accomplishment is a seamless integration with the site, a modesty of presence built into the immediacy of its staging. The only drawback is that, over the years, various components of the commission have been mishandled. Some are in disrepair, others have been buried under renovations, others have simply gone missing. On a tour of the building in the spring of 1993, Snow and I, working with a sheet of placement-notes as a reference guide, could find only about half of the original works made for the commission, and many were ruined.

While the North York project began this process of unmaking, however, Snow was busy with another one, the Eaton Centre's *Flightstop* (1979), the commission that would forever identify his name with public art in Toronto. This work proceeded with a new strategy: a consciously displaced literalism in which one kind of realism would insert itself into another. The job at hand was to design a hanging sculpture for the skylit galleria ceiling of a downtown Toronto indoor shopping centre, with three storeys of wide balconies conducting pedestrians on a north-south axis between Dundas and Queen streets. If this were

North York, we would have seen a photographic referencing of the space, visual games being played with the long view of natural light and glass that presents itself from either end. But Snow, working with the north/south orientation, came up with an altogether different solution: he would solve this particular puzzle of references with a flock of Canada Geese breaking migratory flying formation as if they were about to land at the south doors of the complex to feed.

*Flightstop* is a funny work, when you contemplate the associative leap between an air-space full of geese and a floor-space full of shoppers; funnier still, when you notice the formal perceptual play between the lead geese suspended while landing and the rising and falling banks of nearby elevators. But all of this potential comedy is smoothed over by the intricate detail-work of the geese. They are remarkably lifelike, each wearing a photographic "suit" generated from close-up pictures of a Toronto Island goose. The various images were matched and stitched over an under-form to create what is, in effect, a fully three-dimensional photograph. One imagines Snow smiling to himself for accomplishing a technical feat that is largely invisible amid the naturalistic rush of perception that likes to read these objects, time and again, as real birds. On certain days, when the crowds are thin and the air conditioning erratic, you can see the geese wobble and swing back and forth on their wires and the piece seems both morose and hokey because of its degeneration into artifice. But when the crowds come and the busyness of the place edges nerves into a fast, quick state of distraction, the geese indeed fly or, rather, appear ready to stop flying. This is a supremely ambivalent state of animation, one that, with its hesitating clarity, aptly covers the ironies of the piece.

Snow likes congested, overlapping reality games, and the Eaton Centre work, for all its ingratiating accommodation of the architectural premises of the building, nonetheless in the end manifests a rich experimentation with the imaginative possibilities of the space. His commission work for the staff cafeteria at the Canadian Embassy in Washington, D.C., designed by Arthur Erickson, which followed ten years later, does this as well. Here, the ostensible intent of the piece, which occupies a curving back wall under a narrow skylight, is to carry the view of a ceremonial entranceway into the interior eating room. What Snow has picked up on is that Washington is a city of contrived sightlines, a city where allegorical and geographical relationships between monuments and their viewing axes are intended to impress themselves on the hearts and minds of citizens. He tunes in to this visual context, then makes a work that literally miniaturizes it.

This miniaturization — an effort to stress the difference between conceptual dimensions and material dimensions — begins with the presentation of the architectural scale-model shown in the photographic mural. Other compressions also figure into the picture, such as the way the peachy tones of the colour photograph mimic the ambient

lighting in the room. Here, pink is the optical average of patriotically coloured red-and-white cafeteria furniture illuminated by hot tungsten spotlights. This colour camouflage blends the photographs into the décor of the cafeteria, yet, because it is mounted under plexiglass, the surface of the photograph also carries broken daylight reflections of the entranceway outside the cafeteria window. This interlacing of interior and exterior spaces is in itself a complicated space, but another layer of perceptual confusion is added by the photographic image of the architectural model, shown in the reflective presence of the actual architectural. Styrofoam columns, bits of tape, and stray paper-clips — all of them beefed up to an outlandish scale by the 3-by-9.1 metre size of the photograph — wreak havoc on the atmosphere of elegant monumentalism that is the *raison d'être* of Erickson's structure. It is a building which, given the challenging aspect of the mural, seems to be only a crashing stone's throw away through the window.

This kind of subversion is part and parcel of Snow's public work. Increasingly, his commissions operate as wilful alternatives to their host spaces. This is especially obvious in his work for Toronto's SkyDome stadium (1989) and in his more recent work for the head office of Confederation Life Insurance, also in Toronto (1992). The SkyDome work, called *The Audience*, involves two loge boxes set 15.2 metres high on either side of the north face of the building. The concrete bays are filled with gigantic figures that loom out and over their setting to dominate what ought to be indomitable architecture.

Seemingly responsive to the alphabetical simplicity of the A-frame buttresses that carry the profile of the structure, Snow returns a like simplicity in his figures. They have the exaggerated features of Daumier caricatures, together making a rogue's gallery of audience types. There is a fat hot-dog eater, a featureless camera-buff, a small boy, a nose-thumbing cowboy, and more. Nearly all gesticulate with hand-signals, communicating responses either of approval or of dismay. In sum, the two settings make a lexicon of non-verbal expression within crowds. Coupled with the false sense of mass generated by the *faux* bronze fibreglass casting process for the figures, they seem a wildly unreliable company of characters. They bloom into voluminous stereotypes of fandom and yet, at one and the same time, the scale and the dynamic sculptural handling gives them a mythic, heroic character.

One wonders how to read the piece with its ambivalent counter-point of human type and sculptural form. It is both a monument and a set of parade floats stranded fifty feet in the air. And no other contemporary public work pushes its context or its design purpose so completely. From a kilometre away, *The Audience* fully appropriates the building, turning the architecture into a form that simply looks like a support for the art. The piece transfers the potent energy of the spectator action inside the stadium to the spectators of the building on the outside. But the closer one draws, the more looming is the act



of representation involved. There is a disturbing challenge to any act of identification with the figures. They have a way of focusing individual attention on their viewer, pointing precisely at you amid the crowd. It is as if the work had been conceived with a warning function. The figures have ancestral roots in Dante's *Inferno* ("Abandon hope, all ye who enter here"). They mock the expectation of higher culture by elevating the fact and energy of contemporary mass entertainment.

Whither go the fans, so go the actuaries in Snow's Confederation Life piece, dating from 1992 and entitled *Red Orange Green* (after stoplights and the seasonal changes of foliage). The difference, however, is that here the aggressiveness is blunted by the artist's playfully intersecting stainless-steel trees, cut with descriptive designs marking the passage of Nature's time, as if counterpointing the timely calculations of life-insurance policies. A subtle kinetics figures into this work, which takes shape as one moves around the piece; a sculpture largely geared to being experienced from a car, it is sited in relation to curving, merging roadways. Seeing it loom up and shift from winter to summer through the passenger window as you lean into the curve around the site, the piece is nothing so much as a 7.6-metre-high flip-book that tells the story of a brisk passing of years as you pass by. Sometimes, too, there is the added thrill of seeing someone eat lunch in the stainless-steel shade of the "tree."

Who would have thought such an experience was to be had, rounding Mount Pleasant south onto Jarvis Street? But then, this is what one wants from public art. And like any contemporary art, it has to take its opportunities where it finds them.

**Red Orange Green** 1992 (top)
**The Audience** (bottom)

# Holography, "mode d'emploi":
# On Michael Snow's Approach to Holography

Derrick de Kerckhove

Michael Snow's work has been related, as he himself says, to every major art movement of our times. Perhaps no category is specific enough. One item that seems to fit Snow's work more closely is "cognitivism." Cognitive art would be that which takes perception and cognition as its principal material, and makes remembering or recognition its principal aesthetic experience, rather than impressions or emotions. Its aim is to bring us back to the origin of time and space, or, as Snow says at the end of the artist's statement for the catalogue of the retrospective of his work at the Hara Museum in Tokyo, Japan, *Time. Now.*

Holography is in and of itself a commentary on representation. Because it pushes the image to such a high level of definition, but without providing a direct evidence of material support for it, holography brings attention to the process of representing, rather than to the content of the representation. In this regard, Snow's holographic work is not essentially different from his other investigations in media, most if not all of which is concerned with how we represent things to ourselves. His other work, generally, has a neo-baroque quality that brings out the medium before the message, the moment before the object, or the humour before the meaning. Thus, in the general ambit of an era committed to technology, Snow's experiments with holography stand out like his experiments in other media, film, photography, sculpture, music, etc. They point the attention away from content and narrative to bring it back to the experience at hand.

However, Snow is not a techno-fetishist; he is not expressly concerned with the medium *per se*, but with what the medium does or can reveal about the perception of the viewer. Or rather, to be precise, he is concerned with bringing his own viewers to see "otherly," hence to discover the outer edge of representation, to reveal its functioning. This is true of the Walking Woman series, of *Wavelength*, or of his moving and humorous *Quintet*, in which a child photographed from the back is held up by his father to see a painting of a nude woman (the photographic part starts at the edge of the painting's frame, neither truly in nor truly out of the painting).

The consequence of Snow's cognitive option is that most of the holograms in this exhibition contain a reference to the process, rather

than just the effect of seeing. For example, *In/Up/Out/Door*, as a title, could be the *mode d'emploi* of the hologram, as one's gaze goes first to the plate, then to the top, only to realize that all the figures in the hologram are looking out and up. In *Maura Seated*, the stooping, snooping eye follows the curve of the subject's body to the mirror and back. In *Exchange*, the eye tries to get a good look at the images, searches and roves, only to find the images turning about, facing the viewer directly and making faces. The whimsical and benign confrontation prefigures Snow's monumental *The Audience* at Toronto's SkyDome, consisting of two groups of gigantic spectators poking fun at the public. Here, then, are some considerations about holography that might be interesting to Snow....

## Support/surface

Holography defeats our expectations regarding the relationships between the image and its support. The image of the hologram does not come from an inscription or a reflection on a surface. It cannot be said that it has no support, because it is generated by light going through or reflecting from a plate; however, the image does not occur on the plate but at an appreciable distance from it, at the intersection of light waves crossing each other in regular patterns. This is the reason why laser beams, rather than normal light-sources, are needed to record holograms, so that the light source is coherent and controlled. The space of the image is called "virtual." The absence of direct contact with its support and the consequent absence of surface give a mirage-quality to the hologram. It seems to be produced *ex nihilo*, to hover over reality, one kind of space invading another. Some holograms, such as that of the flag in Snow's *Redifice* (1986), for example, are called "pseudo-scopic"; they actually project the image outside the field of the frame to the viewer, thus invading the viewer's space.

## Matter

Michael Snow brings out this alien quality of holography by creating installations around the holographic plate: as, for example, the real skillet in *Egg*, the office door in *In/Up/Out/Door*, the real typewriter in *Typewriter*, the real trunk in *Steamer Trunk*, and the elaborate structure of *Redifice*. There is a powerful contrast between the material and the virtual objects; the real and the virtual spaces seem to check each other out, as if to see who, after all, is for real.

This magical appearance of the image out of nowhere, the fact that it seems to have no origin and no fixed space, is what gives the "ghostly" character to holograms. This effect is particularly strong when people appear in the field, as in *In/Up/Out/Door*. These ghosts look dead and alive at the same time, as ghosts should. They challenge our gaze to store them somewhere. They are contradictory, being obviously quite material and at the same time consisting

of "pure" information.

The notion here is that representation is liberated from matter. In holography, high fidelity and high definition combine with 3-D effect to propose the completed visual rendition of the volume of objects. The appearance of movement comes from shifting one's point of view, or when it is part of an animation hologram. To such cues we grant, by inference, the substance of objects. Our notion of "body" is still so largely informed by "vision" that we quite readily ignore the weight of objects. Intense work by holography artists and engineers concentrates on improving size, colour, grain and other features to augment the fidelity of the image. There is a kind of demiurgic need at work: that of doing away with matter, without losing it; of having one's cake and eating it; or of having one's wine and drinking it, as in the bread-and-wine hologram, *Redifice*. The fact that holography only selects the visual appearance, editing out touch, weight and the effects of the other senses, is often ignored by those who would see it as a "perfect illusion."

### Senses

During the aesthetic era immediately following the Renaissance, Western-European artists began to cultivate the typically Baroque conceit of putting all the senses under the domination of the eye. Whether consisting of refinements on perspective or *trompe-l'oeil*, or of texture- and shape-rendering in sculpture as well as in painting, the single-minded purpose of art was to lead us to and through the royal way of the eye. It is arguable that the attempt to translate all the non-visual sensory modalities into a visual rendering expressed the consequences of the growth of literacy, which allowed more and more human experience to be translated first into print, and then from printed words into mental images. The dominant code of alphabetic letters led readers and the people who depended upon their power (in the state, in schools, in universities and in hospitals) to favour vision and visual material. Hence, it is possible to interpret the Baroque project as the conquest of the other senses by the eye.

As we adopt a new, dominant code — the binary 0/1 code of the computer for the translation of sensory inputs into a string of numbers — we find a renewed attention to the specificity of all the senses. Force-feedback and tactility research in Virtual Reality labs, for example, represent a return to touch as a form of bodily contact and not as one of visual stimulation, as it was in *trompe-l'oeil*. We find that the dominance of vision in representation is challenged by the possibility not only of coding and making use of other sensory inputs, but also of translating these sensory inputs into the characteristics of one another. Michael Snow often confesses or professes to be a musician or a sculptor when painting, and a painter or photographer while playing jazz. His art plays in and between the senses, in and between

also of translating these sensory inputs into the characteristics of one another. Michael Snow often confesses or professes to be a musician or a sculptor when painting, and a painter or photographer while playing jazz. His art plays in and between the senses, in and between his media, to reveal their edges. Holography allows him to take an important part in the dialogue between touch and vision that the new technologies are re-introducing into the culture. Among his growing collection, there is an extremely amusing hologram that shows a stuffed fox staring at you very intently. You know that you cannot caress its alluring fur, but you really want to.

## Memory

It is very difficult to remember a hologram without actually looking at it. While it is very precise when you see it, in memory the whole image appears to be an uncertain blur, in hues of red and green and blue, or oil-slick rainbow shards. Surprisingly, the three-dimensionality does not fit the mind very comfortably. This may reflect the difficulty of seizing the full image at once, because no one can resist shifting around a hologram. There may be a conflict of interest between the form and content of memory, a cognitive dissonance in trying to remember how we remember visual data. The neurobiologist Karl Pribaum, whose work has strongly influenced some holography artists, notably Brigitte Burgmer, and inspired much philosophical reflection, proposes the hypothesis that memory works according to the same interference principle as that which rules holography, perhaps by the interferences of neural processes in the brain.
Holography does not provide the instant editing facilities that memory gives one, but, according to Pribaum, it could be the model of how our biological memory stores and processes images. It is an interesting suggestion that may lead
to the discovery of a strategy of how our minds organize their own storing devices. Do we really think holographically, or don't we? Wasn't there a — still recent — time when we seemed to beam our thoughts in our mind-space like a projection on a screen? This puzzling third dimension is exciting, but we still don't quite know what to do with it. Michael Snow is very eager to search in that direction.

## Narrative

The cutting edge in the research and development of holograms is to make them move. But such a feature is not indispensable to Snow, who can make holograms tell stories by juxtaposition. *Redifice*, for example, is a narrative explosive, with familiar scenes, daily occurrences, drama and institutional contexts. It is a wild memory-test, a huge composite hologram with 3-D and two sides, forcing the viewer to move around it and remember the other side in detail. It has windows to look into, rather than to look out from. It is a high-rise in

beginning, middle and end, nor with a unilinear sequence. It bears reading left-to-right and in reverse, left and right, up and down, back and forth, in and out, etc.

Symbols and allusions in *Redifice* are all more or less directly connected with redness. The title is a hyper-pun ("*Redificio*" means "I make red" in Snow-bound Latin). A linguistic implosive: everything red, read, ready, etc., the title *Redifice* also replaces "art" with "red," as in "artifice." The holograms included in the installation emphasize the redness of a fire-extinguisher, of blood, of the "red-light" district, of wine, of words that mean "red" in German, Italian and French. Thus *Redifice* also becomes a sort of interference gallery made of the visual and symbolic encounters of objects and notions bearing the colour red as their unifying, stabilizing feature. The coherence needed to create holograms is here symbolized by that very colour which, for the purpose of creating a "red-laser" hologram, is produced by the passage of light through argon gas.

Thus, *Redifice* behaves as a huge idiographic pun. One of the window of *Redifice* is stacked to the brim with old Chinese newspapers. Chinese poetry conveys the nuances of colour such as red, for instance, not by calling it orange, pink or crimson, but by juxtaposing many icons which have a well-connotated element of redness — for example, the characters for an orange, a rose, and blood. The proper assembly of logograms provides the expert reader with the right mixture of tones, hues and saturation that conveys the precise colouring. The *Bildung/*building of *Redifice* stands as a mirage, a construct in a gallery, a place where people go to see things but not to use them for their own purpose or to take them away.

### *"L'intuition de l'instant"*

Another key aspect of holography is its relationship to time. Because the third dimension can only be recorded if the configuration of light patterns remains constant, holography is more exacting than photography. The exposure of an object to the holographic plate requires either absolute stillness or a non-second recording. Because of its instant speed, the exposure to a pulsed laser allows the seizure of the three dimensions of an object even when it is in movement. The French call snapshots *"instantanés"*; they are taken in an instant, they mark the instant. They abstract it from the apparent flow and continuity of life and things. Pulsed-laser holography permits the representation of an object, in full detail, without blurring, at speeds which make it otherwise unavailable to the human eye. It is the clarity of the image of arrested motion that gives one the illusion of having come closer to the root, the core, the essence of the instant. Pulsed-laser holography turns photographic recording into an epiphany of time. It is almost Proustian in its power to evoke a fragment of time past in time present.

Holography reveals what Paul Virilio calls *"la profondeur du temps"*

*Redifice* (details, over)

("the depth of time") — an allusion to the photographic notion of "depth of field." What Virilio means is that, by digging into time, with today's available time-based technologies, we can expand the visible spectrum of objects and space. This is nowhere more evident than in Snow's *Egg*. The holographic element of *Egg* allows one to see the fall of the contents of a broken egg arrested in mid-air. Of course, *Egg* is also an installation, with a substantial frying-pan waiting for the egg to land. Sorry, I take that back; the pan is not waiting at all. We are bridging the gap between the egg and the pan in a state of anxious contradiction. Meanwhile, the artist — for *Egg* is also a portrait of the artist as a middle-aged cook — seems to be enjoying the cooking process, perhaps reflecting on the ingredients of our perplexity.

When he showed me *Egg*, Michael Snow invited me to observe two things: one, that the shape of the artist's hand cupped to break the shell was that of binoculars. I didn't catch the allusion right away. Later, after meditating on how Snow had taken care to transpose, in the filmic mode, the process of paying attention in *Wavelength*, a forty-five-minute zoom on a picture of ocean waves, I thought that the binoculars in a hologram were a kind of window on time. Forget the egg, look at this wonderful moment! The hologram shows the very attentive eyes of the artist, in line with the binocular-shaped hands, looking down through them towards the falling egg-content. If you lean a certain way beneath the hands, you can almost see the artist's eyes through the reverse direction. The second observation was that, by a lucky (unplanned) stroke, the shadow of the subject had been projected on the holographic plate at the instant of recording. Snow was very excited by this effect, as it brought in yet another spatial relationship to the critical moment.

## Illusion

The pulsed-laser hologram gives, more intensely than photography, an appearance of objectivity to time, just as photography usually gives a satisfactory appearance of objectivity to space, even when it is in black and white. The hologram can give this feeling of "this is it, this is the very moment!" Even the dead, corpse-like texture of most holograms does not really raise doubts as to their authenticity or the fidelity of their representational value. Holography is to theatre what photography is to perspectivist painting, that is, not merely the addition of the third dimension, but also the scientific, objective processing of representation, instead of a hand-made, man-made object, often deemed to be unreliable, doubtful. The old "illusion of reality" granted to film is also granted to holography. The supplement of depth only adds to the credibility. However, Snow is not at all interested in illusion; quite the opposite, he would probably count himself among those who fight it as hard as they can. His use of holography is part of his strategies to deal with precisely that challenge.

By questioning and revealing the strategies of seeing, Snow is at the forefront of a paradigmatic shift from space to time concerns in the immediate subconsciousness of the world culture. This shift is brought about by technology: even as the world populations and their communications networks saturate the available spatial resources with distant control and instant retrieval systems, it is becoming possible to consider time as the new frontier. Imploding, folding in upon itself, multiplying and filling all space, the human intelligence on the planet is condensed and compressed into new levels of individual and collective expressions. Of course, the mastery of time is an age-old science practised by many cultures before our day. Our libraries are full of testimonies to that effect. Snow's *Last LP*, which very convincingly simulates ancient musical traditions, is a formidable take-off on our hypocritical fetishism of ancient wisdom. The problem with the technological state-of-mind is that is can only begin to perceive the relevance of such an issue as the conquest of time, in terms of a technological control basis. We know about cryogenics, life-prolonging practices and substances, because they offer yet another technological fix for the problem of time. Snow's work deals with time as an experience beyond technology. He invites us to explore time as if it were a spatial evidence. *Egg* and *Maura Seated* seem to have the same purpose, the first addressing time, the second using space as the raw, global referent.

Depth of space is bizarre in holography; it is as if we didn't perceive space from within but from without, containing it all, so to speak. Most holograms are smaller than our field of vision. And most of them require us to "round them up," as if we summed up all the visual cues given by the additional task of moving one's head up and down and twisting one's body to catch the best angle. Jean Cocteau suggested that mirrors didn't go deep enough in their reflection: "*Les miroirs feraient bien de réfléchir davantage avant de nous renvoyer notre image*". Cocteau's poetic and filmic work was intended to transgress the barrier of the mirror, to go beyond its surface, something now available to cybernauts in Virtual Reality, and to people exposed to Snow's work.

In *Maura Seated*, we look down on a reflection of Maura looking at herself in a mirror. Thus there are two distinct and entirely believable three-dimensional spaces reflected into one, the mirrored reflection of Maura and the holographic one, the contained image supporting the authenticity of the containing one. The representation of a representation is akin to Freud's observation about the dreamer who dreams that he is dreaming: paradoxically, the content of that dream is "real." The dreamer is really dreaming. Likewise, can we say that Maura is really "seeing" when we see her reflection in the reflection of a reflection hologram? Perhaps this question is too rhetorical, however; what we can say is that the very fact of seeing in *Maura Seated* is put forward. That makes this piece resonant with the subject of Velasquez's famous

*Las Meniñas*, who is portrayed as looking at the spectator through her reflection in a mirror. This was Velasquez's way of bringing attention both to the medium of painting and to the participation of the viewer — the art patron — in the experience. His painting is meant to bring the viewer's attention to himself or herself, not as a voyeur, but as an epiphany of seeing itself, a mysterious faculty, not to be taken for granted. The point of so much of Snow's work is similarly to throw one back on oneself, not in a narcissistic way, but in a liberating one.

What this bubble of space in holography brings to the fore, even more forcefully than the effect of perspective in painting, is the distance, the foreignness, the otherness of time and space. The objectification proffered by holograms is a kind of guarantee that space and time are really "out there," even when they are not being holographed. This is a very powerful reinforcement of the illusion of reality. To be able to reveal it and make a clear statement is to throw light on the foundations of our perception. Looking at some of Michael Snow's work, I am reminded that I am a newcomer to this world — or maybe it is the world itself that has just sprung up from nowhere.

**Dimensions are given in centimetres, height preceeding width preceeding depth, unless otherwise indicated.**

1. *Window* 1960
   Wood, acrylic, polyethelene, glass, paper, cotton, wire, sheet metal and chrome-plated sheet-metal
   96.8 x 67.9 x 8.9 cm
   National Gallery of Canada, Ottawa

2. *Four to Five* 1962
   Black-and-white photographic prints mounted on cardboard
   Edition of 3
   68.0 x 83.3 cm
   Signed and dated (l.r., in ink): SNOW '62
   S.L. Simpson Gallery, Toronto

3. *Une nuit d'amour* 1963
   Photo-offset collage
   66.8 x 63.8 cm
   Mr. and Mrs. G. Montague, Toronto

4. *Announcementouncementment* 1964
   Offset lithograph mounted on board
   101.6 x 186.9 cm
   Signed and dated l.r.: SNOW '64
   S.L. Simpson Gallery, Toronto

5. *Sleeve* 1965
   Installation piece comprising twelve different parts: paint, wood, vinyl, masonite, acetate, photograph, canvas, polyethylene, plexiglass, etc.
   365.8 x 365.8 x 304.8 cm
   The Vancouver Art Gallery, Funds from the Volunteer Committee, Vancouver Foundation Endowment Income, Canada Council and B.C. Cultural Funds Matching Grants

6. *A Wooden Look* 1969
   Polaroid photographs on plywood with black marker and bronze plaque
   94.2 x 246.8 cm
   Montreal Museum of Fine Arts, Gift of Mr. and Mrs. Gyde V. Shepherd in memory of the parents of Mr. Shepherd, Françoise Vanier and William Francis Shepherd

7. *Crouch, Leap, Land* 1970
   Colour photographs (3 parts), plexiglass, metal
   Each: 40.6 x 35.6 cm
   S.L. Simpson Gallery, Toronto

8. *Sink* 1970
   Eighty 35-mm colour slides, colour photographic print
   78.7 x 45.7 cm
   S.L. Simpson Gallery, Toronto

9. *Venetian Blind* 1970
   Twenty-four Ektacolour prints
   Edition of 3
   Four sections: 126.0 x 234.0 cm
   The Canada Council Art Bank, Ottawa

10. *Of a Ladder* 1971, reprinted 1981
    Set of ten laminated photographs
    34.29 x 50.8 cm
    Albright-Knox Art Gallery, Buffalo, New York, Sherman S. Jewett Fund, 1973

11. *Glares* 1973
    Photographs, glass, light, painted wood frame
    149.2 x 100.3 cm
    North American Trust, Toronto

12. *Morning in Holland* 1969-74
    Photographs, adhesive tape, paper, enamel
    129.0 x 123.0 cm
    Private Collection, Montreal

13. *Red 5* 1974
    Dye-transfer print on paper
    66.0 x 79.2 x 4.0 cm (framed)
    Inscribed (l.r.): SNOW 74
    National Gallery of Canada, Ottawa, 1976

14. *Field* 1973-74
    Black-and-white photographs on cardboard in painted wood frame
    179.1 x 170.2 cm (framed)
    Inscribed (l.r.): SNOW 73-74
    National Gallery of Canada, Ottawa, 1974

15. *Light Blues* 1973-74
    Colour photographs, lamp, colour filter, frame
    98.8 x 178.5 cm (framed)
    Private Collection, Montreal

16. *Midnight Blue* 1973-74
    Wood, acrylic, colour photograph, wax
    73.0 x 66.0 x 12.5 cm
    Musée National d'Art Moderne, Centre Georges Pompidou, Paris (1979)

17. *Log* 1973-74
    Wood on plexiglass base and colour

photograph
2 sections: c. 280.0 x 100.0 x 24.0 cm
The Canada Council Art Bank,
Ottawa
18. *Slide* 1974
Painted plexiglass
76.0 x 147.5 cm
The Canada Council Art Bank,
Ottawa
19. *Imposition* 1976
Colour photograph, wood frame
Edition of 2, plus Artist's Proof
195.0 x 117.3 cm
Private Collection, Montreal
20. *Multiplication Table* 1977
Laminated colour photograph
109.2 x 187.9 cm
S.L. Simpson Gallery, Toronto
21. *Traces* 1977
Colour photograph
109.5 x 93.0 cm
The Canada Council Art Bank,
Ottawa
22. *Plus Tard* 1977
25 Ektacolour prints
Each: 86.0 x 107.2 cm (framed)
National Gallery of Canada,
Ottawa, 1977
23. *Hearing Aid* 1976-77
Sound installation work consisting
of four small cassette tape-recorders
and one metronome mounted on
the floor
Variable dimensions
S.L. Simpson Gallery, Toronto
24. *Painting (Closing the Drum Book)*
1978
Colour photograph, wood frame,
wood base
116.8 x 116.8 x 99.1 x 110.5
(irregular sides); height: 24.0 cm
Private collection, Montreal
25. *The Squerr (Ch'art)* 1978
Oil on canvas
194.7 x 209.2 cm
National Gallery of Canada,
Ottawa, 1979
26. *Chair-Back* 1978
Laminated colour photograph,
acrylic paint, wood frame
212.7 x 142.9 cm
S.C. Johnson Wax, Racine,
Wisconsin, U.S.A.; presented by
Canadian Johnson
27. *Waiting Room* 1978
Installation in three parts:
a framed laminated photograph,

a constructed cardboard projector
and a plywood base for the projector
124.2 x 110.5 cm (framed);
31.0 x 23.0 x 21.0 cm;
32.5 x 122.0 x 62.0 x 15.0 cm
London Regional Art and Historical
Museums, London, Ontario
28. *Times* 1979
Colour photograph, wood frame
175.3 x 170.0 cm
Milwaukee Art Museum,
Gift of Karen Johnson Boyd
29. *Bees Behaving on Blue* 1979
Colour photograph
74.5 x 90.5
The Canada Council Art Bank,
Ottawa
30. *iris-IRIS* 1979
Colour photograph, acrylic paint, post-
card on masonite mounted on panel
121.9 x 119.4 cm
Signed and dated (lower-right
centre): SNOW '79
Art Gallery of Ontario, Toronto,
purchased with assistance from
Wintario, 1980
31. *Door* 1979
Photograph, wood frame
Edition of 2, plus Artist's Proof
228.6 x 119.3 x 15.2 cm
Collection of the artist
32. *Black Burn Back* 1979
Colour photograph
114.3 x 101.0 cm
Dr. Harry and Barbara Rosenberg,
Toronto
33. *Blue Blazes* 1979
Colour photograph
87.6 x 72.4 cm
McInstosh Art Gallery,
University of Western Ontario,
Gift of John Labatt Ltd.
34. *Was Red* 1979
Colour photograph
199.0 x 67.3 cm
Fine Arts Program, Department of
External Affairs and International
Trade Canada
35. *Shade* 1979
Photo-transparency laminated
between plexiglass
122.0 x 107.0 cm
The Canada Council Art Bank,
Ottawa
36. *Rendez-vous* 1979
Colour photograph
76.5 x 113.0 cm

The Canada Council Art Bank,
Ottawa

37. *Watercolours* 1979
Colour photograph and acrylic
48.0 x 78.0 cm
Marielle L. Mailhot, Montreal

38. *P.29* 1979
Colour photograph and acrylic paint
26.8 x 50.8 cm
Mrs. S. Pollock, Ottawa

39. *X30* 1979
Colour photograph, painting
104.1 x 109.2
S.L. Simpson Gallery, Toronto

40. *Still-Living (9 x 4 Acts, Scene One)* 1982
36 colour photographs on nine pages
and one title-page
Each: 55.9 x 44.5 cm
S.L. Simpson Gallery, Toronto

41. *Zone* 1982
Plexiglass
7.9 x 2.97 m x 36.5 cm (sight)
S.L. Simpson Gallery, Toronto

42. *Sighting* 1982
Welded aluminum
38.1 x 104.1 x 27.9 cm
S.L. Simpson Gallery, Toronto

43. *Seated Sculpture* 1982
Steel
1.4 m x 53.0 cm x 2.34 m
S.L. Simpson Gallery, Toronto

44. *Stereo* 1982
Mixed media, polaroid photograph
22.9 x 38.1 x 33.0 cm
S.L. Simpson Gallery, Toronto

45. *Monocular Abyss* 1982
Alkyd-painted polyester resin
111.8 x 69.2 x 139.7 cm
S.L. Simpson Gallery, Toronto

46. *#47* 1983
Oil paint and paper on silver
gelatin print
169.5 x 119.5 cm (framed)
Fine Arts Program, Department of
External Affairs and International
Trade Canada

47. *Handed to Eyes* 1983
Oil on photograph
119.4 x 99.1 cm
S.L. Simpson Gallery, Toronto

48. *Location, Date, Size, Weight,
Materials, Condition* 1983
Photograph
64.1 x 107.3 cm
Harry and Ann Malcolmson, Toronto

49. *Meeting of Measures* 1983
Black-and-white photograph,

hand-tinted with watercolour
176.0 x 126.0 cm
The Canada Council Art Bank,
Ottawa

50. *Core* 1982-84
Unglazed ceramic
10 sections: 206.5 x 107.0 x 82.0 cm
The Canada Council Art Bank,
Ottawa

51. *Quintet* 1984
Oil on canvas with photograph
87.6 x 149.7 cm
Burle and Louise Yolles

52. *Race* 1984
Black-and-white photograph,
paint and collage
Four parts: 175.7 x 78.7 cm
Agnes Etherington Art Centre,
Queen's University, Kingston,
Purchase, Chancellor Richardson
Memorial Fund, 1991

53. *In/Up/Out/Door* 1985
Hologram, door
243.8 x 91.4 x 12.7 cm
S.L. Simpson Gallery, Toronto

54. *Maura Seated* 1985
One hologram in three-sided
plastic enclosure
Hologram: 152.4 x 139.7 x 91.4 cm
S.L. Simpson Gallery, Toronto

55. *Egg* 1985
One hologram and iron skillet on base
91.4 x 106.7 cm
S.L. Simpson Gallery, Toronto

56. *Redifice* 1986
Twenty holographic compositions,
nine holograms, eleven photographs
2.4 m x 6.0 m x 76.2 cm (overall)
S.L. Simpson Gallery, Toronto

57. *Derma* 1990
Acrylic on canvas
170.9 x 127.0 cm
S.L. Simpson Gallery, Toronto

58. *H.M. is Supposed to Have Said* 1991
Oil, acrylic on canvas
170.9 x 149.9 cm
S.L. Simpson Gallery, Toronto

59. *Conception of Light* 1992
Two round colour photographs
mounted on plastic
182.9 x 182.9 cm
S.L. Simpson Gallery, Toronto

60. *Recombinant* 1992
Slide-projector, 80 slides, cylin-
drical painted plastic stand, wall
relief (painted wood)
152.4 x 121.9 cm (approx.)

S.L. Simpson Gallery

61. *Speed of Light* 1992
Edition of 2
91.4 x 12.7 x 15.2 cm
Artists for Kids Trust, North
Vancouver School Board, Vancouver

### Books

62. *Michael Snow: A Survey* 1970
Trade edition and limited edition
(125), 125 pp., ill.
Published by the Isaacs Gallery,
Toronto and the Art Gallery of Ontario
Michael Snow/S.L. Simpson Gallery,
Toronto

63. *Cover to Cover* 1976
Published by the Nova Scotia
College of Art and Design Press
and New York University Press
Collection of the artist

64. *High School* 1979
An "education" book of drawings,
questionnaires, etc. published by
Impulse Editions, IWI
Communications and the Isaacs
Gallery, Toronto
Michael Snow/ S.L. Simpson Gallery,
Toronto

### Public Commissions

65. *Expo Walking Woman* 1967
Eleven parts, dispersed stainless
steel sculptures
Ontario Pavilion, Expo '67,
Montreal, Quebec; now in the Art
Gallery of Ontario, Toronto
Fairfield and Dubois Architects

66. *Timed Images* 1973
Collaboration with the architects
on initial concept for new buildings
at Brock University
Dispersed wall compositions,
including photography and closed-
circuit television
2.7 x 3.7 m
Brock University, St. Catherines,
Ontario
Raymond Moriyama, Architects

67. *Government of Canada Building* 1978
Twenty separate works in several
public and private locations (foyer,
offices, elevator, bathrooms, ceil-
ing, floor)
Various uses of photography
Yonge Street and Sheppard Avenue,
Toronto, Ontario
Steve Irwin/Dubois Architects

68. *Flightstop* 1979
Sculpture consisting of sixty sus-
pended three-dimensional pho-
tographs of Canada Geese
Eaton Centre, Toronto, Ontario
Zeidler/Strong Architects

69. *Ducks Drawn Back* 1981
Silk-screened images of waterfowl
of North America on suspended
transparent plastic sheets
Shaw Industries Head Office,
Toronto, Ontario

70. *The Spectral Image* 1986
Massive exhibition centred on
holography
All works, lighting, installation, con-
struction and sound by the artist
Vancouver, British Columbia
Note: several of the individual works
are listed above

71. *The Audience* 1989
Two groups of seven painted fibre-
glass figures, 15.2 metres above
ground
Height of each figure: 6.1 m (approx.)
The SkyDome, John and Peter
streets, Toronto, Ontario.
Rod Robbie, Architect

72. *Reflections* 1989
Photographic mural
9.1 x 3.0 m
Canadian Embassy, Washington, D.C.
Arthur Erickson Architects

73. *Red, Orange and Green* 1992
Stainless-steel sculpture
9.1 m (height)
Confederation Life, Jarvis and
Mount Pleasant streets, Toronto,
Ontario
Zeidler/Strong Architects

### Music

74. *The Music Room: Sonography*
 1. "Mamie's Blues", piano solo,
Michael Snow, 3:47, 1948
 2. "Victory Club Stomp", piano solo,
Michael Snow, 2:38, 1948
 3. "Montana in Toronto", Michael Snow,
3:46, 1948
 4. "Royal Garden Blues", Michael Snow,
piano and Ken Dean, trumpet,
2:55, 1949
 5. "McDougal and Brown", Michael
Snow, piano and Ken Dean, trumpet,
3:13, 1949
 6. "Willie the Weeper", Michael Snow,
piano and Ken Dean, trumpet,

2:40, 1949

7. "When the Saints Go Marching In", Ken Deans Jazz Band, 2:26, 1950
8. "Dippermouth Blues", Ken Deans Jazz Band, 3:04, 1950
9. "Save It Pretty Mama", piano solo, Michael Snow, 3:58, 1950
10. "Cherry", piano solo, Michael Snow, 3:12, 1950
11. "Ja Da", Pee Wee Russell, clarinet and Michael Snow, piano, 3:54, 1950
12. "Blues for the Baron", Brussels Band, 5:36, 1953
13. "I'll Be Glad When You're Dead", Brussels Band, 3:02, 1953
14. "New Orleans", Mike White's Imperial Jazz Band, 4:33, 1959
15. "Sweet Georgia Brown", Mike White's Imperial Jazz Band, 3:50, 1959
16. "Anything Goes", Mike Whites Imperial Jazz Band, 4:43, 1959
17. "Steamboat Stomp", Mike White's Imperial Jazz Band, 3:22, 1959
18. "Savoy Blues", Mike White's Imperial Jazz Band, 6:11, 1959
19. "Theme/The Jeep is Jumping", Mike White's Imperial Jazz Band, 6:49, 1962
20. "Theft", Mike White's Imperial Jazz Band, 2:26, 1962
21. "Is it Addicting?", The Artists' Jazz Band, 19:58, 1973
22. "Falling Starts, Part One", Michael Snow, solo, 22:43, 1975
23. "W in the D", Michael Snow, solo, 25:54, 1975
24. "Fool Moon", CCMC, 25:02, 1976
25. "Smoke", The Artists' Jazz Band, 14.43, 1977
26. "Che Wiz", The Artists' Jazz Band, 19:16, 1977
27. "October 4th", CCMC, 21:47, 1977
28. "Circuitry", Michael Snow and Larry Dubin, 4:51, 1977
29. "Qui ne sert qu'a nous faire trembler", CCMC, 7:46, 1977
30. "Free Soap", CCMC, 11:09, 1979
31. "AKA Friday the 13th", CCMC, 24:23, 1979
32. "Two Radio Solos (Excerpt)", Michael Snow, 11:50, 1980
33. "Around Blues", piano solo, Michael Snow, 45:27, 1987
34. "Wu Ting Dee Lin", The Last LP, Michael Snow, 6:06, 1987
35. "Si Nopo Da", The Last LP, Michael Snow, 3:44, 1987
36. "Amitabha Chenden Kala", The Last LP, Michael Snow, 6:23, 1987
37. "Raga Lalat", The Last LP, Michael Snow, 2:58, 1987
38. "Sinoms" (excerpt), Michael Snow, 9:13, 1989
39. "Things Go", CCMC, 24:07, 1990
40. "Chants Meeting", CCMC, 11:23, 1990
41. "Interpretation of Dreams", CCMC, 10:12, 1990
42. "Chips and Hammers", CCMC, 12:49, 1990
43. "Somewhere Else", CCMC, 10:01, 1992
44. "I Found", Jack Vorvis and Michael Snow, 5:40, 1993

**Films**

Although some of Michael Snow's films are discussed in this text, they are not individually listed here, as they form part of the film retrospective presented by the Art Gallery of Ontario and are listed in the documentation accompanying that retrospective.

# A Selected Chronology: 1970-1993

## 1970

"For the last three or four years, I have been influenced by films and by the camera. When you narrow down your range and are looking through just that narrow aperture of the lens, the intensity of what you see is so much greater." (Snow, quoted by Brydon Smith, ed., in *Michael Snow/Canada* [Ottawa: National Gallery of Canada, 1970], catalogue of the XXXV International Exhibition of Art, Venice, 24 June to 31 October 1970, p. 19].)

"[In 1970, 14 February–15 March] the Art Gallery of Ontario presented a major retrospective of Snow's work...." (Adele Freedman, "Michael Snow: Impresario of Thought" *ARTnews* 82 [June 1983]: 97).

As well, "The Toronto-born painter and maker of avant-garde films was the National Gallery's sole choice to represent Canada at the [Venice] Biennial [24 June –31 October 1970]. This was the first time representation was narrowed down to a single artist." (Kay Kritzwiser, "Art: Venice 'best ever' for Snow", *The Globe and Mail* [Toronto], 18 August 1970.).

"Michael Snow with Joyce Wieland spent ten weeks of the fall semester as visiting artist at the Nova Scotia College of Art and Design. He had just finished filming *La Région Centrale* in northern Quebec and was editing it in Halifax." (Editorial note in Charlotte Townsend, "Converging on Michael Snow's La Région Centrale", *artscanada* 38, nos. 2 and 3, issue nos. 244–245 and 246–247 [March 1982]: 124–125 ; reprint of an earlier text, published in vol. 28, no. 1, no. 152–153 [February–March 1971].)

Appointed professor of Advanced Film at Yale University.

## 1971 [1970?]

"...Snow exhibited the machine for *La Région Centrale* at the National Gallery of Canada in Ottawa as a video sculpture entitled *De La Région Centrale*. He also had a one-person show at the Bykert Gallery in New York and a film retrospective at 8 Mostra Internazionale del Nuovo Cinema in Pesaro in Italy. With Frampton, Gehr, Landow, Jacobs, Sharits, Wieland, David Rimmer and Barry Gerson he participated in 'Form and Structure in Recent Film' in Vancouver." (Simon Field, "Michael Snow: A Filmography", in "Sighting Snow", *Afterimage*, no. 11 [Winter 1982–83]: 16.)

Snow and Joyce Wieland return to Toronto from New York.

From this time on, "Snow [will] devote a large amount of his time to playing with *The Artists' Jazz Band* and with *CCMC* (the Canadian Creative Music Collective), the latter being a free improvisation group which continues to make regular tours in North American and in Europe. Both have made recordings, released through the Isaacs Gallery in Toronto." (Simon Field, "Michael Snow: A Filmography": 19.)

Attends a conference of Canadian artists. "[T]he organizing of artists is something that can be done." (Michael Snow, in Joe Medjuck, "The Life and Times of Michael Snow", *Take One* 3 [January/February 1971]: 6.).

## 1972

"Snow had made seven films in New York by the time he and Wieland returned to Toronto in 1972". (Adele Freedman, "Michael Snow: Impresario of Thought": 101.)

"[Snow] exhibited films, photographic and sound pieces at the Center for Inter-American Relations in New York, the exhibition and catalogue entitled *About 30 works by Michael Snow*." (Simon Field, "Michael Snow: A Filmography": 16.)

Included in the exhibition *Toronto Painting: 1953–1965*, organized by the Art Gallery of Ontario.

Receives a Guggenheim Fellowship.

On 5 July, delivers a speech at the opening of *Boucherville, Montreal, Toronto, London 1973*.

## 1973

"*La Région Centrale* was first shown in Britain at the 2nd Independent/Avant-Garde Film Festival in London in 1973. Snow's ambition to 'make a real landscape film' coincided with similar interests in British avant-garde film (with works by William Raban, Chris Welsby, Le Grice and others). Since then the 'landscape' film has virtually acquired the status of a 'genre' within this area of film, both in Europe and the US." (Simon Field, "Michael Snow: A Filmography": 15.)

Publication of *The Artists' Jazz Band*, a two-LP album, by Gallery Editions, Toronto.

## 1974

"*Two Sides [to Every Story]* was made for the occasion of a group exhibition, 'Projected Images', at the Walker Art Center in Minneapolis." (Regina Cornwell, "Michael Snow: Cover to Cover and Back...", *Studio International* 191 [March/April 1976]: 194.)

Visiting Artist, for a second time, at the Nova Scotia College of Art and Design in Halifax.

## 1975

Receives an Honourary Doctor of Laws degree from Brock University, Peterborough, Ontario.

Publication of *Michael Snow: Music for Whistling, Piano, Microphone and Tape Recorder* by Chatham Square Records, New York.

## 1976

"In 1976, he became the first Canadian to have a one-man show at the Museum of Modern Art in New York." (Adele Freedman, "Michael Snow: Impresario of Thought": 97.)

Ten photographic pieces by Michael Snow were shown at the Museum of Modern Art [New York] in the winter/spring of 1976. It is disturbing that this complex and moving work by a major artist, produced during roughly the same period, 1967–1976, as his historically significant work in film, received almost no critical attention in New York." (Amy Taubin, "Doubled Visions", October 4 [Fall 1977]: 33.)

"*Two Sides to Every Story*... and *Cover to Cover*, a book of photographs completed in late 1975, published as part of the Nova Scotia [College of Art and Design] Series on the eve of two Snow exhibitions which opened simultaneously on 19 February at the Museum of Modern Art in New York, a film retrospective extending through 4 March and a small show of photographs continuing until 25 April." (Regina Cornwell, "Michael Snow: Cover to Cover and Back...": 193.)

"[*Two Sides to Every Story*]...was shown at the Art Gallery of Ontario in April 1976." (Peter Perrin, "Cover to Cover: A Book by Michael Snow", *artscanada* 33, no. 3, issue no. 208–209 [October/November 1976]: 46.)

"*Michael Snow: Sept Films et Plus Tard* toured France after opening at the Centre Pompidou.

"*The First Dalhousie Drawing Exhibition* [is] organized and selected by Michael Snow for the Dalhousie University Art Gallery, January 9–28. This major and exten-sive exhibition of almost 100 drawings included works by Michael Snow, Royden Rabinowitch, Joyce Wieland, John Meredith, Ron Martin and Dennis Burton." (Anon., "The First Dalhousie Drawing Exhibition", *artscanada* 33, no. 1, issue no. 204/205 [April/May 1976]: 49.)

The work of Michael Snow is included in *17 Canadian Artists: A Protean View* organized by curator Alvin Balkind for the Vancouver Art Gallery [31 May–4 July]. (John Noel Chandler, "17 Canadian Artists: A Protean View", *artscanada* 33, no. 3, issue no. 208-209 [October/November 1976]: 56.)

Snow becomes member of CCMC; *CCMC* volumes 1 and 2 are published.

## 1977

In March, Michael Snow gives a music performance within the context of the contemporary art conference *03 23 03*. (Anon., "Reportage sur 03 23 03", *Parachute*, no. 7 [Summer 1977]: 5.)

Included in *Another Dimension*, which opened that year at the National Gallery of Canada in Ottawa.

Included in *Documenta* held in Kassel, Germany.

Publishes *CCMC*, volume 3, and *Larry Dubin and CCMC*, Music Gallery Editions, 1976–77.

## 1978

"Perhaps now in Europe the consideration of Snow as a 'filmmaker' exclusively will change, or at least broaden, in light of his long-travelling exhibition, entitled 'Michael Snow', which opened in Paris at the Centre Pompidou from December 13th to January 29th [1978], and is now making its way to museums in Lucerne [Kunstmuseum], Rotterdam [Boyans Museum], Bonn [Rheinisches Landesmuseums] and Munich [Lenbachhaus], before crossing the Atlantic to end in Montreal from December 13 to ... [January 27] 1980." (Regina Cornwell, "Snow-Bound Camera" *Artforum* 17 [April 1979]: 42–45; Adele Freedman, "Snow show an intricate delight", *The Globe and Mail*, 15 December 1979); Anon., "Michael Snow: Vernissage at the Centre Pompidou in Paris", *artscanada* 35, no. 4, issue no. 224/225 [December 1978/January 1979]: 70.)

Completes a public commission for the Government of Canada Building in North York, Ontario and a video-photo environmental sculpture for Brock University, Peterborough, Ontario.

"An English version of the catalogue was published by the Kunstmuseum, Luzern, and includes essays by Cornwell, Théberge, Noguez and an interview with Snow." (Simon Field, "Michael Snow: A Filmography": 19.)

## 1979

"...in 1979, the artist once described by critic Peter Schjeldahl in *The New York Times* as an 'avant-gardist's avant-gardist'" created *Flight Stop....* Even the geese have become famous — as an oft-reproduced symbol of Toronto's soaring aspirations." (Adele Freedman, "Michael Snow: Impresario of Thought": 97.)

"The Whitney Museum in New York held an exhibition of film and video works during the Spring and called it *Re-Visions: Projects and Proposals in Film and Video*." (John Locke, "Re-Visions at the Whitney: Schwartz, Snow, Watts, Behrman, Diamond, Beirne, Anastasi, Fisher", *Parachute*, no. 16 [Fall 1979]: 53.) In addition to Michael Snow, Buky Schwartz, Bill Beirne, William Anastasi, Morgan Fisher and the trio Robert Watts, David Behrman and Bob Diamond were invited to participate in the exhibition.

"A show at the Isaacs Gallery in Toronto ... included several new photographic pieces." (Simon Field, "Michael Snow: A Filmography": 20.]

Invited by Jean-François Lyotard to introduce some of his films at a conference on Lyotard's work at the Chateau of Cerisy-La-Salle in Normandy, France.

*CCMC* volumes 4 and 5 are published.

## 1980

"...PMA Books, Toronto, published Regina Cornwell *Snow Seen: The Films and Photographs of Michael Snow*, the first book length consideration of his work." (Simon Field, "Michael Snow: A Filmography": 20.) "[Upon the artist's return] from a six-week European tour with his improvisational ... band, CCMC", the book is launched at The Kitchen in New York on 12 June 1980. The book was launched earlier, in April of the same year, at the Isaacs Gallery in Toronto. (Roy Kekewich, "Snow Seen — and feted at New York launching", *The Globe and Mail*, 14 June 1980; see also same source on 19 April 1980.)

"... as I walked into the Galerie Gilles Gheerbrandt in Montreal in mid-January

[12 January–7 February], in my first glance over the exhibition of new Snow works all dating from 1979 I caught sight of four large photographs of flames...." (Regina Cornwell, "Michael Snow: The Decisive Moment Revised", *artscanada* [April/May 1980]: 1.)

Michael Snow is selected for *Pluralities/1980/Pluralités*, "which was offered this past summer (5 July–7 September)." (Robert Handforth, "Pluralities/1980/Pluralités", *artscanada* 37, no. 3, issue no. 238–239 [December 1980–January 1981]: 35.)

Provides a text for Roald Nasgaard's catalogue *10 Canadian Artists in the 1970s*, which opened that year at the Art Gallery of Ontario.

## 1981

Michael Snow exhibition [21 March–11 April] opens new 49th Parallel/49e Parallèle Gallery in New York. (Ronald Christ, "Michael Snow", *artscanada* 38, no. 1, issue no. 240/241 [March/April 1981]: 63.)

"...twice-weekly jams with CCMC at the Music Gallery." (John Bentley Mays, "Michael Snow in flurry of activity", *The Globe and Mail*, 4 July 1981.)

Artist's films are censored. (John Bentley Mays, "Michael Snow in flurry of activity" and "Censorship and bickering...", *The Globe and Mail*, 4 July 1981 and 2 January 1982.)

CCMC artists in residence at La Chartreuse, Avignon Festival, France.

## 1982

"'THIS'IS THE KEY WORD, IMAGE, demonstrative sign in Michael Snow's latest film, *So Is This* (1982)." (M.E. Brodzky, "This is About Michael Snow's New Film *So Is This*", *artscanada* 39, no. 1, issue no. 248–249 [November 1982]: 70.)

Snow's work is included in *Le Festival International du Nouveau Cinéma*, held in Montreal in October/November 1982. (Stephen Sarrazin, "Le Festival International Du Nouveau Cinéma", *Parachute* 30 [March/April/May 1983]: 46.)

Provides a text for the catalogue of Murray Favro retrospective exhibition, organized by the Art Gallery of Ontario.

## 1983

*Michael Snow: Selected Photographic Works* (22 February–20 March) opens at the Frederick S. Wight Art Gallery, University of California, Los Angeles.

*Venetian Blind* included in *"The Hand Holding the Brush": Self-Portraits by Canadian Artists*, organized and circulated by the London Regional Art Gallery.

Snow receives the L.A. Film Critics' Association Award for *So Is This* as "The Best Experimental Film."

Receives the Order of Canada.

Walking Woman Works opens at the Herbert F. Johnson Museum of Art, Cornell University in Ithaca, New York. Organized by the Agnes Etherington Art Centre at Queen's University in Kingston, Ontario, the exhibition toured until 1985 to such centres as Kingston, Halifax (Dalhousie Art Gallery), London, Ontario (London Regional Art Gallery), Victoria (Art Gallery of Greater Victoria) and Toronto (Art Gallery of Ontario).

Participates in the OKANADA exhibition, organized by the Akademie der Kunste, West Berlin, West Germany

## 1984

The work *Portrait 1967* is included in *Edge and Image*, an exhibition (11 January–4 February) organized by Reesa Greenberg for the Galeries Sir George Williams in Montreal. (Johanne Lamoureux, "Edge and Image. Cadrage Image", Parachute, no. 35 [June, July, August 1984]f: 28.)

*Wavelength* is included as part of the experimental film series at the Festival of Festivals held in Toronto (6–15 September). (Dot Tuer, "Experiments: The Photographic Image", *Vanguard* 13 [November 1984]: 48.)

**1985**

Works by Michael Snow are featured in *Aurora Borealis: Un Editoriale Canadien* (15 June–30 September), an exhibition held at the "newly formed International Centre of Contemporary Art)" in Place du Parc, Montreal. (Jean Tourangeau and F. Dagenais, F. "Aurora Borealis: Un Editoriale Canadien", *Vanguard* 14 [November 1985]: 21–25.)

**1986**

"At Expo 86 in Vancouver, Michael Snow has just designed and arranged his holographic gallery, The Spectral Image." (Gilles Rioux, "Michael Snow/Holographe", *Vie des Arts* 31 [June 1986]: 26.)

Work included in *How We See What We Say*, organized by the artist Ian Carr-Harris for the Art Gallery at Harbourfront, Toronto. (William Wood, "How We See What We Say", *C Magazine* 10 [Summer 1986]: 76–78.)

With the artist Juan Geuer, participates in the *Visionary Apparatus* exhibition, held at List Gallery, MIT, Cambridge, Massachusetts.

**1987**

Four works are included in *Toronto: A Play of History (Jeu d'histoire)*, The Power Plant's inaugural exhibition (1 May–17 June 1987).

Publishes *The Last LP* with Art Metropole, Toronto.

On 2 May, receives an Honorary Doctorate from the Nova Scotia College of Art and Design.

**1988**

Solo exhibition of the artist's work at the Hara Museum of Contemporary Art in Tokyo, Japan and at the Ruine der Kunste in West Berlin, West Germany. A statement by Snow is included in the Hara catalogue.

Included in the exhibition *Vanishing Presence*, organized by the Walker Art Center in Minneapolis and toured to a number of locations in Canada and the United States.

Completes *Reflections*, a public commission for the Canadian Embassy in Washington, U.S.A., and *The Audience*, for the SkyDome in Toronto.

**1990**

On 15 November, CCMC presents a concert at Montreal Musiques Actuelles — New Music America.

Snow participates in the exhibition *Passage de l'image*, organized by the Centre Georges Pompidou, Paris. The exhibition travels to Barcelona (Fundacio Caixa de Pensiones), Columbus, Ohio (Wexner Art Center), and San Francisco (Museum of Modern Art).

**1991**

Last Isaacs Gallery exhibition, Toronto. Snow is now represented by the S.L. Simpson Gallery in Toronto.

**1992**

A *Michael Snow* festival (films, exhibition, concerts, lectures) organized by the San Francisco Institute's Walter/McBean Gallery and San Francisco Cinemathèque, is held between 16 February and 21 March.

# A Selected Bibliography: 1970-1993

**Please note that, with a few exceptions, this is primarily a bibliography related to Michael Snow's visual art activities.**

Allègre, Christian. "Michael Snow, un architecte de la perception." *Le Devoir* (Montreal), 14 March 1970.

Anderson, Laurie. "Reviews and Previews." *ARTnews* 72 (January 1973): 82.

Anon. "Michael Snow." *The Telegram* (Toronto), 14 February 1970.

Anon. "On Exhibition." *Studio International* 179 (April 1970): 192.

Anon. "Venice 1970: The 35th Biennale." *Art International* 14 (May 1970): 98.

Anon. [Untitled]. *Vanguard* 1 (March 1972): 2.

Anon. [Untitled review of Center for Inter-American Relations, New York, exhibit]. *Art and Artists* 7 (December 1972): 9.

Anon. "In Review." *Art Magazine* 55 (Winter 1973): 35.

Anon. [Untitled]. *Vanguard* 2 (December 1973/January 1974): 19.

Anon. "The First Dalhousie Drawing Exhibition." *artscanada* 33, no. 1, issue no. 204/205 (April/May 1976): 49-51.

Anon. "Reportage sur 03 23 03." *Parachute*, no. 7 (Summer 1977): 5.

Anon. "Paris: Michael Snow." *artscanada* 35, no. 4, issue no. 224/225 (December 1978/January 1979): 70.

Anon. "First Snow exhibit opens in Montreal." *The Globe and Mail* (Toronto), 14 December 1979.

Arn, Robert. "The uses and transformation of history in the work of Bloore and Snow." *artscanada*, no. 198/199 (June 1975): 38-51.

Balkind, Alvin. *17 Canadian Artists: A Protean View*. Vancouver: Vancouver Art Gallery, 1976.

Battcock, Gregory. "Critique: Art and Politics at Venice/ A Disappointing Biennale." *Arts Magazine* 45 (September/October 1970): 26.

Benbow, Charles. "New canadian art a waste of time." *The Globe and Mail*, 4 March 1971.

Beveridge, Karl. "Words on Michael Snow/ Bykert Gallery/ New York/ April 1971." *artscanada* 28 (August/September 1971): 51.

Boice, Bruce. "Reviews: Center for Inter-American Relations." *Artforum* 11 (February 1973): 83-86.

Borgeaud, Bernard. "Paris." *Arts Magazine* 45 (May 1971): 50.

Borsa, Julianna. "Snow's Paris exhibit acclaimed by thousands." *The Globe and Mail* (12 February 1979).

Borsa, Julianna. "A Canadian in Paris: Michael Snow at the Centre Georges Pompidou." *Artmagazine* 10 (February/March 1979): 10-13.

Brodzky, M.E. "This is About Michael Snow's New Film *So Is This*." *artscanada* 39, no. 1, issue no. 248-249 (November 1982): 70.

Chandler, John Noel. "Reflections on/of Michael Snow." *artscanada* 31, no. 188/189 (Spring 1974): 49-52.

Chandler, John Noel. "17 Canadian Artists: A Protean View." *artscanada* 33, no. 3, issue no. 208-209 (October/November 1976): 56-59.

Christ, Ronald. "Michael Snow." *artscanada* 38, no. 1, issue no. 240/241 (March/April 1981): 63.

Cornwell, Regina. "Michael Snow: Cover to Cover and Back...." *Studio International* 191 (March/April 1976): 193-7.

——. "Michael Snow: The Decisive Moment Revised." *artscanada* (April/May 1980): 1-9.

——. "Snow-Bound Camera." *Artforum* 17 (April 1979): 42-45.

——. *Snow Seen: The Films and Photographs of Michael Snow* Toronto: Peter Martin Associates Books, 1980.

Dault, Gary Michael. "Artist extraordinaire/the snowstorm is now a blizzard." *The Toronto Star*, 24 April 1976.

——. "Michael Snow: The Isaacs Gallery." *Vanguard* 13 (May 1984): 31-32.

——. "Snow's Angel: The Bachelor Stripped Bare by His Bride(s)." *Vanguard* 14 (April 1985): 24-26.

de Duve, Thiérry. "Michael Snow" in *Passages de l'image*. Paris: Musée national d'art moderne, Centre Georges Pompidou, 1990.

Dewdney, Christopher. "Michael Snow." *Vanguard* (February 1983): 36.

Dompierre, Louise. *Toronto: A Play of History*. Toronto: The Power Plant, 1987.

———. *Walking Woman Works: Michael Snow 1961-67*. Kingston: Agnes Etherington Art Centre, 1983.

Dubois, Philippe. *L'Acte Photographique*. Paris: Fernand Nathan, 1983.

Field, Simon. "Michael Snow framed." *Art and Artists* 7 and 8 (November 1972): 20-25.

———. "Michael Snow: A Filmography." *Afterimage*, no. 11 (Winter 1982-83): 4-20.

Foreman, Richard. "Critique: Glass and Snow." *Arts Magazine* 44 (February 1970): 20-22.

Freedman, Adele. "Snow show an intricate delight." *The Globe and Mail*, 15 December 1979.

———. "Michael Snow: Impresario of Thought." *ARTnews* 82 (June 1983): 97-102.

———. "Snow discovers being Canadian a serious matter." *The Globe and Mail*, 19 April 1980.

Fry, Jaqueline. "Le Musée dans quelques oeuvres récentes." *Parachute* 24 (Fall 1981): 33-45.

Gale, Peggy. "A tableau vivant." *Parachute* 39 (Summer 1985): 33-35.

Graham, Mayo. *Another Dimension*. Ottawa: National Gallery of Canada, 1977.

Greenberg, Reesa. "Unframing the Canadian Frame." *Vanguard* 13 (February 1984): 34-36.

Grenville, Bruce. "Michael Snow." *Parachute* 35 (June-July August 1984): 36-37.

———. "Object and Reference." *Parachute* 43 (June, July, August 1986): 33-34.

Hale, Barrie. "The Vanguard of Vision: Notes on Snow and Wieland." *Saturday Night* (June 1974): 20-23.

———. "The Inventions of Michael Snow." *The Canadian Magazine* (*The Toronto Star*), 1 January 1977: 4-7.

Handforth, Robert.

"Pluralities/1980/Pluralités." *artscanada*, 37, no. 3, issue no. 238/239 (December 1980/January 1981): 35-38.

Hayum, Andrée. "A Casing Shelved." *Film Culture*, no. 56-57 (Spring 1973): 81-89.

Hume, Christopher. "Snow's back and in good humour." *The Toronto Star*, 19 May 1991.

Keeler, Judy. *Lives and Works of the Canadian Artists: Michael Snow (1929-)*. Toronto: Dundurn Press, 1977.

Kekewich, Roy. "Snow Seen – and feted at New York launching." *The Globe and Mail*, 14 June 1980.

Klepac, Walter. "The Order of Words/ The Order of Things: Deconstruction in Contemporary Art." *C Magazine*, no. 3 (Fall 1984): 42-51.

Kritzwiser, Kay. "FROM ISLAND TO IMAGE: AT THE GALLERIES: An exhaustive Survey of Snow at AGO." *The Globe and Mail*, 14 February 1970.

———. "Art: Venice 'best ever' for Snow." *The Globe and Mail*, 18 August 1970.

Lamoureux, Johanne. "Edge and Image/ Cadrage, Image." *Parachute*, no. 35 (June, July, August 1984): 28.

Leclerc, Denise. *The Crisis of Abstraction in Canada: The 1950s*. Ottawa: National Gallery of Canada, 1993.

Locke, John. "Re-Visions at the Whitney: Schwartz, Snow, Watts, Behrman, Diamond, Beirne, Anastasi, Fisher." *Parachute*, no. 16 (Fall 1979): 53-55.

Lord, Barry. "Snow in Venice." *Art and Artists* 5 (June 1970): 51-53.

McGrath, Jerry. "The Red Fox: Michael Snow." *C Magazine* 16 (December 1987): 20-21.

Mays, John Bentley. "Canada's art child christened." *The Globe and Mail*, 21 March 1981.

———. "Censorship and bickering, tight belts and slow sales." *The Globe and Mail*, 2 January 1982.

———. "'It's often necessary,' Snow says, 'to define your own direction.'" *The Globe and Mail*, 1 December 1984.

———. "Michael Snow in flurry of activ-

ity." *The Globe and Mail*, 4 July 1981.

———. "Walking Woman returns: Snow's smart and sassy icon goes on tour." *The Globe and Mail*, 11 February 1984.

Medjuck, Joe. "The Life and Times of Michael Snow." *Take One* 3 (January/ February 1971): 6-12.

Mekas, Jonas, Michael Snow and Pierre Théberge. *About 30 Works by Michael Snow*. New York: Center for Inter-American Relations, 1972.

Micha, René. "Paris: Michael Snow." *Art International* 9 (February 1979): 45-51.

Michelson, Annette. "About Snow." *October* 8 (Spring 1979) pp. 111-25.

———. "Toward Snow." *Artforum* 9 (June 1971): 30-37.

Monk, Philip. "Colony, Commodity and Copyright: Reference and Self-Reference in Canadian Art." *Vanguard* 12 (Summer 1983): 14-17.

Nasgaard, Roald. *10 Canadian Artists in the 1970s*. Toronto: Art Gallery of Ontario, 1980.

Needham, Gerald. "Michael Snow." *artscanada* 36, no. 4, issue no. 232/233 (December 1979-January 1980): 75-76.

*Options and Alternatives: Some Directions in Recent Art*. New Haven, Conn.: Yale University Art Gallery, 1973.

Patton, Holly. "AROUND TOWN: Michael Snow Retrospective." *Art Magazine* 1 (Spring 1970): 9.

Payant, René. "L'Art à propos de l'art." *Parachute* 18 (Spring 1980): 25-32.

Perrin, Peter. "Cover to Cover: A Book by Michael Snow." *artscanada* 33, no. 3, no. 208/209 (October/November 1976): 43-47.

Pontbriand, Chantal. "*Plus Tard*, Plus Tard...Michael Snow." *Parachute*, no. 17 (Winter 1979): 35-38.

Rioux, Gilles "Michael Snow, Holographer." *Vie des Arts* 31 (June 1986): 26-29.

———. "Neige sur Paris — Michael Snow." *Vie des Arts* 25 (Summer 1979): 35-37.

Roque, Georges. "Une autre dimension." *Parachute* no. 9 (Winter 1977-78): 22-24.

Sarrazin, Stephen. "Le Festival International du Nouveau Cinéma." *Parachute* 30 (March, April, May 1983): 46.

Smith, Brydon, ed., with statements by Michael Snow and Joyce Wieland. *Michael Snow/Canada*. Ottawa: The National Gallery of Canada 1970.

Taubin, Amy. "Doubled Visions." *October* 4 (Fall 1977): 33-42.

Théberge, Pierre. "Michael Snow: Lacöon of the People." *Parachute* 56 (October 1989): 40-42.

———. "Michael Snow, la realité et les apparences." *Michael Snow*. Tokyo: Hara Museum of Contemporary Art, 1988.

——— and Christopher Dewdney. *Michael Snow: Selected Photographic Works*. Los Angeles: Frederick S. Wight Art Gallery, University of California, 1983.

———, A. Sayag, D. Noguez and Michael Snow. *Michael Snow*. Paris: MNAM, 1979.

———, Michael Snow, Regina Cornwell and D. Noguez. *Michael Snow*. Luzern, Switzerland: Kunstmuseum, 1979.

Tourangeau, Jean and F. Dagenais. "Aurora Boréalis: Un Editoriale Canadien." *Vanguard* 14 (November 1985): 21-25.

Townsend, Charlotte. "Converging on Michael Snow's *La Région Centrale*." *artscanada* 38, nos. 2 and 3, issue no. 244-245 and 246-247 (March 1982): 124-125.

Tuer, Dot. "Experiments: The Photographic Image." *Vanguard* 13 (November 1984): 48-49.

Wood, William. "Back to the Walls: How We See What We Say." *C Magazine*, no. 10 (Summer 1986): 36-38.

Young, Dennis, Robert Fulford, Richard Foreman, P. Adams Sitney. *Michael Snow/A Survey*. Toronto: Art Gallery of Ontario, 1970.

Youngblood, Gene. "Icon and Idea in the world of Michael Snow." *artscanada* 27, no. 140-141 (February 1970): 2-14.

## Colophon

*Exploring Plane and Contour*
 Editing: Alison Reid
*Around Wavelength*
 Editing: Karen MacCormack
 Frame enlargements of *Wavelength*:
 Kathryn MacKay
*Embodied Vision*
 Editing: Robert Stacey

Design: Bruce Mau
Design Associates:
 Kathleen Oginski and Greg Van Alstyne
Design Team:
 Kathleen Oginski, Nigel Smith, Kevin
 Sugden and Greg Van Alstyne
Film and Print Coordinator: Guy Poulin
Colour Separations: Bowne Imaging
Bookbinding: York Book Bindery
Printed in Canada by Bowne of Canada, Ltd.